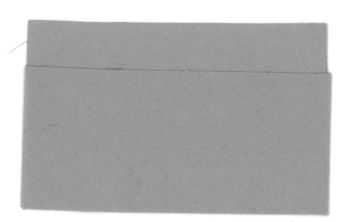

Building Jerusalem

Building Jerusalem
Art, Industry and the British Millennium

John Pick and Malcolm Anderton

ho
ap

harwood academic publishers
Australia • Canada • China • France • Germany • India • Japan
Luxembourg • Malaysia • The Netherlands • Russia • Singapore
Switzerland

Amsteldijk 166
1st Floor
1079 LH Amsterdam
The Netherlands

British Library Cataloguing in Publication Data

Pick, John, 1936-
 Building Jerusalem: art, industry and the British millennium
 1. Arts – Great Britain – Finance
 2. Art and state – Great Britain
 3. Great Britain – Civilization
 I. Title II. Anderton, Malcom Hey
 700.9'41

ISBN 90-5702-434-9

CONTENTS

ILLUSTRATIONS

ACKNOWLEDGEMENTS

In 1989 the Council of Gresham College generously agreed to sponsor my research into the historical relationship of the arts and private industry. At that time, I had no wider ambition than nailing a political lie. For several decades politicians of all hues had been saying that British industry had never been much involved with supporting the arts, and that the arts had only prospered when the state began to subsidise them in post-war Britain. Mrs Thatcher's Ministers had taken matters further, claiming that the state in the eighties was no longer capable of bearing 'the full burden' of supporting the arts, and therefore new ways must be found of bringing 'art' and private industry together, so they could fuse within a curious entity which they had already begun to call 'the arts industry'.

From the first this had seemed to be (at the least) a distortion of British history. Even a cursory study of our cultural past suggested that the relationship between art and industry in Britain is complex and of long standing, that the state has always played a comparatively minor role in the support of the arts, and that the links between art and private industry which the government was proposing were not new at all. So I and my fellow researchers simply set out to reclaim something of the real economic history of the arts in Britain.

The first step was to bring together a number of aspects which were then being forgotten (or deliberately hidden) by our state bureaucrats – including the long history of Royal and Church patronage, important cultural developments outside London and the plain fact that all of the arts in Britain had for long periods been run on a purely commercial basis, and had themselves often been profitable businesses. For their enthusiastic contributions to this basic work I was immediately indebted to Professor Simon Roodhouse (who also generously gave me sight of some of his papers on Industry and the Arts), Dr Ruth Bereson, Alexis Moustakis and Terri Palmer.

We collected evidence – all of it interesting, though much of it repetitious – from local history libraries and from local newspaper archives throughout Britain, including Bath, Birmingham, Blackpool, Bristol, Cardiff, Edinburgh, Exeter, Glasgow, Hull, Leeds, Leicester, Liverpool, Manchester, Newcastle, Nottingham, Otley, Plymouth, Sheffield, Skegness and Swansea. Valuable assistance was given in

London by the Guildhall Library and the South Bank University Library. For the central role he took in that first stage, I wish now to record my particular thanks to my colleague Dr Malcolm Anderton. I was delighted, when the research widened in scope, that he generously agreed to work with me as co-author. His constant support and meticulous eye for detail have throughout the years proved invaluable.

Dr Anderton and I published a short summary of our first findings *(Industrial Support for the Arts,* Rhinegold 1991*)*, in which we suggested that there really was no such thing as a single 'British system' of support for the arts, but instead offered some twentyfour different models of the ways arts organisations actually operated in contemporary Britain. Shortly afterwards we published a second pamphlet *(Artists and the Arts Industry,* PSI with Gresham College 1992*)*, which pointed out, amongst much else, that the 'arts economy' looked very different when one concentrated, not upon arts organisations, but on the way individual artists earned their livings.

However, as we were completing our initial findings, a series of new political developments seemed to compound the original distortion. First was the effect which the movement towards European economic integration was plainly having both upon art support systems and upon British industry in general. Second was the restoration in Britain, for the first time in more than 160 years, of a national lottery. Third was the growing desire of governments to 'celebrate' the year 2,000 as 'The Millennium'. In all of these developments it seemed that cultural history was being rewritten or discarded; that economic forces, rather than historical evolution, were becoming the primary determinants of the new culture, and judgements about artistic quality were now being made, not by a critical caucus or indeed by the public at large, but by a new and sinister breed of government bureaucrats.

More seriously still, in all these processes it seemed to us that the English language – and hence common sense – was being bludgeoned into pulp, that critical, historical and artistic terms were now being used by the political manipulators in quite new senses. Almost every kind of activity was now described as an 'industry', while 'the arts world' no longer referred to such as poets, painters, dancers, musicians or sculptors, but to semi-secret cabals of state officials, project assessors, and strategic planners. The bureaucrats' allies, the postmodernists, meanwhile assured us that pop songs and bingo were as significant as Shakespeare or Schubert, and that nothing, including the meaning of words, was now determined by its past: 'history was dead'.

A terrible mindlessness seemed to threaten, in which critical and artistic

traditions were lost in a sea of newly minted slogans about such inbred bureaucratic notions as 'Arts Development', 'The Millennium Experience' and 'The Creative Industries'. So it seemed necessary, in order to demonstrate what wan and illusory things these modern 'developments', 'industries' and 'experiences' really were, that we should widen our analysis and (running the inevitable risks of falling between academic stools, of attempting to make too many connections, and in the process passing too lightly over the surface of too many historical processes) try to write a general study which would not only investigate the long relationship between industry and art, but would also attempt to account for some of the obvious confusions within our contemporary culture; in particular those familiar words – 'leisure', 'charity', 'tourism', 'gambling' and 'lotteries', 'the millennium,' 'experience' and even 'people' – which were once generally understood but now played a part in the new Orwellian phrasebook of the state planners.

We have not been lacking in support. *Real* people still exist and among those to whom we are most indebted are Dr Adrian Seville, who has passed on to us detailed accounts of past British lotteries; Professor Caroline Gardiner, for much useful advice and in particular for drawing attention to Maria Edgeworth's novel; Peter Stark, for valuable information about working class leisure pursuits; Ian Robinson, for a vigorous critique of my 1997 Gresham lectures and invaluable notes on the dislocation of contemporary English; Professor Patrick Boylan and Mrs Pam Boylan, for scholarly assistance; and Dr Robert Protherough, for permitting us to make use of his work into the growth of literacy and for his trenchant commentary on the new arts and education 'industries'. Throughout my co-author and I have also been conscious of the debt we owe to Dr John Elsom, whose own research and critical writings (particularly in the realms of broadcasting and the media) are close in spirit to our work, and have proved a constant source of energy and inspiration. For their generous help in the preparation of this volume, we would also wish to offer our grateful thanks to Ryan Parker, Juliette Treece and to our sympathetic publisher.

Finally, we must acknowledge the patience and understanding of the Council of Gresham College, and in particular the Bursar, Maggie Butcher. To be given the time and opportunity to work in this area at all was a privilege, but the Council raised no objection either to the change in focus, or to the publication of the work in a form which runs dangerously counter to almost every fashionable tenet of modern cultural analysis. We must, therefore, make clear that neither Gresham College, nor any of the aforementioned, nor any others who are quoted in the text, can be held

responsible for the book's general argument, or for any misjudgements or errors of fact which it may contain. Those remain the authors' sole responsibility.

John Pick

Introduction:
The Shock of the Old

Bring me my bow of burning gold!
Bring me my arrows of desire!
Bring me my spear! O clouds unfold!
Bring me my chariot of fire!

I will not cease from mental fight,
Nor shall my sword sleep in my hand
Till we have built Jerusalem
In England's green and pleasant land.

Wlliam Blake, *The New Jerusalem* 1820

If truth were established merely by repetition, then anyone writing about either British industry or the state of the arts in Britain during the last decade of the second millennium would consider themselves well blessed. For constant repetition of the same song, sung by massed choirs consisting not just of old time Thatcherites, but of the guardians of New Labour, of arts councils, media pundits and of industrial correspondents, accompanied always by the fluting descant of sycophantic academics, has surely established beyond question the authorised version of Britain's cultural history. This official testament to 'industry' and 'art' is now embedded within every cultural pronouncement made by the movers and shakers of our times. So all aspiring pundits need to do to find favour with the authorities, and to establish their reputations as *bona fide* researchers, is to repeat the familiar phrases, taking care not to dilute their sweetness with any discordant historical truth.

The authorised version runs along these lines. There was very little contact between hard-nosed 'industry' and dreamy 'art' before the second world war. Indeed before the inspired creation of the Arts Council of Great Britain in 1945, there was not much art and what little there was

owed nothing to industrialisists, who naturally enough were preoccupied by their own concerns, and it owed still less to any kind of support from the common people. No, in the past virtually all British art was sustained by a special class of rich 'patrons', who in each age gave succour to a few worthy – though unworldly – artists. Before the Second World War nobody else came near to sharing the vision and concern for standards that these men had. Politicians for example were all mean-spirited, and devoid of ideals. So, lacking leadership either from state or private sector, and being of course unequipped with taste or feelings of their own, the mass of ordinary people were left to gape incomprehendingly at the tiny fragments of art which chanced to fall their way.

However, since 1945, Britain has become a very much more civilised nation. This is largely because, having taxed private patrons out of existence, the state has felt honour-bound to take over the patrons' former role in supporting the arts. And the state's new cultural helmsmen have steered a triumphant course. High among their many successes has been the twinning of industry with the arts, which has pushed artists and arts managers into the real world, and has led to the birth of a vibrant new 'arts industry', which is booming on every side. A second success has been the creation, for the first time in British history, of a national lottery, which is now pouring huge sums of new money into 'good causes' of all kinds and bringing joy to every corner of the land. Most exciting of all, lottery funds are leading the cultural industries in putting our cultural fabric back in order and in celebrating something called the 'Millennium Experience'.

This may be slightly over-coloured, but as a summary of the arts establishment's version of recent history it is not so far from reality. The researcher regularly finds just such beliefs embedded within the minds of the captains of our cultural vessels, their truth ingrained by an adamant refusal to consider alternative accounts. Indeed so insistently and so devoutly are these beliefs held and repeated that the researcher begins after a while to fear that many of these well-meaning folk have been possessed by a devilish force which is forcing them to speak in strange tongues. What else can explain their wilful misuse of so many common terms? – 'art' and 'industry' of course, but also much simpler words such as 'modern', 'public', 'quality', 'private', 'development', and even such easy-to-grasp notions as 'The Millennium'. How otherwise can we explain why our cultural planners continue to believe in their systems, and in their version of cultural history, when the real arts do not ever fall into their tidy historical grooves, and when Britain's arts support systems, equally plainly, have fallen apart?

Their hysteria must not be condoned. They must be made to confront

the fact that their strategic planning, like their authorised version of cultural history is, quite simply, wrong. It is compounded of myths and simple lies, truly believed only by the shadowy bureaucrats who wax fat by reporting from the imaginary hinterland of the 'cultural industries'. It is repeated only because of its political usefulness in seeming to bring order to what we call 'cultural policy', and giving an air of purpose to our newly-developed system of the state 'supporting the arts'

Yet the truth is that very little of the post-war apparatus of state support for the arts is new. We have had an arts council, in all but name, in Britain before. And we have long used the 'arm's length principle' in our public affairs, for all the authorised version's insistence that it is a post-war creation. Neither is Britain's new state lottery its first, although we may prefer to ignore the story of the previous lottery's collapse. More important still, the commercial sector of the British arts world has always been very much larger and of greater importance than the state-supported one. Indeed, the relationship between industry and art, which according to the authorised version had until recently been slight, has in reality long been of extraordinary richness and intimacy.

Far from having hitherto relied almost exclusively upon the patronage of the rich, the arts in Britain have in fact thrived in a great variety of economic circumstances. Over recent centuries, the arts have often been supported by industry, and even more interestingly, industry has itself sometimes been supported by the arts. At other times the arts have prospered commercially within the private sector, and have also in certain circumstances thrived unaccompanied by *any* sort of commercial transaction. Often the arts in Britain have lived by another means, which the state bureaucrats may now find convenient to forget, but which in fact has played a crucial part in our economic and cultural history – the system of public subscription.

The virtues of public subscription – the means by which a locality could invest, however humbly, in their chosen amenities and recreations – is another of the main themes of this book. We cannot be reminded too often that for centuries British theatres, museums, assembly rooms, libraries, galleries, pleasure parks, concert halls and music societies have been created and sustained by subscription schemes of various kinds. As a traditional means of funding the arts in Britain, such schemes are more significant than state support, industrial patronage or assistance from local authorities, Church or Royal Family.

Between the wars, various kinds of public subscription schemes in Britain still sustained, amongst other things, a large number of book clubs, museums, art societies, music clubs, circulating libraries, industrial

brass bands and theatre clubs. Some of the largest cinema chains and most of the small town kine-variety theatres were also built on public subscription. The Odeon cinema circuit for instance grew between 1933 and 1936 by a clever mixture of subscription and franchise. Each proposed new Odeon cinema was constituted as a separate company and asked to raise the necessary capital from local subscribers. The proffered link with the community almost invariably produced strong local support and the number of Odeon cinemas rose in three years from 26 to 142.

One of the few recorded failures of a public subscription appeal between the wars, significantly enough, was in Cambridge, where a scheme launched in 1934 and designed to yield £15,000 in subscription shares to the fledgling Arts Theatre flopped dismally. Even after intensive local campaigning, only 2,300 of the £1 shares were taken up. Following this failure the chairman, Lord Keynes, purchased the remaining shares, and in due course presented them to the Arts Theatre Trust together with a further £5,000 from his own private fortune, making him, at a net cost of £17,000, also the Cambridge Arts Theatre's chief patron.

Whether that experience contributed at all to Keynes' mistrust of populism is debatable, but what is beyond doubt, and of considerable importance to Britain's post–war cultural history, is that Keynes thereafter refused to acknowledge that any part of the British arts world had ever sustained itself by public subscription. Indeed, he went further and denied that the arts had ever thrived by any means other than the patronage of the rich – but then, of course, Keynes also maintained that before the second world war Britain had not had much in the way of art, or arts facilities, at all:

> There never were many theatres in this country or any concert-halls or galleries worth counting. Of the few we had, first the cinema took a heavy toll and then the blitz, and anyway the really suitable building for a largish audience which the modern engineer can reconstruct had never really been there. The great number even of large towns, let alone the smaller centres, are absolutely bare of the necessary bricks and mortar.

This generalisation, though often repeated by state planners, seems to betray either supreme arrogance or a determined refusal to look at the evidence. For there were not just hundreds, but thousands of theatres, concert-halls and galleries in pre-war Britain. And even setting aside their cathedrals, chapels and churches, luxury cinemas, ballrooms, museums, college halls and library meeting rooms, each of our provincial cities, like London, still boasted many buildings eminently adaptable for 'largish audiences' – Glasgow's Kelvin Hall, Bristol's

Colston Hall, Nottingham's Albert Hall, Manchester's Free Trade Hall and Bingley Hall in Birmingham come immediately to mind. And, in the 'smaller centres', quite apart from the cinemas, there still remained a vast network of libraries, assembly rooms, parish halls, town halls, churches, hotel ballrooms, chapels, school halls, dance halls, memorial halls and corn exchanges in which local people had met and danced, held public meetings, listened to concerts, read, recited and watched plays for decades. In the face of all this, for Keynes to insist that Britain was 'absolutely bare of the necessary bricks and mortar' was surely perverse.

Yet it is possible that it was neither ignorance nor perversity which led him to make the claim. In Keynes' mind, there may have already been forming that post-war redefinition of 'art' which was going to mean that only cultural activities supported by state subsidy were real and 'worth counting'. To hasten the creation of the state system Keynes not only had to ignore a great number of arts facilities and a great deal of popular art, but also had to assert that real art, the art that counted, had never been supported by the common people. The new Arts Council had to be presented as a benevolent new agency, handing over powers of patronage, for the first time in history, to the general populace.

As our account will show, this was not only a false promise, but it was based on a misleading picture of how things were. For it was not true, as Keynes insisted, that the second world war had:

...led us to one clear discovery; the unsatisfied demand and enormous public for serious and fine entertainment. That certainly did not exist a few years ago.

On the contrary, it was already clear that, given certain conditions, an enormous public for serious and fine entertainment had long existed in Britain. Two centuries before it had been clear to Johnathan Tyers, when in 1749 he staged a public rehearsal of Handel's *Music for the Royal Fireworks* in the Vauxhall Pleasure Gardens on the south side of the Thames, and drew an audience of 12,000 people, paying 2s.6d. each. A century after that it was equally clear to Charles Dickens, as he urged his publisher to increase print runs to 40,000, confident that his total readership now numbered not in the tens but in the hundreds of thousands. It was clear to Walter Besant when in the 1890s he set up the People's Palace in the Mile End Road, its main theatre three times the capacity of the largest auditorium in our present Royal National Theatre.

That an enormous public for fine work most certainly did exist in Britain was always known to such as Andrew Ducrow, John Murray, Madame Vestris, Henry Cole, Emma Cons, Henry Wood, Sidney

Bernstein, Allan Lane, Oswald Stoll, Thomas Beecham, Edward Hulton and a host of other cultural popularisers.

Yet its truth was denied again, and more vehemently, by the new Labour government's 1965 White Paper, *A Policy for the Arts; The First Steps:*

> There is a dearth of good buildings for showing and practising the arts. Part of the reason is that after the war there was such urgent need for houses and factories that little provision could be made for the civilising influences of concert halls, theatres or arts centres. Money, labour and materials were not available. Habits of neighbourliness and cooperation in community projects were not developed. The damage then unavoidably done is only now being remedied. *People who had never known what they were missing did not press for galleries, theatres and concert halls.* [Authors' emphasis]

Again, this is determinedly blind to the truth. While it could be said that for the most part people did not agitate for the *state* to provide them with galleries, theatres and concert halls, it was not because they 'had never known' what it was to relish art and design, to enjoy drama and to be moved by music. They *had* known galleries, theatres and concert halls in abundance, as well as pleasure gardens, inns, coffee houses, circuses, music halls and libraries, provided for the most part to meet a genuine need, usually by artists and businessmen working within the private sector. And now, in 1965, they were again enjoying art and design, drama and music in abundance, albeit in different forms, not because of the enlightened patronage of the rich, nor because of the provisions of the post-war welfare state, but – as had happened in the eighteenth century and again in the latter part of the nineteenth – because Britain's artists and designers, through straightforward commercial enterprise, and through the technical means that were at hand, had once more found a popular audience.

1965, the year of the *White Paper*, was also the tenth anniversary of the opening of commercial television. 15,000,000 homes received ITV in addition to the state-run BBC services, but, contrary to expectations, rocketing viewing figures had not led to a catastrophic fall in broadcasting standards. The commercial cinema, whose death had long been forecast and whose cultural impact was generally supposed to be damaging, was in fact buoyant in 1965, with high-quality films such as *The Loved One* and *The Girl With Green Eyes* drawing large first-run audiences, and films of the early sixties such as *Tunes of Glory* , *Tom Jones, The Loneliness of the Long Distance Runner* and *Taste of Honey* proving enduring international successes.

Commercial publishing houses were finding large new readerships, particularly amongst the young, for novels by such as William Cooper,

CREMORNE
GARDENS.

Open on WHIT-MONDAY, May 31, 1852.

A GRAND GALA & BALLOON ASCENT
By the celebrated Spanish Aeronaut, GUISEPPE LUNARDINI,
who will make his First Appearance this Season.

M. EUGENE ROCHEZ AND HIS COMICAL DOGS.

PERFORMANCES ON THE TIGHT ROPE
By MDLLE. VIOLANTE.

PROFESSOR TAYLOR & HIS SON, THE DOUBLE-SIGHTED YOUTH.

Grand Vocal and Instrumental Concert
BY THE CREMORNE BAND.
Conducted by BOSISIO.

THE NEW GRAND BALLET
Entitled AZURINE, or the Naiad of the Enchanted Waters.

CREMORNE BRASS BAND,
Led by SIDNEY DAVIS, will Play Selections during the Afternoon.

BRANDON LEDGER'S TROUPE OF ETHIOPIAN HARMONISTS.
CLASSICAL ILLUSTRATIONS OF SCULPTURE AND DESIGN.

DANCING TO ALL THE NEW AND FASHIONABLE MUSIC.

Kaffir Chiefs from their Native Wilds.

TERRIFIC ASCENT BY MDLLE. VIOLANTE,
SURROUNDED BY A
MAGNIFICENT DISPLAY OF FIREWORKS
BY THE CHEVALIER MORTRAM.

Doors open at Three o'clock. Balloon Ascent at Half-past Seven.

Admission, ONE SHILLING. Children, Half-Price.
SUNDAYS, after Four o'Clock—ADMISSION FREE, by Refreshment Card, SIXPENCE.

PETTER, DUFF, AND CO. PLAYHOUSE YARD, BLACKFRIARS.

Figure 1 The entertainment at the Cremorne Gardens in 1852, ranging from brass bands to ballet, gives some indication of the range of the popular arts in the Nineteenth Century.

Kensington and Chelsea Public Libraries

Kingsley Amis, Muriel Spark, Alan Sillitoe, Iris Murdoch, Keith Waterhouse, Margaret Drabble and Malcolm Bradbury. An unconventional but nevertheless hugely successful entrepreneur, Peter Cook, having created and run satirical nightclubs in London and New York, was now the majority shareholder in the highly successful satirical magazine *Private Eye*. The stridently commercial record industry was booming, selling tens of thousands of classical recordings and hundreds of millions of pop records. The Beatles alone – at the height of their popularity in the year of the *White Paper*, – sold 200 million records between 1962 and 1967.

The *Design Centre* had been opened by the Council for Industrial Design in 1956 and its influence, in large part created through the Design Centre Awards, had grown rapidly in the early sixties. By 1965 there was an unprecedented commercial boom in fashion and interior design, exemplified by entrepreneurs such as Terence Conran who had opened the first *Habitat* shop in 1964. A host of contemporary furniture makers, fashion designers, craftsmen in ornaments, photographers, fabric printers, lighting artists, set designers, toymakers and hairdressers were for the first time in British history becoming popular cultural icons – a development noted by Michael Wolff, writing in the journal of the *Society of Industrial Arts*:

> ...it is true that the sorts of designers in Britain who have really given people a bang in the last two years are Ken Adams, Art Director of the James Bond films: Frederick Stark, with his clothes for Cathy Gale, and Ray Gusick, with his daleks. People like Mary Quant and John Stephen have had the same sort of impact on a more limited age range. It is their zing, and their zest, and their vigorous understanding of what design is all about which should be one of the main contributions of industrial designers to modern society.

In the midst of all this vivid commercial success, the *White Paper* struck a muted and rather peevish note. Its pawky assertion that young people would in future want 'gaiety and colour, informality and experimentation' was rendered stillborn by the fact that young people were already plainly being offered those things in abundance by the commercial world. And for the document to add huffily:

> But there is no reason why attractive presentation should be left to those whose primary concern is with quantity and profitability.

compounded the offence. The whole of the unsubsidised arts world – all the musicians, novelists, painters, designers and entertainers who worked without subsidy – was seemingly dismissed as so much fancy packaging. The document took refuge in one of the earliest of the state bureaucrats'

post-war cultural dogmas, that nothing which is commercially successful can be real art.

The denigration of those 'whose primary concern is with quantity and profitability' would later return to haunt the arts bureaucracy, but even in the year of its publication it was strangely ill-judged. For it was not only the realms of films, television, publishing, satire, art, fashion and design which were commercially successful. Generally, British business could at last be said to be booming, though what were significantly called 'industrial relations' were a growing problem. For the moment however there was still full employment, and the 1965 average weekly earnings were almost treble their 1950 figure at £20.30. As during the same period the retail price index had barely doubled, the general sense, if not the grudging tenor, of Macmillan's assurance that Britons had 'never had it so good' seemed justified.

It is important to our argument throughout this book, and crucial to understanding the nature of the cultural changes wrought by Mrs Thatcher and her governments, that we now make a first distinction between ordinary business activity, and the very much wider economic and social judgements conveyed by the words 'industry', and 'industrial'. In the eighties, terms as various as 'industry', 'business', 'commerce', 'the market', 'enterprise' and 'the private sector' were used smearily, as if they were more or less interchangeable, with the result that they all ended up conveying more about the attitude of the speaker than denoting any very precise entity. Yet they had previously all meant quite different things.

For several centuries 'industry' had meant the cultivation of 'industrious' habits, dilligence in applying oneself to hard work. Then, in the early nineteenth century, the term industry also began to refer to the new 'industrial' processes of mass production. Then as that process ran its course, and some of the dire social consequences of industrialisation became clearer, 'industry' and 'industrial' became in part pejorative terms. In Arnold Toynbee's 1881 lectures – in which the term 'industrial revolution' was first publicly used in English – 'industrial' meant much more than the organisation of production. It meant an entirely new, and on the whole bleaker, way of life. The revolution that industry had brought involved much more than a change in the way people worked. It had affected the whole of existence, bringing with it a radical and bruising alteration to the social order, and what many saw as a standardisation of the human spirit.

That is why so many late nineteenth and twentieth century artists are impelled to warn us about the widely dehumanising effects of the Industrial Revolution. Dickens, Ibsen, Eisenstein, Conrad, Picasso,

Lawrence in their different ways can all be said to stand against the effects of that new kind of 'industry'. Yet 'industry' in its old honourable sense could still be evoked, as R. H. Tawney memorably showed in 1921 in *The Acquisitive Society*:

> There is no more fatal obstacle to efficiency than the revelation that idleness has the same privileges as industry, and that for every additional blow with the pick or hammer an additional profit will be distributed among shareholders who wield neither.

Concurrent use of the two senses of 'industry' in the first half of the twentieth century forced artists and the art world into a false position. For by setting themselves against the dark and dehumanising forces of the industrial revolution, artists seemed also to be setting themselves against industry in both of its senses, seemed also to be standing against the 'real world' of manufacturing and profit, and also much more dangerously to be detaching themselves from the everyday world of work.

It was useless to protest that it was industrialisation, not industriousness, that was the enemy of progressive thought. The word 'industry' still referred to either, or both. So for half a century and more artists were seen as fey, unworldly beings, attempting to set themselves outside the great social and economic forces that shaped the lives of ordinary working people. As a result, underlying the authorised version of our cultural heritage has been the belief that all artists were by nature workshy creatures who had to be guided through the real economic world either by their rich patrons or by their heirs, the state bureaucrats.

This particular lie is easily exposed. We need only take a cursory look at British cultural history to remind ourselves of the myriad ways in which artists have worked with the Church, with the Royal Family, but most frequently by straightforward commercial processes, making art and selling it in the market place, in order to earn their livings. That historical account will also show us the true ancestry of many of the terms which are now so airily misused by the arts establishment, and will show us that the strategic plans made by arts bureaucrats to accommodate a 'European dimension', the creation of the 'arts industry' and the highly–developed state plans for 'celebrating the Millennium', far from bringing a new hard-nosed realism into cultural planning, have drowned artists, art and arts criticism in an ocean of political vacuity. For the authorised version of British culture is essentially a still life, a stagnant post-modernist sea beneath which the past lies buried and on which the bleached vessels of the cultural planners lie becalmed.

Pulling art, artists and arts criticism back up to the surface is a dangerous business. It sets the waters swirling, and forces the planners to confront their cultural confusions, the slimy things that:

> *crawl with legs*
> *Upon that slimy sea.*

A Millennium that is being approached with neither joy nor terror, but merely as something that will provide a memorably expensive 'experience'. A Lottery on which the average household is losing several pounds a week but by which 'everybody is a winner'. Lottery funds going to restore the nation's 'cultural fabric' – civic palaces with nothing worthwhile to put in them and into which thousands of Britishers living in their own cultural fabric of cardboard boxes in shop doorways cannot afford to enter. A new 'European' culture which is somehow different from the European culture of the Renaissance, and which is now to be fashioned by politicians rather than by artists or people.

As for 'the arts', they have become a strange hybrid. They are still Lord Keynes' arts, a social benefit deserving of state charity, but they are now simultaneously a profitable 'industry', 'a highly successful part of Great Britain Plc', as the Secretary General of the state-funded Arts Council excitedly announced in 1985. So by a series of convoluted distortions the profitability and commercial success of 'the arts' is now used to bolster the argument for even greater state subsidy against their inevitable commercial failure. As the 1988 PSI report, *The Economic Importance of the Arts in Britain* artlessly put it:

> ...it became apparent only as recently as 1983...that the economic importance of the arts was attracting an interest across Europe. This was a time when central government spending on the arts was levelling off. Arguments based on their intrinsic merits and educational value were losing their potency and freshness, and the economic dimension seemed to provide fresh justification for public spending on the arts.

We might take some comfort from the fact that such tortuous arguments for increased public subsidy of the 'arts industry' plainly convinced neither economics nor politicians, for since its publication, state subsidy to the arts (of the kind the authors affected to think desirable) has in fact declined.

Yet the PSI report of a decade ago was nevertheless important. It was a portent, a harbinger of the new mindlessness about the relationship of economics, industry and art. It opened the door a little wider to the postmodern barbarians, the cultural spin-doctors who would seek not only to deny the reality of cultural traditions, but who would wish to

eradicate critical thought, who would blithely assert that quite different things such as 'industry' and 'art' can be lumped together, and insist that anything can be described as 'art', and almost anything described as one of art's consequences, providing that some immediate political purpose is achieved.

Such people have an arrogant contempt for artists and for ordinary people. They believe that their sound bites about the 'great success' of the present lottery will submerge any public consideration of the dangerous and destructive forces it has unleashed. They believe that calling 2,000 years a millennium, and insisting that it is a 'significant date' will be quite enough to convince people that their money should be spent celebrating it. In spite of public protests and public petitions they still believe that they have the right to decide behind closed doors what shall be termed 'public art' and placed in public places at the public taxpayers' expense. All this and more the modern bureaucrats believe, and all because we have neglected the duty of guarding our own cultural heritage. We have let secret bureaucratic cabals take over what should be a public concern, have let them liquify our critical language and rewrite our cultural history.

In February 1943 the wartime Education Minister, R.A.Butler, suggested to Lord Keynes that a post-war funding body for the arts should bear the title 'The Royal Council for the Arts'. It would certainly, in view of Britain's cultural history, have been more appropriate than the neo-governmental title which it in fact assumed, but then *any* title which denied the fact that Britain's art and artists have through history lived primarily by the support of ordinary people – and have more often prospered despite the assistance of church, government or Royal family than because of it – would have rested upon an historical lie.

The Virgin Queen

The masquers and mummers make the merry sport,
but if they lose their money, their drum goes dead.
Nicholas Breton,
Fantasticks 1626

In their patronage of artists the Tudors were frequently generous, sometimes mean and never quite predictable. On occasion they made the grandest of public gestures, as when Henry VII commissioned Torrigiano to create the ornate tomb for Queen Elizabeth of York and himself which was to lie in his chapel in Westminster Abbey. Even more expensive was Henry VIII's gesture of 1520 when he chose to face down Francis I of France at the Field of the Cloth of Gold. Royal artists and designers created the most sumptuous of settings for this early exercise in cultural diplomacy. The King was personally attended by five thousand colourfully dressed courtiers, and the surrounding display of flags, tents and pavilions would have put most of the modern world's millennium exhibitions to shame

For Henry was rich. He had an income of £300,000 a year, at a time when the average weekly pay of his subjects was about 15d. a week. A part of his riches he hoarded. The Royal inventory made after his death in 1547 runs to four volumes and lists more than 100,000 possessions. His wealth enabled him to bequeath a capital endowment to his successors which, in spite of their recurrent fears of bankruptcy, in the event lasted them until the Civil Wars. Much of the remainder was spent, generously, flamboyantly and often recklessly, in a way which mirrored Henry's multi-faceted personality. Each time he received an important visitor, he had the Royal apartments completely redesigned and refurnished. He

built magnificent royal residences, most notoriously Hampton Court, to which the King had turned his attention after Wolsey's fall, and which he had completed by 1529. It serves still as an magnificent monument to that part of him which yearned for grace and splendour.

He was also capable of the greatest generosity to favoured artists. In 1532, when Holbein returned from Basel to London, Henry magnanimously overlooked the fact that his previous stay had been within the circle of the now discredited Sir Thomas More, and commissioned from him the well-known series of royal portraits, the most famous of which hints at the carnal and crueller side of the King's nature.

Yet artists could just as easily find sudden disfavour with the Tudors. It was in character with her family's often uncertain temper that his daughter Elizabeth should, early in her reign, peremptorily sack her Interlude Players, because on one particular evening she did apparently not much like their choice of music. It seemed a randomly malicious act for, in the puzzled words of a court spectator, the luckless musicians' only crime had lain in chancing to choose for their evening's programme, 'such matter that they wher commondyd to leyff of....'

However, this and similar acts of royal caprice find their explanation less in the Tudor genes than in the fluctuating state of the English economy. Although we shall argue throughout this book that there is no direct relationship between any country's economic well-being and the creation of its greatest art, there is nevertheless an obvious link between a country's wealth and the kind of patronage offered at that time to its artists. In this sense the profligacy of Henry VIII, attractive though it must have seemed to his favoured coterie, caused great difficulties for his successors, who found that their dubious inheritance was largely composed either of items looted from the monastries or, more precariously, of stolen goods – chattels taken from Henry's disgraced opponents, Wolsey, Norfolk and Buckingham. The result was that the young Queen Elizabeth feared, when she ascended the throne, that not only did she face the looming possibility of national economic disaster, but that it was by no means impossible that the state might impound many of her goods and push her into a state of bankruptcy. In that light her decision quickly to remove the Interlude Players from the Royal payroll might have stemmed from prudence rather more than malice.

Yet in the event there was during Elizabeth's reign no economic collapse, and indeed the late sixteenth century English ecomony was to grow unprecedentedly strong. That this transformation came about was in large measure due to the remarkable work of Thomas Gresham, the Queen's closest financial adviser, whose influence both on the nation's wealth and its culture extends far down the years.

In 1551, Gresham had been appointed 'Royal Merchant', a post which involved him working on behalf of the British court in the financial centres of Europe. It was then his task to 'transport' (in modern circumstances we should have to be frank and use the term smuggle) large amounts of bullion to England from the Continent, to act as Royal spy in the foreign business centres and to raise and repay loans for the Royal purse from German and Flemish governments. He was successful in each of the three roles, but most particularly in the latter. At his appointment the long-standing interest on the foreign debts incurred by Henry VIII amounted to £40,000 a year, and the pound sterling was worth sixteen Flemish shillings. Within three years the pound was worth twenty two Flemish shillings, and Gresham was able to discharge all the King's debts.

For our purposes it is particularly interesting to see how Gresham himself describes his skilled manipulation of the exchange markets. In a letter written to Elizabeth shortly after her 1556 accession, he patiently explains the significance of monetary exchange rates:

> the exchange is the chiefest and richest thing only above all other, to restore your Majesty and your realm to fine gold and silver, and is the mean that makes all foreign commodities and your own commodities with all kinds of victuals good cheap, and likewise keeps your fine gold and silver within your realm.... So consequently the higher the exchange riseth, the more shall your Majesty and your realm and commonwealth flourish, which thing is only kept up by art and God's providence.

Gresham took a central role in the revaluation and overhaul of the coinage in 1561 and in 1568 founded the Royal Exchange. He is therefore, in an important sense, the founder of the British capitalist system. In Gresham's time, the creation of new reserves of capital, which could be invested in all kinds of enterprises, created a rapidly expanding economy which, amongst much else, enabled British musicians and actors gradually to lessen their former dependence on noble patronage. In due course it also enabled artists of all kinds, in different centuries and for differing lengths of time, to turn the making of art into a profitable commercial activity.

That fluctuating process will form a central part of our story, but for the moment it is important that we stand back and examine our terms more closely. For Thomas Gresham curiously refers to his skill in the exchange markets not as good politics, nor as sound economics, nor yet as an application of scientific principle, but as an *art*. This immediately plunges us into deep waters, as each of the terms of our inquiry has undergone frequent and radical changes of meaning, and what was understood in the

sixteenth and seventeenth century as 'art' was plainly quite different from the ways in which the term is most commonly used today.

Until the end of the seventeenth century 'art' was not considered to be a commodity. Neither were 'the arts' a particular collection of products nor yet a group of activities. Its later, more sublime sense did not exist either; 'art' had not yet become a magical elixir distilled from the most excellent creations of the greatest creators. Yet the word did have a clear meaning, and when we understand what it was it will no longer surprise us that Gresham should describe his actions upon the money exchanges in that way.

For operations within any kind of human activity – political, economic, religious, even the realm of witchcraft – could be described by the word. In broad terms, 'art' meant 'skill'. From the first it could refer to either of two different realms. Used or applied 'art' could, in the terms of the ancient Greeks, either be Apollian or Dionysian in nature – that is, inspirational or disruptive. The skills of art could be deployed either for high-minded, inspirational purposes, or could be used to achieve darker and more duplicitous ends. For example, we read in Ben Jonson's *Epicoene* (1609):

> *Give me a look, give me a face*
> *That makes simplicity a grace:*
> *Robes loosely flowing; hair as face;*
> *Such sweet neglect more taketh me,*
> *Than all the adulteries of art;*
> *They strike mine eyes, but not my heart.*

The adulterous, 'art' mentioned here is close to its uncomplimentary cousin 'artifice', a treacherous and disruptive entity, misleading us by its surface attractions.

'Art' could be an even darker and more disruptive force. It could refer to sorcery and devilry, and to the dark arts of witchcraft. In Shakespeare's Scottish play, when the Witches have shown Macbeth three apparently comforting apparitions, he asks a further question of them about the murdered Banquo:

> *Yet my heart,*
> *Throbs to know one thing; tell me – if your art*
> *Can tell so much, – shall Banquo's issue ever*
> *Reign in this kingdom?*

Here the witches' 'art' is diabolic and evil, and practised for the most basely disruptive of purposes. (As we shall later see, this is all a long way

from the clap-happy modern redefinition of the term, wherein 'the arts' are alleged to bring nothing but lofty thoughts and untold economic benefit to one and all.)

In earlier centuries too 'art' could also mean a skill in honestly acquired and used. Thus Milton speaks warmly in *L'Allegro* (1632) of the 'faithful Herdsman's art'. It is in this second wholesome sense of the term that King Duncan, once more in Shakespeare's *Macbeth*, while musing on the perfidy of the traitor Cawdor, laments the lack of a useful skill that might have enabled such treachery to be detected:

> *There's no art*
> *To find the mind's construction in the face:*

Here the 'art' is conceived of as entirely Apollonian, the very opposite of the dark arts of witchcraft. So bearing this duality in mind, and knowing Thomas Gresham to have been a highly literate man, it does not seem too fanciful to suggest that, when he wryly concluded that the Queen's realm and commonwealth were sustained only 'by art and God's providence', the Royal Merchant was cunningly using the term 'art' in *both* of its early senses.

The most important thing is that the application of Thomas Gresham's economic 'art' had a profound impact upon our history. Even within his lifetime new world markets were opened up, new trade created, and for Elizabethan England there followed an unprecedented period of national prosperity. Thereafter the Merchant Adventurers – still loosely organised in the old medieval way as a 'regulated company' with each member trading on his own capital – already well established as great exporters of cloth, were quickly able to seize the new opportunities. In turn they were joined by many new 'joint stock' companies, in which trade was conducted by the corporation as a whole, and profits and losses divided amongst the shareholders. New companies included the Russia Company (incorporated in 1553), the Eastland Company (1579) and the Levant Company (1581). As a result of their work, England's overseas trade grew rapidly. By the end of the sixteenth century some 130,000 cloths were being exported annually from the Port of London, which was greater than the annual export from all the English Ports during the last years of Henry VIII.

This trading boom, allied to the favourable exchange rates masterminded by Gresham, were two of the main reasons for the increase in national wealth. There was also a third, and crucial, factor. From the early years of the sixteenth century Spain had received supplies of gold from the exploitation of conquered American lands. On top of this, in

1545, came the Spanish discovery of the silver mines of Potosi, and from then on treasure from the Indies poured into her coffers. Yet Spain was still a relatively backward country, unable to resist the well-organised encroachments of its enemies. In a short space of time – partly through legitimate trade, partly through being forced into payment of Crown debts, but more particularly because of straightforward plundering – much of this newly acquired wealth found its way into England and Western Europe.

Spanish booty brought back by such adventurers as Francis Drake, whose *Golden Hind* returned from its second triumphal expedition in 1580, provided a further massive stimulus to the Elizabethan economy. Of the plunder from that expedition Keynes wrote in *A Treatise on Money:*

> [it] may fairly be considered the fountain and origin of British Foreign Investment. Elizabeth paid off out of the proceeds the whole of her foreign debt and invested a part of the balance (about £42,000) in the Levant Company; largely out of the profits of the Levant company there was formed the East India Company, the profits of which during the seventeenth and eighteenth centuries were the main foundations of England's foreign connexions, and so on.... It was not the absolute value of the bullion brought into the country – perhaps not more than £2,000,000 or £3,000,000 from first to last – which matters, but the *indirect* effect of this on profits and enterprise....

Yet although the crown was restored to solvency, and both her landed nobles and her merchants enjoyed great prosperity, Elizabeth did not resume Royal patronage on the scale employed by Henry VIII. Such patronage as she bestowed was through the Office of her Master of Revels, whose accounts were scrutinised by her Privy Council, and whose annual expenditure rarely exceeded £1,500. Instead the grand gestures were made by her courtiers and by the new merchant class, who built their great mansions and patronised musicians, actors and artists on her behalf, in 'Gloriana's' name.

The great Elizabethan houses came to embody the court culture. A mansion such as Longleat in Wiltshire, built by Sir John Thynne between 1568 and 1580, contained splendid ornaments and tapestries, resounded to the sound of good music, and sometimes played host both to the best of the companies of travelling players and to the Queen herself. Much the same could be said of many of the other great Elizabethan houses – Wollaton in Nottinghamshire, Burghley House in Northamptonshire, Haddon Hall in Derbyshire and Moreton Old Hall in Cheshire are among many surviving examples.

Although there were many professional musicians who earned their livings playing in churches and the great country houses, they were complemented by a rising number of amateur music-makers, for it was

now considered an important part of an Elizabethan aristocrat's accomplishments to acquire a proficiency in playing musical instruments. The impetus to this had been given given by the publication of Thomas Hoby's *The Courtier* in 1561. The book, a translation of Castaglione's *Cortegiano*, was a forceful attempt to draw a picture of the new post-renaissance European gentleman. He was to pursue learning, to patronise artists (in the case of the Englishmen this took the form of buying tapestries in preference to larger pictures) and of course relax with his music. The cultured gentleman would be an accomplished dancer, and would certainly play the virginal, joining in musical ensembles where the strings of the viols supplied chords to the contrapuntal melodies of hautboy and recorder. Such civilities would be expected of each of the Queen's hosts as she made her way around her kingdom. Thus although her Triumphal Progress was undoubtedly a great expense upon the English nobility, it was, by way of consolation, also a civilising influence upon them.

We should perhaps remind ourselves at this point that Elizabethan England was a mixture of two quite distinct economic systems. A large part of the country through which the Queen travelled was still functioning much as it had done in the Middle Ages. Its small villages, like its estates, were all but self-sufficient, and the people in them lived within a hierarchical social order that had hardly changed since feudal times.

The traditional arts which filled the non-working hours of the commoners would have baffled modern 'arts consultants', for they involved little in the way of economic transactions, and required no professional animation from above. Within the rural communities, the Church's Holy Days (in particular Christmastide, with St. Stephen's Day, St. John's Day, Holy Innocent's Day, New Year's Day and Epiphany; Easter Week and Whitsuntide) were celebrated in much the same way as secular holidays such as the Maying, Midsummer Day, Harvesting, and alongside family celebrations of weddings, births and funerals. Many of these celebrations took local forms, and some survive until the present day. Most involved elements of ceremonial drama, singing of ballads and dancing. As there was then a less rigid separation of work and leisure, there were also ballads and celebrations closely linked to work. Some of these have also survived, notably a number of Elizabethan sea shanties and the dark border ballads of the North of England.

Overlaying this ancient bucolic England was the new merchant capitalism, centred on the City of London – which by the middle of Elizabeth's reign accomodated more than 100,000 inhabitants – and which had also spread to several other main ports and trading centres.

Some of them were also growing substantially – Bristol, York and Norwich, the three largest towns, now had expanding populations of 20,000 and more. This vibrant commercial growth was forming itself around what was already recognisable as a new kind of social order, more like the class sytems of the eighteenth century than the old feudal system, with the wealthy clothiers in particular establishing themselves as a new managerial class and organising their labour within what we shall later call the manufactories:

> Two hundred men, the truth is so,
> Wrought in these looms all in a row.
> By every one a pretty boy,
> Sate making quills with mickle joy:
> And in another place hard by,
> An hundred women merrily
> Were carding hard with joyfull cheer
> Who singing sate with voices clear.

The author, 'Jack of Newbury', was doubtless taking a roseate view of weavers' sixteenth century working conditions, but the scale of his observation was accurate. Some clothiers, by the end of the sixteenth century, were employing more than a thousand people. It was also true that their work was sometimes organised broadly along the lines of an early shift system.

However it is important to remember that work in the clothiers' weaving sheds would not have been termed a manufactory, still less an 'industry' by their contemporaries. 'Industry' certainly had then a quite different meaning. It was not yet used in its later, particularised sense, but as a more general noun. Until the end of the eighteenth century, 'industry' meant only 'hard work', 'serious application', or what we might nowadays call 'commitment'. As a result – although to us it may seem perverse – a painter, writer or musician might be enjoined to eschew the false and wicked blandishments of 'art', and turn instead to 'industry'. Artfulness and artifice were both frowned upon; industry was applauded. Yet, although organisation of some businesses in the sixteenth and seventeenth centuries faintly foreshadowed the huge production industries of the nineteenth century, they were most certainly not 'industries' in the later grim and revolutionary sense.

The contrasting sides of Elizabethan England that we have so far considered have of necessity been presented as absolute opposites. In reality, the two economic systems were in constant flux. At many points they overlapped. Most people were still nurtured by the old feudal system but they now found their lives touched at many points by the burgeoning

new mercantile world. In part this happened because people travelled more. They left their estates and villages – in the way of business, to visit religious shrines, or to indulge in the new fashion of visiting one of the spas. Buxton was the favoured health resort, boasting fine new lodging houses which the Earl of Shrewsbury had built to enhance the town's attraction to visitors.

For all such travellers, the Inn was a welcome refuge, and in contemporary descriptions we can glimpse something of its cultural importance to the times. Elizabethan Inns functioned as museums, displaying travellers' 'curiosities', as centres for oral history when travellers told tales around the fireside, as dance halls, as occasional theatres when travelling players set up their shows in the yards, and most particularly, as the well-travelled Fynes Moryson tells us, there were also places of music:

> While [the traveller] eats, if he have company especially, he shall be offered music, which he may freely take or refuse. And if he be solitary, the musicians will give him good day with music in the morning.

Old feudal England mixed with the new commercial England in other ways. The country houses, the heart of so many insular rural communities, had long been accustomed to buying in the troupes of travelling entertainers to perform to their households and cottagers. The Earl of Northumberland, for instance, records in his household book for 1512 that it was his custom to give £10 to troupes that played at his house between 'Chrystynmas and Candilmas', and £20 to the favoured company that gave the special Shrove Tuesday performance. Such practices now became more common, as the travelling companies, who were by the middle of Elizabeth's reign presenting plays rather than mixed programmes of music, dance and drama, became more numerous. People from the neighbourhood were now sometimes invited in to enjoy what had once been a much more narrowly domestic occasion.

Another leavening feature of Elizabethan life was the fair. There were already many fairs well-established by the sixteenth century – Stourbridge, Bartholomew and Greenwich among them – and during her reign Elizabeth granted royal permission for many more. The fair was an important event in a neighbourhood, and was promoted in a manner which meant that it fitted easily into the rhythms of local life, aroused little opposition and had an audience readily to hand. It was held each year at the same appointed time, and had an established place in the local commercial calender.

For the fair did not offer only entertainment. It was a market, often at-

tracting specialist traders from a wide region. It also functioned as a labour exchange, for it was there that the farmers hired their hands. Many churches organised their annual 'feast' for their parishioners during the time of the fair, and local schools also took part in the festivities; schoolchildren were even granted holidays to attend. In the University towns the fair was totally integrated with the local colleges. Stourbridge Fair, held on Midsummer Common in Cambridge, was for instance declared open each year by the Vice Chancellor of the University, who rode down to the Newmarket Road and performed the office in full academic fig.

Alongside the fair's trading market were the entertainers performing on the open fields or in makeshift booths. These might include travelling puppeteers, jugglers, tumblers, ballad-singers, stilt walkers and innumerable animal acts – dogs, horses, bears and 'educated' pigs, donkeys and even apes. The showmen were full-time entertainers moving from fair to fair in the summer around the developing 'circuits' and then eking out a more precarious living in the winter by taking such private engagements as could be had. Most worked for themselves, although a few combined in small travelling troupes.

Their lives, and indeed those of the professional musicians and the swelling corps of professional actors, were however being shaped as much by Elizabeth's increasingly restrictive legislation as by her generosity in licensing new fairs, inns, theatres and other places of public entertainment. Elizabeth was a great legislator. Acts were passed to curb irregularities in manufacture, commerce and trading. (It was Thomas Gresham who remarked, 'As the merchants be one of the best members in our common zeal, so they be the very worst if their doings be not looked into in time; and forced to keep good order.') Elizabeth also enacted the first laws creating charities, which were for nearly four centuries considered to be for the benefit of those who had suffered through war, or through industrial or natural disasters. Only in the late twentieth century were charities discovered to be a useful vehicle for allotting taxpayers' money for the support of the more privileged of the arts.

Although the main focus of legislation may have been upon trade and the doings of her merchants, Elizabeth's new laws certainly affected the entertainers. Working within the new legislative framework was not easy, partly because the new laws were based on the sturdy belief that all reputable tradespeople, and hence all honest citizens, were either modern merchants or members of one of the ancient craft guilds. It became an increasing embarrassment to writers, musicians and players that they were neither of these things.

Matters finally came to a head in 1563 when the *Statute of Artificers*

passed into English law. This important bill created a national apprenticeship and training scheme for all established professions. It laid down that every craftsman in town or country now had to learn his craft for a full seven years from a Master who was responsible for his initiation into the craft, for his education and for his social development, creating a national education and training scheme that survived until the ravages of industrial revolution. In the face of this the entertainers, lacking the protection either of the commercial City or of an ancient guild, attempted to comply, by setting up apprenticeship schemes of their own, but they were not considered to be a *bona fide* part of the new social fabric and as a result they were, together with vagabonds and beggars, pushed by this Statute a considerable way down the path to second class citizenship and social outlawry.

In later years and in order to ameliorate the plight of the entertainers, Elizabeth decreed that each group of players could pursue their work with, at the least, licences from two Justices of the Peace, but preferably letters patent from a noble Patron, who would be the 'Lord and Master' of the whole troupe. *The Queen's Act of 1572* provided that:

> all ydle persones goinge about in any Countrey of the said Realme – having not Lord or Maister...and all Fencers Bearewardes Comon Players in Enterludes and Minstrels, not belonging to any Baron of this Realme or towardes any other honorable Personages of greater Degree...which...shall wander abroade and have not Lycense of two Justices of the Peace at the leaste...where and in what Shier they shall happen to wander...shall bee taken adjudged and deemed Roges Vacabondes and Sturdy Beggers...

This was not, however, the end of the entertainers' worries. Two years afterwards, the London City Fathers issued an Order of the Common Council, *In Restraint of Dramatic Exhibitions 1574* which effectively banned all unlicensed stage performances from the City:

> whereas heartofore sondrye greate disorders and inconvenyences have beene found to ensewe to this Cittie by the inordynate hauntynge of great multitudes of people, speciallye youthe, to playes, enterludes and shewes... in great Innes... Now therefore... by yt enacted that... from henceforth no Inkeper Tavern Keper, nor other person whatsoever within the liberties of this Cittie shall openlye shewe, or playe, nor cause or suffer to be openlye shewed or played with in the hous yarde or anie other place... anie playe enterlude comodye, tragidie, matter or shewe which shall not be firste perused, and allowed.

The legislative noose tightened. It soon became necessary for all troupes, even those playing well beyond the City boundaries, to have each new work that they intended to perform (including rewritten plays) 'perused' and a licence issued from Elizabeth' s Master of Revels.

A censorship over all books in English had already been established by *The Proclamation of 1538*, and printing of all books was in the control of the Stationers' Guild. Control extended to the visual arts. It was forbidden to import foreign paintings, and in London painting was the monopoly of the corporation of the Company of Painter Stainers. Yet publishing and the drama were the most strictly controlled. Even a play licensed for performance could only be printed if the printer had first obtained a licence from the Archbishop of Canterbury's officials and had entered its title in the Stationer's Register. Publishing was further restricted in 1575 when Elizabeth licensed Tallis and Byrd to hold the monopoly on the printing of all music in England. Meanwhile in 1552 the travelling players had been further proscribed by the *Licensing of Inns,* an act directed less at the consumption of alcohol than at the plays and other entertainments which took place within their walls.

Indeed this ever-tightening noose of legal restriction explains the rather devious way in which the London theatres established themselves. In the year that *In Restraint of Dramatic Exhibitions* was proclaimed, one enterprising player, James Burbage, obtained a Royal Warrant to allow him to erect a building in which to perform the drama (the first purpose-built English theatre, set just outside the City of London boundary in Shoreditch). Burbage's license permitted him and 'other servants of the Earl of Leicester' to perform 'Comedies, Tragedies, Enterludes and Stage playes' both in The Theatre (as it became known) and elsewhere.

The Theatre was completed and successfully opened in 1576. So successful was its construction that when their Shoreditch ground lease expired in 1598, Burbage's two sons, assisted by other players in the Earl of Leicester's company (almost certainly including their young playwright William Shakespeare) by night transported the materials of The Theatre and reassembled them on land they had newly leased south of the Thames on Bankside. They called their second theatre The Globe, which, until its destruction by fire in 1613, witnessed the full flowering of Shakespeare's talent.

The company, which now bore the title of The Lord Chamberlain's Men, had by then been constituted as a Joint Stock company with the Burbage brothers, Shakespeare and others as shareholders. By this arrangement, Richard and Cuthbert Burbage held five shares between them, and William Shakespeare, John Hemings, Augustine Phillips, Thomas Pope and Will Kemp one apiece. In addition to having a share in the general profits of the company, each of the playing members of the company held in addition an actor's share of the day to day takings, and the company's dramatists were paid a further fee for their performed works.

The theatre 'take' was split, much after the modern fashion. The owner or lessee of the theatre did not take the entrance money paid to the 'gatherer' at the theatre's main entrance but took a half of the additional sums (penny or twopence) which entrants paid to pass from the ground floor to the roofed galleries. However, the theatres – the Globe seems to have held about 1700 people – played to capacity only on public holidays. On other days, there seems to have been, except on opening nights of a new piece, a much lower attendance, usually of between 25 and 40 per cent. On such days the 'take' would seldom be more than £10, of which the production company would get just over half.

As a single bespangled costume could cost £6 or more, and the licence for each new play cost a further seven shillings, we can see how important it was that the season was carefully balanced between old favourites and the new pieces (which sometimes did not survive their expensive opening performances). Thus at holiday times popular and well-tried pieces were given. New pieces were tried out on other days. If successful they were given a 'run', but if not, they had to be immediately withdrawn from the repertoire. As it was also the custom to rotate even established pieces, the actors usually had to play a different piece on each afternoon of the week, often including – despite frequent attempts to prohibit them – a performance on Sundays. It was gruelling work.

Yet in spite of the demands it made upon the ordinary players, the new professional theatre was for some a great commercial success. It is calculated that Shakespeare received £400 annually as a sharer in the Globe, £180 as a player and between £7 and £10 more for each play of his that was produced. This meant that he was well able, in 1597, to purchase Stratford New Place for £60, then to spend £320 in 1602 purchasing further land in the town, and in 1604 able to pay £440 for a 32 years' lease of part of Stratford tithes, which brought him a yearly income of more than £60. At his retirement there he was comfortably the richest man in Stratford upon Avon.

An even more notable success was however made by his contemporary Philip Henslowe, who was neither dramatist nor actor, but who made his fortune from building and then managing theatres; the Rose in 1587, the Fortune in 1600 and the Hope in 1613. An interesting early example of the economic impact of theatregoing on its immediate neighbourhood is the fact that towards the end of his career Henslowe went into partnership with a waterman, Jacob Meade. Meade was an entrepreneur who had built up his capital from his business ferrying theatregoers from the City across the Thames to the Bankside theatres.

Overall, however, the financial state of the ordinary players was

frequently precarious. Outbreaks of the plague such as those of 1592, 1593 and of 1603 – the year of Elizabeth's death – regularly closed the London playhouses and forced the companies to tour. Touring involved the players in much extra administration, as a contemporary account indicates:

> In the city of Gloucester the manner is, as I think it is in other like corporations, that when players of enterludes come to towne, they first attend the Mayor to enform him what noblemans servants they are, and so to get licence for their publike playing; and if the Mayor like the actors, or would show respect to their lord and master, he appoints them to play their first play before himself and the Aldermen and Common Counsell of the city; and that is called the Mayors play, where everyone that will comes in without money, and the Mayor giving the players a reward as he thinks fit to show respect unto them.

Furthermore the companies could not perform as frequently on tour as in their London theatres, so their weekly returns, whether from performing the Mayor's play or from subsequent public performances, were always likely to be lower than in the capital. Touring was not an attractive commercial proposition.

In the later stages of Elizabeth's reign there were other pressures. There was for example mounting inflation. The period 1550–1640 was a period of prosperity for the 'New Men' of commerce but it was also a period of great anxiety for ordinary folk, who saw prices rapidly outstripping wages. By 1650 prices were approximately three times what they had been in 1500. The lag of wages behind prices of course enabled profits to quadruple between 1550 and 1600, but it also fuelled inflationary pressures. Authors found it difficult to sell their books; Milton made only £10 from the complete sales of *Paradise Lost*. The theatre companies were doubly affected. Inflation raised their production costs, and also limited the freedom to spend for a part of their audience. The playhouses thus became marginally more dependant upon middle class support, which in turn increased the power which the London Merchants and their commercial allies were able to wield over the acting companies.

The objections to the drama, which had begun before Elizabeth was crowned, which mounted in volume during the reign of King James and which had reached their crescendo in the 1640s, came from two main sources. On the one hand objections came from the world of commerce, in particular the City of London, and on the other from the growing Puritan movement. The Puritans regarded the playhouses as Ungodly, not least because they spread immorality and disease:

> I understand [the common plays] are now forbidden because of the plague. I like the policy well if it hold still, for a disease is but lodged or patched up that is not

cured in the cause, and the cause of plagues is sin, if you look to it well; and the cause of sin are plays; therefore the cause of plagues are plays.

They were also Ungodly because they encouraged idleness, and it was on that front that the City made common cause with the Puritans. The theatres stood accused of many other things – of blasphemy, of condoning lewd and anti-social behaviour and of incitement to riot – but most insistently they were accused of one unforgiveable crime. In the eyes both of the Puritans and of London's merchants, theatres promoted idle habits and were hence the enemies of industry.

As we have already seen, the *1574 Order of Common Council* when forbidding plays in the City deplored their effect upon everyone, but 'speciallye youthe'. This professed concern for the young was a frequent refrain. The merchants feared that their young apprentices would be tempted to turn their backs on industry and become, in a phrase Stephen Gosson uses in *Plays Confuted* (1579), 'Sonnes of idlenesse'. Players (and their audiences) were thus depicted as subversives, preaching against the carefully nurtured habits of industry which masters taught their apprentices, and a threat to the social order. The players stood accused of being little better than beggars, as in Stubbes' *Anatomie of Abuses'* (1583):

> Awaie therefore with this so infamous an arte; for goe they never so brave, yet are they counted and taken but for beggars. And is it not true? ...Are the not taken by the Lawes of the Realme, for roagues and vacabounds?

In 1594 London's Lord Mayor wrote angrily to the Lord High Treasurer, objecting in particular to the fact that the plays, presented during what should have been working hours, attracted the workshy, and were a threat to good English habits of industry and religion:

> Which may better appear by the qualitie of such as frequent the sayed plaues, being the ordinary places of meeting of such vagrant persons and maisterles men that hang about the Citie, theeues, horsestealers, whoremongers, coozeners, connycatching persones, practizers of treason and such other lyke, whear they consort and make their matches to the great displeasure of Almighty God and the hurt and annoyance of hir Majesties people.

The Lord Mayor here speaks both for commerce and for Puritanism, echoing the Puritan view that good industry was a part of true Godliness. This note was sounded even more insistently by his successor in 1597. Then the Lord Mayor joined with the City Aldermen to send a detailed four-part argument against licensing the public drama to the Privy Council. Its last point is that the theatres help to spread the plague ('in the time of sickness' those at the theatres 'are infected') but its first three

points harp repeatedly upon the theatres' threat to the established commercial system, and to habits of Godly industry:

> The inconueniences that grow by Stage playes about the City of London.
>
> 1. They are a speaciall cause of corrupting their Youth... whereby such as frequent them, beinge of the base and refuze sort of people or such young gentlemen as haue small regard of credit or conscience, drawe the same into imitation and not the avoidinge the like vices which they represent.
> 2. They are the ordinary places for vagrant persons, Maisterles men, thieves, horse stealers, whoremongers, coozeners, Conycatchers, contrivers of treason, and other idele and daungerous persons to meet together...
> 3. They maintaine idleness in such persons as have no vacation and draw apprentices and other seruantes from theire ordinary workes...to the great hinderance of traides and the prophanation of religion established by her highnes within this Realm.

In summary, though the dramatists and their theatres were generally absolved of the charge of being over-decorated and attracting people by gaudy ornament – cleared in other words of the accusation of deploying 'art' – they did stand condemned, first by the London City Fathers, then during the early Stuart period by the whole of the swelling Puritan movement, on the very much graver charge of hampering and subverting industry.

It is important then to recognise the full significance of King James' action in 1603 when he awarded Shakespeare's company protection against the Puritans and Merchants by issuing letters patent appointing them the King's Players. The letters patent (which interestingly use the word 'art' in its early sense of 'skill') clearly address the theatre's chief persecutors:

> James by the grace of God, etc. To all Justices, Mayors, Sheriffs, Constables, Headboroughs, and other our officers and loving subjects, greeting. Know ye that we of our special grace, certain knowledge and mere motion, have licensed and authorised and by these presents do license and authorise our servants Lawrence Fletcher, William Shakespeare, Richard Burbage, Augustine Phillips, John Hemings, Henry Condell, William Sly, Robert Armin, Richard Cowley and the rest of their associates, freely to use and exercise the art and faculty of playing Comedies, Tragedies, Histories, Interludes, Morals, Pastorals, stage plays and such others, like as they have already studied, or hereafter shall use or study, as well for the recreation of our loving subjects as for our solace and pleasure, when we shall thank God to see them during our pleasure.

Of course, the King's action did not offer a refuge to the English theatre as a whole. It offered protection only for one company, albeit one that was almost certainly the best. There is no doubt that the King looked after his players well. They were dressed in his fine livery, and at Christmas 1603

they were paid £30 (considerably more than they were used to receiving from Elizabeth) for acting one play before the King at Wilton near Salisbury.

There is even less doubt that the King's action had the result of enclosing the English theatre, making its survival conditional less upon popular support than on Royal approval. Although the patent does make passing reference to the recreation of his loving subjects, it is clear that the King is now looking upon his favoured troupe as essentially court players, there for his private 'solace and pleasure'. The national drama was thus brought under the direct protection of the Royal Family. It was a profoundly significant act, which (as we shall see) continues to affect us at the millennium and beyond, as our major state-aided companies – still spoken of in the arts world as the 'jewels in the crown' – continue to make strenuous efforts to attach the protective epithet 'Royal' to their titles.

James exercised Royal patronage in other ways, most directly on the masques – many by Ben Jonson and Inigo Jones – which after 1611 were expensively staged every winter for nearly forty years at the Whitehall Palace. On occasion, he also moved to protect the recreations of the common people. Although he had on his accession in 1603 banned Sunday bear-baiting, plays and bull-baiting, it was put to him when he was visiting Lancashire in 1618 that ordinary folk were harmed by these measures, and could not take 'honest exercise' after Sunday service. As a consequence, James published his famous *Book of Sports,* which still forbade Sunday plays, interludes and bear-baiting but which now permitted sporting recreations such as dancing, archery, leaping, vaulting and dancing around maypoles. As the King put it:

> When shall the common people have leave to exercise, if not upon the Sundayes and holy daies, seeing they must apply their labour and win their living in all working daies?

The Puritan objection, however, was to one of the performing arts in particular, the anti-industrious, Godless stage drama. In the *Declaration* of September 2, 1642 stage plays were briefly linked with Sunday sports in their impiety, but it is the stage plays in particular that bear the blame for national calamities:

> Whereas the distressed Estate of Ireland, steeped in her own Bloode, and the distracted Estate of England, threatened with a cloud of Blood, by a Civil Warre, call for all possible meanes to appease and avert the Wrath of God appearing in these Judgements; amongst which Fasting and Prayer have been often tried to be very effectual, have been lately, and are still enjoyned, and whereas publicke Sports do not well agree with publicke Calamities, nor publicke Stage–playes with the seasons of Humiliation, this being an exercise of sad and pious solemnity, and the

other being Spectacles of, too commonly expressing lascivious Mirth and Levitie. It is therefore thought fit, and Ordeined by the Lords and Commons in this Parliament Assembled, that while these sad Causes and set times of Humiliation doe continue, publicke Stage-playes shall cease, and bee foreborne.

The overwhelming objection was to flesh and blood actors. Puppet shows were permitted to continue.

Nor did all of the other arts suffer more than might have been expected in a period of turmoil and civil war. Moreover, although Cromwell is conventionally pictured as a humourless killjoy who dispensed no patronage, such a picture is less than fair. London's musical life for instance continued virtually unchecked during the 1650s, and Cromwell himself licensed Sir William Davenant's presentation of *The Siege of Rhodes*, a drama sung 'in recitative music' and considered to be the first English opera, which was given at Rutland House in 1656. Portrait painters continued to enjoy commissions from his household, and the practice of literature may even be said to have flourished during his regime, for Cromwell employed two secretaries that were poets – one of them, John Milton, a great poet.

We have evidence that during the Civil Wars – which were after all wars of ideas – many of Cromwell's yeomen enlarged their libraries and read seriously. Numbers of books published annually certainly increased dramatically during the Commonwealth. 13 books had been published in 1570, 28 in 1539, 85 in 1550, 150 in 1580, around which figure it settled until 1640 when it rose to more than 200, dropping again at the Restoration to little more than 100 titles a year.

Nor was the Lord Protector without his lighter side. History books tell us that his followers so disliked any manifestation of pleasure that they even destroyed England's maypoles and banned morris dancing. This is true, but on the other hand, his followers did not check the rumbustuous country fairs which continued to be held throughout the country in which were regularly staged 'drolls' – the code name for illicit dramatic performances. Some actors continued discreetly to ply their trades in other ways. John Rhodes, who had been wardrobe master at London's Blackfriar's Theatre, set up a London bookshop, in which he quietly continued to school apprentices in the forbidden art.

Cromwell himself enjoyed music and dancing. On special occasions, such as his daughter's wedding, he hired great companies of musicians to play. Perhaps most surprising of all is the fact that he had four paid buffoons – court jesters – in constant attendance on him throughout his period in office, which might suggest that as a politician he had at least one uncommon quality. He had a sense of humour.

The Royal Enclosures

These two subjects God and the Soul, being only
forborn: In all the rest, they wander at their pleasure.
In the frame of *Men's bodies*, the ways for strong,
healthful and long life: In the *Arts of Men's Hands*
those that either *necessity, convenience or delight*
have produced; In the work of *Nature*, their help,
their varieties, redundancies, and defects; and in
bringing all these to the uses of *humane Society*.

T. Sprat. The History of the Royal Society of London for the
Improving of Natural Knowledge. 1667

In recent times we have come to use the word 'patronage' as if it were
simply an economic term, meaning gifts of money made to a talented,
though usually impoverished, artist. Yet formerly the word had at least
two other meanings.

Patronage could be given in a blander, less tangible form, and could
mean that the patron simply took a kindly interest in the progress of his
protège – it could for instance simply mean that an artist or a
manufacturer had permission to make use of a patron's name and title.
Then there was another sense which the patron assumed total
responsibility for the protège, and sought to exercise absolute control
over them. This latter is the sense that we have in mind when we accuse
someone of *imposing* their patronage upon us and, in a rather
objectionable way, of 'being patronising'.

So when historians say that following the lavish generosities of Henry
VIII Royal patronage in Britain declined, they are using the term only in
its first, narrowly economic sense. We have already seen that, whatever
her natural inclinations may have been, Elizabeth I was forced by
straitened circumstances to exercise frugality, and the Stuarts in their turn

were no better able to match Henry's legendary generosity. When the monarchy was restored in 1660 it was even poorer, so the Kings and Queens of England never regained the flamboyance of their Tudor ancestors.

The differences are made clear in many ways. Whereas Henry VIII had roamed freely through twenty great houses, Charles II ran just seven: Whitehall, St. James', Somerset House, Hampton Court, Greenwich, Windsor Castle and the Tower of London. Although, when he resumed the throne, Charles had begun building new palaces at Greenwich and Winchester, his resources were so severely limited that neither of his projects reached fruition during his reign.

Nor did his successors ever complete them. Indeed the great differences in style and character of successive monarchs meant that throughout the late seventeenth and eighteenth centuries there was no one settled royal residence. William III turned Charles' proposed Greenwich palace into a home for retired seamen, concentrating his energies on refurbishing Hampton Court. Queen Anne in her turn left Hampton Court severely alone, and spent much of her reign at Windsor. George I disliked Windsor and transferred the Royal affections to Kensington Palace. George II then reverted to Hampton Court. In his turn George III turned his back on all of them and instead purchased a totally new London residence, Buckingham House, as his personal retreat.

There was thus no common thread of taste running through successive reigns. Architects received capricious Royal commissions, sometimes uncertain whether the projects they were asked to undertake could ever be completed, and not altogether certain that they would be fully paid even if they were. For Royal households were now working on tight budgets. Even after parliament had guaranteed that the king would receive the full value of the Civil List, it meant for George I an annual income of only £700,000, and for George II £800,000. On the face of it this may seem a reasonable sum but after the monarch had paid the salaries of the courtiers, ministers, judges and diplomatic services (as was the practice), had met family expenses, and had paid for the upkeep of all the Royal residences, there was little left over for any sustained display of arts patronage.

In all this the British Royal household was quite different from that of the French. Versailles was not merely the gracious residence of all French monarchs, but its capacious dwellings housed a self-sufficient community of more than 10,000 people. The French Royal household had its own self-contained culture. Versailles had private concert halls, opera house and galleries, and among its staff were eminent artists, singers, fencers,

actors and scientists. By contrast successive British monarchs never had more than 1,500 staff, and although that figure included a few musicians and a part-time poet laureate, their households were neither big enough nor rich enough to enable them to stage their own large-scale domestic entertainments. So when British monarchs of the seventeenth and eighteenth centuries wished to see an opera or watch the latest play, they went out into London and joined their subjects at the public theatres.

One result of this was that the tastes of the British Royal families have been much more public than were those of their French counterparts. Patronage in Britain has been bestowed more often by public notice of an artist, or by Royal attendance at a public performance, than by a summons to perform privately at court, or by a cash payment. So, as British artists became wealthier, it was not unknown for them to reverse the traditional procedure and to try to buy the Royal family's notice and patronage.

Socially ambitious painters sometimes offered free portrait sittings to members of the Royal circle. Writers extravagantly dedicated their books to them. Managers built ornate 'Royal' boxes in their theatres, concert rooms and pleasure gardens in order to give the appearance of being constantly under Royal notice, and hence under Royal patronage. On the other hand British monarchs sometimes by their attendance bestowed unsought and unexpected approval on a cultural activity, not because their subjects had bribed them to do it, but because it suited their personal tastes – another example of the quirkiness of British Royal patronage

One early example of this is Queen Elizabeth I's resistence to the doleurs of the 'British Sunday'. The Queen had inherited a formidable swatch of sabbatarian legislation accumulated over the previous three centuries. Richard II had banned Sunday football and Sunday tennis as early as the thirteenth century (although this was less to fill the churches than to encourage full attendance at archery practice). Henry VI had forbidden Sunday fairs and markets. Elizabeth's father Henry VIII had written in *The King's Book* (1543) that Sunday should be spent in holy works – although he conceded that if people were otherwise impelled to idle pastimes, it might be better for them to go to work. Meanwhile, women:

> ...should better bestow their time in spinning of wool, than upon the sabbath day to lose their time in leaping, and dancing, and other idle wantonnness.

Nor was there support from Elizabeth's own clerics for any relaxation in the observance of the Sabbath, either for work or play. In 1547 Prebendary Thomas Becon fiercely condemned both business and pleasure when he defined how Sunday should properly be spent:

Mrs. SIDDONS' Benefit.

(And positively the Last Time of her ever Appearing on this Stage.)

Theatre=Royal, Hull.

SATURDAY Evening Feb. 1, 1812, their Majesties' Servants will act Shakespear's Play, in Five Acts, called The

Winter's Tale

Leontes, King of Sicilia, (first time)	-	Mr MANSEL	Archidamus, -	Mr WOOD
Mamillius,	-	Miss JARMAN	Shepherd, -	Mr KELLY
Camillo,	-	Mr EVATT	Clown, -	Mr HALL
Antigonus,	-	Mr FOSTER	Autolycus, (with Songs)	Mr RUSSELL
Cleomenes,	-	Mr DANIELS	Perdita, -	Miss MATHEWS
Dion, -	-	Mr HOPE	Paulina, -	Mrs JARMAN
Phocion,	-	Mr COPE	Emilia, -	Mrs CUMMINS
Keeper of the Prison,		Mr JARMAN	Lamia, -	Mrs FRENCH
Polixenes, King of Bohemia,		Mr CUMMINS	Hero, -	Miss CUMMINS
Florizel,	-	Mr F. BROWN	Mopsa, -	Mrs WARD
			Dorcas, -	Miss DECAMP

Hermione, Queen of Sicilia, Mrs SIDDONS.

In Act 3d, the TRIAL of the QUEEN.——In Act 4th, the SHEEP SHEARING SONG by Miss MATHEWS, and a PAS SEUL by Miss S. DE CAMP.
Act 5th. the STATUE SCENE.
After which, a Musical Entertainment, in one Act, called

MATRIMONY.

Baron de Limberg,	-	Mr FOSTER	Clara, -	-	Mrs M'GIBBON
Delaval,	-	Mr MANSEL	Lisetta, -	-	Miss DECAMP
O'Clogherty,	-	Mr KELLY			

To which will be added, a Musical Farce, in One Act, called

The Purse;

Or, BENEVOLENT TAR.

The Baron,	Mr WOOD	Theodore,	Mr HOPE	Edmund,	Mr PAYNE
Will Steady,	Mr HALL	Page,	Miss JARMAN	Sally,	Miss DECAMP

To begin at Half past Six o'Clock.
Tickets to be had of W. Rawson, the Printer hereof, Lowgate, and of Mr Firth.

No PLAY on MONDAY.

Figure 2 Until the Second World War the performing arts in Britain relied almost wholly upon local subscribers for their support. Mrs Siddons' 1912 Benefit in Hull, which showed her in one of her most popular roles, was held on a Saturday evening, when the house was sure to be crowded.

Hull Public Library

...not to pass over that day idly in lewd pastimes, in banqueting, in dicing and carding, in dancing and bear-baiting, in bowling and shooting, in laughing and whoring, and in such like beastly and filthy pleasures of the flesh; nor yet in bargaining, buying and selling...but...to apply our whole mind and body unto godly and spiritual exercise.

Yet it must be said that not everyone was so strict. In 1557, two years into Elizabeth's accession, a story was told about a disaster which had occurred in Beverley. One Sunday evening there had been a poor attendance at church, many people preferring to pass their time at local amusements. Unhappily, however, many of the staunchly faithful were seriously injured when, during the service, a part of the Minster roof collapsed. A local wag, reversing the usual Puritan threats of dire retribution for enjoying oneself on the Sabbath, was allegedly heard to observe, 'Now maie you see what it is to be at euensong when you should be at the bere baytynge...'

Nevertheless, in spite of the accumulated state legislation, and in the face of opposition from her more vocal clergy, throughout her reign Elizabeth publicly supported and hence patronised Sunday recreation. She refused to ban Sunday fairs, and when in 1580 she was finally persuaded to sign an order prohibiting Sunday performances of plays, she limited it to the City of London from whence the main agitation had come. She also made clear that the law applied only to public shows, and in practice did nothing to enforce the edict. In like fashion, her 1558 *Act of Uniformity* rendered all those who did not attend church liable to a fine of 12s. for each offence, but this too, once it had been passed, lay unheeded on the statue books.

Meanwhile, she gave her own example to her subjects. She continued to make music and to dance on Sundays (though she is said not to have kicked her legs so high on the Sabbath). Indeed there are numerous examples of her as house guest enjoying the Sunday recreations provided for her by her hosts. Staying at Kenilworth Castle she was offered on a Sunday night a 'morris dance, some sports, a play, and an Ambrosiall Blanket'. In 1559 on a Sunday night at Lord Arundel's, she was given 'soper, blankett, and maske, with drumes and flutes, and all the mysycke that cold be, tyll mydnyght...' Nor did Elizabeth believe it right just to play on the Sabbath and not also to be industrious; during her reign Parliament and the Privy Council frequently sat on Sundays.

One consequence of Elizabeth's libertarian views is that Cromwell is often left with the blame for having created the 'English Sunday'. Yet Cromwell did not create it. He merely enforced legislation which had long been on the statutes and supported by Royal decree, but which, as he often

reminded the country, some members of the Royal family had recently and illegally chosen to flout. This he makes clear in the *Ordinance* of February 1643 which calls upon the people to repent sins which included 'wicked prophanations of the Lords Day, by Sports and Gamings, formerly encouraged even by Authoritie...' One document which had given notable encouragement to Sunday pastimes, King James' *Book of Sports*, was ceremonially burnt in 1644 by the public hangman. In the same year statutory fines were imposed for various offences against the Sabbath code:

	Fine
Trading on Sunday	Ten shillings
Travelling without Cause	Ten shillings
Working on Sunday	Five shillings
Games, Sports and other Pastimes	Five shillings

The Puritans had always tended to link lasciviousness and immorality with plays, dancing and music. Now many of the venues, instruments and costumes of the actors, dancers and musicians came by extension to be seen as wicked in themselves. Organs were removed from churches. London's major playhouses were one by one pulled down and destroyed, and those actors who did not rally to the King's colours either played in country fairs where Puritan supervision was far less rigorous, or went into voluntary exile abroad.

Although his impact upon life in London and the great towns is clear, one must not overestimate the impact which Cromwell had upon the recreations of rural folk. There is a good deal of evidence that in addition to the fairs many other country feasts and revels, and even 'heathenish' Morris dancing, continued much as before. Sometimes the defiant mood of the countryside can be clearly seen, as in a 1652 report of 300 West Country revellers who, armed with muskets and swords, '...with a drummer and fidler...went in a riotous and warlike manner to Pewsey, and there very disorderly danced the Morris dance drinking and tippling till all of them were drunk.'

Neither should we in its turn overestimate the impact of the Restoration upon popular recreations. For most ordinary people the return of Charles in 1660 was of little importance, and made little material difference to their lives. Charles II did not for example remove the Puritans' reimposed prohibitions on Sunday recreations. Nor did he republish *The Book of Sports*. Indeed, in 1667 the King actually approved a *new* Act prohibiting all except essential Sunday trading, and waggoners, drovers and boatmen were now forbidden even to travel on the Lord's Day. Thus for many

ordinary people life was certainly no less, and in some respects rather more restricted than it had been under the Puritans.

In one important respect, however, the Restoration marked the further development of the legalistic kind of Royal patronage, in which approval, freedom to operate, and monopolistic legal protection were all granted by a powerful new form of Royal Patent. This new patent came about in a curious way. A Tyrolese inventor, Jacobus Acontius, persuaded the British government in 1559 that they should adopt the Italian practice of awarding originators a monopoly patent on their inventions. On his return to power Charles immediately recognised that Acontius had placed a powerful new tool in his hands. For when this new monopoly patent was used in conjunction with the long-standing right of the sovereign to issue letters patent (letters written under the Great Seal, which enabled the recipient freely to perform acts which might otherwise be proscribed or forbidden) it was doubly powerful. Charles' new Royal Patent not only granted the right to trade, but also destroyed competition by granting the recipient a monopoly. Thus by the *Royal Patent of 1660*, the London theatre companies were not only given the freedom to present plays upon the London stage, but were simultaneously granted the *sole right* to do so.

For Londoners the Restoration brought change in other areas, for the newly patented theatre was only one part of a new cultural freedom for the metropolis. In the churches the old Anglican service was once more heard. The music was no longer the horizontal polyphony of Tallis and Byrd, but the vertical harmony of chords for orchestra and organ. This was as new to the boy choristers and the younger men as it was to the young Pepys, who records in his diary for 8 July:

> Lord's Day. To White Hall chapel...here I heard very good music, the first time that I ever remember to have heard the organs and singing-men in surpluses in my life.

Samuel Pepys had been with the fleet that brought the King back to England in 1660, and was 27 when Charles was restored. He had lived all of his adult life under the Puritans, and his wonder at the new London which sprang into life around him is a recurrent theme of his diaries. In 1660 he records his astonishment at the fact he is now able to travel by water on a Sunday. In 1662 he is delighted by London's first Punch and Judy show in Covent Garden. In 1667, although now used to heavy gambling by the royals and the aristocrats, and used to the new British Sunday, he is nevertheless surprised when he observes the Queen publicly enjoying both freedoms and playing cards on the Sabbath.

The Restoration theatre that Charles II patented was also quite different from the theatre of Elizabethan, or even Jacobean England;

indeed it is a misnomer to say that the theatre was 'restored'. This most dangerous of the arts, against which the Puritans had vented most of their anger, was given the Royal patent to resume only in London. There it became what had been threatened by James' apppointment of 'The King's Players' in 1603. It became, quite decisively, a court theatre – patronised by the court and aristocracy, and taking its licencious tone from Charles' own rumbustuous manners and morals. The theatre buildings were themselves also quite different, roofed and with rectangular auditoria. They had a proscenium arch stage, increasingly ornate settings, a pit for the musicians and a closet intimacy with the spectators more nearly resembling the high elaboration of Royal Jacobean masques than the spare 'Wooden O' of Shakespeare's time.

Only two theatre companies received the Royal Patent. The first was the Duke's Company, managed by William Davenant (an old friend of Charles', knighted for valour shown during the Civil War at the Seige of Gloucester), and the second the King's Company, with Thomas Killigrew as manager. Davenant, who had before the Civil War received letters patent from Charles I, and had during the Commonwealth continued to stage musical works in London, was the senior of the two. He attracted back into his newly-formed company some stage veterans, and also recruited a number of rising young actors. For a short while he played in the Salisbury Court Theatre in Fleet Street, a bijou house which had escaped destruction by the Puritans. Then for ten years – interrupted only by the new outbreak of the plague in 1665, when the theatres were once more closed – he presented his company in a converted tennis court in Portugal Street. Finally in 1671 the Duke's Company moved to a new purpose-built theatre in Dorset Garden. This had a greater capacity, seating more than 1,000 spectators.

Killigrew meanwhile in 1663 opened the King's Theatre in Drury Lane (the first of four theatres to be built on this site). For their opening performance the King's Company played Beaumont and Fletcher's *The Humorous Lieutenant*, a production notable for the first appearance of an English actress on the English stage, the part of Celia being taken by a Mrs Marshall. This signalled the start of that short but scandalous period in the history of London theatre, during which the new term 'actress' sadly came to be synonymous with 'prostitute', a link which took many decades to uncouple in the public mind.

For some years the two Royal theatre patents were thus used, not to encourage the development of the national drama, but largely to promote and protect the personal amusements of the King, his courtiers and fashionable London. For that reason, Royal licence did not extend to the

provinces, yet in spite of that some theatrical performances did cautiously resume in the provincial towns. At first they were managed and presented much after the old Jacobean fashion, with troupes of strolling players again playing on fit-up stages in inn-yards, barns and local halls. Some companies – the Duke of Grafton's and Lord Strange's, for example – still travelled under Letters Patent from noblemen, as they had in Elizabethan times, for this old form of protection had not been annulled by Charles' creation of the new Royal Patent.

By the beginning of the eighteenth century, many of these groups had settled as resident players in one of the new provincial theatres – the first opened in Bath in 1705, followed by Bristol (1729), York (1734), Ipswich (1736), Liverpool (1740), and Birmingham in 1741. Such theatres were not of course patented, and could not present the full spoken drama of Shakespeare or Dryden as could their London counterparts. Instead they presented bills which included short playlets set alongside items of singing and dancing, or plays which were intercut with music so they did not offend the London patent. The provincial playbills of the period – now called 'posters' when they were displayed outside the theatres, the term deriving from the Drury Lane practice of fixing playbills on the posts by the theatre to which horses were tethered – carefully spelt out that the evening's programme would include the permitted proportions of music, singing and dancing.

Both in London and the provinces, and equally in the Royal and the non-patent theatres, the old 'sharing system' that Shakespeare and his colleagues had known fast disappeared. Actors, dancers and musicians were now more usually contracted to appear in a troupe by an all-powerful manager. This person had sometimes never worked in the theatre either as writer or performer; for them the drama was purely a business speculation. Even when the manager came from the theatre world there was little room for sentiment, as Charles Dibdin the younger reminds us when he describes the authoritarian way John Astley contracted him and his wife to work for three seasons with Astley's touring company:

...he instantly proposed Terms – *as usual* – the highest they gave to *Singers* – a horsewoman was their *Prima Donna*...John Astley made proposals – an engagement for both for three years; with a conditional clause, that his father should be at liberty, at any time during that period, to cancel it. with regard to either or both of us, by giving a month's notice; – with no power of giving notice on our parts. Mrs D was to play all the principle singing and comic acting Business, I was to be Author to the Theatre, and... bound to produce *annually Twelve Burlettas; Twelve Serious Pantomimes!! Twelve Harlequinades!!!* exclusive of such comic songs as might be wanted... write Puffs etc. etc. etc. etc. for the weekly salary of a Guinea and an half

for my Wife, and for myself a *Guinea and a half also!!* neither to be paid but for such nights on which the Theatre was not open...

There were no restraints upon the theatre manager's readiness to cut costs and to take the largest possible profit, and thus actors were in general poorly paid throughout the late seventeenth and eighteenth centuries, with salaries of two or three pounds common even for experienced players.

One result of this was that from the time of the Restoration stage performers grew accustomed to making up their inadequate salaries by taking an agreed 'benefit' from which they might take the proceeds or profits, or a proportion of either. Samuel Pepys reports an early benefit performance 'for the women' being given at Drury Lane in 1668. Benefits were rife throughout the eighteenth century, and continued until the end of the nineteenth, with spasmodic recurrences in the early twentieth century.

It is important that the players' regular benefits should not be confused with the many charitable performances given by musicians and actors over the centuries, even though the latter are also sometimes confusingly also referred to as 'benefits'. The personal benefit performance was an important element in an actor's contract, and particularly so if the performer was well known. Leading players at the patent houses relied upon the agreed benefit for a large part of their annual income. Here for instance is a table showing the proportions of regular salary to agreed benefit income of the leading players at Covent Garden in 1798/9:

	Salary	Benefit
Mr Incledon	413	499
Mr Holman	380	230
Mr Pope	380	215
Mrs Pope	254	271
Mr Fawcett	380	412
Mr H Johnston	380	214
Mr J Johnstone	318	358
Mr Knight	318	272

In aggregate, almost half of the leading players' income – some 48% – was made up from their official benefits. Some received more from benefits than from their official salary.

When King Charles had died in 1685, the greatest excesses of licentious London died with him. After the glorious revolution of 1688, the English found William III and his pious Queen Mary a very different kind of Royal family, about as distant in spirit from the rumbustuous Charles as

it was possible to be. It is therefore unsurprising that William and Mary's decorous reigns should provide fertile soil for a growth in the numerous 'Societies for the Reformation of Manners' at the end of the seventeenth century. The activities of these societies are a barometer of changing public attitudes. In just over forty years they were responsible for the persecution of 101,683 persons in the London area alone, for such offences as swearing, sabbath-breaking, lewdness and drunkenness – all activities which had been openly displayed by King Charles' entourage a few years before.

Indeed, Queen Anne's assumption of the throne in 1702 saw a general respite from cultural extremes. Her patronage, inevitably modest in scale, was neither flambouyant nor insular. Her tastes were conventional. When for instance, Handel pleased her in 1713 with his *Te Deum* and *Jubilate*, written to celebrate the peace of Utrecht, she became his patron, rewarding him with a life pension of £200 a year, a sum doubled by George I shortly after he came to the throne.

In other realms, Anne's reign saw the burgeoning of a more stately and mannered London life. Fashionable London now boasted the Kit-Cat Club, of which Whig politicians and artists such as Walpole, Marlborough, Vanbrugh, Addison, Steele and Congreve were founders. Members met in a room in the house of their publisher secretary, Jacob Tonson. In due course, this room was decorated by the famous series of Kit-Cat Club portraits of members by Godfrey Kneller, all of a size – 36 by 28 inches – which enabled them to fit into the panels of Tonson's clubroom. Handel and the Kit-Cat Club later joined forces in one of the most surprising cultural enterprises of the early eighteenth century, the first Royal Academy of Music – startling because in all but name this Royal Academy was Britain's first arts council.

It developed in a roundabout, even haphazard way. By 1703 the Duke's Company, in their cramped Lincoln's Inn Field theatre, were suffering from competition with their better-endowed rivals in Drury Lane. Vanbrugh, anxious to improve their fortunes, enlisted the help of his fellow Kit-Cat Club members to design and build a new playhouse for them. This new and more spacious building, known until 1714 as the Queen's and then after George's accession, as the King's theatre, was in the Haymarket, then at some distance from the heart of the City, on the site of a former inn. A contemporary note from an anonymous pamphlet, *Rehearsal of Observator*, observes:

> The Kit-Cat Clubb is now Famous and Notorious, all over the Kingdom. And they
> have built a Temple for their Dragon, the new Play-House in the Hay-

Market...And there was such Zeal showed, all Purses open to carry on the Work, that it was almost as soon finished as begun.

Although it opened, prophetically, with an Italian opera, it was for four years largely run as a playhouse for the Duke's Company, with the programme occasionally interleaved with more expensively staged musical presentations.

Unfortunately, the company's rivals at Drury Lane were attempting to attract the town with much the same kind of programme. The competition between the two companies became so overheated that in 1707 the Lord Chamberlain intervened to revise the conditions of the respective Royal patents:

> Whereas by reason of the Division of Her Majesty's Comedians into two distinct houses players were not able to gain a reasonable subsistence for their encouragement in either company, nor can plays be always acted to the best advantage, whereas the charge of opera and comedies at the same house is too great to be supported; Therefore to remedy these inconveniences and for better regulation and support of the theatres, I do hereby order and require:
>
> All operas to be at the Haymarket, with full power and authority to the manager to engage any performers in music, dancing etc.
>
> And I do hereby strictly charge and forbid the manager to represent any comedies, tragedies, or any other entertainments of the stage, or to erect any other theatre for the purpose, upon pain of being silenced for breach of this my order.

Court edict had now effectively confined the legitimate drama to the two London patent theatres, and had made the continuous presentation of Italian opera mandatory upon a third, the newly patented Queen's.

The playhouse managers felt constrained by these measures, and threatened by the opera's new-found attraction for the free-spending nobility. They began to look for work which included music and spectacle, which would attract the town but which could not be mistaken for grand opera, or otherwise fall foul of the Lord Chamberlain's new guidelines. This search at first led the manager of one patent house, Colley Cibber, to present a new series of music and dance extravaganzas, which from the start were called by their old Roman name, and have remained with us as 'traditional' Christmas entertainments. So in 1717 Cibber presented at Drury Lane a 'New dramatic entertainment of dencing, after the manner of the ancient pantomimes, called *The Loves of Mars and Venus*.

The 'pantomime', now firmly embedded in the British 'cultural heritage', was at first offered rather timorously to the British public, as Cibber explains:

...at the time I am speaking of, our English music had been so discountenanced since the taste of Italian opera prevailed it was to no purpose to pretend to it. Dancing, therefore, was now the only weight in the opposite scale, and as the new theatre sometimes found their account in it, it could not be safe for us wholly to neglect it. To give even dancing therefore some improvement, and to make it something more than motion without meaning, the fable of *Mars and Venus* was formed into a connected presentation of dances in character... at the same time, from our distrust of its reception, we durst not venture to decorate it with any extraordinary expense of scenes or habits: but upon the success of this attempt it was rightly concluded that if a visible expense in both were added to something of the same nature, it could not fail for drawing the town proportionately after it.

Its success marked the birth of that peculiarly British form of entertainment, which, as so often happens, had assumed its first form and character not because of any pressing artistic need – still less from the pressure of British tradition – but simply as a profitable means of filling the theatre, while not offending contemporary restrictions.

Meanwhile, the designated work of the newly created Royal opera house was proving expensive. Singers were already being paid much more than actors. In the first full opera season some of the women singers received £400, probably twice as much as any performer in the straight theatre. Later, when such singing became popular, the well-known castrato Nicolini was paid as much as £860 for one season. To try to raise income to meet the high costs of singers, orchestra and scene painters, costly subscriptions were sold for the opera seasons, with ticket prices about four times higher than those for the playhouses.

By 1719, Handel had already contributed the first of the 29 successful operas he eventually composed for the King's theatre. As a result he was certainly well aware of the problems of financing an opera house, particularly one in which the operas were sung in Italian and which thus frequently involved the additional expense of buying-in Italian companies and singers.

So, to cope with the unprecedented funding problems, Handel made common cause with some 62 noblemen – largely members of the Kit-Cat club – who between them subscribed a total of £15,600, and in 1720 launched a radical new kind of funding body to deal with the budgetary problems of staging opera. They could not of course depend on Royal financial patronage – there was no possibility that the impoverished King George could afford to foot the whole of the annual bill – but they knew that they still nevertheless required Royal patronage in another sense. It was important that the new body used the Royal name, and it duly acquired a Royal Patent.

The new organisation was the first Royal Academy of Music. Unlike its namesake founded a century later, it had no teaching or performing function. It was created solely to help with the financing of the King's theatre. In some respects, it certainly resembled a latterday British arts council. It was an agency with a Royal Charter whose prime responsibility was to support the Royal opera house by offering peer group advice on its operation, and supplying deficit funding for its activities.

The founders of the Academy hoped that the money which had been subscribed would cover the opera house's losses for some 21 years. However their hopes were soon dashed. Financing the opera proved even then to be something of a bottomless pit. At the end of two seasons the funding body had already paid out £4,524 to cover two years' losses – some 29% of their total capital. In the following years expenses became ever greater. The castrato Senesino was paid £2,000 a year; the sopranos Cuzzoni and Faustina some £1,500. Even with some additional Royal monies – George I also paid a modest £1,000 each year to his opera house – and ever more frantic attempts to devise new forms of subscription, the venture was soon running a mounting deficit. However when the final blow came to the Royal Academy it came from an unexpected quarter.

From the first the Royal opera house had been subject to the same kinds of attack as is its modern equivalent. There were those who simply took exception to the seemingly bizarre conventions of Italian opera – an exotic and irrational entertainment', according to Dr Johnson – and there were those who particularly minded the fact that the performed works were not sung in English. In *The Spectator* of March 21, 1711, Addison delivered his famously sardonic account of its seeming fatuities:

> The next step in our refinement was the introducing of Italian actors into our opera; who sung their parts in their own language, at the same time that our countrymen performed theirs in their native tongue. The king or hero of the play generally spoke in Italian, and his slaves answered him in English...

> At length the audience grew tired of understanding half the opera; and therefore, to ease themselves entirely of the fatigue of thinking, have so ordered it at present, that the whole opera is performed in an unknown tongue...I cannot forbear thinking how naturally an historian who writes two or three hundred years hence, and does not know the taste of his wise forefathers, will make the following reflection: 'in the beginning of the eighteenth century, the Italian tongue was so well understood in England. that operas were acted on the public stage in that language'.

In addition, there were those who objected to the high expense and fashionable display which surrounded London's opera house, and there

were other political voices objecting not simply to the fact that the opera attracted privileged audiences, but who also believed that patrons' funds would be better spent on charitable causes concerned to help the underclasses of eighteenth century society.

All of these attitudes are given voice in John Gay's powerfully subversive work, *The Beggar's Opera*, first presented in 1728. This ballad-opera occupies a theatrical position broadly equivalent to the best political cartoons of the time. It is populist in sentiment but sharply satirical. The opera is presented to the audience not by grandly dressed fashion plates but by a scruffy beggar, who has bottonholed one of the players to help him with the production. The elaborate conventions of fashionable opera are thus turned on their heads. The whole text is in English, and the songs are simply accompanied by traditional English airs. The customary high-minded hero is replaced by a highwayman, Captain Macheath, and the traditional heroines by two doxies, Polly Peachum and Lucy Lockit. The sentiments of the piece are far from highflown, and pithily spoken by a horde of highwaymen, con-men, whores and other denizens of the underclasses, who replace the usual operatic chorus. Even the opera's ending, in which by tradition characters get their just deserts, is presented sardonically. Macheath, horrified that he is about to be saddled with not one but several wives, demands to be taken away in the conventional manner and hanged:

Player: The catastrophe is manifestly wrong, for an opera must end happily.

Beggar: Your objection, sir, is very just; and is easily removed; For you must allow that, in this kind of drama, 'tis no matter how absurdly things are brought about – so–you rabble there – run and cry a reprieve – let the prisoner be brought back to his wives in triumph.

Player: All this we must do, to comply with the taste of the town.

The text is more subversive than may at first appear. The characters of the corrupt Lockit and Peachum were plainly based upon the then Prime Minister, Walpole, and Lord Townshead, who had recently quarrelled with him. Some of Walpole's well-known political aphorisms are put more or less directly into Lockit's mouth, and ridiculed by their context.

The piece caused controversy in the highest places. The King refused to go and see it. One of his coterie, the Duchess of Queensbury, 'proverbially beautiful', and 'at the top of the polite and fashionable world', was caught by George II raising subscriptions for the opera in the King's own drawing room. She was summarily banished from the court. Unfazed by this, she promptly wrote in reply:

The Duchess of Queensbury is surprised and well pleased that the King hath given her so a agreeable a command as to stay from Court, where she never came for diversion, but to bestow a greater civility upon the King and Queen...

Banishment from George's court did not at all affect the Duchess's position in cultured society. She remained a prominent first-nighter at the opera, continued to give masquerades and balls at her fashionable home, and continued to receive the cream of London society.

Gay's script was at first offered to Colley Cibber – still managing the patent house at Drury Lane – but he had refused to stage it, perhaps recognising the dangerously anti-Royalist sentiment hidden beneath its folds of irony. However Rich, now managing the smaller and less popular patent house at Lincoln's Inn fields, had no such qualms. He immediately presented it, and was triumphantly justified for, from its opening, *The Beggar's Opera* was a massive critical success, running for an unprecedented 63 consecutive nights at Lincoln's Inn Fields. It 'made Gay rich, and Rich gay', became the fashion of the season and emptied the houses of rival London entertainments. There was a catastrophic drop in takings at the King's opera house, where income fell so sharply that the funding body, the Royal Academy of Music, was plunged into bankruptcy and collapse. Thus the functioning of Britain's first (private) arts council was effectively undermined and destroyed by the *vox populi*.

The ballad-opera's triumph caused the first shadowy battle lines between 'high' and 'low' art to be drawn up. For the first time it began to be suggested that popularity might be incompatible with excellence. The populist Dr Johnson was strongly of the opinion that *The Beggar's Opera* combined the two attributes. The purist Defoe spoke against it.

When he attended a performance, Walpole, with the public eye upon him, was forced to applaud it heartily. However, in 1729, when Gay attempted to stage a sequel, *Polly*, in which Macheath is transported to the West Indies, Walpole helped to persuade King George that his officers should ban it from the stage. (In the event, and somewhat ironically, this ban proved to be to Gay's financial advantage. The eighteenth century reading public had by then grown sufficiently large for Gay to make more from the sale of the text of *Polly* in the bookshops than he had made from the stage performances of *The Beggar's Opera*.)

The scandalous success of Gay's satire was also one element in the decision of the Walpole administration to pass the *Licensing of Theatres Act 1737*. Amongst other things this act abolished at a stroke any hopes the provincial theatres might have had of soon being permitted to present plays openly for hire, gain or reward. It unambiguously affirmed the sole right of the Royal London patent houses to present the legitimate drama,

or, in the case of the King's theatre, the Italian opera. It also established the position of the Lord Chamberlain as the Royal licensor and censor of the drama. Under Section 2 of the Act no new plays nor even additions to old ones might henceforward be acted until they had received a licence from the Lord Chamberlain, 'of His Majesty's Household'.

The short-term effects of the Act were less extreme than is sometimes alleged. A few theatre companies even continued to be granted licences to play their established repertoire in provincial towns. Others evaded the law by such means as selling tickets to a 'concert' – with a play given in the interval. After a few years the situation in London was also eased. An act of 1752 permitted local magistrates in London and Westminster to grant licenses to places of amusement operating within a radius of twenty miles. Under this Sadler's Wells received a licence for its summer performances, as did the Haymarket theatre in 1766. In 1777 the circus proprietor Astley was granted a Royal patent for his travelling horse riding show. Meanwhile Royal patents started to be granted for certain provincial theatres. Thomas Ivory achieved a Royal Patent for his theatre in Norwich in 1768, the same year in which a Patent was given to the Orchard Street theatre in Bath, while Bristol achieved its Royal Patent in 1778.

The longer-term effects of the 1737 Act, taken in conjunction with earlier Royal restrictions, were however considerable. The British theatre remained damagingly split between the Royal 'legitimate' drama, and the 'illegitimate' populist spectacles of melodrama, variety, musicals and pantomime. This was sometimes made startlingly clear in the battles to gain patent theatre status. In Birmingham for example, the manager of the New Street theatre, Yates, was moved to make the following promises in an eighteenth century newspaper advertisement:

> February 17, 1777. To the Gentlemen, Manufacturers, Tradesmen, etc. of the Town of Birmingham, and its Environs. Whereas a Petition is now depending in the Honourable House of Commons. for a Royal Theatre in the Town of Birmingham, and it having been suggested to several Gentlemen of the said Town that a bad Use might be made of the Power intended to be vested in the Person to whom it may be granted: the following Conditions are submitted for their Consideration:

> First, that no public Diversions, such as Rope-Dancing, Tumbling, Puppet-Shows etc. which have been lately exhibited, and are so greatly complained of, shall ever be permitted at the New-Street theatre.

> Second, That the Time for performing Plays shall be limited to four months.

His efforts were unsuccessful. Birmingham did not acquire a Royal patent for its theatre for another thirty years.

The British theatre was by other means long kept under court control. The texts of all plays remained subject to Court censorship in Britain until the 1960s. The prefix 'Royal' still bestows prestige, and still allows exemption from some of the more irritating corners of the licensing law. It is therefore still an earnestly-sought appendage to the titles of our major British companies – the Royal Opera, the Royal National Theatre, The Royal Ballet, the Royal Shakespeare Company. In this way the Royal enclosure of the performing arts, which may be said to have reached its apotheosis in 1737, affects us still.

In other realms Royal patronage was given with a lighter touch, and can be said to have been of general benefit to a wider public. This is notably true of the Royal Society, which received its own Royal Patent in 1660, and came fully into being in 1665, with weekly meetings in Oxford and London. The idea of such a learned society to promote inquiry had first been mooted by Christopher Wren in one of his Gresham College lectures. Wren proposed that the main lines of inquiry should be 'philosophical'. Under this broad heading members' interests were diverse, covering areas which we now variously term the arts, theology, architecture, engineering, farming and husbandry, as well as science. It is interesting in this respect to note that literary figures were often prominent members. Samuel Pepys became a fellow in 1664, and Isaac Walton in 1667. It was not until 1848 that it became an exclusively scientific society.

By the middle of the eighteenth century, education had not been sharply compartmentalised into modern 'subjects'. 'Science', for example, referred to many different kinds of numerate skills or calculative inquiries, and we can even uncover examples where 'science' seems to be used interchangably with the term 'art', as when Daniel Defoe suggested in 1729 that money being spent on hiring Italian opera singers would be far better deployed in giving a musical education to selected children:

> So that instead of giving £1,500 per annum, the price of one Italian singer, we shall for £300 once in ten years, have sixty English musicians regularly educated, and able to live by their science.

Nor had recreation yet been subdivided into its mutually exclusive categories. Most people in town and country followed a variety of sporting, artistic and scientific pursuits without being aware that they were crossing any cultural boundary.

It should not then surprise us to learn that at its creation in 1754, the first Royal Society of Arts was formed as the *Society for the Encouragement of Arts, Commerce and Manufactures in Great Britain* in the belief that there is a natural and easy affinity in the older senses of the

terms, between 'arts', 'commerce' and 'industry'. The prime mover in the society's creation, William Shipley, had no difficulties in describing their purposeful interaction:

> As riches are acknowledged to be the strength, Atts and Sciences may justly be esteemed the ornaments of nations. Few kingdoms have ever been formidable without the one, or illustrious without the other, or very considerable without both. – Does it not then behove every nation to cultivate and promote amongst the members of her own community what are so apparently and eminently conducive to her interest and glory? Encouragement is much the same to Arts and Science as culture is to Vegetables: they always advance and flourish in proportion to the rewards they acquire, and the honours they obtain. – The Augustan age among the Romans, and some preceding ages amongst the Greeks, were remarkable for the delicacy of their taste and the nobleness of their production; they have recommended and endeared themselves to all posterity by many valuable monuments of genius and industry...
>
> Profit and honour are two sharp spurs, which quicken invention, and animate application; it is therefore proposed that a scheme be set on foot for giving both these encouragements to the liberal sciences, to the polite arts, and to every useful machinery.

Shipley's society was financed in the accustomed eighteenth century manner, by the raising of a subscription from interested parties, and soon had more than 2,000 subscribers. At first it awarded prizes to amateur painters and architects, but concentrated awards upon 'the useful arts', men or women whose work or inventions seemed likely directly to benefit society. Prizewinners ranged from people who had invented new dyes to help the cotton trade, to landowners who were growing timber for use in British shipyards.

It made waves in the visual arts when in 1761 it organised the first large-scale public exhibition of domestic art ever held in Britain. The exhibition was an immediate success and more than 20,000 people attended. To Shipley and his followers, this was entirely in tune with the purposes of the Society whose aims were 'to render Great Britain the school of instruction as it is already the centre of traffic to the greatest part of the known world'. The exhibition had achieved its purpose of raising the status of Great British painting, and had dented the belief of the eighteenth century connoisseur that continental classical work was innately superior to anything which could ever be achieved by British artists.

The movement to create a separate British Academy of Art had grown alongside the creation of the Royal Society. Throughout the 1740s and 1750s many prominent artists had argued for a British Academy, on the lines of the French one. In 1749 the author of *An Essay on Design*, John

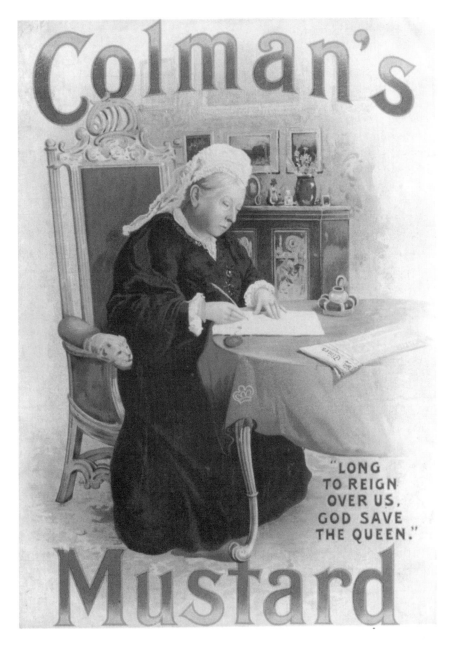

Figure 3 Royal patronage was for long periods a simple matter of trade. In return for a fulsome dedication, or a generous supply of the product, free use could be made of the Royal name.

Gwynn, called for an Academy to be formed of 'Painters, Sculptors, and Architects...to be supported by Voluntary Subscription (till a Royal Foundation can be obtain'd)'. In 1755 a committee of twenty-six artists formed a plan for such an Academy, and put it both to the *Society for the Encouragement of Arts, Manufactures and Commerce* and to the *Dilettanti Society*, the best-known club for art connoisseurs.

The aim of the new academy was primarily to refine public taste, but it also had more than an eye to the development of the market, not just for painters but also for artists as various as domestic designers, jewellers, carriage builders and trinket-makers. However the plan was not accepted either by the Royal Society or by the connoisseurs. (In Hogarth's scornful opinion, this was because the *Dilettanti* wanted to be 'Lords and Masters' of any new academy.) So the artists split from their parent society, and set up their own Society of Artists of Great Britain, known after its 1765 Royal Charter as the *Incorporated Society of Artists*.

For several years rivalry between the two bodies was intense. In 1769 the Incorporated Society expelled some 35 of its own members who had been discovered exhibiting in the Royal Society's summer show. Eventually however, the Incorporated Society overextended itself, committing too many resources to a new exhibition gallery in the Strand, which misjudgement led to its financial collapse. When the Royal Society eventually opened its (rather more modest) exhibition and meeting rooms at Somerset House in 1780 their rivals had expired. *The Royal Academy*, as it was thereafter called, now existed in much the same way and in the same form as the French academy.

Its influence on taste in the visual arts was great, and Reynolds, its first President, in his *Discourses on Art*, had reaffirmed the relationship between industry, in its older sense, and the modern artist:

> If you have great talents, industry will improve them; if you have but moderate abilities, industry will supply their deficiency.

The annual exhibitions attracted large crowds. In 1778 and 1779, in its last years as the Royal Society, attendances were 29,511 and 27,616 respectively. After the new Academy moved to its larger premises in Somerset House in 1780 attendances soared; 61,381 people visiting the annual exhibition in its first year in its new home. The Academy became highly profitable and during the 1780s was able to invest some £13,800 in government stock. The Academy certainly did not need Royal patronage in the form of cash, and it could be said that it more than repaid its right to use the prefix 'Royal'. Its advice to the Royal Family and its influence upon the market values of painting and works of art

perforce made it a collaborator in the inexorable rise in the value of the Royal Art Collection, still the richest in Britain.

Over the nineteenth and twentieth century direct financial patronage of the high arts by the Royal family has in general declined almost to invisibility. Queen Victoria was in that regard particularly parsimonious, even reducing the annual payment for her Royal box at Covent Garden from £400 to £250, causing Macready's famous 1837 outburst:

> If this be Royal Patronage, commend me to popular favour! Patronage is a declining art.

The Royal family's varied interest in popular entertainment however has in another sense offered more generous patronage. Though grudging towards the theatre Victoria showed great enthusiasm for entertainment, particularly circus acts, going to see the animal trainer Van Amburgh at Drury Lane three times in a fortnight. On her third visit, when Van Amburgh was presenting one of his show pieces, holding a new-born lamb beneath the nose of one of his caged leopards, the leopard sprang upon the lamb and wrenched it from Van Amburgh's grasp. The other animals in the cage closed in. An awestruck Victoria wrote in her diary:

> It was an awful moment, and we thought all was over, when Van Amburgh rushed to the leopard, tore the lamb unhurt from the leopard which he beat severely, took the lamb in his arms, only looked at all the others, and not one moved though they had been in the act of devouring the lamb. It was beautiful and wonderful, and he was immensely applauded.

Long after the death of Prince Albert, and when she had ceased to visit the theatre and had to be coaxed into commanding a play or opera performance at a Royal residence, Victoria nevertheless repeatedly commanded circus performances – Ginnett's in 1893, Hengler's in 1886, 'Lord' George Sanger's many times. During her Golden Jubilee year in 1897, as an elderly and dignified sovereign, she astonished her court by sallying forth to visit no fewer then three London circus performances – a French circus in March, and 'Buffalo Bill' Cody's Wild West Show twice during the summer – visits which gave rise to a familar-seeming jibe from the Music Hall star Vesta Tilley:

> *She's seen the Yankee Buffaloes,*
> *The circus, too, from France.*
> *And may she reign until she gives*
> *The English show a chance.*

It was not the last time that there was resentment over the Royal family giving their patronage to non-British artists.

King Edward VII was a more enthusiastic theatre buff than his mother, and had more catholic tastes, admiring Kean and Irving in his youth and being also an enthusiast for burlesque and the London music hall. His motives for loving theatre were however slightly suspect but when he became King he did not curb his theatrical enthusiasms. In 1909 he took Queen Alexandra to a music hall bill at the Empire, famous amongst other things for its 'Ladies of the Promenade', during which a newspaper report remarked artlessly 'that he used his opera glasses very freely'. Later in the same year he took the Queen to the equally notorious Alhambra, and on both occasions the Royal couple stayed for the full bill, including the newsreels on the Bioscope.

That was the last time for forty years that a reigning British monarch saw a public showing of a film, although more raffish segments of the performing arts were the objects of official Royal notice. The first Royal Command Variety show – which included 160 music hall acts but excluded the risqué Marie Lloyd – was held in 1912. Profits from the seats sold amounted to £2,739 and were at King George's request distributed amongst music hall charities. Thus Royal patronage for the music hall helped to narrow the gap between the legitimate and illegitimate theatre, and helped to establish music hall as a popular 'art'. Curiously, the even more popular film had to wait very much longer for the Royal accolade; not until 1948 was there a Royal Command Film Performance.

Industriousness And The Lottery

A Lottery is a taxation,
Upon all the Fools in Creation;
And, Heavens be prais'd,
It is easily rais'd,
Credulity's always in fashion:
For Folly's a Fund
That will never lose Ground,
While Fools are so rife in the Nation.

Henry Fielding, *The Lottery* 1731

The first record we have of a public lottery in Britain dates from 1567:

A Proposal for a very rich Lottery, general without any Blankes, containing a great No. of good prices, as well of redy money as of Plate and certain sorts of Merchandises, having been valued and prised by the Commandment of the Queenes most excellent Majesties order, to the extent that such Commodities as may chance to arise thereof, after the charges borne, may be converted towards the reparations of the Havens and Strengthe of the realm, and towards such other public good workes. The No. of Lotts shall be foure hundred thousand, and no more; and every lott shall be the summe of tenne shillings sterling only, and no more. To be filled by the feast of St. Bartholomew. The shew of Prises are to be seen in Cheapside, at the sign of the Queenes armes, the house of Mr. Dericke, Goldsmith, Servant to the Queen. Some other Orders about it in 1567-8. Printed by Hen. Bynneman.

The writers of the order seem confident that Elizabethans were already sufficiently familiar with lotteries for no further explanations of their nature to be necessary, but emphasised the fact that the number of lots

would be limited, and that the odds would be fair, presumably because their readers also suspected that a number of previous lotteries had been unfairly fixed.

They were probably right on both counts. The well-travelled London merchants, to whom the order was primarily addressed, would be familiar with the many lotteries already run in Western Europe. As early as 1521 there was a civic lottery drawn at Osnaburg, in Germany, with finely embroidered cloaks as prizes. In 1549 the revenue from a lottery had paid for the building of a church steeple in Amsterdam. There are moreover early records of disputes over the ways lotteries had been run in Hamburg and Paris, and the fact that in sixteenth century Europe lotteries were already a familiar public activity is suggested by the title that the Dutch painter Daniel Vinckenbooms (1578–1629) gave to one of his best-known townscapes. *The Drawing of a Lottery at Night* can still be seen in the Amsterdam Municipal Collection.

The 1567 announcement stresses that the profits of the British lottery would go to 'public good workes'. This means that although this was probably not the first lottery to be run in the country, and certainly not the first lottery that well-travelled Londoners would have encountered, it was almost certainly the first publicly-run state lottery in Britain. So its promoters were naturally anxious to dissociate a lottery bearing Queen Elizabeth's name from previous enterprises. And as the 'public good workes' were primarily concerned with safeguarding state business – the havens were the protected overseas ports in which British ships deposited and collected their cargoes – we can also see the cautious hands of her Majesty's Merchant Adventurers behind the new venture.

The drawing of the first state lottery was to have taken place in the house of Mr Dericke, who was the Queen's jeweller, but in the event interest was so great that it was drawn in public, at the west door of St. Paul's Cathedral, on the 11th. January 1569. According to one source drawing continued, day and night, until the 11th May, but – even allowing for the number and variety of prizes – that seems unlikely. What is certain is that it was from the first a hugely successful means of raising government revenue, and a British state lottery continued to function, sometimes at fever pitch, sometimes more falteringly, but without long interruption until, with righteous disapprobation, it was 'finally' discontinued in the early nineteenth century.

Throughout Elizabeth's reign, interest in the lottery was more or less confined to the London merchant classes, although the relatively small number of punters meant that prizes had to become ever more sumptuous so that interest did not flag. In 1586 there was a particularly attractive prize:

A Lotterie, for marvellous rich and beautifull armour, was begunne to be drawn in London, at St Paules Churchyard, at the great west gate, (An house of timber and boord being there erected for that purpose,) on St. Peter's day in the morning, which lotterie continued in the drawing day and night for the space of two or three daies.

Lord Burghley mentions the same lottery in his diaries: 'June, 1586, the lottery of armour under the charge of John Calthorp determined'.

By the early seventeenth century it is apparent that lotteries were being held outside London in some of the richer towns. In the *Register of Charitable Gifts to the Corporation of Reading* there is a record of one held there in 1619. This appears in one respect to have resembled the modern British lottery in that (through the generosity of the agent who ran it) a portion of the profits was given in trust to deserving local people rather than to public buildings and public services – to 'good causes' rather than to 'public good workes':

Whereas at a Lottery held within the Borough of Reading, in the Year of our Ld. God 1619, Gabriel Barker Gent. Agent for the sd. Lottery for the Councell & Company of Virginia of his own good Will and Charity towards poor Tradesmen, Freemen and Inhabitants of the sd. Borough of Reading, & for the better enabling such poor Tradesmen to support & bear their Charges in their several Places & Callings in the sd. Corporation from time to time for ever freely gave & delivered to the Mayor and Burgesses of this Corporation the sum of forty Pounds of lawfull Money of England upon Special Trust and Confidence...

Lottery profits were thus for the first time going to a charitable cause, albeit by a circuitous route. Mr Barber's gift was to gather interest for five years and then, in 1626, the Mayor and Corporation of Reading were enjoined to choose 'six poor tradesmen', who lived within the town and did not keep 'either Inn or Tavern', who would receive the sum of £6. 13s. 4d. over the next five years. When that five years was over another six deserving Reading tradesmen would be chosen, given the same sums and so on, 'successively, for ever'.

There is no record of how long such charitable bequests were sustained, but we can be more sure of the lasting importance of some of the good works financed by the national lottery. In 1612 King James I granted a lottery, once more drawn at St Paul's, in favour of the plantation of English colonies in Virginia. In 1630 the favoured good works were closer to home. One Michael Parker proposed a scheme whereby he, John Lyde and Sir Edward Stradling would bring fresh water into London and Westminster from 'certain springs of water' in Hertfordshire. There followed the first reference to lotteries in the Statute Book:

> For defraying the expenses where of, King Charles granted them a special license to erect and publish a lottery or lotteries, according to the course of other lotteries here to fore used or practised.

London thus gained its first regular supply of fresh water by means of a lottery. In general lotteries flourished under Catholicism, and there are many records of lotteries being drawn to provide for the welfare of its Bishops and Cardinals. In 1588 Louis, duc de Nivernois, established a lottery in Paris for the purpose of assisting the poor but virtuous young women on his estates. Pope Sextus V immediately promised those who promoted lotteries for such worthy causes should have complete remission of their sins.

In Britain the Puritans were more wary, but Cromwell did not altogether forbid them. In November 1653, in the middle of the Commonwealth years, on the pages of the weekly newspaper *Daily Intelligence* where there is set out in bold print:

> At the Committee for Claims for Lands in Ireland.Ordered. That a Lottery be at Grocers-Hall, London, on Thursday 15, December. 1653, both for Provinces and Counties, to begin at 8 of the clock in the forenoon of the same day; and all persons concerned there in are to take notice thereof.

Yet as may be expected the lotteries flourished more openly in the years following the Restoration. Charles II rewarded his followers after his resumption of the throne by awarding them 'plate lotteries', gifts of Royal plate which came with Royal permission for the recipient to use it as a prize in their personally promoted lottery. To regulate the plate lotteries Charles set up what was the first permanent lottery office. Anyone wishing to apply for the right to run one:

> ...may repair to the lottery office, at Mr Philip's house in Mermaid Court over against the mews, where they may contract with the trustees commissioned by his majesty's letters patent for the management of the said patent, on the behalf of the truly loyal, indigent officers...

Also popular during Charles' reign were the 'book lotteries', which for the first time directly link the national lotteries with the arts. The book lotteries were not however set up to offer charity to publishers or booksellers but were so called simply because they offered valuable books as prizes. The titles and values of the main prizes offered at a popular 1665 lottery offer a salutary reminder that, for all its gaudiness and hedonism, Restoration society still regarded major works of serious literature as attractive prizes:

The first and greatest Prize contains:

An Imperial Bible, valued at	£25
Virgil Translated, valued at	£5
Homer's Illiads, valued at	£5
Homer's Odysses, valued at	£4
Aesop's Fables, valued at	£3
A second Collection of Fables	£7
His Majesty's entertainment passing through the City of London, and Coronation	£2
Total	£51

The second Prize contains

One imperial Bible	£25
Homer, complete, in English	£9
Virgil	£5
Aesop, complete	£6
The Description of China	£4
Total	£49

The Third Prize contains

One royal Bible	£10
Home's works in English	£9
Virgil	£5
The First and Second Volume of Aesop's' Fables	£6
The description of China	£4
His Majesty's Entertainment	£2
Total	£36

There are twenty eight individual prizes, the winner of the twenty eighth prize gaining a Royal Bible, valued at £5. Then the prizes come in multiples. Ten people each win the next prize, a complete Homer, valued at £5, and no fewer than 530 people win the thirty sixth listed prize, a copy of the second volume of Aesop's Fables, valued at £3. The total value of the prizes was £3.368; and the most that the organisers could receive from a complete sale of the five shilling tickets was, according to the bills, £4,110. Moreover the organisers promised to hold the draw irrespective of whether all tickets had been sold, though plainly believing that the prizes were sufficiently attractive to ensure a rapid sell-out. (It is interesting to speculate on whether modern lottery organisers would be

equally sanguine about their sales if the prizes were literary or artistic works rather than money.)

By the late seventeenth century, Britain was in the first flush of its recurrent lottery fever, with the authorities trying hard to retain control over the outbreak. On September 27, 1683, the *London Gazette* carrried a government notice prohibiting the drawing of any lotteries 'except those under his majesty's letters patent for thirteen years'. However, there was some scepticism about the character of the Royal monopoly when the Gazette announced almost immediately afterwards, on October 1st, that the next lottery would be to raise the wind for Prince Rupert's impoverished estate by offering his jewels as prizes. It seems that authority sometimes felt compelled to turn a blind eye to breaches of the lottery law, particularly if the perpetrator was well-connected. In 1688, for instance, the London Gazette has no compunction in publishing the details of what was almost certainly an unlicensed draw, when Ogilvy, 'the better to carry on his Britannia, had a lottery of books at Garraway's Coffee House, in' Change Alley.

In 1707 a company was formed in London with the ostensible purpose of lending money at legal rates of interest to the poor. Known as 'The Charitable Corporation', it was at first capitalised at some £30,000, but over the next twenty four years its capital was gradually extended to £600,000. Then in 1731 it yielded yet another eighteenth century financial scandal when both the cashier, George Robinson M.P., and the warehousekeeper, John Thompson, abruptly disappeared. The hastily-summoned committee of inquiry soon determined that the Charitable Corporation had been defrauded of the greater part of its capital, and was bankrupt. Parliamentary vengeance was belatedly taken. Two of the directors of the corporation who were implicated in the frauds, M.P.s Sir Robert Sutton and Sir Archibald Grant, were like Robinson expelled from the House of Commons. Then, in 1733, parliament ordered that the major lottery of that year should have the express aim of assisting the impoverished shareholders. As a result creditors were paid 9s.9d. in the pound as recompense for their loss.

The Charitable Corporation swindle took place in the wake of the South Sea Bubble, and alongside various new lottery swindles. The most spectacular of these had been the 'Harburgh Lottery' of 1729, promoted by yet another corrupt Member of Parliament, Lord Barrington. His lottery supposedly was held for the benefit of maintaining trade 'between Great Britain and the king's territories on the Elbe', so not only was it unlicensed, but impudently it also used the sovereign's name in its promotional material. This was going too far. The lottery was suppressed

and Barrington was both expelled from Parliament and ordered to repay all stakeholders.

Lotteries now began to attract criticism, and the state promoters made strenuous efforts to prove that their operations were above suspicion and that the public works chosen to receive lottery largesse were of general benefit. The lottery of 1736 for example was held for the purposes of raising £100,000 for the building of Westminster Bridge. It advertised the details of its budget in the minutest detail. It was to sell 125,000 tickets at £5 each. The odds on winning a prize were good, for there were little more than three blanks to each prizewinning ticket. The 125,000 lots would include 30,616 winning tickets, with the larger prizes distributed as follows:

1	Prize of	£20,000
2	Prizes of	£10,000
3	Prizes of	£5,000
10	Prizes of	£3,000
40	Prizes of	£1,000
60	Prizes of	£500
200	Prizes of	£200
300	Prizes of	£50
1000	Prizes of	£20
2880	Prizes of	£10

The prize money totalled £523,000, which together with two extra 'bonus' prizes of £1000 meant that a full subscription yielded a profit of precisely £100,000. That sum was not however sufficient to complete the construction of the bridge and in the following years successive lotteries were held to raise the further sums required for its completition.

In 1737, a private lottery was licensed, in which the first prize was a mechanical organ. Lord Orford, who coveted the instrument, wrote to a friend after the draw:

> I am now in pursuit of getting the finest piece of music that ever was heard; it is a thing that will play eight tunes Handel and all the great musicians say that it is beyond anything they can do; and this may be performed by the most ignorant person; and when you are weary of those eight tunes you may have them changed for any other that you like. This I think much better than going to an Italian opera, or an assembly. This performance has been lately put into a lottery, and all the royal family chose to have a great many tickets, rather than to buy it, the price being I think £1000, infinitely a lesser sum than some bishopricks have been sold for. And a gentleman won it, who I am in hopes will sell it, and if he will, I will buy it, for I cannot live to have another made, and I will carry it into the country with me.

The Westmintster Bridge lotteries seem to have been the last state lotteries in which no fee was taken. In 1739, the licensed organisers lottery took 15% of the proceeds in fees, inspiring in *The Champion* of January 1740 the following, modern-sounding, doggerel:

> *The lottery can never thrive,*
> *Was broker heard to say.*
> *For who but fools will ever give*
> *Fifteen per cent to play.*
>
> *A sage with his accustomed grin,*
> *Replies, I'll stake my doom,*
> *That if but half the fools come in*
> *The wise will find no room.*

In 1753, the lottery took an even more familiar form. Early in the year, Parliament had taken the historic decision directly to fund the visual arts, by agreeing to purchase Sir Hans Sloane's collection of paintings with a view to creating a national gallery. The sum members voted was, however, insufficient, and so it was agreed that government funds should be supplemented by the proceeds of the lottery, an uneasy form of dual financing for art provision which was again to be employed, in rather different circumstances, nearly two hundred and fifty years later.

But criticism of lotteries was now running deeper. In 1731, the *London Journal* had outlined the general objections:

> The natural life of man is labour or business; riches is an unnatural state; and therefore generally a state of misery. Life, which is a drug in the hands of idle men, never hangs heavily on the hands of merchants and tradesmen, who judiciously divide their time between the city and country.
>
> This is so true, that a wise man would never leave his children so much money as to put them beyond industry; for that is too often putting them beyond hapiness...
>
> These thoughts were occasioned by the present state lottery; which plainly discovers that people would run into the excesses of the South Sea year, had they the same opportunities... This sets them a madding after lotteries; business is neglected, and poverty, vice, and misery spread among the people. It is hoped that the Paliament will never come into another lottery. All other gaming should also be discouraged.

The main current of objection lay in the fact that the lotteries ran counter to industriousness, in its early sense of good habits of industry. Like other forms of gaming, it offered false rewards, unlinked to work, and relied upon the devilish machinations of chance rather than upon the balanced

rhythms of the natural order. In 1755 Dr Johnson encapsulated such objections neatly in his *Dictionary* when he defined a gambler as 'a knave whose practice it is to invite the unwary to game and cheat them.'

There was a further undercurrent to the criticism. From the first, the state lotteries in Britain had been targeted on the aristocracy and well-to-do merchants. Whereas governments had tended to persecute the poor for gambling they tolerated it in the rich, providing that it took place out of sight of the general public. It was for this reason that the Jockey Club, an aristocratic gambling society founded in the middle of the eighteenth century, was able to work closely with successive governments in the regulation of horse-race betting. But the state lottery could not be so easily contained. The lure of sudden wealth and the excitement of gambling inevitably attracted punters from other classes. Even though the price of lottery tickets had risen by the late eighteenth century to £17.10s., poorer people nevertheless found a way of participating in the lottery by creating lottery clubs in their own communities, who would band together to buy a half or quarter ticket, or by buying one of the much smaller ticket shares which unscrupulous stockbrokers sold.

At the same time, the journals and newsheets of the mid-to-late eighteenth century are liberally sprinkled with stories of ordinary folk being gulled into buying bogus lottery tickets, or being cheated of their rightful prizes by unscrupulous London touts, and falling into beggary, going mad ot killing themselves as a consequence. It became an archetypal news story of the period. Typical of the genre was a sad little paragraph in the *Universal Magazine* in November 1757:

> Mr. Keys, late clerk to Cotton and Co.,who had absented himself ever since 7th. October, the day the £10,000 was drawn in the lottery, (supposed to be his property,) was found in the streets raving mad, having been robbed of his pocket book and ticket.

Plainly Mr Keys could blame London's criminal fraternity for his unfortunate state. Others were able to blame the lottery directly, as in this report from the *Gentlemen's Magazine* of 1787 which consists of:

> ...a copy of a paper left by an unhappy young gentleman who lately shot himself with two pistols in Queen-street, Westminster, wherein he execrates 'the head that planned, and the heart that executed, the baneful, destructive plan of a Lottery'.

Different again was an earlier story in the *Gentlemen's Magazine* for January 1777:

> A young man, clerk to a merchant in the city, was found in the river below bridge drowned; he had been dabbling in the lottery with his master's money, and chose this way of settling his account.

On this occasion it would appear that the young man could blame only himself for his misfortune. However looked at in another way the three accounts are similar. Each features an impoverished victim who has been duped into playing a lottery designed for his betters, and who has paid for his folly.

Although it is much more genial in tone than such newspaper stories, Henry Fielding's musical play *The Lottery*, first performed in London in 1732, also takes as its theme the folly of ordinary folk becoming entangled in a form of gaming designed for aristocrats. In it the heroine, Chloe, has been told by a fortune-teller that her undrawn lottery ticket is a certain winner. She makes plans to live a life of luxury, abandoning her trusted suitor and fleeing to London with an adventurer from the City, Jack Stocks, who has wooed her under an assumed aristocratic title, Lord Lace. 'Lord Lace' duly marries Chloe – only to discover on the wedding night that her lottery ticket is a blank.

Thereafter, all is recantation and denunciation. Jack denounces the lottery and swears he will have nothing more to do with it. Chloe's former suitor, Mr. Lovemore, is sorry he ever let Chloe go, denounces Jack Stocks and buys him off for £1,000. Chloe falls into the arms of her true suitor denouncing the aristocracy and their ways: 'A Lord! faugh! I begin to despise the name now as heartily as I liked it before.'

It was not easy for industrious folk to escape the lottery's tentacles, although they were repeatedly warned, in Adam Smith's words, that 'lotteries destroy ...habits of continued industry [for] delusive dreams of sudden and continued wealth'. In *The Wealth of Nations* Smith argued that lottery overvalued the 'vain hope of gaining some of the great prizes and undervalued 'the chance of loss'.

There were many subtle ways in which ordinary folk could be ensnared. The lottery broker, for instance, ran 'little goes', miniature lotteries in between the main events, for which tickets cost as little as a shilling or even sixpence. If you had such a ticket, or had a share of a ticket in one of the bigger lotteries, you were then often enticed into buying 'insurances' against your ticket being a blank. Or you were tempted to put your ticket into pawn, receiving for it less than its face value and standing little chance of ever being able to afford to retrieve it, particularly if it proved to be a winning lot. For these and other reasons by the end of the century the feeling against lotteries grew stronger. An Act of 1802 sought both to check the 'little goes' and the illegal insurances.

In 1808, the Whig government set up a Select Committee to try to establish 'how far the Evils attending Lotteries have been remedied by the Laws passed respecting the same'. Almost all the evidence offered to them

was hostile to lotteries. That of a London magistrate was typical:

> ...it is a scandal to the government thus to excite people to practice the vice of gambling, for the purpose of drawing a revenue from their ruin; it is an anomalous proceeding by law to declare gambling infamous, to hunt out petty gamblers in their recesses, and cast them into prison, and by law also to set up the giant gambling ot the State Lottery, and encourage persons to resort to it by the most captivating devices which ingenuity, uncontrolled by moral rectitude, can invent.

Not unsurprisingly in the face of such vehemence, the Select Committee's interim report expressed great anxiety, saying that if governments were going to continue to extract money from such practices – they were then receiving in excess of £300,000 a year from the lotteries – 'a spirit of adventure must be excited amongst the community' which destroyed the sense of virtue in work, and mitigated against honest industry:

> ...by the efforts of the Lotteries, even under its present restrictions, idleness, dissipation and poverty are increased, the most sacred and confidential trusts are betrayed, domestic comfort is destroyed, madness often created, crimes, subjecting the perpetrators of them to the punishment of death, are committed, and even suicide itself is produced.

The Select Committee finally came out strongly against the lottery, and recommended that it be discontinued, for the adverse effects of state lotteries could 'only be done away with by the suppression of the cause from which they are derived'. Coupled with the continuing rumours of malpractice (a recurrent one was that the Blue Coat Schoolboys who put in and drew out the tickets from the great lottery wheels had been got at), and the growing opposition from Methodism, the lotteries began their final descent from public favour.

Though in the early nineteenth century the lottery remained a conspicuous part of everyday city life. Edwin Hodder, writing from the high moral ground of the last months of Victoria's reign, draws in *The Life of the Century* a vivid picture of the lottery's final decades:

> That gambling was very prevalent in all classes, and by both sexes, is not to be wondered at, seeing that the Government systematically demoralised the people by means of lotteries, which yielded to the state a early revenue of about £350,000 besides the licenses of the brokers, at £50 each...In London and throughout the provinces, offices were opened for the sale of tickets; hoardings were placarded with advertisements, newspapers had columns of information, and literary fortune-tellers issued pamphlets and scattered them broadcast.

Though their actions were deplored by methodists and social reformers, London City fathers nevertheless took the opportunity to make a quick profit in the lottery's last years:

The drawings generally took place at the Guildhall, and for many years the City Corporation made a good income from the letting of seats. When the drawing day arrived, the excitement reached its highest. Papers were put into a hollow wheel inscribed with as many numbers as there were shares or tickets. One of these was drawn out by a Blue Coat boy and the number shouted out; another Blue Coat boy then drew out of another wheel a paper denoting either "blank" or a "prize" for a certain sum of money, and the purchaser of that particular number was awarded a blank or a prize accordingly. Whether the man who drew a blank or a prize was the more fortunate it is difficult to say; the newspapers of the day abounded with stories of the ridiculous way in which, in many cases, the money was spent, and the folly and crimes on the part of those whose disappointments on drawing a blank led them to the verge of insanity.

Hodder is certain that the British lottery had adversely affected the industry of the people, and drawn them into sloth and superstition. His contemptuous remarks about the fancies engendered by the lottery have an uncannily modern air:

> The mischief created by a system so glaringly immoral it is impossible to calculate. Everyone was 'making haste to be rich' ...everyone was buoyed up by false hopes and kept in a state feverish excitement fatal to steady industry. Theories of 'chances' and of 'lucky numbers' were discussed with a fervour almost incredible...A number corresponding with the date of the year or of the drawer's birth, was considered lucky; or a combination of alternate or odd and even numbers, or 666 the 'number of the beast', or the numbers of successful drawings in previous lotteries.

Yet the income generated by the lottery was still sufficiently large for cash-starved governments to resist calls for the lotteries' immediate closure. They staggered on through the first decades of the century until, in 1821, Lord Liverpool's government finally decided to enact their abolition. Even then it was another five years before the British state lottery breathed its last.

Finally it was the Great Lottery of 1826, drawn on October 18th. at the Cooper's Hall in Basinghall Street, that was thought certain by its organisers to be the last–ever state lottery in Great Britain. There was a funereal – perhaps one might say millennial – feel to the occasion, sharply captured by a little item in William Hone's 1826 edition of his *Every Day Book*:

<div align="center">

EPITAPH
In Memory of
THE STATE LOTTERY
the last of a long line.
During a period of 257 years, the family

</div>

> flourished under the powerful protection
> of the British Parliament
> As they increased it was found that their
> continuance corrupted the morals, and encouraged a spirit of Speculation and
> Gambling among the lower classes of the people; thousands of whom fell victim to
> their insinuating and tempting allurements.

Now that it had finally been laid to rest, the epitaph continued, the state lottery's final demise was 'unregretted by any virtuous mind'.

Indeed public opinion had already moved so firmly against lotteries that the organisers had found it extremely hard to sell tickets for the final draw. That was in spite of the unprecedented efforts made to advertise it. In addition to a plethora of notices in the newspapers, the organisers staged a number of expensive publicity stunts. A wagon bearing a specially constructed twenty foot high advertising drum travelled daily through the streets of central London, and in the last week before the lottery another bizarre parade wound its way laboriously through the city's suburbs:

The Final Lottery Procession 1826
1. Three men in liveries, scarlet and gold.
2. Six men bearing boards at their backs and on their breasts with inscriptions in blue and gold, 'All Lotteries end Tuesday next, Six £30,000.'
3. Band of trumpets, clarinets, horns & c.
4. A large purple silk banner carried by six men, inscribed in large gold letters, 'All lotteries end for ever on Tuesday next. Six £30,000.'
5. A painted carriage, representing the Lottery wheel, drawn by two dappled grey horses, tandem fashion.
6. Six men with other lottery labels.
7. A square Lottery carriage, surmounted by a gilt imperial crown, the carriage covered with labels, 'All Lotteries end on Tuesday next.'
8. Six men with labels.
9. Twelve men in blue and gold with boards on poles with 'Lotteries end for ever on Tuesday next.'
10. A large purple silk flag with 'All Lotteries end on Tuesday next.'

The procession was headed by a man with a bell who ever and anon cried out dolefully, 'O yea! God Save the King! Death of the Lottery on Tuesday next!'

That funereal pomp, like all the other gimmickry, was of course designed to stir the populace into protesting against the fact that all state lotteries were going to end, for ever. Yet it was all to no avail. Large numbers of tickets for the final lottery were never sold.

Public sentiment had been turned against the lottery not just by the

What's the odds?—while I am floundering here the
gold fish will be gone; and as I always was a dab at
hooking the right Numbers, I must cast for a Share of
the SIX £30,000 on the 18th July, for it is but
" giving a Sprat to catch a Herring" as a body may say,
and it is the last chance we shall have in England.

Figure 4 In some respects the first British State Lottery resembled the second. The
Drawing of the Lottery at Guildhall (top), theatrically performed in front of a 'live
audience', seems quite familiar, although Advertisement for the Last Lottery (below)
is rather less hysterical than today's advertising.

Hone's Every Day Book, William Tegg

Methodists' general condemnation of gambling, but by the hostile depiction of the lottery's machinations in contemporary print, stage melodramas and popular novels, such as *The Lottery*, written by Jane Austen's contemporary Maria Edgeworth, and first published in 1799.

The central characters in the book, Mr and Mrs Robinson, win a lottery prize of £5,000. However the prize brings them nothing but sadness, and they decide that they will not enter the lottery again. They have another ticket, but they resolve to sell it. When Maurice Robinson goes down to the lottery office the author does not spare the reader the harrowing personal sadnesses the lottery brings in its wake:

> Maurice...went directly to the lottery office to sell his ticket. He was obliged to wait some time, for the place was crowded with persons who came to inquire after tickets which they had insured.

> Many of these ignorant imprudent poor people had hazarded guinea after guinea, till they found themselves overwhelmed with debt; and their liberty, character and existence, depending on the turning of the wheel. What anxious faces did Maurice behold! How many he heard, as they went out of the office, curse their folly for having put into the lottery!

> He pressed forward to sell his ticket. How rejoiced he was when he had parted with this dangerous temptation, and when he had received seventeen guineas in hand, instead of anxious hopes! How different were his feelings at the instant from those of many that were near him! He stood to contemplate the scene. Here he saw a poor maid-servant, with scarcely clothes to cover her, who was stretching her thin neck across the counter, and asking the clerk, in a voice of agony, whether *her* ticket, number 45, was come up yet?

> "Number 45?' answered the clerk, with the most careless air imaginable. "Yes" (turning over the leaves of his book):

> "Number 45, you say – Yes: it was drawn yesterday – a blank." The wretched woman clasped her hands, and burst into tears, exclaiming, "Then, I'm undone!"

> Nobody seemed to have time to attend to her. A man servant, in livery, pushed her away, saying, "You have your answer, and have no more business here, stopping the way. Pray, sir, is number 336, the ticket I've insured so high, come up today?'

> "Yes, sir – blank." At the word blank, the disappointed footman poured forth a volley of oaths, declaring that he would be in jail before the night; to all which the lottery-office keeper only answered, "I can't help it sir; I can't help it. It is not my fault. Nobody is forced to put into the lottery, sir."

In the midst of such relentless hostility, the supporters of the lottery were hardly heard. One observer of the final draw wrote that it was a fact that 'the public in general have now no relish for these schemes'.

So for more than a century state lotteries lapsed. Yet in Victorian

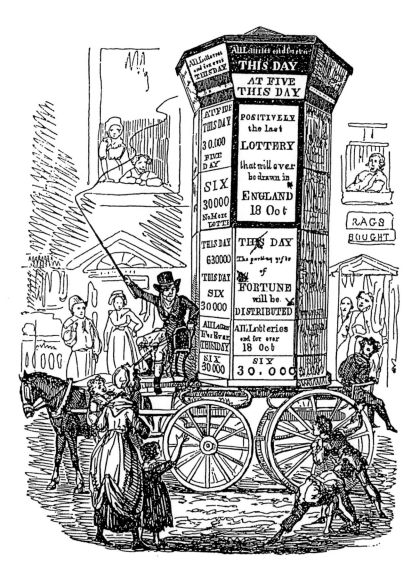

Figure 5 The note of finality on the 1826 'Lottery Cart' is unmistakable. All British lotteries were ending 'for ever'.

Hone's Every Day Book, William Tegg

Britain, curiously, small private lotteries were again allowed, but only for one particular group of people. After 1846, of all things, it was artists who could hold a lottery – *providing that the prizes were works of art, and provided that the game was limited to approved art lovers!* This was the curious consequence of the *Art Union Act 1846,* which legalised the formation of associations for the purpose of buying paintings, drawings or other works of art, and allowed them to be 'distributed by chance', that is by lottery, among the members and subscribers who formed part of that association.

This little-noticed act quietly reunited the machinations of lotteries with Royal patronage, for to operate with impunity the 'art unions' had either to be incorporated by Royal Charter or approved by the Privy Council. Such Royal art societies were then exempt from prosecution for running 'illegal lotteries, little goes or unlawful games'. The majority of people, who did not move in such privileged circles, had to wait for a century and more before there were civic lotteries, and a British state lottery, again.

By then it was clear that for the general public at least works of art were no longer sufficiently alluring as prizes. Lottery prizes had to be in hard cash. The best the artist could hope for was either the fifteen million to one chance of winning a major prize, or the slightly higher (yet still remote) possibility that the artist would be selected as a beneficiary, a 'good cause', and given a handout from the new lottery's massive profits.

The Glory of Commercial Art

At one time it was the devil and alls task to make
haste to the cloth fair or the cheese fair before all
custom had vanished before us; but now it is the
merchants who seek us out and beg us to attend that
they may do lively busyness; for folk will walk out of
theyre way to see a three breasted woman or a
learned pig and may therefore be trapped into buying
cheese or gingerbread or jewjaws for their finery.

Faux, the fairground illusionist, quoted in the *Gentleman's*
Magazine 1731

Italian opera and the spoken drama, constrained by the Royal Patent,
remained largely metropolitan amusements, accessible only to a
comparatively small number of people, the musicians and actors
operating within tightly proscribed commercial systems. By contrast
many other eighteenth century artists began to prosper within new, free
arts markets, which after 1750 extended far beyond the capital. For the
first time in British history artists and craftsmen as various as poets,
essayists, painters, sculptors, instrumentalists, composers, architects,
garden designers, dancing masters, elocutionists and novelists had an
alternative to relying on the patronage – in all senses – of the aristocracy.

There were of course still some notable patrons: the Dukes of Bedford,
Burlington, Chandos, Dorset and Halifax and the Duchess of Newcastle
prominent among them, for it was, as Reynolds said, still a desire of the
nobility 'to be distinguished as lovers and judges of the arts' in a century
with a 'greater number of excellent artists than were ever known before at
one period in this nation'. Yet as the distinction between the landed
aristocracy and the merchant class became increasingly blurred, as

noblemen 'sank into trade' and increasingly prosperous merchants bought their country estates, it was the resultant, newly-affluent middle class which fuelled the new markets for artists and art.

Alongside its older usage meaning skill, artifice, or embellishment, the word 'art' now began to be more confidently used in a wider and more significant sense. Although in 1688, in his survey of the British economy, Gregory King had still found it natural indiscriminately to lump together 16,000 British households as deriving their livings from 'the liberal arts' and 'sciences'. In 1684, in the same decade, Dryden confidently used the term 'art' in a sharper and more elevated definition, contrasting the moral and spiritual dimensions of art with the base commerce of London life in the well-known couplet:

> So poetry, which is in Oxford made
> An art, in London only is a trade.

In *An Essay on Criticism*, published in 1711, Pope speaks of the ways in which true art may be recognised:

> First follow nature, and your judgement frame
> By her just standard, which is still the same:
> Unerring nature, still divinely bright,
> One clear, unchanged, and universal light,
> Life, force and beauty, must to all impart,
> At once the source, and end and test of art.
> Art from that fund each just supply provides,
> Works without show, and without pomp presides:

It is by the work of the critic, a new figure in English life, that the significance of art is now recognised and established. True judgement is honed through criticism – which transcends scholarship and even connoisseurship – for the critic initiates a dialogue with reader or spectator in which historical, moral and spiritual meanings of all of the arts are systematically discerned and tested. The arts now embody meanings of much wider significance than the artifice used in their creation. Art in this new sense is to be sharply distinguished from mere ornamentation, and Pope scorns those inferior artefacts which depend upon it:

> Poets, like painters, thus unskilled to trace
> The naked nature and the living grace,
> With gold and jewels cover ev'ry part
> And hide with ornaments their want of art.

Augustans believed that from 'the common putsuit of true judgement' developed the most precious faculty of the period, good taste. The

possession of good taste was the prime requisite of cultivated life in the eighteenth century.

The cultivated life was by no means lived exclusively in the mind, nor exhibited solely within the domestic circle. It also took a number of public forms, including the establishment of the societies such as those in Edinburgh (below) which were such a notable feature of privileged British life in the eighteenth century. Dozens of mutual

MAJOR CLUBS AND SOCIETIES IN EDINBURGH 1700–1900

1733	Cape Club (James Mann's Tavern)
1758	Ante Manum Club
1758	The Luggy Club
1762	Poker Club (Thomas Nicholson's Barn)
1773	Aesculapien Club
1773	Pantheon Literary Club
1775	Wagering Club
1775	Wig Club (Fortune's Tavern and Royal Exchange Coffee House)
1778	Mirror Club (Stewart's Oyster House)
1778	Crochallan Fencibles
1787	New Club
1803	Friday Club
1814	Piglet and Wrong Club
1823	Bannatyne Club
1825	Gawk's Club
1825	Caledonian United Services Club
1833	Oyster Club
1842	Bonaly Friday Club
1845	Young Edinburgh Club
1851	Marrow Bone Club
1852	Monks of St. Giles
1866	University Club
1874	Scottish Artists' Club
1877	Conservative Club
1879	Liberal Club

improvement societies as varied as the *Spalding Gentleman's Society* (1710) and the *Manchester Mathematics Society* (1718), together with

learned gatherings such as *Swarley's Club* in Newcastle, grew up in the century's first decade, their memberships drawn from the leisured and literate classes.

Such groupings were in part defensive, created by elements among the intelligensia anxious that knowledge, and the habit of free inquiry, should not be spread too freely – with all the attendant dangers – amongst the labouring classes. Such societies tended to be secretive in nature, and their development is closely linked with the notable development of English Freemasonry in the eighteenth century. In the previous century Modern Freemasonry had first taken root in Scotland. As early as 1670, more than three quarters of the members of the Aberdeen Lodge were 'accepted' masons – that is, not workers in stone – but in the whole of England at the same time there was still only one non-stonemason in a Masonic Lodge: Elias Ashmole, the founder of Oxford's Ashmolean Museum. Even at the founding of the Grand Lodge of England in 1717 there were still only four lodges in the country, but thereafter growth was rapid and by the end of the century there were more than 300 lodges in England alone. Their number more than doubled in the next fifty years.

As the century drew on masonic links between the Royal family, the landed proprietors and elements of the intelligensia grew stronger. The first Royal Grand Master to be installed, in 1782, was the Duke of Cumberland, the younger son of George II, and in the same decade both the Prince of Wales (the future George IV) and his brother William (the future William IV) were initiated. Not everyone took these secretive couplings seriously. Hogarth, who like Mozart and Haydn was a Freemason, made fun in his engravings of the self-importance and pomposity of the Brotherhood. More radical elements however saw in Freemasonry's growth a new and supple channel for Royal patronage, and grew alarmed when national bodies with apparently straightforward purposes such as the *Society for the Encouragement of Learning*, formed in 1735, proved in fact to be masonic.

Many of the working class organisations, such as the Friendly Societies which were forming themselves at the same time, were early trades unions in all but name. They were not national but essentially neighbourhood organisations, concerned to establish local power bases in such trades as printing, mining, bricklaying, carpentry or shoemaking. Well before they were wholly outlawed by the *Combination Act 1799* such gatherings operated outside the law, and as Sidney and Beatrice Webb commented in their *Histoy of Trade Unionism* all early unions possessed legends of:

...the midnight meeting of patriots in the corner of the field, the buried box of records, the secret oath, the long terms of imprisonment of the leading officials.

From the middle of the eighteenth century the Trade Union 'Lodges' mirrored the language, rituals and secret bonding of upper class Freemasonry. A Yorkshireman, Henry Price, recalls in his *Diaries* the formal initiation oath of a new member:

> I......, woolcomber, being in the awful presence of Almighty God, do voluntarily declare that I will persevere in endeavouring to support a brotherhood, known by the name of the Friendly Society of Operative Stuff Manufacturers, and other Industrious Operatives, and I solemnly declare and promise that I will never act in opposition to the brotherhood in any of their attempts to support wages... And I will never give my consent to have any money belonging to the Society divided or appropriated to any other purpose than the use of the Society and support of the trade, so help me God, and keep me steadfast in this my most solemn obligation; and if ever I reveal either part or parts of this my most solemn obligation, may all the Society I am about to belong to, and all that is just, disgrace me so long as I live, and may what is now before me plunge my soul into the everlasting pit of misery. Amen.

In the Friendly Societies, but more particularly in the Corresponding Societies which grew up towards the end of the century in places such as Liverpool, Sheffield, Leeds, Newcastle and Derby, there was also an earnest desire for self improvement, for raising standards of literacy and for rational discussion. In the 1750s the Manchester Small-Ware Weavers were already berating their own members for forgetting their higher purposes:

> If we consider this Society, not as a Company of Men met to regale themselves with Ale and Tobacco, and talk indifferently on all Subjects; but rather as a Society sitting to Protect the Rights and Privileges of a Trade by which some hundreds of People...subsist...how awkward does it look to see its Members jumbled promiscuously one amongst another, talking indifferently on all Subjects...

There were other voices speaking out against the drunken revelries of the labouring classes. John Wesley recorded his extreme dislike of the 'savage ignorance and wickedness' of the Newcastle colliers who in 1743 assembled on Saturdays to dance, sing, drink and play at 'whatever came next to hand'. At Otley in 1766, on the local Feast Day, he found a town lost in 'noise, hurry, drunkeness, rioting, confusion' to the 'shame of a Christian country'. Although the sounds of battle were as yet muted, the great struggle between the entertainers and the improvers for the leisure time of the labouring classes had already begun.

Combinations of workers for political purposes were rigorously persecuted, but there was more tolerance for the Friendly Societies which primarily aimed at alleviating hardship amongst their workmates, though they also offered chances for self-improvement by teaching reading and writing, holding society debates and even running brass bands. When *The Friendly Societies Act 1793* gave legal protection to their funds, they had at that time more than 700,000 official members, about ten per cent of the male working population.

Women were of course excluded from both Freemasonry and Trade Unionism. When they did attempt to play any stronger political part than sewing banners for male reformers they were usually derided as 'petticoat reformers', or scorned by such as the *Manchester Courier* as 'degraded females'. Cobbett however spoke up characteristically for female reform:

> Just as if women were made for nothing but to cook oat-meal and to sweep a room! Just as if women had no minds!

Yet for most people the proper place for women of all classes remained the home. A woman should enjoy the arts, but as a domestic accomplishment for, as Hannah More said, a watchful mother 'must have the talents of her daughter cultivated, not exhibited'.

The daughters of middle class households duly became proficient in music, dancing, needlework, letter-writing and in making conversation. They read women's periodicals such as the *Town and Country Magazine* or the *Ladies Mercury*. They attended exhibitions, country balls and subscription concerts, and visited the libraries – though records suggest that women were almost always in the minority of subscribers. Hardly any women painters exhibited publicly – not least because of the scandalous associations of the artist's studio – although many sketched and painted watercolours within the family circle. More earned reputations as milliners and a few, such as Anna Maria Garthwaite with her woven silks, established reputations in the world of fashion.

In the performing arts and in literature women were able to make more of a public mark. At the Royal Opera House there were highly paid divas, and in different realms there were such as Madame Zazel, who in 1877 was being nightly fired 'from a monstrous cannon' at West's Amphitheatre. There were several well-known comediennes, the most famous of which, Kitty Clive, notoriously outshone the famous Macklin on the London stage. The actress convulsed her audience when, in the character of Portia in *The Merchant of Venice*, she imitated leading barristers of the day when playing the trial scene.

Certainly women dancers and actresses were now quite respectable, and

the leading actor of the day, David Garrick, ever careful not to offend popular sentiment, felt it proper both to marry Eva Maria Viegel, who had under the name of Mme. Violetta been a well-known dancer, and to take a well-known actress, Peg Woffington, as his mistress. In theatre management, several women succeeded quite independently, such as Sarah Baker, the redoubtable manager of the Kent theatrical circuit. Charlotte Clarke, youngest child of the actor and poet laureate Colley Cibber, profitably ran a licensed puppet theatre in London in the early 1730s, before making an ill-judged and financially disastrous move to Tunbridge Wells in 1739. Even more successful in the same field was the mysterious Madame de la Nash, who opened a satirical puppet theatre in the Haymarket in the year of Walpole's *Licensing Act, 1737*, and phrased her advertisements in a style that was to become familiar as other managements sought a means of evading that act's restrictions:

> Madame de la Nash will open her large Breakfast Room for the nobility and gentry in Panton Street near the Haymarket ...where she will give the very best of Tea, Coffee, Chocolate and Jellies. At the same time she will entertain the Company gratis with that excellent old English entertainment called a Puppet Show.

Her 'Breakfast Room' admitted people at midday and at 7 p.m., and as the show was free, the company paid 3s. to drink their tea and coffee in a box, 2s. to drink it in the pit, and 1s. to take their refreshment in the gallery.

There were several notable women connoisseurs, most notably Swift's friend Mrs Pendarves, later Mrs Delaney, who startled City sophisticates by announcing that Dublin and Edinburgh were each the equal of London. And a number of women authors ranging from the energetic Aphra Behn to Mrs Fielding and the popular Fanny Burney, were commercially successful. By the end of the century the powerful Gothic novelist Ann Radcliffe was not only established as a best-seller but was being paid considerable advances. Yet it remained true that for most middle class women their major cultural influence was wrought within the home. This was particularly so in the field of music. Locke had placed music last in the talents needed by a gentleman because 'it wastes so much of a young man's time, to gain but a moderate skill at it'. As a grand piano cost around £75.00, and an upright £20.00, it was middle class women who became accomplished pianists in the eighteenth century; not until the end of the nineteenth did the piano appear in working class homes. The private drawing room concert made its appearance in the towns, and at gatherings in the country houses the after-dinner entertainment was music in the drawing room, with the host's paintings looking down from the wood panelled walls.

Figure 6 William Hogarth's 'Industry and Idleness' is a useful reminder of the fact that until our own times, industry and recreation were antithetical. Here Tom Idle is about to be beaten by the Beadle for idling away his time on a Sunday morning.

That domestic cultivation of the arts, together with the spread of the societies for improvement, and the increasing sophistication of life in many provincial towns, cumulatively meant that although London grew in size – nearly doubling its half million population during the century – it gradually lost its exclusive hold on the nation's cultural life. A survey of 1739 noted that the capital already contained more than a thousand public salons – 551 coffee houses, 447 taverns and 207 inns – which were used for all kinds of professional, society and private meetings. The London literati would meet at Will's Coffee House or the Bedford in Covent Garden; insurance brokers and shipping clerks in Lloyd's in Lombard Street; traders in government stocks at Jonathan's in Exchange Alley. Yet literary and artistic life was no longer confined exclusively to the capital. The spa towns – Bath, Buxton, Epsom, Tunbridge Wells, Harrogate, Scarborough – and a number of the wealthy new manufacturing towns – Birmingham, Bristol, Manchester and Leeds among them – joined Oxford and Cambridge in becoming educational and cultural centres in their own right.

By the end of the eighteenth century London boasted about 120 public libraries of all kinds, yet in the provinces there were more than 1,200. And although London's musical life prospered, there was an even more impressive growth in provincial music making. Some of that was in the numerous provincial pleasure gardens, such as those in Norwich, Birmingham, Buxton, Manchester, Tunbridge Wells, Leicester and Scarborough, but musical life also flourished in provincial cathedrals and churches, in the new music festivals such as the Three Choirs Festival, begun in 1713, the Birmingham Festival (1768) and the Norwich Festival (1770), in new concert series such as William Herschel's 'weekly garden concerts' at Newcastle, and through the musical clubs which by the end of the century were well established in such major centres as Hull, Liverpool, Leeds and Bristol.

In the late eighteenth century almost every town of any size had its theatre, its tea and coffee houses, inns and assembly rooms, its bookseller and its printshop. To take just one example, Leicester, with a population of fewer than 17,000, in 1800 opened the new Theatre in Horsefair Street, its actors offering competition to the well-established theatre in the Assembly Rooms, three booksellers (George Calladine, Thomas Combe and Ireland and Son), five major inns of which two (the Bell Inn and the White Hart) had reading rooms, a Permanent Library, two printers, tea rooms and dancing rooms, and the popular summer concert seasons at the Vauxhall Pleasure Gardens in Bath Lane. The social life of many other provincial towns was also highly regarded. In York, said Defoe, 'a man

may converse with all the world as effectually as at London' and in Litchfield there was 'good conversation and good company' William Wilberforce recalled Hull's theatres, balls and concerts as providing delight for 'the principal merchants and their families'. Many artists now found they could make as good a living amongst the provincial merchants as they could make in the capital.

The growing arts markets were underpinned by a long period of relative financial stability and firmer regulation. However, it took the early upheavals caused by the infamous South Sea Bubble to form more settled ways of raising capital and of constraining investment. Before the turbulences of 1720 the British government had seemed to adopt contradictory fiscal policies, first financing the setting up of a national Bank of England in 1694, which led to greatly increased stock market activity, then borrowing heavily to finance its wars against the French, before finally in 1711 passing on liability for the accumulated national debt to a wholly private company. This latter, at first unnamed, comprised a specially convened group of merchants and leaders of industry who in return for agreeing to purchase £10 million of government stock (effectively buying off the government's £10 million debt) were given monopoly trading rights in the South Seas, thereafter being known as the South Sea Company.

The wealth that the trading concession offered in the event proved more illusory than real, but for six years public confidence in what was in effect a monetary corporation remained high. When in 1717 the South Sea Company asked that their stock be increased to £12 million, investors still continued to be attracted. Finally in early 1720 the company made an even bolder move and applied to purchase a further £30 million of government stock with repayment first set at an annual 5%. In the course of negotiations the company reduced the repayment rate to 4%, in order not to be bested by the one rival bidding for the same stock – the national Bank of England.

The private South Sea Company's growth and financial acumen impressed most contemporary politicians. One exception however was Walpole. In a stormy parliamentary debate he warned of:

> ...the dangerous practice of stock jobbing, which will divert the nation from real trade and industry. It will hold out a dangerous lure to decoy the unwary to their ruin by making them part with their honest earnings for a prospect of imaginary wealth. This principle is evil. It raises artificially the value of stock by exciting and keeping up a general infatuation and by promising dividends out of funds which will never be adequate for the purpose. If it succeeds, the stock market will run the nation, but if it fails, as it will, it will bring massive discontent.

His prescient warnings went unheeded. The Commons agreed, by a vote of 172 to 55, to give the company the additional £30 million stock it was asking for. The Lords agreed with an even more emphatic majority, and on the 7th. April the South Sea Company Bill had its third and final reading.

Meanwhile, following the Commons vote, the company's value on the exchange had tripled. Frenzy gripped would-be investors. London's Exchange Alley, where stocks and shares were then bartered, was packed daily. Many people sold all they had gained from 'real trade and industry' and flocked to London in order to invest in the boom. They came from all walks of life, as Pope dryly reminds us:

> *Statesmen and patriots plied alike the stocks,*
> *Peeress and butler shared alike the box.*

A picture further coloured by contemporary doggerel:

> *The greatest ladies hither came,*
> *And plyd in chariots daily,*
> *And pawned their jewels for a sum*
> *To venture in the Alley.*

For a brief and giddy summer, the whole of Britain seemed to be, in Pope's bitter phrase, 'sunk in Lucre's sordid charms'.

The South Sea Company was not the sole cause of the hysteria. A flotilla of smaller speculative companies was launched, many speculations seeking capital upon the flimsiest of pretexts. For example, one hopeful demanded, and even more incredibly acquired, investors in 'a Company for the carrying on an undertaking of great advantage but nobody is to know what it is'... For a short time it seemed that patents could be granted and capital raised for almost any kind of venture – whale fishing, a company for the insurance of all sick people in Britain, a company to revolutionise the manufacture of snuff, one for furnishing funerals 'to any part of Britain', a company for making glass bottles in Derbyshire, and, perhaps inevitably, a group that claimed to have rediscovered the ancient secret of making 'fine metals' out of base materials.

Yet, as Walpole had warned, funds were not remotely adequate to sustain for long the dividends that were promised. As Spring gave way to Summer the bubble began to show signs of bursting. In May and June of 1720 the South Sea Company had to prop up their value on the exchange by employing rumour-mongers to spread stories in the City of 'new wealth' just discovered in the South Seas'. Even that (then legal) action did not check the steady downward slide of their shares. More

alarmingly, a number of the smaller speculations collapsed completely, disappearing as abruptly as they had arrived. Both London and provincial newspapers began to express alarm. The politicians began to urge that the monster they had helped to create should be shackled and caged.

The first move towards regulation of Exchange Alley came with an order on the 12 July by the Lords Justices, which made it clear that patents would not be issued to some eighteen of the smaller speculations which were then trading:

> Their Excellencies, the Lords Justices in Council, taking into consideration the many inconveniences arising to the public from several projects set on foot for raising of joint stock for various purposes, and that a great many of His Majesty's subjects have been drawn in to part with their money on pretence of assurances that their petitions for patents and characters to enable them to carry on the same would be granted, to prevent such impositions, their Excellencies have this day ordered that these petitions be banned forthwith.

Meanwhile the value of the South Sea Company's shares continued to fall. During the summer months the Directors tried to arrest the slide by sending out agents to buy up their own stock. For a brief time this ruse, also quite legal, was effective. Yet by September the price was falling again. Public confidence now waned rapidly and by mid-October the flimsiness of the whole South Sea Bubble had become only too apparent. The company fell bankrupt. Thousands of angry investors faced seemingly irredeemable losses. The private sector's vaunted partnership with government was exposed, in Smollett's words, as 'tasteless vice and mean degeneracy'.

In order to restore its credibility, the government moved swiftly to regulate both dealing in stocks and shares and the wider operation of the Exchange. A Parliamentary Enquiry was set up on 9th. December to look into the affairs of the South Sea Company. It found abundant evidence of fraud, and exacted swift revenge when the company's directors were called before it. Two were sent to the Tower. Others were fined: Sir John Blunt lost all but £5,000 of his £180,000 fortune, Sir John Fellows all but £10,000 out of £420 000 and Edward Gibbon (the grandfather of the famous historian) had only £10,000 left from £106,000. In all, the government reclaimed more than £2 million from such fines and was even able, in the Spring of 1721, to pay a modest dividend to the former subscribers. Equally briskly, new and stringent conditions were established early in 1721 for the selling of stocks and shares, and, of even greater importance, for their purchase – with the result that for several decades only substantial landowners were permitted to speculate on the stock exchange.

The bursting of the South Sea Bubble had a profound impact upon the British concept of honest industry, and served in the public consciousness to elevate the industrious country squires and Northern merchants above the untrustworthy financial brokers of the City of London. The country squires, usually Justices of the Peace, their legal power within their local communities then at its height, temporarily attained the highest pinnacle of public respectability. Countrymen such as Squire Allworthy in Fielding's *Tom Jones*, an 'honest, wise and noble-hearted magistrate', were for a time seen as the purest embodiment of English decency.

Sentiment moved sharply against the City, and in general the capital sank in public esteem. Young in *The Farmer's Letters to the People of England* fulminated over the fact that it was now far too easy for honest country youth to be seduced by the capital:

> ...the numbers who have seen London are increased tenfold and of course ten times the boasts are sounded in the ears of country fools, to induce them to quit their healthy clean fields for a region of dirt, stink and noise. And the number of young women that fly thither is almost incredible.

London society was spoken of as shallow, more concerned with fashion than art, and of interest only to empty-headed creatures like Mrs Hardcastle in Goldsmith's *She Stoops to Conquer*:

> There's nothing in the world I love to talk of so much as London, and the fashions, though I was never there myself.

Many of the diaries of the mid eighteenth century suggest that even Mrs Hardcastle would not have found fashionable London to be quite what she imagined. For, in spite of the new codes of financial conduct, fashionable London was often corrupt. The young William Hickey, for example records in his diary that in 1767 his honest lawyer father went to Bath for a month, leaving his rakish son to act as 'the out-of-door clerk':

> ...that is, executing all business at the different law offices, issuing writs, and every other process in the progress of a cause, delivering briefs, and all other documents to counsel, and paying the fees. My error commenced in not keeping my pocket money distinct and separate from that belonging to the office. The consequence of not doing so was that I had unconsciously trespassed upon the latter before I was aware, and at the first discovery thereof was greatly alarmed. This proper feeling, however, soon subsided, and, like all those that once commenced upon bad habits, I became by regular gradations first uneasy, next indifferent, and by continued practice callous. Finding the balance every week considerably increasing against me, I endeavoured to counteract it by introducing sums I had never disbursed, entering others higher than I actually paid...

His dishonesty did not prevent him from thinking himself superior to conventional souls, as his diary goes on to report:

> I now became a constant frequenter of the Bedford and Plazza coffee houses, but my chief place for eating was Young Slaughter's, in St Martin's Lane, where I supped every night with a set of extravagant young men of my own stamp. After some time we were displeased with the noise, and the promiscuous company that frequented the coffee room, chiefly to read the newspapers, especially half a dozen respectable old men, whom we impertinently pronounced a set of stupid, formal, ancient prigs, horrid perriwig bores, every way unfit to herd with such bloods as us...

It was not however the rowdy young bloods, or the brothels which so blatantly adorned Covent Garden, or the sedition and blasphemies uttered in the coffee houses, which so blemished London's reputation in the eyes of many country dwellers. Nor was it the disastrously high consumption of cheap gin, which had between 1720 and 1750 apparently caused the death rate to exceed the rate of baptism in the capital. Rather it was the financial chicanery, the shady dealings of Exchange Alley, which still set the capital so much at odds with the general populace 's notions of honest industry.

The City's 'Moneyed Interest' in general, and stock jobbing in particular, had come under immediate attack when the South Sea Bubble burst. In 1723 Trenchard and Gordon angrily enquired:

> What Briton, blessed with any sense of virtue, or with common sense; what Englishman, animated with a public spirit, or with any spirit, but must burn with rage and shame, to behold the nobles and gentry of a great Kingdom, men of magnanimity, men of breeding, men of understanding, and of letters; to see such men bowing down, like Joseph's sheaves, before the face of a dirty stock-jobber, and receiving law from men bred behind counters, and the decision of their fortunes from hands still dirty with sweeping shops!

Forty years later such sentiments still persisted. As Churchill scathingly observed in his picture of London in *The Ghost* (1762):

> *Where to be cheated, or to cheat,*
> *Strangers from ev ' ry quarter meet:*
> *Where Christians, Jews and Turks shake hands,*
> *United in commercial bands,*
> *All of one faith, and that to own*
> *No god but interest alone.*

The same feelings were still being voiced a decade later. In 1770, in the House of Lords, Lord Chandos contrasted the duplicitous London Moneyed Interest with the law-abiding virtues of industrious tradesmen and landowners:

There is a set of men, my Lords, in the city of London, who are known to live in riot and luxury upon the plunder of the ignorant, the innocent, the helpness; upon that part of the community, which stands most in need of, and that best deserves, the care and protection of the legislature. To me, my Lords, whether they be miserable jobbers of Change Alley, or the lofty Asiatic gentlemen of Leadenhall Street, they are all equally detestable... My Lords, while I had the honour of serving his Majesty, I never ventured to look at the Treasury but at a distance... The little I know of it has not served to raise my opinion of what is vulgarly called the 'Moneyed Interest'... and I hope, my Lords, that nothing I have said will be understood to extend to the honest industrious trademan, who holds the middle rank, and has given repeated proofs, that he prefers law and liberty to gold.

It was the provincial merchants of cotton, wool and mining, the shipping magnates, but above all the enlightened new landowners, who were now admired for being the 'Honest industrious tradesmen' of Britain. As Boswell observed in 1765, 'Honest industry is entitled to esteem'. It was they who determined standards of public life, and as time went by it was natural that the industrious should also become the arbiters of taste, for as Adam Smith averred, the new landed proprietors were 'the best of all improvers'.

It was partly to emulate the old aristocracy, partly to ensure they had votes which counted, partly to ensure that they could invest, if they chose, in the newly regulated stock exchange, but mainly because it seemed a natural and proper investment in the growing national wealth, that so many successful business entrepreneurs who were making their fortunes in Lancashire cotton, in Yorkshire wool and cloth, in Midlands mining or in shipping, proceeded in the middle years of the century to buy themselves lands and estates. Together with some of the landed aristocracy, the shrewdest of whom had joined what Cobbett called 'the grand affair of business' by encouraging the processing of the valuable raw materials which lay on or beneath their estates, the enterprising eighteenth century business proprietors formed the kernel of the buying public for the work of the new artists and the new designers.

They were not, in the later sense of the word, 'industrialists', although in the term's earlier sense they stimulated local industry. Their businesses often involved mining for or processing materials on their estates, and when, as in the cotton trade, it depended upon the import of raw materials, a surprising amount of the work was done in their own homes by those that they employed. It was not mass production in the later nineteenth century sense, and the commercial units were not yet called factories, but manufactories.

The classical derivation of the word is revealing. In the eighteenth century the words manufactory and manufacture were used

interchangably, as nouns meaning a unit of organised production. Both derive from an obsolete verb 'to manufact', which was in turn derived from the Late Latin 'manufactus', from 'manus' meaning hand and 'factere' meaning 'to make'. The work in the manufactories was indeed organised, but it was largely done by hand, and the results of the work were organised only in the loosest sense, without the workers assembling in one production line. (When workers later were gathered together in large numbers to produce goods by mechanical means the products were standardised. A part of the old term, 'manus' was dropped, and the new units of organisation called 'factories'.)

The landed proprietors of the eighteenth century who developed the manufactories did not have to invest much of their wealth in business capital. There was little need. They had no buildings to erect, no machinery to buy, and the workers worked in their own homes using their own tools. As a consequence their business assets were almost entirely bound in stock waiting to be processed, goods in the process of manufacture and products waiting to be bought. Dr Edwards gives an illustration of a weaving concern in the eighteenth century whose assets were reckoned at £180,000. Its stock accounted for more than £120,000, its normal commercial debtors for almost £60.000. The value of its plant and machinery was put at just £160.

The landed proprietors were therefore able to put more of their capital into the purchase of art than they needed to put into business – so that they stimulated the local economy as much by their art purchases as by the operation of their manufactories. They hired local architects and garden designers to redesign their new homes, bought handsome furniture and pottery, commissioned portrait and landscape painters to decorate their walls, and purchased books, maps and prints from the local printers and booksellers to furnish their new libraries. As Dr. Flynn remarks:

> The first goal of many a merchant was the acquisition of a landed estate with a stately home, and an unknown proportion of all mercantile profits in the eighteenth century was poured into this form of conspicuous consumption.

An example of the new kind of proprietor was William Denison, who had successfully built up his clothiers' business from the family home in Leeds, largely by a judicious move into the woollen export trade. With his spare capital he purchased a second home in Lincolnshire in 1759, and in due course added three Yorkshire estates, two in County Durham, a further estate in Lincolnshire and – his personal favourite – Ossington in Nottinghamshire, which he bought in 1768 for £34,000. By the time of

his death in 1782, when his assets were reckoned at some £650,000, he had become a landed proprietor of considerable means.

The importance of just one such wealthy buyer in the new arts markets can be gleaned from the fact that at Ossington alone Denison paid for the relandscaping of the grounds (including a lake with decorated arbours on its banks) and sumptuous refurnishing of the house, commissioned paintings for its walls, created a library of some 350 volumes, hired Carr to design a peripteral temple in the grounds, and built a large hot-house for the cultivation of plants. For this Cotton was commissioned to undertake the iron work, and 3,500 square yards of glass, and 460,000 bricks were transported by horse and cart from nearby Newark. Large new coppices were planted on the newly-enclosed lands, the felled timber being floated down the Trent to Gainsborough, from whence it was taken to be sold in Yorkshire. Thus the overall impact on the East Midlands economy of improvements in just one estate was considerable, and its value rose accordingly. When Denison briefly considered selling it in 1779, Ossington was valued at £60,000, almost double the price of eleven years before.

The culture of the eighteenth century gentleman was not of course solely confined to the arts and crafts. This was also an age of science and reason. It was seen as a sign of the new scientific enlightenment when in 1717 the old maypole was taken down from its traditional place in the Strand, and used by Sir Isaac Newton to raise the great telescope at Wanstead. Old myths and bucolic customs were now of less interest to the educated gentleman – in 1790 Edward Williams from Glamorgan was plaintively writing in the *Gentleman's Magazine* that in the new age of reason he found himself one of only two surviving druids in the whole country. Great houses had churches and chapels in their grounds, but they now also housed private laboratories and observatories in which their owners could pursue their scientific interests.

Yet such new sophistication did not altogether replace the more communal of the older country pastimes, on which occasions the new cultural élite would go some way to reaffirming their kinship with ordinary folk. At the village feast, at the town fair, and on hunt days the landed proprietors would still mingle with their labourers and local working people, joining in the rough and ready entertainment. Thus the great art-collector and agricultural reformer, Thomas Coke of Holkham in Norfolk, thoroughly enjoyed bare-knuckle boxing and cock fights (neither of which pursuits were forbidden until the nineteenth century), and Sir Thomas Parkyns, the architect and Latin grammarian, was also a notable public wrestler. Nor did the civic authorities eschew cruder entertainments. In 1773 the Cardiff Aldermen were still sponsoring bull

baiting, a spectacle which attracted 'both high and low' and which in that year resulted in one luckless citizen being gored to death.

At the beginning of the century the cultivated aristocracy had numbered little more than a few hundred families, about one seventieth of the total population. Only later, when the cultivated middle class began to grow, did the arts markets grow with them. That growth was steady rather than spectacular. In the 1740s even the most successful of the journals, the *Gentleman's Magazine*, which would be taken by all householders with social ambitions, was still selling only 3,000 copies an issue.

So although Pope is correctly reported as having made £4,000 from the sale of his completed volumes of *The Iliad* in 1720, it must not be taken as a sign that the market for his work was large. This impressive profit was achieved by selling to a small rich coterie of readers – fewer more than a thousand sets were sold, and at the comparatively high price of £6.6.0d. each. Another famous publication of the age, Dr Johnson's *Dictionary,* took more than four years to sell 2,000 copies after it was published in 1755. And although in the middle years of the century the new three-volume novels were priced more cheaply – it cost about 13s 6d to buy the complete volumes of a work by Richardson or Fielding – the market was still quite small. For example a best-seller such as *Joseph Andrews* sold only 6,500 copies in the thirteen months following its 1742 publication, and Smollett's *Roderick Random*, published in 1748, sold just 5,000 in its first year.

However, as both personal and public libraries grew in number, the people and societies who could afford to buy books certainly bought more of them. There were more than 300 books published each year in the century's last decade, as against 100 or so each year during the 1750s. Subscription libraries now had substantial holdings. Ireland's Library in Leicester, already mentioned, had 2,500 books in it by the end of the century; the Leeds library with 450 subscribers boasted 4,500 volumes, Sibbalds in Edinburgh had 6,000. The rapid growth of the subscription libraries and the book clubs from the middle years of the century offers evidence that the reading public was from the first very much larger than the book purchasing public. Recent estimates have tended to raise the estimated literacy rate, and it is now thought that at the middle of the century 60% of men, and 40% of women could be called literate – yet fewer than 5% of them bought books.

The major limiting factor was undoubtedly price, for cheap publications sold in huge numbers. Ballads, printed on broadsheets and sold in the streets for $\frac{1}{2}$d. or 1d., sold in tens and sometimes hundreds of thousands – particularly in the case of the 'testamentary ballads',

supposedly written by condemned men on their way to the gallows. Pamphlets, which sold at prices ranging from 3d. to 1s., were already selling in the tens of thousands by the 1750s. In 1776, Price's *Observations on the Nature of Civil Liberty* sold 60,000 copies and Paine's *Rights of Man* reputedly sold more than 1,500,000 copies in 1791. Almanacks, with their detailed information on tides, weather, phases of the moon, together with their folk astrology, and of real significance to workers in what was still overwhelmingly an agrarian economy, regularly sold more than 1,250,000 copies a year.

Newspapers, although at first far too expensive to be bought by many individuals, and more usually consulted in clubs, coffee houses and inns, nevertheless gathered a steadily increasing readership during the century. The first English daily newspapers, the *Daily Courant*, 'Sold by E. Mallet, next door to King's Arms Tavern at Fleetbridge', appeared on March 11, 1702. At first it was printed on only one side of the paper but after a month it used both sides of the sheet and contained half a column of small advertisments. The second daily publication in 1711 was by contrast a literary journal – Addison and Steele's *Spectator* – but there then followed a succession of London newspapers, including the *Post* in 1717, whose contributors included Defoe, and the *Daily Journal* (1720).

Although they were weekly rather than daily publications the rapid early growth of provincial newspapers is equally striking. Britain's oldest newspaper, the *Lincoln, Rutland and Stamford Mercury*, was first published in 1695, and is almost a century older than London's oldest surviving daily, *The Times*, which dates from 1785. The first decades of the century saw the birth of, among others, the *Norwich Post* in 1701, the *Edinburgh Courant* (1705), *Nottingham Journal* (1710), *Newcastle Journal* (1711), *Liverpool Courant* (1712), *Bristol Times* (1713), *York Mercury* and the *Glasgow Courant* (1715), *Leeds Mercury* (1723) and the *Manchester Gazette* in 1730. As early as 1711, a statement prepared for the Treasury said that the total weekly sale of all British newspapers was 44,000, some 2,250,000 copies a year. The imposition of the Stamp Tax on newspapers in the following year does not seem to have stemmed the flow, and when the tax was doubled in 1757, it was estimated that the yearly sale had multipled by eight and stood at 18,000,000 copies a year.

Newspapers and journals accelerated the development of the arts markets in two ways. First, they carried paying advertisements, although few were as straightforward about the fact as the *Daily Advertiser*, which announced on the occasion of its first edition on Febuary 3rd. 1730:

This Paper will be given Gratis to Coffee-Houses Four Days Successively, and afterwards Printed every day, Sundays excepted, and deliver'd to any Person within the Bills of Mortality One Penny per single Paper, or Six Shillings per Quarter... All advertisements of moderate length will be taken in at Two Shillings each...This paper is intended to consist wholly of Advertisements, together with the Prices of Stocks, Course of Exchange, and Names and Descriptions of Persons becoming Bankrupt...

Secondly, most publications hastened the development both of arts markets and common judgement by publishing criticism of the contemporary arts.

The long-running newspaper tensions between advertising and criticism led to the early creation of the advertising and public relations expert. One such character, Mr Puff, is the central character of Sheridan's comedy *The Critic* (1777), which both satirises the growing practice of newspaper 'puffing', and shows the ways in which the new advertising mediums dangerously drive the arts, and arts criticism, into the world of fashion. In the first act, Puff, producer of a new theatrical piece we later see rehearsed, explains to his friends the techniques by which he promotes his own productions in the newspapers, something that has never been 'reduced to rule before'. Puffing, he explains, is of various sorts, '...the principal are, the puff direct – the puff preliminary – the puff collateral – the puff collusive, and the puff oblique, or puff by implication.' Each mingles news with advertisement. For example the puff collateral:

...is much used as an appendage to advertisements, and may take the form of anecdote – 'Yesterday, as the celebrated George Bon-Mot was sauntering down St James's Street, he met the lively Lady Mary Myrtle, coming out of the Park, – 'Good God, Lady Mary, I'm surprised to see you in a white jacket– for I expected never to have seen you, but in a fully trimmed uniform and a light horseman's cap!' – 'Heavens, George, where could you have learned that?' – 'Why,' replied the wit, 'I just saw a print of you, in a new publication, called the Camp Magazine, which, by the by, is a devilish clever thing, and is sold at No. 3. on the right hand of the way, two doors down from the printing office, the corner of Ivy Lane, Paternoster Row, price only one shilling.

Such techniques will seem remarkably familiar to the modern reader.

In certain ways the tension between critical comment and advertising is greater in the late eighteenth century press because a very much higher proportion of advertisements were then concerned with selling artistic publications and arts services to their middle class readers. In the first issue of *The Observer* (December 4th. 1791) there is a lengthy review of Mrs Cowley's play, *A Day in Turkey*, which had opened the previous

evening at Covent Garden. Elsewhere there are some 42 advertisements, filling eight columns over two pages. 13 of these are for household, personal and domestic items (largely medicines, but including an advertisement for tickets in the National Lottery, and one for Teas, which luxury sells at between 3s.4d. and l0s, a pound!), while the remaining 29 are, in various ways, advertising cultural goods and services. The latter break down as follows:

18 literary publications (poetry, novels, biography)
4 collections of musical scores
3 travel books
1 book on fortune-telling
1 book on conjuring
1 print (of Sir Charles Douglas, Bart.)
1 invitation to subscribe to the enlargement of a Public Library.

The final advertisement is particularly interesting and worth quoting at length, for it reminds us of the most favoured means of financing the creation and operation of arts organisations from the middle of the eighteenth century to the middle of the twentieth — public subscription.

The advertisement is placed by the trustees of a central London library, which is being moved from Greek Street to St. Martin's Lane. The trustees first remind readers of their noble objectives and then ask for new subscribers:

The principal object of the Society is to establish, on a broad, liberal and permanent basis, a PUBLIC LIBRARY for General Use, carefully avoiding the evils which the introduction of Books without discrimination into families, is well known to give rise to, by selecting such publications only as shall be found to promote useful knowledge, and virtuous dispositions. No book can therefore be received or purchased, but by the direction or approbation of the Committee.

Every subscriber to pay Two Guineas, to be laid out in Books, or to send in Books to the value of that sum, which will entitle him to a share in the property of the library; and he is also to subscribe annually One Guinea, to defray the current expenses of the Society and to purchase new publications; but any Subscriber paying Ten Guineas at one payment, in lieu of such annual subscription, will be considered as an Annual Subscriber during his life.

By such advertisements subscribers were solicited, not only to finance the 1,000 or so subscription libraries which grew up in the eighteenth century, but also to create the initial capital and necessary annual revenue for the thousands of assembly rooms, theatres, galleries, concert halls and music and arts societies which interwove to form Britain's cultural fabric over the following two hundred years.

According to the ways in which they were regulated, subscription schemes allowed either a few dozen, several hundred or an even larger number of people to become involved in their local cultural enterprises, with a voice in their programmes, and a stake in their financial success. Nearly every building and most societies were financed and run in the eighteenth century by some variant of the subscription scheme, and although other capital-raising and operational systems later became equally popular, variants of such schemes played an important part in financing the arts until the middle of the twentieth century.

In the eighteenth century subscription schemes for national projects, such as the first Royal Opera House, would call upon 'Persons of Quality' for subscriptions of as much as 50 or even 100 guineas. In the provinces however subscription schemes were more varied in nature, and usually pitched at a slightly lower level. Then they provided a means whereby traders and members of the professions, lower in rank than the landed proprietors and country squires, could invest in cultural growth. Those listed as subscribers to the new Assembly Rooms in Sheffield in 1750, for example, included local surgeons, apothecaries, lawyers, clergymen, army officers and leading local shopkeepers.

Some schemes however, even in the eighteenth century, were set up with the avowed political intention of encouraging more humble families to become subscribers to reading rooms, educational institutes, lending libraries, galleries or concert halls. In them subscriptions would be very much lower, and paid weekly; some early Artisans' subscription libraries charged as little as $\frac{1}{2}$ d. a week. In larger towns there would be subscription schemes of different types, and with quite different levels of fee, advertising for support from different segments of the local market. Manchester's first subscription library, for example, which opened in 1765, had sought subscriptions of one guinea to set itself up, but at the same time had also allowed 'half subscriptions' of only 10s 6d. In 1781 entrance to the rather more exclusive Manchester Literary and Philosophical Society cost two guineas, with an annual subscription thereafter of a guinea. The Manchester Gentlemen's Choral Society, formally created in 1770 and more prestigious than either, at first asked for an annual subscription of two guineas, which had risen as high as four guineas by the end of the century.

The middle classes, those whose family income was between £50 and £200 a year, made up rather more than a quarter of the population by the end of the century. In discussing their transformation we must not lose sight of the fact that there remained still a huge labouring underclass of more than half the population, who were not rich enough to play any part

in subscription schemes, neither sufficiently literate nor well educated to acquire the luxury of 'good taste', nor indeed able to participate in any meaningful enjoyment of the arts. As Fielding noted in 1753 in his *Proposal for Making an Effectual Provision for the Poor*, the needs of the lower classes were talked about much less than their vices 'not from any want of compassion but because they are less known.'

Nevertheless the eighteenth century saw a great rise in charity work for the poor and destitute. In *The Stoic* (1741), the philosopher Hume had told his readers of the virtue of such work, 'What satisfaction in relieving the distressed, in comforting the afflicted, in raising the fallen...!'. In his *Essay on Man* (1735) Pope had even asserted that charity was a part of the natural order, part of the nobility of mankind:

> *Wide and more wide, th'o'erflowings of the mind*
> *Take ev'ry creature in, of ev'ry kind,*
> *Earth smiles around, with boundless bounty blest,*
> *And Heav'n beholds its image in his breast.*

It was of course inevitable that in the eighteenth century charity would be linked to the arts world, but when that link was forged it most decidedly was not the modern one. Not for another century and a half did anyone suggest that the arts themselves should, alongside the poor and needy, receive charitable support. In the Augustan age, through the nineteenth century and indeed up to our own time it is the arts that have been major supporters of charitable causes. Whether raising funds for third world countries, for hospitals and schools, aiding victims of natural and man-made disasters, or giving assistance to the infirm, the aged, the poor and needy, it is the charity concert, the charity theatre performance, the exhibition in aid of charity, and latterly the charity media spectacular, which again and again has been the major fund raiser, with artists and performers shaping and heading the commercial successes. The notion that the arts are *themselves* charities, 'good causes' on a par with Oxfam and the Red Cross, and that rich and poor alike have a duty through their taxes to support them, is a late twentieth century idea which, we shall suggest later in this book, does not sit easily with long-established notions of what constitutes a 'good cause'.

Yet the arts undoubtedly owe a part of their organisational growth in the eighteenth century to the needs of charity, for both public art exhibitions and public concerts developed as they did because of charity work. It was William Hogarth's initiative in supporting Sir Thomas Coram's charity and exhibiting his newest works in the public rooms of London's Foundling Hospital – in the belief that those who 'came to stare'

at his paintings would 'stay to give' – that did much to establish the habit of visiting public art exhibitions in the eighteenth century. Handel organised innovative musical concerts for the same charity, and made similar efforts on behalf of the Mercer's Hospital in Dublin and the charity for the Support of Decayed Musicians (afterwards retitled *The Royal Society tor Musicians*).

Charity performances and charity concerts could be given for almost any kind of deserving cause. Sometimes it was for repair of a civic building. As early as 1706 *Hamlet* was given at Drury Lane to raise funds for 'the charge of repairing and fitting up the chapel in Russel-Court'. Sometimes it was for a political cause. In 1769 a benefit concert was given at Sunderland for 'those sons of Liberty, the brave Corsicans'. Sometimes it was for local people. In 1778 the resident company at Leicester's Theatre gave a charity performance for a business couple in the town who were in great need, 'through misfortune, sickness and a large family...' Almost any kind of need, it seems, would be met by setting up a charity appeal, with benefit concerts or play performances at the core.

It also seems to have been a regular practice throughout the eighteenth and early nineteenth centuries for a manager touring the provinces, in return for being granted a licence to appear by the local authorities, to give one or more benefit performances. Sometimes these were for local causes, and sometimes for national ones, but there is no doubt that they were often a considerable drain on a manager's income. Thomas Shaftoe Robertson, theatrical manager and father of the well-known nineteenth century playwright, records that in his tours at the end of the eighteenth century he felt bound in each town to give one charity performance on behalf of 'the patriotic fund at Lloyds'. He lists the amounts he raised, and although they may seem small to our eyes – Lincoln £29.11.0d., Spalding £27.12.6d. – one can see clearly enough that in a small outfit they could make the difference between a reasonable profit and just scraping by.

Large organisations sometimes fared worse. Alexander Ducrow, performer/manager of Astley's touring circus in the early nineteenth century, was invariably pressured to mount charity performances on tour - even for such apparently well-to-do businesses as the shoemakers of Northampton. The sums mount up – £20 for the Manchester Fever Hospital in 1827, £25 for the Dispensary at Hull in 1835, and, rather more pathetically, £5 given in 1836 to the debtors in Newcastle gaol, 'enabling the authorities to restore to the bosom of their families 2 of the small debtors...'. Such charity benefits were routinely expected, and were in the case of the larger companies expected to yield substantial sums.

Ducrow later claimed that he had made as much as £182.6s. for the charities of Edinburgh, and £85.11s. for those of Bristol. Certainly, when a charity benefit at Aberdeen once failed to attract a good house, Ducrow felt obliged to chip in £10 from his own pocket to keep up his reputation.

Although it was the most famous of the travelling troupes, Astley 's was by no means unique. In the second half of the eighteenth century the numbers of travelling showmen grew in number, and some showmen's families combined their talents and financial assets to create larger touring units – Wombwell's Travelling Menagerie, Sieur Richard's Company of Performers or Richardson's touring theatres, for example – which played the fairs and provincial pleasure gardens. The larger organisations, on whom a larger burden of staging the charitable benefits fell, nevertheless seem to have paid this 'charitable tax' more or less willingly.

That was not just from a base desire to ingratiate themselves with the bigwigs, nor were they wholly impelled by a disinterested desire to assist good causes. At least a part of their motive lay in the showmen's wish to ally themselves with society's reformers and improvers. Their sideshows, menageries and travelling museums were now frequently advertised as 'educational', 'improving' and even, 'uplifting', suggesting a high moral intention even if the actuality sometimes descended into drunken riot. The ambiguity about the purposes of the fairs was a political necessity.

For reasons other than this the entertainments at the wakes, feasts and fairs of the eighteenth century are of more than passing significance. There was amongst the horse-riding displays, ventriloquism, freak shows, puppetry, clockwork mechanisms and waxwork displays an insistent satirical undercurrent, which mocks the elevated world of the fine arts and high fashion. Freaks, monkeys in human clothing and the masked tumblers mocked metropolitan pretension in the fairground just as they did in the cartoons.

Is there not something of this, for example, about the famous dwarf Matthew Buchinger, who, though lacking feet and thighs, and having instead of arms 'two fin-like excrescences growing from his shoulder blades' nevertheless made his living demonstrating his skill as an artist, calligrapher, musician and dancer? Is not middle class education mocked by the learned asses, horses (and the 'English dog who actually, reads, writes and answers various questions') who all demonstrated in the showmen's booths 'to the entire satisfaction of the company' that they were as learned as the local priest and schoolmaster?

Then there was 'The Wonderful Stone Eater' who was an annual attraction at the Birmingham fairs, sitting down to a grandly laid table

every half hour and eating silver platefuls of local gravel, and in the supreme mockery of high fashion, there would often be a 'pig-faced woman', dressed in the height of fashion, and assuming all the airs of the gentry, including the prized ability to play the piano. As was slyly remarked of one of the most famous of these curious beings:

> In taste and stile of execution on the pianoforte she is as much a prodigy as in personal appearance, the most difficult pieces of Handel producing to her no apparent labour or difficulty...

It is hard to avoid the thought that the rough fairground audience probably played their part in the mockery, judiciously applauding the seeming pig-lady as she lifted her trotters to the keyboard, and crudely affecting the posturings of fashionable concert-goers as they discussed her 'art'.

Industrial Revolution

In many counties where manufactures flourish, they
have sucked up the village and the single cottages.
Birmingham, Manchester and Sheffield swarm with
inhabitants; but look at them, what a set of mean
drunken wretches!...The business of agriculture is as
permanent, and moves as regularly, as the globe. But
is that the case with manufactures? May not some
event overturn them? And who is then to maintain
the mechanic?

John Byng, Viscount Torrington,
Tour to the North 1792

In 1801 the Reverend George Austen, vicar of Steventon in Hampshire,
retired and moved with his family to a pleasant home in Bath. In her
letters to family and friends his daughter conveys a calm and untroubled
picture of the minutiae of daily life in the town:

We did not walk long in the Crescent yesterday. It was hot and not crowded enough;
so we went into the field, and passed close by S.T. and Miss S. again. I have not yet
seen her face, but neither her dress nor air have anything of the dash or stylishness
which the Browns talked of; quite the contrary; indeed her dress is not even smart, and
her appearance very quiet.)

Jane Austen's experience of the even tenor of life in Bath is akin to that of
Catherine and Mrs Allen in *Northanger Abbey*, for whom each morning:

...brought its regular duties; – shops were to be visited; some new part of the town
to be looked at; and the Pump Room to be attended, where they paraded up and
down for an hour, looking at every body and speaking to no one.

Bath is pictured as the centre of a calm, almost pastoral world; its visitors
well educated, well-mannered and pretty well provided for. So attractive
does it seem that we may even be lulled into thinking that life in the rest of

Britain was equally peaceful, and similarly unthreatened by social disruption.

Such an illusion would be doubly deceptive. If we try to use such novels as historical records we are doing them a gross disservice. And if we allow their delicate splendour to blind us to the brutality and squalor of much of the rest of contemporary Britain we are doing an equal disservice to historical truth. For although Jane Austen does not allow the coarser realities of ordinary life to impinge upon her characters, the fact is that the years following her move to Bath brought bleak and sudden changes for many Britons. As people were forced to tramp between the new factory towns in search of work, they left all vestiges of settled rural life behind them. For many, daily existence became grimmer, working conditions more brutal and food scarcer. An old social and economic order was breaking down. As John Byng had observed at the end of the eighteenth century, even the country markets were disappearing:

> There were formerly, at short distances, small market towns to which, on a stated day in every week, the corn and every produce of the country was brought; and it made a little holiday; but now all these little markets are disused, as the corn is engrossed and all the other produce bought up by higglers, so these towns are decaying, nor are their fairs better attended, as the horse dealers go round and purchase all the nags.

The scarcity and high price of wheat (in 1800 three times the price it had been eight years before) had indeed raised fears of general famine. In 1800 there had been food riots throughout Britain. In 1801 £4,000,000 was spent on the relief of poverty in England and Wales alone, and the King issued a proclamation ordering each family to reduce its consumption of bread by at least a third. In desperation bread rationing was introduced, each person being limited to one quartern loaf a week, for which they were charged the exhorbitant price of 1s. 10d..

Many of the remaining agricultural workers faced the same hardships as the urban factory workers, as rural smallholdings were swallowed into ever bigger farming units. William Cobbett told 'the Industrious Classes' in 1820 – using the words 'industrious' and 'artful' in their older sense – that they had been deceived by 'artful and interested men.'

The 'artful' men were a new species – industrial speculators. Unlike the landed proprietors of the eighteenth century the new speculators did not develop their own or local resources. Instead, their 'art' consisted of borrowing capital (Usury Law fixed short term interest repayments at a maximum of 5%) to invest in factory plant and new machinery –

allowing them to employ cheap labour in processes that were soon sufficiently profitable to 'repay pounds in guineas' and still make the speculators wealthy. It was the speculators who were responsible for much of the early growth of the nineteenth century factory system. They were also busy in agriculture. In 1806 Cobbett spoke out bitterly against them, claiming that in rural Britain their operation had:

> ...drawn the real property of the nation into fewer hands; it has made land and agriculture obiects of speculation; it has, in every part of the kingdom, moulded many farms into one; it has almost entirely extinguished the race of small farms; from one end of England to the other, the houses which formerly contained little farms and their happy families, are now sinking into ruins, all the windows except one or two stopped up, leaving just light enough for some labourer, whose father was, perhaps, the small farmer, to look back upon his naked and half-famished children...

Mr Bennet's financial difficulties, which form a delicate sub-plot in *Pride and Prejudice*, were not unrelated to this rural poverty, or to the plight of the 'new poor' in the factory towns. Income tax was first introduced in 1799 to meet the £100 million debts arising from the latest French wars – the memory of the South Sea Bubble was still well enough remembered to rule out any possibility of private interests again taking over the national debt. When the tax was reintroduced in 1803 it was also to help pay for the escalating costs of poor relief at home. This new tax provoked alarm in the middle classes. They could see clearly enough the conflict between the financial prudence that was necessary to allow government to clear the war debts, and the need for increased welfare spending to lighten the load of poverty, but they could not see how such conflicts could ever be resolved. The pessimists feared that income tax was there to stay, and agreed with Sydney Smith's doleful prophecy:

> The schoolboy whips his taxed top; the beardless youth manages his taxed horse with a taxed bridle on a taxed road; and the dying Englishman, pouring his medecine on which he has paid seven per cent, into a spoon which has paid fifteen per cent flings himself back upon his chinz bed on which he has paid twenty two per cent, and expires in the arms of an apothecary, who has paid a license of one hundred pounds for the privilege of putting him to death.

In truth Britain's highways in the century's first decade were already in a fearful state, while the country roads along which Jane Austen's heroines travel with such insouciance were often lined with beggars, or with the unemployed 'on the tramp' to the new factory towns in hope of work, with footpads and robbers an ever-present threat. It was not until 1805 that horse patrols were instituted to try to limit the highway robberies on

main roads leading out of London, and most provincial roads remained chronically dangerous for at least another quarter of a century.

The mines and factories on which much of the new wealth was now based were oppressive, the workforce often consisting of women and children working cruelly long hours, in insanitary conditions, and until the *1834 Poor Law*, almost wholly without legal protection. In any case the benign legal authority of the eighteenth century squirearchy had almost disappeared, and commoners could now expect little mercy in the courts. A report of just one session of the Old Bailey, of September 24th. 1801, reads:

> Sentence of death was then passed upon Thomas Fitzroy, alias Peter Fitzwater, for breaking and entering the house of James Harris, in the day time, and stealing a cotton counterpane; William Cooper, for stealing a linen cloth, the property of George Singleton in his dwelling house; J. Davies, for a burglary; Richard Emms, for breaking into the dwelling house of Mary Humphrey, in the day time, and stealing a pair of stockings; Peter Foster, for a burglary; Magnus Kerner, for a burglary and stealing six silver spoons; Robert Pearce for returning from transportation; Richard Alcorn, for stealing a horse; John Nowland and Richard Freke, for burglary and stealing four tea spoons, a gold snuff box etc: John Coldfrede, for stealing a blue coat; Joseph Huff, for stealing a lamb; and John Pass for stealing two lambs.

Executions were still public, and the gallows, pillory and the stocks were familiar sights in Britain's major towns. Even the well-educated middle classes would visit lunatic asylums such as Bedlam in Moorfield to see the inmates exhibited for public amusement. Assizes still condemned petty criminals of both sexes to public whippings.

The pillory was not abolished until 1837, and public hanging continued until the 1850s. Visitors to Nottingham during the first decades of the nineteenth century would, for example, have been regularly greeted by the sight of executed criminals' bodies swinging on top of Gallows Hill on the Mansfield Road; more than 200 people were hanged in the town between 1800 and 1831. In 1844, 12 people were crushed to death and 100 seriously injured when a Nottingham crowd which had assembled to watch a public hanging ran out of control. Five years later, in 1849, things were at least better organised when colouful posters advertised a special 'hanging excursion' from London to Norwich with pre-booked grandstand seats enabling the trippers to watch the last agonies of Rush, the Stanfield Hall murderer.

In 1801 there were eighteen prisons in London alone. Conditions in them were vile. In Newgate, in the early years of the century, the women prisoners, who numbered in excess of 100, were each allowed eighteen

inches breadth of sleeping room, and were 'packed like slaves in the hold of a slave ship'. Even in John Howard's 'model' prison at Cold Bath Fields, Chesterton reported in his *Revelations of Prison Life* that:

> Men, women and children were indiscriminately herded together in this chief country prison, without employment or wholesome control; while smoking, gaming, singing, and every species of brutalising conversation tended to the unlimited advancement of crime and pollution.

Crime and pollution were not easy to identify. Growing revulsion against the authorities' tolerance of drunkenness and gambling, coupled with growing working class poverty, helped to foster the rapid growth of Methodism. In 1800 there were only 90,000 Methodists; by 1830 almost 250,000. Yet this created another tear in the fabric of British life, as church was now frequently set against chapel. In the more traditional rural parishes there was often violence. Sometimes the Mr Collinses of the day would look on as local yobboes beat up visiting Noncomformist preachers.

Meanwhile, some indication of the horrors of medical treatment is given by the fact that respected anatomy professors thought it quite seemly to pay 'body snatchers' to plunder recent graves for cadavars on which they might practise their skills. During Jane Austen's lifetime, the usual payment to the 'resurrectionists' was fifty pounds down, and nine or ten pounds on delivery of a fresh corpse. Other professionals were capable of equal barbarity. Officers in the armed forces, who in contemporary novels almost always exhibit the finest of good manners, in real life presided regularly over the bloody administration of the lash – four or five hundred strokes was not an unusual sentence – on members of the ranks who were deemed by them to have committed an offence.

Yet the overpowering difference between real contemporary Britain and the fictionalised estates of the Austen novels lay in the fact that an agrarian economy was being rapidly and brutally transformed into a manufacturing one. The mechanised 'factories' which were erupting in the fields and the forests of Britain find no place in Jane Austen's fiction, yet in the first half of the nineteenth century the new factory system was growing relentlessly. Between 1800 and 1850 in Britain, annual production of coal rose by 450%, iron by 1,000% and cotton by 1,400%. The national census of 1851 shows that in the year of the Great Exhibition, factory workers and urban labourers in total already outnumbered the 1,800,000 people (including servants) still working on the land. By that time, there were 219,000 coal miners, 80,000 iron workers, 537,000 cotton workers, 380,000 milliners and dressmakers,

284,000 wool workers, 64,000 lace workers, together with 442,000 builders, 65,000 railway workers, 376,000 labourers and 1,039,000 persons in urban domestic service.

In l801, the only city in Britain was London, yet by 1891 there were 23 cities. Even in the first half of the century urban growth was spectacular:

	Population in 1800	Population in 1850
London	1,117,000	2,685,000
Liverpool	82,000	376,000
Manchester	75,000	303,000
Glasgow	77,000	357,000
Birmingham	71,000	233,000
Edinburgh	83,000	202,000
Leeds	53,000	172,000
Bristol	61,000	137,000
Sheffield	46,000	135,000
Bradford	13,000	104,000

The traditional spas and the old market towns played little part in this rapid expansion. For the most part their populations remained stable, and their townscapes altered no more during this turbulent period than during the previous fifty years. Bath, for instance, which at the end of the eighteenth century had been the ninth largest urban conurbation in Britain, looked little different in 1850 from the town in which Jane Austen had gone to live in 1801.

Older communities comfortingly prided themselves on their history, their ancient fairs and markets, and their modestly-scaled manufactories – although when John Byng was touring Britain in the 1790s, such places were already beginning to sound strangely archaic:

> The road, of beautiful features, continues by Gamston and Idleton villages. with a view of the Forest to the left, and of Mr Eyre's seat, the Grove, to the right. The vale towards the Retfords is rich verdant, and the two churches appear to advantage: I always judge well of a town when I observe a good footpath of distance to it. Retford, tasting of a navigation and of manufactories, shows in gaiety! I walk'd my horse over the stones.

> There is a new-built town hall in West Retford, for both East Retford and West Retford joining form together a great place. I walk'd around the great churchyard, below which is a worsted manufactory.

The differences between the old market towns with their loosely-organised manufactures and the new factory towns were stark. It was not just a difference in scale, but also involved a crucial difference in the

relationship between managers and workers. And of particular importance to our history is the fact that the recreations of the new urban workers were now of necessity much different from the traditional pastimes and pleasures of country folk.

Josiah Wedgwood's pottery manufactory, Etruria in Burslem, which had began operations in 1759, illustrates all those differences well. Some commentators have argued that in essence it was the same kind of establishment as the nineteenth century factory. It has been said that because his workers no longer worked in their own homes, and were no longer on piece work, but paid for time spent in the factory, that the Etrurian workers were to all intents and purposes working a shift system. Moreover because most members of the workforce followed distinct and specialised tasks, it has also been argued that Etruria was also operating on the principle of the subdivision of labour. Therefore, on both counts, Etruria was a 'factory'.

Yet there are compelling reasons to insist that Etruria was one of the last and most successful of the old manufactories rather than a primitive stage in what was later called 'the industrial revolution'. First there is the comparatively simple question of scale. At the height of his operations in 1790 Wedgwood had a mere 160 specialist male employees working variously as slip mixers, clay beaters, throwers, plate makers, dish makers, hollow ware pressers, turners of flat ware, turners of hollow ware, handlers, biscuit-oven firemen, slippers, brushers, placers and firemen in the glost oven. They were supported by a smaller group of men working as coal getters , modellers, mould makers and as sagger makers, and in addition Wedgwood also trained and employed women as colour-grinders, painters, enamellers and gilders. It was not by any standards a large, or even a medium-sized operation. In the second half of the nineteenth century the average Bradford woollen mill employed more than 700 people, and as early as 1841 the average size of all factories in Manchester was 285.

Moreover, what is glibly called the subdivision of labour in Etruria was not to optimise production of the most profitable lines – the cardinal purpose of nineteenth century factory organisation – but to make the best use of individual and traditional skills. Wedgwood did not negotiate wages *en bloc*. He paid his workers variable rates according to the skill (or art) which each displayed in their work. Nor were production processes ever modified to short cut the traditional potters' skills. Etruria's products were never standardised to the point that the particular talents of a Flaxman or Hackwood could not be recognised in the finished article by the buying public.

A Summer Scene in the Potteries.

Down in the Potteries it's " a sight,"
The whole day long, from morn till night,
To see the girls, and women grown,
The child, the damsel, and old crone
By the well-sides at work, or singing,
While waiting for the water's springing;
Telling what Francis Moore presages,
Or who did not bring home his wages.
P'rhaps one exclaims, " time runs away !"
Her neighbour cries, " Why, what's to-day?"
And, when she knows, feigns mighty sorrow—
She thought to-day would be to-morrow?
Another thinks another's daughter
Grows monstrous tall——" Halloo! the water !"

Figure 7 Life in the manufactories was still more rural than urban, industrious rather than industrial.

Finally, the 'shift system' employed by Wedgwood had none of the harsh rigidity of the factory mills. Etruria varied its working hours with the seasons, closing down early if the light began to fail, while at the other end of the day Wedgwood was remarkably tolerant of latecomers, as his instructions to his gatekeeper show:

> Those who come later than the time appointed should be noticed and if after repeated marks of disapprobation they do not come in due time, an account of the time they are deficient should be taken, and so much of their wages stopt as the time comes to.

Perhaps most important of all was that Etruria did not change the location and quality of the workers' family and recreational lives. At night Wedgwood's workers returned to their rural homes. In the evenings and at weekends they followed their traditional pursuits. At holiday times they enjoyed, by and large, the same recreations as their forebears had done. Wedgwood did not seek to change and control the whole of his workers' existence, as the nineteenth century factory-owners inevitably did.

That did not mean that such enlightened employers did not take an interest in the welfare of their workers. They did, but it was an interest concerned with older and wider notions of industriousness rather than with new ideas of industrial efficiency. It was a benign concern, frequently involving the workers' education and recreation. Robert Owen, in his model society at New Lanark, insisted that every child of each of the workers was taught to read, to recite and to sing. John Strutt of Belper gave all his workers time off work to receive free musical instruction, and signed up the best on seven year contracts to play in his works orchestra.

In the late eighteenth century, the leading Cardiff manufactories were owned and run by the Harfords, an enlightened Quaker family. They paid for the children of local workers to attend the Quaker school at Whitchurch, and founded the local library. In 1786, they helped form a Benefit Club at their Mellingriffiths tinplate works, which levied each worker 1s, and in return paid out between 5s. and 7s. a week to workers and their families in need. However, in the first decades of the nineteenth century, this latter practice was adopted and distorted by the new speculators, who in place of a levy upon their workers paid them a part of their wages in tokens, which could only be redeemed at the 'tommy shops' owned by the factory owners themselves.

This practice was roundly condemned by another of the surviving Welsh landed proprietors, the Lord Lieutenant and local MP, the Marquess of Bute, who called it 'artificial, atrocious and cruel'. Nor did his opposition to the speculators end there; he fought for a public Cardiff

police force in place of the factory owners' private one, and championed the poor in their fight against the tied wages and poor housing offered to them. By comparison, Bute was himself a model landlord. He set his own rents at affordable levels and between 1821 and 1848 gave back 7% of his rent income, some £25,000, to local charities.

Workers in other towns were less fortunate with their housing and with their landlords. The long hours the new cotton and woollen mills, iron and steel works, and mines – the factories that were forming what was now tellingly called not industrious, but *industrial* Britain – forced workers to live in any kind of dwelling that could be rented within walking distance of work (though that sometimes still involved weary daily journeys to and from the factory gate). These dwellings were almost always hastily-made, insalubrious places, and frequently owned by the 'industrialists' themselves. They were a world away from the Crescent at Bath – as Dr Farriar showed when in 1805 he wrote his famous description of the subterranean dwellings in which many Manchester factory workers were forced to live:

> ...they consist of two rooms under ground, the front apartment of which is used as a kitchen, and though frequently obnoxious by its dampness, and closeness, is generally preferable to the back room: the latter has only one small window, which, though on a level with the outer ground, is often covered with boards or paper, and in its best state, is so much covered with mud, as to admit little either or air or light. In this cell, the beds of the whole family, sometimes consisting of seven or eight, are placed. The floor of this room is often unpaved: the beds are fixed on the damp earth.

Such were the conditions which helped to bring about the great cholera epedemic of 1831–2, which wrought most havoc amongst the urban poor, where sanitary conditions were often deplorable. Of 4,000 houses in Low Town in North Shields in 1849 only 300 had a piped mains water supply, and the entire area contained only 62 lavatories, which were largely in tradespeople's houses. Such insanitary conditions, coupled with the backbreaking daily demands of factory work, created a vast discrepancy between the life expectancies of the different classes. Edwin Chadwick's *Report on the Sanitary Condition of the Labouring Population* showed that in Bethnal Green in 1839 the average age of death could be starkly tabulated:

No. of deaths		Average age of deceased
101	Gentlemen and professional Classes	45 years
273	Tradesmen and their families	26 years
1,258	Mechanics, servants, labourers, etc.	16 years

The wretchedly low average life expectancy of the urban poor could partly be explained in the cotton and wool trades by the widespread employment of very young children – not until 1819 were children below the age of nine prohibited from working unlimited hours in cotton mills – but it was still low in other kinds of industrial town, where children were given no education but simply used as factory fodder. In the iron and steel city of Sheffield for instance the average age of death for all classes in 1841 was still only 24. In 1845 in Nottingham the average age of death was lower, 22.3, and in the St. Anne's district, where many of the city's lace workers lived, it was 18.1.

So for large numbers of factory workers in the early years of the nineteenth century it makes little sense to talk of their preferred 'pastimes' or 'recreations'. They had little recreational time as the factory consumed virtually the whole of their waking lives. Later, as things slowly improved, the rigid factory shift system made 'leisure' at first a more clearly defined, then a more desirable and ultimately a partly attainable entity, to be bargained for together with better working conditions and higher wages. After notable legislation such as the *1847 Ten Hours Act* the demand for more leisure makes a more frequent appearance in negotiations between employers and workpeople, and in popular ballads such as this one from Nottingham we hear of the factory workers' envy of the conspicuous leisure enjoyed by the upstart industrial bosses:

> His father was a pauper and his uncle likewise,
> And in Greasley workhouse the latter clos'd his eyes
> But Charley of late such a valiant man is grown,
> He struts about the town like a toad upon his throne.

And in a Lancashire ballad there is bitterness at the lack of leisure time in the lives of the cotton workers, and an ironic regret that the new mechanised looms no longer leave the workers time to stroll for two or three hours a day in their spacious gardens:

> So, come all you cotton weavers, you must rise up
> very soon,
> For you must work in factories from morning till
> noon:
> You mustn't walk in your garden for two or three
> hours a day,
> You must stand at their command, and keep your
> shuttles in play.

In one sense the shift system meant that the newly defined commodity of

leisure was forced upon the nineteenth century worker. Yet that same system at first denied the worker the kinds of home, environment, amenities and spending power he would have needed to enjoy it. The factory worker had been wrenched from the greens and commons on which traditional sports and arts had been practised, and as the *Pall Mall Gazette* remarked, 'the little dwellers in our slums are excommunicate, not of the churches, but of nature'.

But the meagre leisure of tens of thousands had nevertheless to be filled, and a complicated battle was now joined for the leisure time and leisure spending of the new urban working class. At its most simple, this can be presented as a battle between the exploiters and the improvers – between on the one hand the lure of the cheap press, public houses and travelling showmen, and on the other the Mechanics Institutes, reading rooms and uplifting public lectures.

The reality was always more complicated than that. In the nineteenth century, the private sector – the supposed exploiters – frequently joined forces with the charities and the civic authorities – the supposed improvers – to create all kinds of cultural institutions. One remarkable aspect is the open-mindedness and fluidity in raising funds which all kinds of organisations showed; as there was no 'British system' of support, all kinds of subscription schemes, fund-raising and patronage were tried in every conceivable combination. A second aspect is the great variety of platforms from which the call for cultural improvement came – the new local government, private philanthropists, the churches and chapels, charitable organisations, local newspapers, and the public meetings of the reformers all played their part.

Not infrequently the initiative came directly from the working class unions and societies. In the pubs of Nottingham for example there developed a remarkable network of workers' subscription libraries. In 1835 the first workers' library was opened in the *Rancliffe Arms*; in the following year two more were founded, in the *King George on Horseback* and *The Pheasant*. In 1841 a fourth opened at *Queen Adelaide* in Sneinton, the *Cricket Players* at Hyson Green following suit a year later, with the sixth, the *White Swan* at Radford, opening in 1844. Each library contained some 1,000 volumes, and set initial membership at 2/6d., with a weekly subscription of 1d.

Descriptions of urban recreational planning between the middle of the eighteenth century and the formation of the *Royal Institute of British Architects* in 1834 generally confine themselves to the spas – the parklands of Harrogate, the Woods' creation of Queen Square and the Crescent in Bath, Papworth's spacious Montpellier Pump Room at

Cheltenham – together with the obligatory footnote on Nash's Royal Pavilion at Brighton. Yet that is to ignore the struggle for improved amenities going on throughout every part of provincial Britain, about which each town has its distinct story to tell.

For example by the 1790s Cardiff already had paved streets and raised walkways throughout its centre, and Scarborough was already attracting holidaymakers to its spa buildings and lamplit seafront promenades. In 1818, three years before Brighton's Royal Pavilion was completed, the newly-formed Glasgow Gaslight Company raised a subscription of £40,000 to introduce gas lighting throughout that city. Even more ambitiously, in the same year, the industrial town of Sheffield benefited from an act 'for cleansing, lighting, watching and otherwise improving the town of Sheffield' which was fully enforced within a $1\frac{1}{2}$ mile circle, with the parish church at its centre. The operations of cleansing, street lighting and what was in effect policing the town centre were in the hands of the Sheffield Trustees: Master and Wardens of the Cutler's Company and 80 specially chosen public commissioners.

More remarkable still is the story of Puritan Plymouth. There in 1810 the corporation ambitiously conceived the building of what we should nowadays call a tourist arts complex – hotel, assembly rooms and a large theatre 'for the greater convenience, accommodation and amusement of persons resorting to this town'. They appointed John Foulston, a man of independent mind, as architect, and he immediately chose a site near George Place, which was isolated from the existing town centre. When the corporation bridled at the distance, Foulston offered his often-quoted and modern-sounding reply:

> Isolated! Let me raise the fabric and you will soon see a vast addition of houses in that locality.

Foulston's plan, formed with local architect George Wightwick, included a large hotel, assembly rooms for music, concerts and conferences, restaurant, coffee rooms, theatre (with green room and foyers) and stabling for the more affluent visitors. The whole was brought together in a heavily-pillared quadrangle. The final cost of building was estimated at £60,000.

The corporation showed extraordinary ingenuity in raising the necessary capital, although their methods caused much controversy in the South West, not least because their first step in fund-raising involved selling religious benefices. The Plymouth city fathers held the advowsons of two parishes, St. Andrews and Charles Church, but of course appointing mere parish priests brought no financial reward, so they decided to sell them to the private sector. Although this raised rather more

than £10,000 it was clearly not enough. So the corporation next decided to run their own lottery, which raised a further £20,000. Finally they opened a public subscription scheme. Shares were £10. As an inducement to buy subscribers were asked to nominate people for a kind of 'annuity raffle', in which the last surviving person on each list of ten was paid £100 by the corporation. By such unorthodox means the Plymouth corporation raised £46,000 in three months. In 1811 work began. The classical complex, built around what was from the first known as the Plymouth Theatre Royal, opened with much ceremony in 1813, although sadly it never proved successful.

The new local authorities are often given almost all the credit for the development of urban cultural amenities in the nineteenth century, but it is important to remember that their financial resources were strictly limited, and, as we have already seen in the case of the Plymouth arts precinct, their developments almost always involved partnerships with other funding sources. Most commonly, local authorities worked in tandem with public subscription schemes. A typical illustration of this was Bolton. In 1852 its corporation decided to build a Museum and Library in the town. A halfpenny rate levied for the purpose realised only £250, so a subscription scheme was launched. It was decided that the mayor and leader of the corporation should 'wait upon parties assessed [to] the rates at more than £500 per annum', and two slightly less notable figures should 'call on those assessed at £200 to £500'. By November of that year these approaches had produced a further £800. Public meetings then organised the smaller subscriptions – including works contributions organised by a working men's group – and soon enough had been subscribed – £3,000 – for building to start. The Bolton Museum and Library opened in October 1953.

In other enterprises the local authorities acted as enablers, by such means as offering freehold on corporation land. That was the case with the Manchester Institute for the Promotion of Literature, Science and Art, founded in 1823, and to which the corporation gave a site in Mosley Street. The Institute decided to raise the £23,000 it needed for its fine new building by offering 'hereditary governerships', which could be passed on down the family, for £42, 'life governerships' for £26, and more modest 'annual governerships' for £2.2s. a year. The money was duly raised. The Institute flourished in a fine classical building which Charles Barry designed, and which today operates as the City Art Gallery.

Other institutions claiming to improve the quality of life for the factory workers were run for the working classes rather than by them. This was certainly true of the Mechanics Institutes. The movement was begun by

George Birkbeck, copying the methods of the Birmingham Brotherly Society which had been giving free scientific lectures to the working class for many years. Birkbeck was instrumental in creating the first Mechanics Institute in Glasgow in 1823. The idea was immediately copied in Edinburgh and London, and soon spread to most parts of the country, Newcastle for example opening its Institute in 1824. However, popular demand meant that the original intention of concentrating upon science teaching had to be gradually abandoned. A typical development was that in Nottingham, which did not have a Mechanics Institute until 1838, and where only five subjects were taught in the first year; arithmetic, chemistry, French, English and drawing. The syllabus for the second year however embraced no fewer than 28 subjects, including music, poetry, painting, astronomy and printing.

The Mechanics Institutes were run as a philanthropy, by middle class instructors anxious to patronise workers by offering instructive ways of filling their leisure. 'Education' became a puritanical, morally cleansing activity, set in opposition to the theatre, saloon bar or racecourse, and firmly allied with abstinence, thrift, Godliness and, rather less easily, the profitable purposes of the new industrialists. The gap between the improvers and the entertainers was pictured as being much greater and more absolute than it needed to be, and was too much insisted upon, as in this *Public Letter* sent by the Methodists to the Cornish miners in 1829:

> I am asked 'Why do you not go to the wrestling?' For eight good reasons. Because I can employ my time better. Because it is throwing my money away. Because I wish not to be seen in bad company. Because I would not encourage idleness, folly and vice. Because I should set a bad example. Because God has forbidden it...Because I must soon die!

There were many moralisers who saw it as cause for regret that throughout the century the Mechanics Institutes never became a more potent source of popular instruction than the broadsheet, the fairground orator or the popular theatre. Yet other and perhaps more perceptive critics took a different position. As Dickens himself wrote:

> The narrow-minded fanatics who decry the theatre and defame its artists are absolutely the advocates of depraved and barbarous amusements. For, wherever a good drama and well regulated theatre decline, some distorted form of theatrical entertainment will invariably arise in their place.

Ironically it was only popularisers such as Dickens who could regularly draw large crowds to the Mechanics Institutes. As a North Eastern writer said:

> The toiling mining populations of Northumberland and Durham proceed over the hills in rain, sleet and frost that they may learn the great truths that civilisation has made manifest.

Dickens took the skills of the entertainer – powerful characterisation, mesmeric delivery, broad humour and power to shock – to his improving addresses. And meanwhile many popular entertainments bridged the gap in the opposite direction, adopting a highly educational tone in their advertising. Charles Weldon's circus, on tour in Southern Scotland and the North East of England in the 1840s, thought fit to advertise itself in these terms:

> The crowds of delighted pleasure-seekers who nightly throng this popular resort, prove, incontestibly, that the varied amusement submitted to public criticism, and the efforts made to furnish an Entertainment entirely divested of all objectionable features, are fully appreciated and liberally acknowledged, and which, whilst inducing healthful vigour and tone to the over-taxed brain, also relieves the monotony of the handicraftsman's daily labour, recruits the wasted energies, and supplies that most essential recuperative stimulus, necessary to refresh both the mental and physical powers.

There is much about this to interest historians, not least in the demands it places upon the reading abilities of the workers, and in the earnest concerns of a Northern showman a decade before Dickens presented us with Sleary's life-enhancing but anti-education circus troupe in *Hard Times*. There is the earnest attempt to make 'Entertainment' as socially significant as was art, without the box office disadvantages from which showmen suspected that art suffered, of being linked in the popular mind to the privileged and leisured classes. Here 'Entertainment', is pictured as driving away mundane thoughts, bringing Charles Weldon's circus alluringly close to Keats' 1817 redefinition of art:

> The excellency of every art is its intensity, capable of making all disagreeables evaporate...

Yet in spite of Keats' certainty, the unified Augustan notion of art was fracturing. The nature of true art was being debated in different terms within different art forms. As in Shelley's *To A Skylark,* the Romantic poets toyed with notions of art in harmony with nature:

> *Hail to thee, blithe Spirit,*
> *Bird thou never wert,*
> *That from heaven, or near it,*
> *Pourest thy full heart*
> *In profuse strains of unpremeditated art.*

In the visual arts the concerns were rather different. The gradual encroachment of the state seemed to some to threaten a bureaucratic redefinition of art. As Constable said in 1824, when considering the imminent founding of a state supported National Gallery:

> Should there be a national gallery (as is talked) there will be an end to the Art in poor old England, & she will become the same non entity as any other country which has one.

The contrary view had been expressed by Johan Feseli, Professor of Painting at the Royal Academy, who in 1801 had urged the public support of the visual arts, claiming that the old certainties in art had disappeared when 'public grandeur gave way to private splendour' and 'the Arts became the hirelings of Vanity and Wealth'. Meanwhile controversy over whether English painters should devote themselves to their native landscapes or compose paintings in the classical continental manner continued to rage, as the state slowly developed its own means of control – setting up, for example, the *Government School of Design* in 1837 while four years later a Government *Fine Arts Commission*, chaired by Prince Albert, mounted a competition for contemporary political cartoons to decorate the new House of Commons.

Traditional popular music, in the form of street ballads, shanties and work songs, were now downgraded by music teachers, in contrast with the musical art of the concert platform. When Francis Place was called before the Select Committee on Education in England and Wales in 1835 to give evidence on the state of musical education, he primly announced that he could not bring himself to utter the popular songs of his youth before pure-minded politicians:

> I have given in writing words of some common ballads which you would not think fit to have uttered. At that time the songs were of the most indecent kind; no one would mention them in any society now; they were publicly sung and sold in the streets and markets.

So one way and another, the certainties of the Augustan age were fast disappearing. The newspapers and journals were now serving radically different interests, and critical debate was fragmented. Lacking decisive leadership by Royal patronage, by the aristocracy or the landed interest, notions of good taste became confused, and sectional class interests used 'education' for their own ends. The workers in the factory towns could respond with certainty to 'art' only when it was presented to them in its old sense of high skill, not when it was extolled from middle class platforms as an inspirational but unattainable pleasure enjoyed by the leisure classes. Rowlands, one of the larger touring waxworks shows,

would have touched the popular understanding of 'art' when it advertised its:

Colossal Exhibition of
WAX FIGURES
and
MECHANICAL WORKS OF ART

Although the show included a display of panoramic oil paintings and a 'splendid brass band', it was the automata which were unblinkingly termed 'art'.

Neither did Rowlands hesitate in the description of his customers. Admission was priced at 1s. for 'Ladies and Gentlemen', 'Working people' were 6d., Children – half price. In Weldon's circus, the reserved seats were 3s., Boxes 2s., Pit and Promenade 1s., the Gallery 6d. Children under ten were admitted for half price to all parts except the gallery, and everyone was admitted for half price after nine o'clock.

Admission pricing was in general flexible in the first half of nineteenth century Britain. The managers were not only aware of the huge differences in income between the classes, but were also aware of the radically different wages paid in different parts of the country. Thus a builder's labourer in Glasgow was paid around 12s. a week; the same worker in London was paid 20s. Scottish cotton workers received about 7s.6d. a week, and those in Lancashire 10s. The carpenters of Newcastle received 20s. a week, whereas workers in some Midlands engineering factories were paid 27s. 6d. a week. A Town Clerk on the other hand would be paid £4 or £5 a week. Theatres and Concert Halls therefore offered a wide spread of prices, with a number of concessions; in particular the lowest price was much varied, sometimes dropping to 2d. or even 1d. to attract the youngsters who formed the bulk of many audiences.

Raising the top prices, or realloting the theatre space so that more of it was occupied by the top payers, presented more of a difficulty. The popular audience, usually stakeholders in their local venues by virtue of the subscriptions they had paid, were possessive both of their territorial and economic rights. In 1909, the audience at Covent Garden had rebelled when Kemble attempted simultaneously to raise the price of admission to the pit from 3s. 6d. to 4s., and to convert the theatre's third tier into boxes to shelter the gentry driven from the pit. After sixty seven nights of varied protests, during which time not a single performance was given in the theatre, Kemble was forced to back down. The effectiveness of the 'Old Price Riots' served as a warning to London managers in particular for more than half a century.

Although the existing theatres were frequently enlarged – thanks to generous assistance from Samuel Whitbread, the brewer, the 'new' Drury Lane which opened in 1812 accommodated more than 3,000 – there was a limit beyond which expansion was impossible, and the managers of the Royal Patent theatres found it increasingly difficult both to pay the increasing fees actors and singers demanded, and to hold to the old prices. Elliston, for example, was forced to give Madame Vestris £200 for 50 performances (and a benefit) when she made her Drury Lane debut in 1820. The legitimate theatre ceased to be a good business speculation for outsiders, and the history of nineteenth century theatre management became in part a history of actor-managers, performers who could adjust their own salaries to suit their own production budgets. Madame Vestris in due course herself became the first of an impressive sequence of women actor-managers.

In the provinces however, managers flourished, not least because in the new factory towns speculators could build their venues on a larger scale, attracting high revenues while keeping admission prices low. A typical example was the Star Concert Room at Bolton, opened in 1840 by William Sharples, which held more than 1,000 people and soon expanded to include a museum, picture gallery and menagerie. By 1852 it was estimated to have the biggest share of the four to five thousand people who were estimated to go to Bolton's singing salons each night. At the Cremorne, the nineteenth century Chelsea pleasure garden, where admission was 1s. (with the usual concessions), there was a dance floor accommodating 4,000 people, with an orchestra of 50 playing for the dancers. In Birmingham, Tonks Colosseum (now Bingley Hall) had an auditorium seating 4,000 spectators. On the fairgrounds Richardson's travelling theatres were enlarged and could take more than 700 people while even smaller booths such as Adams 'Sans Pareil' could house nearly 400 for each of the several daily shows.

Times of opening and days of performances and presentations in the nineteenth century are always revealing. The managers of the entertainments were careful to schedule shows at times when the workers had finished shifts; most urban theatre performances offered 'Half Price after nine o'clock' for the benefit of their working customers. Fairground showmen and circus managers tried to arrange their tours so that they would be on a popular urban site at each of the 40 public (or 'bank') holidays which were still kept in 1820, and even more careful to arrange to be in a good location when, in 1830, the number of such holidays was reduced to 18.

The opening times and dates of the 'improving' institutions reveal a rather different picture. For example, in the late eighteenth century the British Museum was only open to those who had applied several weeks in advance and had their rank and station approved by the authorities. In any case it closed at 3 p.m. on weekdays, and was resolutely shut at weekends, on all feasts and feast days, at bank holidays and in the weeks following Christmas, Easter and Whitsuntide – precisely the times at which ordinary people might have been able to visit it. There was slight relaxation in the early years of the nineteenth century, when up to 120 people a day were admitted, but that did nothing to check Cobbett's furious outburst against the Museum, reported by *Hansard* in 1833:

> He would ask of what use, in the wide world, was this British Museum, and to whom, to what class of persons, was it useful? He found that a £1,000 had been laid out in insects; and surely Hon Members would not assert that these insects were any use to the ploughboys of Hampshire and of Surrey, and to the weavers of Lancashire! ...The ploughman and the weavers – the shopkeepers and the farmers – never went near it; they paid for it though, whilst the idle loungers enjoyed it, and paid scarcely anything. ...Why should tradesmen and farmers be called up to pay for the support of a place which was intended only for the amusement of the curious and rich, and not for the benefit or for the instruction of the poor?

Sunday remained a particular problem. Any attempt by the entertainments managers to open on the Lord's Day was greeted with firm disapproval, and even apparently improving ventures were viewed with suspicion. A suggestion that the Leeds corporation might acquire some Botanical Gardens and open them on Sundays to working class visitors brought forth the following from the Leeds newspaper:

> ...it would be a wretched exchange to draw the poor of England out of their Churches, Chapels, Sunday-schools and quiet homes into public exhibitions and places of amusement on the Lord's Day.

The plan was shelved. Not until the 1890s did either entertainers or improvers seriously breach the sabbatarians' defences. Then, in some of the larger resorts, street trading and street entertainments were at first tolerated, and then accepted as a necessity. In Blackpool in 1896 the authorities gave the first official support to Sunday recreation when they started to run their Corporation tramways on seven days a week.

Yet in the early years of the century the factory workers still spent the majority of their holidays at home. The big summer holiday was a refined version of the old 'Wakes', a custom which William Hutton had described in *An History of Birmingham* (1781):

When a church was erected, it was immediately called after a saint...and the day belonging to that saint kept as an high festival. In the evening preceding the day, the inhabitants, with lights, approached the church, and kept a continual devotion during the whole night; hence the name *wake:* After which they entered into festivity. But now the devotional part is forgot, the church is deserted, and the festivity turned into riot, drunkeness and mischief.

By the early nineteenth century it became a largely secular holiday, held for the factory and millworkers under the patronage of local publicans. As with some of the medieval religious festivals, the wakes were times for inversion of the normal social order. Workers appeared in the streets in fancy dress wearing the apparel of their bosses, or the local clergy – or even the local barmaids, for it was also a time of sexual release, as the comic singer George Ware explained in his famous Wakes song:

> *The big boys and girls,*
> *With crinoline and curls,*
> *Get kissing each other,*
> *Like sister and brother,*
> *And lots of other games,*
> *About which I'll not speak...'*

The broadsheet press frequently adopted a mock-horrified attitude to the goings-on at the Wakes. In 1850 *Sam Sly's Birmingham Budget* shared with its readers consternation at one Kate Billy 'a wire bodger' who had neglected her ailing mother to visit the Wake with her fancy chaps, and told of a 'bouncing bedstead maker' from the same street who had distinguished himself at the Wakes by making love to fourteen girls in one night.

The ambivalence of the *Birmingham Budget* reflects not only a general confusion about how leisure should be occupied, but also uncertainty about the developing role of journalism. In the first half of the century *The Times* established its authority and independence, increasing its circulation from 5,000 in 1800 to 50,000 in 1850, and becoming the newspaper of the 'British Establishment'. However it was not unchallenged. The *Morning Chronicle* in the years following John Black's assumption of the editorship in 1817, at a time when John Stuart Mill's father was his closest confidante, ran it close. At the other end of the social scale the struggle for journalistic independence was made more complicated by the emergence of a strong radical press, newpapers of the anti-establishment such as Feargus O'Connor's *Northern Star*, the London *Dispatch*, Edinburgh *New Scotsman* and Chartist organs such as Newcastle's *Northern Liberator*.

In its new sense 'industry' had become a battleground, and segments of the arts world press-ganged into the warring battalions. In the 1830s and 1840s it became commonplace to see bills announcing the 'unavoidable postponement' of a concert or other entertainment because the assembly rooms, concert hall or theatre were needed for a public meeting of the Anti-Corn Law League or the Chartists, and it was not uncommon when the concert did take place for the profits now to go to support the factory workers' causes rather than a conventional charity. With their increasing sense of power the factory workers themselves sometimes even adopted the role of patrons, commanding their own kind of 'artist' to appear, as in this 1848 example:

PURVIS'S MERRY NIGHT

At Spark's Buildings, Commercial Street, Middlesborough

On Wednesday evening, the 22nd. Inst., to commence at half-past 7 O'Clock

By DESIRE and under the judicious PATRONAGE of the

FORGEMEN AND WORKMEN

of the

MIDDLESBORO' IRON WORKS

MR PURVIS

Grand Magical

ILLUSIONS.

In the minor theatres and the penny gaffs – the makeshift theatres that had sprung up semi-legally in the factory towns before the *Theatres Act 1843* diminished the patent theatres' exclusive rights to present legitimate drama – managers offered radical entertainment such as John Walker's *The Factory Lad*. The factory of the title is owned by Squire Westwood, who 'sneeringly' espouses laissez-faire, Benthamite views:

Allen	A poor man has now less wages for more work.
Westwood	The master having less money, resulting from there being less demand for the product manufactured.
Allen	Less demand!
Westwood	Hear me! If not less demand, a greater quantity is thrown upon the markets at a cheaper rate...Don't you buy where you please, at the cheapest rate?

The play's sympathies are made clear enough when the leader of the factory insurgents, Rushton, has an early encounter with a judge, Bias:

Bias The law is open to you, is it not?
Rushton No, I am poor!
Bias And what of that? The law is made alike for rich and poor.
Rushton Is it? Why, then, does it so often lock the poor man in a gaol, while
 the rich goes free?

The rough-hewn radical arguments and broad sentiment of Walker's piece are typical of much of early nineteenth century writing for the popular drama. In the minor theatres and semi-legal 'Penny Gaffs' – in the 1830s there were more than 100 of them in London alone – such crudely written melodramas were peopled by stock characters, the factory owners and landlords as raucous villains, generally intent on increasing their profits, but finding time to sack a few worthy heroes and despoil a few rustic heroines *en passant*. The urban factory system was thus set up in stark opposition to the old values of rural life. When characters were discovered dwelling in 'A Country Cottage' it was a sure sign that they were pure and innocent, though almost always unwittingly on the brink of being corrupted by the 'artful and interested men' of the new industrial Britain.

Popular writing was equally radical in its opposition to the new industrialism, and as the reading public swelled – its growth assisted first by the reduction of the stamp tax in 1836 from 4d. to 1d., and then by the railways' speed in disseminating printed material – the novel became a more dangerous, less controllable, force than the popular drama. The new 'industrial novels', such as Mrs Gaskell's *Mary Barton* (1848), had all the sentimental power of the street ballads and the popular melodrama, but with the factory workers' living conditions more acutely realised, and the characters illuminated by the novelist's ability to convey the minutae of their shadowy lives. Such books were soon being read by many more people than would ever see even the most popular of melodramas.

Perhaps the most important of the radical writers of the first half of the nineteenth century, though he is frequently overlooked, was the bookseller, publisher and satirist William Hone. We have already noted his lugubrious mock-epitaph on the first National Lottery, but his talent for invective was spread over many fields. In particular he targeted the new industrial middle class, with their Benthamite social philosophy and hard-nosed mercantile attitudes. One of his better-known pieces ran:

Our Lord who art in the Treasury, whatsoever be thy name, thy power be prolonged, thy will be done throughout the empire, as it is in each session. Give us our usual sops, and forgive us our occasional absences on divisions; as we promise not to forgive those that divide against thee. Turn us not out of our places, but keep us in the House of Commons, the land of Pensions and Plenty; and deliver us from the People. Amen.

There is here the first hint of the political world of Mr Gradgrind, the Coketown M.P. in Dickens' *Hard Times*, a world in which an economic philosophy justifies the self-centeredness of the factory-owners, and a world which can be threatened only by 'the People' – but more importantly it is simple and effective satire, hitting its target with an accuracy which even the sharpest stage burlesque could not begin to match.

The debt Dickens owed to Hone was great. In 1817, quite early in his own career and still in the lifetime of Jane Austen, Hone had been indicted on the grounds of having published 'blasphemous libels' upon the Catechism, Litany and Creed. After a long and widely-reported trial the satirist had been sensationally acquitted by the jury on every charge. The long-term effect of that verdict was to elevate satire above ordinary slander in British law, and in the long term to render parody virtually immune from successful prosecution in the British courts. The immediate effect was to open the way for Charles Dickens to publish with impunity the best-known of all 'industrial novels', the satire which dared to question the *raison d'être* of Prince Albert's Great Exhibition.

The Great Exhibition

"*But* it's extraordinary the difficulty I have on scores
of such subjects, in speaking to any one on equal
terms. Here, for example, I have been speaking to you
this morning about tumblers. Why, what do you
know about tumblers? At the time when to have been
a tumbler in the mud of the streets, would have been
a godsend to me, a prize in the lottery to me, you
were at the Italian Opera. You were coming out of
the Italian Opera, ma'am, in white satin and jewels, a
blaze pf splendour, when I hadn't a penny to buy a
link to light you."
"I certainly, sir," returned Mrs Sparsit, with a dignity
seremely mournful, "was familiar with the Italian
Opera at a very early age."
"Egad, ma'am, so was I," said Bounderby, "– with
the wrong side of it. A hard bed the pavement of its
arcade used to make, I assure you. People like you,
ma'am, accustomed from infancy to lie on down
feathers, have no idea how hard a paving stone is,
without trying it. No. no, it's of no use my talking to
you about tumblers. I should speak of foreign
dancers, and the West End of London and May Fair,
and lords and ladies and honourables."

<div style="text-align: right">Charles Dickens, Hard Times 1854</div>

Amongst much else, the figure of Josiah Bounderby, Dickens' 'artful
and interested' Coketown mill owner, serves to remind us that,
contrary to the authorised version of cultural history, periods of
prosperity do not automatically lead to the creation of great art. The

bumptious mill owner stands as the epitome of one kind of middle class entrepreneur at the middle of the century: rich, coarse-grained and mean-spirited, a man who will have no truck with art, or with anything 'fanciful'. As his hostility to Sleary's performers shows, even his sympathy with tumblers is bogus. For such as Bounderby, the arts are a relic of a pre-industrial, artistocratic world, which the 'new realism' of the mills has swept away. It is sad old Mrs Sparsit, the gentlewoman living in reduced circumstances as Bounderby's housekeeper, who is still familiar with the Italian Opera, the ballet and the West End.

Bounderby has 'made sixty thousand pounds out of sixpence' by eschewing everything except the severely practical. For him 'progress' is measured simply by economic growth, and all human transactions – even his own marriage – are now a part of the machinery of trade and manufacturing industry:

> Meanwhile the marriage was appointed to be solemnised in eight weeks' time, and Mr Bounderby went every evening to Stone Lodge as an accepted wooer. Love was made on these occasions in the form of bracelets, and, on all occasions during the period of betrothal, took a manufacturing aspect. Dresses were made, jewellery was made, cakes and gloves were made, settlements were made, and an extensive assortment of Facts did honour to the contract. The business was all Fact, from first to last. The hours did not go through any of those rosy performances, which foolish poets have ascribed to them at such times, neither did the clocks go any faster, or any slower, than at other seasons....

Dickens' satire was generally against all those political economists and educationalists who saw 'figures and averages and nothing else', but in particular it railed against the self-justifying meanness of spirit which had taken root amongst the mill owners, with their unshakeable belief that in the new 'cotton millennium' commerce and manufacturing industry would soon be able to meet all deserving human needs. To such people, enjoying the 'long peace' that followed Napoleon's downfall, it seemed that British trade was set on a course of infinite expansion. Running at £67,300,000 at the turn of the century, trade had by 1850 risen to £220,900,000. The new merchant class could ignore the horrors of Empire – such as the one nearest home, the Irish potato famine, which the 1851 census estimated had killed one and a half million people – and instead look only at positive signs, like the 1851 discovery of gold in Australia, which let them glory in their own immutable prosperity, satisfied that nothing much need change in the rankings and social order of the British Empire.

'Civilisation' – a key term for the creators of the 1851 Exhibition – was directly equated with industrial development, though private wealth was

employed in a more functional way than had been the custom over the previous century. In the year of the exhibition John Store Smith noted in *Social Aspects*, 'the middle class family now possesses carpets and hangings, which would have excited great wonderment even at so recent a period as the American War, and not a few of our London middle-class tradesmen possess a better stock of family plate and linen than many a country squire, even of the last generation.' Yet – with a few honourable exceptions, the successful urban factory and mill owners who dominated British life around the middle of the century were concerned only for their own comfort and well-being, showing nothing of that philanthropy, concern for the less fortunate or duty of patronage which had characterised the lives of their forebears.

Considered in this light, Prince Albert's achievement in successfully mounting the Exhibition of the Industry of all Nations in 1851 is the more remarkable, for it was those same mill owners who put up the money for it and supported it to its conclusion. For although the government and the church both gloried in its eventual triumph, the truth is that the Exhibition's success owed very little to the efforts of either establishment. Nor – though the enterprise was led by a Royal personage of unusual political skill – was the Exhibition financially supported by the crown. Instead Britain's greatest cultural display of the nineteenth century was financed almost exclusively from the private sector, from newly-rich industrialists who had to be persuaded into the unfamiliar realms of patronage. It was the political acumen of the Consort in putting the glorification of manufacture and trade at the heart of his enterprise, and using that to lure factory and mill owners into financing it, that both made it commercially viable and gave the Great Exhibition its solid bedrock of popular support.

Had it been sponsored by government, its popularity would have been much less certain, for the reputation of Lord John Russell's Whig administration was at a low ebb in 1851. There was good reason for Disraeli's sardonic comment that the Exhibition was 'a Godsend to the government...drawing attention from their blunders'. Nor would the backing of the Church have ensured popular support either, for in the drift to the new factory towns many had left religious practice behind them. A religious survey of 1851 pointed out that fewer than half of the population went regularly to Sunday worship, the drop in religious attendance being most evident in the cities. In London there were pews in church and chapel for only 29.7% of the population, and in Birmingham for only 28.7% – and even they were not filled.

So it was perhaps fortunate that even the original impetus for the

Exhibition came neither from state nor church but from a private source, the Royal Society of Arts. Prince Albert had been its President since 1844, and had already presided over two small British exhibitions in 1844 and 1845 which had aimed at 'wedding high art with mechanical skill'. On the 30th. June 1849, he formally proposed to the society that it should now mount a giant exhibition with the same purposes but which would this time include all 'civilised' – i.e. industrially advanced – nations. The grand design was memorably recalled after the event by one of the exhibition's other well-known sponsors, Henry Cole:

> The history of the world records no event comparable, in the promotion of human industry, with that of the Great Exhibition of the Works of Industry of All Nations in 1851. A great people invited all civilised nations to a festival, to bring into comparison the works of human skill. It was carried out by its own private means: was self-supporting and independent of taxes and the employment of slaves, which great works had exacted in ancient days.

Once Albert's proposal had been accepted, a Royal Commission was set up under his chairmanship, with the five aims of persuading middle class Britain to rally behind the venture, of raising the necessary capital from the private sector, of building the exhibition hall, of supervising the gathering of its exhibits, and ensuring that it opened on time.

To raise the money, the Commission fell back on the well-tried British formula of raising subscriptions from the private sector. The Prince played an active part in persuading merchants and factory-owners to adopt the unfamiliar role of patrons and remarkably, within less than six weeks, £64,000 had been directly subscribed to the scheme, with a further £200,000 promised as reserve capital. Soon afterwards Hyde Park was determined upon as the location, and some two months after that the winner of the competition held to choose the exhibition hall's design – which had attracted no fewer than 254 entries from many parts of the world – was announced as the Duke of Devonshire's head gardener, Joseph Paxton.

Paxton's design called for a building some 1,848 feet long, 408 feet broad and 108 feet high – the immensity of its length can be gauged by the fact that the Greenwich Millennium Dome is a mere 1,040 feet in diameter – a shell of glass held by prefabricated iron struts, in which would also be contained some of the ninety foot high elm trees then growing on the Hyde Park site. Inspirationally dubbed by Douglas Jerrold 'the Crystal Palace', the design was modelled upon the great glass conservatory at Chatsworth, which of course Paxton knew well. But the Chatsworth head gardener was a man of many other interests, including botany and engineering, but most particularly Paxton was interested in

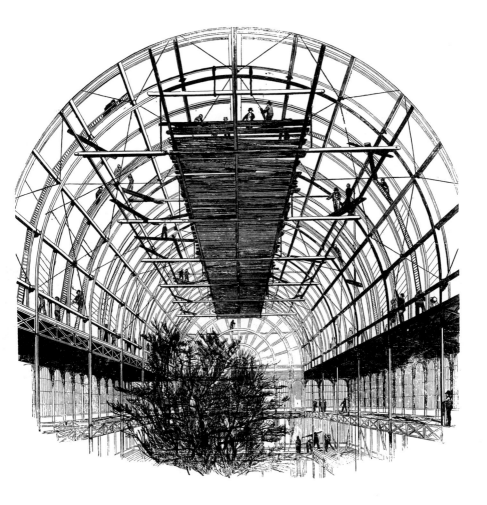

Figure 8 The Crystal Palace, longer than the Millennium Dome and much larger than the 1951 Dome of Discovery, was built more quickly than either.

London Illustrated News

the development of the railways. Indeed the first sketches for the Crystal Palace were doodled on a blotter when he was attending a board meeting of the Midland Railway Co., and the massive dimemsions of his winning design reflected his certainty that the rapidly-expanding rail networks would carry unprecedentedly large crowds to the Exhibition.

Caxton drew up the blueprints for the Crystal Palace in little more than a month, and on the 26th. September 1850, the first of its 3,300 columns was raised on the exhibition site. Within seventeen weeks nearly a million square feet of glass had been fixed to the semi-circular ribs spanning out from the columns by 2,300 girders and sash bars, by means that owed much more to industrial methods than the older notions of industriousness. The parts for the Crystal Palace were all prefabricated, and the workforce, working day and night shifts, was employed on strictly industrial lines, as a progress report on November 20th. in the *Illustrated London News* makes clear:

> Some thousand feet of the joists and framework of the flooring have been fitted, and the glazing of the roofs has proceeded uninterruptedly, though attempts to delay the work have arisen with some of the men. An attempt at an intimidation, for a higher rate of wages, by the glaziers, has been promptly suppressed. The progress in their work was deemed insufficient, and it was determined that they should be paid by piece-work. Urged on by some disaffected individuals, a party of the glaziers struck; but, as men to replace them were readily found, several relented, and asked for re-employment, and were informed that their application would be considered when any additional hands were required.

Thus – by methods of which Bounderby would surely have approved – the construction of the great building was kept tightly to schedule and in January, 1851, the same publication was able to report:

> From the north bank of the Serpentine, the view of the building destined to be the shrine of industry of the present year, is extremely imposing, and the lofty trees add to its character and eminence in a picturesque sense.

A month before the exhibition opened, it was announced that the 13,000 exhibits would, according to a scheme devised by the scientist Lyon Playfair, be divided into four main categories – 'raw materials', 'machinery', 'manufactures' and 'fine art'. The latter category signals a further shift in the labyrinth subdivision of art, for 'fine art' effectively meant high skills applied to industrial products. The words had not yet become fixed in their twentieth century usages, but the Great Exhibition hastened the creation of the two distinct categories of fine art – one, 'design', forward-looking, and the other, 'crafts', concerned with the skills of the past.

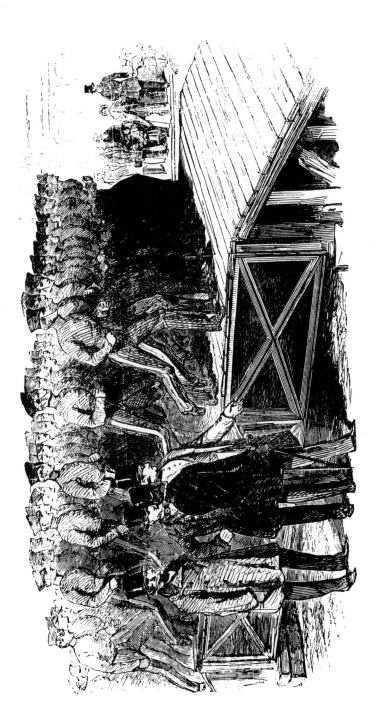

Figure 9 Testing the Flooring of the Crystal Palace

Although there were exhibits from every 'civilised' country, the majority came from the Empire, and of them the largest part came from Britain's manufacturing cities. The organisers gave a number of awards to exhibitors and thus a city like Sheffield could later boast that out of its 300 exhibits – which included such 'machinery' as railway springs, vices, anvils and stove grates, and such examples of the 'fine arts' as newly designed fenders and kettles – it had won 5 carnival medals, 55 prize medals and 50 'honorable mentions'.

There were many alarms before the exhibition was mounted, including the sudden fear that the floor of the Crystal Palace would not withstand the weight of the expected crowds – an anxiety laid to rest on the 18th. February when, in the presence of Queen Victoria, sixty men from the Household Cavalry went without mishap through a forty-minute marching routine upon a suspended 24 ft. section of the flooring. Virtually all the promised exhibits arrived on time, and all public services within the Palace, including cloakrooms, salons and the non-alcoholic drinking bars (operated by Schweppes, who were making their first inroads into the British soft-drink market) were installed and ready for the grand opening.

This took place on schedule, on May 1st. 1851, less than two years since Albert had made his first proposal to the RSA. It is estimated that Hyde Park was filled with more than half a million people when the Queen, her Consort beside her, and making the last part of her journey on foot, entered the Crystal Palace to declare the Exhibition open. She memorably described the opening day in her own diaries, taking no little pleasure in the unusual warmth of the welcome she and Albert had received from the watching crowds:

The Park presented a wonderful spectacle, crowds streaming through it, carriages and troops passing quite like the Coronation Day, and for me the same anxiety, no, much greater anxiety on account of my beloved Albert... The glimpse of the transept through the iron gates, the waving palms, flowers, statues, myriads of people filling the galleries and seats around, with the flourish of trumpets as we entered, gave us a sensation which I can never forget, and I felt much moved. We went for a moment to a little side room, where we left our shawls and where we found Mama and Mary [Duchess of Teck], and outside which were standing the other Princes. In a few seconds we proceeded, Albert leading me, having Vicky [Princess Royal] at his hand and Bertie [Prince of Wales] holding mine. The sight as we came to the middle, where the steps and chair (which I did not sit upon) were placed; with the beautiful crystal fountain in front of it, was magical, so vast, so glorious, so touching. One felt, as so many did whom I have since spoken to, filled with devotion, more so than by any service I have ever heard. The tremendous cheers, the joy expressed in every face, the immensity of the building, the mixture

of palms, flowers, trees, statues, the organ (with six hundred instruments and two hundred voices, which seemed like nothing) and my beloved husband, the author of this peace festival, which united the industry of all nations of the earth – all this was moving indeed, and it was and is a day to live for ever.

Later in the diary Victoria reiterates that the one event that it reminded her of was her Coronation, but 'this day's festival was a thousand times superior'.

The note of triumph, and the unmistakable sense of relief that the opening had passed without incident, are important reminders of some of the other purposes of the Great Exhibition, of which the Queen and her Consort were only too well aware. For the 'peace festival' was about more than the temporary cessation of hostilities in Europe. It was also marking a new domestic peace, and celebrating the fact that the triple dangers of revolution, the overthrow of the monarchy and the establishment of a British republic had all receded.

Only three years previously, it had seemed quite possible that revolutionary fervour in Britain could sweep away both Parliament and Queen. There had been mounting republican agitation in revolutionary broadsheets such as the *Northern Star*, the Edinburgh *New Scotsman* and the Birmingham *Journal*. The 1847 Communist Congress, held in London, had commissioned Marx and Engels to write the Communist Manifesto. To the republican-minded followers of Paine and Godwin, as well as the communists, the 'spectre haunting Europe' involved the overthrow of all European royalty. Kings, Queens and Princes were the essence of tyranny and oppression, and many shared Shelley's hope that 'the free would stamp the impious name of king into the dust.'

Such sentiments had by no means run their course in Victoria's first decades on the throne – veiled attacks on her had even been made in the pages of such staid middle class publications as *Punch* – and there had been at least three public attempts upon her life. Nor was Albert popular in his early years. A poor horseman, given to concerning himself with subjects such as the working conditions of the mill hands, and the parlous state of English education – pronouncing it scandalous that 'out of 4,908,696 children only 2,861,848 had any instruction at all and more than half of these went to school for only two years' – it was scarcely surprising that both middle classes and the aristocracy disliked him, and that the overthrow of the Royal household seemed more than a theoretical possibility.

The events of the French Revolution had both terrified and fascinated the British public who, with two centuries of loyalty to the crown inclining them generally to prefer the *status quo*, were now at least willing

to consider whether a British Republic might not be preferable to the present Royal couple. This duality in the popular mood was reflected, as well as anywhere, within one of London's most popular entertainments, Madame Tussaud's Waxworks, which had permanently established itself in the Portman Rooms in Baker Street in 1835. Like most entertainers in the first half of the century, Madame Tussaud advertised herself as an 'artist', and her show as exhibiting 'works of art'. Like most of her fellows she was anxious to stress the educational nature of her display and, as was also customary, stressed that her exhibition had been seen and highly approved of by all levels of good society. So it was hardly surprising that in the 1840s Tussaud's boasted in its main room a tableau of the 'Coronation of Her Most Gracious Majesty Queen Victoria', with a highly deferential note in the catalogue:

> Her Majesty, to a prepossessing exterior, is understood to add those qualities calculated to endear her to her country, and to place her in that enviable situation in the hearts of a free people which must make her the envy and the admiration of the world.

But, more surprising, in a separate room (not yet known as the 'Chamber of Horrors') could be found reminders, no less romantically inscribed, of some of the French revolutionary leaders – models of the Comte de Lorge, of Robespierre ('...he rendered up his bloodstained soul on the guillotine, at the age of 35') and the severed head of the Princess of Lamballe ('...the murderers carried the bleeding head to Madame Tussaud, the artiste, and obliged her to take a model of it'), together with a model of the Bastille and a working reproduction of the guillotine on which so many aristocrats had perished.

Like all of Europe, Britain was in a turbulent state. Until 1848, agitation had been largely confined to the provinces but in that year the capital seemed suddenly to be threatened. It was mooted that a new chartist petition – reportedly carrying more than six million signatures – would be carried by a great procession from Kennington Common, ending with its presentation at the Houses of Parliament. The chartists claimed they had 400 affiliated societies whose members were ready to swell the procession, fixed for 10th. April. At least half a million people were expected to join it, and it was widely forecast as the date on which the British Revolution would begin. After leaving the special council of war held by the Cabinet on the 9th., the Chancellor of the Duchy of Lancaster wrote sorrowfully to his brother, 'This may be the last time I write to you before the Republic is established!'

Certainly the British authorities took the threat seriously. 170,000 special constables were sworn in to keep the peace, and troops were

billeted in houses lining London's main thoroughfares. Two thousand stands of arms were distributed to members of the General Post Office, and in the city the Royal Exchange, the Bank and Customs House were similarly armed. The Tower guns were primed, and police took over river traffic. In the street, all vehicular traffic was banned, and public buildings sandbagged ready for the insurrection. Meanwhile, the Duke of Wellington assumed military command with 2,600 Household Troops at his additional disposal, and the Queen and Royal Family were quietly smuggled out of London.

In the event it all ended in near-farce. The procession drew only a tenth of the expected numbers – half of them reputedly spectators rather than participants – and its revolutionary zeal began to wane when its leaders fell to arguing over the best way of forming up to walk the proposed route. Their leader, O'Connor, urged that the revolutionaries should disperse and allow him to take the petition to the House in a cab. Disaffection spread amongst the outnumbered marchers, and the protest fell dejectedly apart. For a few hours after that the capital remained watchful, and then, the following morning, the authorities began quietly to dismantle the elaborate defenses they had constructed. April 10th. had not brought civil war. The threat had been overestimated by the authorities – the signatures on the petition in the event numbered fewer than two million, many of them forgeries – but the exaggerated preparations made for it had shown the dangerous chasm of suspicion which had opened up between rich and poor in industrial Britain.

Prince Albert's proposal for a celebration of the 'industry of all nations' had been made only twelve months after these sensational events, and was in part intended to paint over the cracks in the social fabric by uniting all social factions within one great festival of 'peace'. So when the Queen wrote of her joy in the successful opening of her 'beloved husband's' Exhibition, it was only to be expected that a part of her pleasure would be relief that aristocrats, mill owners, and mill workers were on that day united behind the Royal family, and not against them. Nor is it surprising that she should also have been reminded of her Coronation, for the May 1st. opening was staged in a manner which deliberately called that ceremony to mind. For as much as it was to celebrate peace and industry, the Great Exhibition was also intended to persuade the public loyally to reaffirm the old order, with the Queen and her Consort as the crowned heads of the British Empire.

Britain and Russia were the only European countries not to have seen revolution in 1848, and so it is scarcely surprising that an Exhibition which celebrated technical innovation should nevertheless have set itself so firmly against social change. The British social order was ordained by

Providence, which had also, as the Great Exhibition Catalogue made clear, graciously injected the British in particular with rare technical skills. In the words of the flyleaf, written in Latin and helpfully translated into English:

> *Say not the discoveries we make are our own –*
> *The germs of every art are implanted within us,*
> *And God the instructor, out of that which is*
> *concealed,*
> *Develops the faculties of invention.*

Throughout its six month run, there was no attempt made to hide the huge gulf that existed between the social classes in Britain. After the first few days, which were attended by specially invited guests and during which the Queen was a frequent visitor, the Exhibition was either open to the leisured classes, 'the great folks', who paid five shillings for admission, or, on other days, to the working classes who came in much greater numbers but paid only 1/-. Contemporary writers saw nothing strange in the 'working bees of the world's hives' being offered inferior facilities to view an exhibition supposedly glorifying their industriousness. Most took the same reassuring view of British 'industry' and blandly adopted for the purpose the same redefinition of 'art', as did the Dean of Trinity College, Cambridge, the Reverend Dr. Whewell, who in his *Lectures on the Results on the Great Exhibition of 1851* assured his followers that in Britain:

> Art labours ...for the poor... the man who is powerful in the weapons of peace, capital and machinery, uses them to give comfort and enjoyment to the public whose servant he is, and thus becomes rich while he enriches others with his goods.

One of the supposed benefits of the Exhibition was that it would surely teach these great economic truths to the workers. Thus Dr Whewell gloried in the hordes of artisans and factory workers who thronged the capital:

> ...millions upon millions, streaming to [the Exhibition] gazing their fill, day after day, at this wonderful vision...comparing, judging, scrutinising the treasures produced by the all-bounteous earth, and the indomitable efforts of man, from pole to pole.

But the commoner reaction was that the working bees who three years previously had threatened to form the revolutionary mob, seemed to have been turned by the Exhibition into well-behaved and loyal subjects of the Crown.

Excursion trains from every major town and city in Britain brought the bees in to London. Some stayed overnight at cheap hotels such as Mr Thomas Harrison's newly furbished Mechanic's Home in Ranelagh

Road, Pimlico, which accommodated 1,000 working men, and which was conveniently close to Mr Cubitt's Pier from which 'twopenny steamboats' left for London Bridge every two minutes. On such 'ordinary' days there would often be as many as 70,000 visitors in Hyde Park, and though attendances were lower on five-shilling days, overall the Exhibition was a commercial success. By the time it closed on October 11th. it had attracted more than 6,000,000 people, its unfrivolous nature underlined by the fact that Schweppes, who had paid £5,500 for the franchise, sold 1,092,337 bottles of decidedly non-alcoholic drinks, while the refreshment salons sold visitors a weighty total of 1,804,718 best British buns. St. Paul's and Westminster, closed to worshippers for several generations, temporarily opened their doors for public services of thanksgiving for the spiritual succour the Exhibition had brought,

Yet in the arts world some viewed this with less than total enthusiasm. Ruskin sneeringly dismissed the Crystal Palace as being 'neither a palace nor of crystal' but merely a glass envelope built 'to exhibit the paltry arts of our fashionable luxury'. The novelist Charles Kingsley remarked that extolling the virtues of scientific advance could not long conceal the fundamental aetheism of Victorian culture. 'We have,' said the critic Owen Jones in his *Lectures on the Great Exhibition.* 'no principles, no unity; the architect, the upholsterer, the paper-stainer, the weaver, the calico-printer, and the potter run each their independent course; each struggles fruitlessly, each produces in art novelty without beauty, or beauty without intelligence.'

The established arts were moreover financially harmed by the Exhibition. As the *Illustrated London News* pointed out in July:

> ...the Great Exhibition has its unpopular as well as its popular side. City merchants and their correspondents say that it has killed business for the season, and they grumble accordingly. The caterers for public amusements are still louder in their complaints. The theatres do not fill; panoramas are losing speculations, and people are so busy with the one Great Exhibition, that they cannot encourage any minor ones, or find time for them if they would.

The Exhibition soaked up both public support and spare capital, both of which might otherwise have gone to the regular 'public amusements'. Planning had taken no account of the likely impact on the theatres, concert rooms, panoramas and other public exhibitions of central London and nearly all had a bad season. One exception was Charles Morton who in that year set up the first large–scale London music hall in an annexe of the Canterbury pub in South London, and who attracted big houses to an entertainment at which (unlike the Exhibition) beer was served.

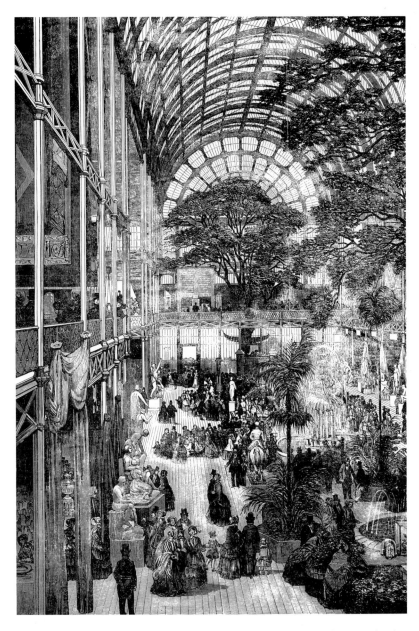

Figure 10 The Great Exhibition could only be viewed in comfort on 'the day of the Great Folks' when admission was five shillings.

London Illustrated News

The Great Exhibition over, the long task of dismantling the Crystal Palace and reassembling it at Sydenham began, and it was possible to calculate the outcome of what, in spite of criticism in some cultural salons, had nevertheless been a remarkable social and financial success. When all subscribers had been repaid there was a surplus of just over £200,000. The organisers had little doubt that the Exhibition had also succeeded in its wider purposes:

> ...to give a true test and a living picture of the point of development at which the whole of mankind had arrived, and a new starting point from which all nations should be able to direct their further exertions.

Although it had been Prince Albert's hope that the eventual surplus would be sufficient to set up Victoria and Albert Museums in all of Britain's leading industrial cities, the modest profits allowed only the purchase of the South Kensington Estate, on which London's Victoria and Albert Museum now stands, and where in 1857, as the South Kensington Museum, it opened its doors.

Not for the first or the last time, there was resentment at the privileges enjoyed by Londoners, exacerbated in this instance by the fact that the capital had benefited both from staging the Exhibition and from its profits. Some provincial industrialists, who had helped to finance the Great Exhibition and whose workers had poured into the capital to see it, were now spurred into retaliation, replicating aspects of Albert's exhibition in their own cities. Having seen the facilities of Hyde Park, a few bought parkland estates in their own cities and opened them as pleasure parks. One such was Adderley Park in Birmingham, purchased and opened to the public in 1856. A second was the Arboretum in Nottingham, purchased in 1851, 18 acres of parkland including a miniature lake, bandstand, treelined walks and which was opened to the public the following year. Admission to the Arboretum cost 6d. (Children under 14, 3d.) and included entry to the glasshouses and refreshment rooms which were built 'in the style of the Crystal Palace'. A third was Glasgow's Kelvingrove Park, 66 acres acquired in 1852 for £77,945 by a consortium of local businessmen. In 1888, Kelvingrove housed the first Glasgow International Exhibition – which in its turn raised the funds for an art gallery and museum 'worthy of the city', which was eventually built within the park.

It was however in the capital of the 'cotton empire' that the most decisive action was taken. Manchester was not prepared to be bested by London, not least because it had already staged its own, rather less well noticed, *Exhibition of Industrial Products* in 1845. So, in 1852, one of the largest cotton businesses in Lancashire, Entwistles of Rusholme, set out to create

Manchester's own exhibition. As with London, the initiative came from the private sector, not from the authorities. Throughout the enterprise, Manchester Corporation played no financial part, the necessary capital again being raised by private subscriptions, 32 Manchester businessmen giving £1,000 each, and 80 others giving £500. A site was chosen in Old Trafford park, close by the railway station so that visitors could go straight in. The exhibition was to be housed in a building 656 feet long and 200 feet wide, with walls of corrugated iron and a semi-circular glazed roof – reminiscent of the Crystal Palace – spanning 104 feet. It opened on 5th. May and closed on 17th. October 1857, and during that time attracted some 1,338,715 visitors, more than 3,000 a day. It housed 12,000 exhibits, only 1,000 fewer than the Crystal Palace.

However, it is the dissimilarities with the London exhibition that make the Manchester enterprise remarkable. The Great Exhibition's prime role had been to celebrate 'industry', both in its worthy, older sense and in its newer sense of 'mass production'. Its major progeny, the Victoria and Albert Museum, was likewise conceived in support of manufacturing industry. As Herbert Read pointed out in 1932, in his seminal *Art and Industry*:

> Those splendid institutions in Trafalgar Square and South Kensington, now treasure-houses which attract pilgrims of beauty from every corner in the world, were first conceived as aids to the manufacturer in his struggle with foreign competitors. The National Gallery and The Victoria and Albert Museum in London, prototypes of similar institutions all over the world, were not founded as Temples of Beauty but as cheap and accessible schools of design.

Many of the indirect consequences of the Exhibition, such as the creation of the first seventeen Schools of Art with a £6,850 grant from the Committee of Council on Education, also in 1857, were thus subordinate to the supposedly unignorable demands of the new industry. The 'fine arts' taught in them were conceived of as skills having a direct application to industrial processes.

By contrast, Manchester's exhibition took account of the criticism which Ruskin and other artists had made of the phillistinism of the Great Exhibition, and was conceived from the first as a 'Temple of Beauty' – a celebration of art in its older Augustan sense. The full title of the Old Trafford display was the *Manchester Great Exhibition of Art Treasures*. The exhibition hall contained pictures and sculptures borrowed from private collections, such as the Entwistle family's, and the concurrent programme of critical discussions, lectures, readings and concerts was dedicated almost exclusively to art.

Although the progeny of Manchester's exhibition was different in nature, it was no less remarkable than the creation of the Victoria and Albert Museum in London. For Manchester's 1857 exhibition helped to remould the Hallé orchestra in its present form. Until that time Charles Hallé's had been a small group, working on a shoestring, but in the Spring of 1857, the Manchester exhibition organisers made a grant of £4,516 to enlarge the orchestra so that it could provide a series of high class daily concerts for visitors in the Old Trafford exhibition hall. These proved popular, and Hallé retained his enlarged orchestra for the following season of Winter Concerts at Manchester's Free Trade Hall. By 1865 the full Hallé orchestra was firmly established and making annual profits of around £2,000.

Provision for the People

I am told that instead of spending my hard-earned
money in visiting places of amusement, I ought to
imitate my shopmate Jones, who will go home after a
hard day's work and employ himself in cultivating his
garden, or making or repairing some article of
household furniture; or to take example by Brown,
who devotes his evenings to serious study, and the
acquisition of some art or science. But from doing as
Jones does I may readily be excused, as I am a single
man, and being 'only a lodger', I have neither garden
or household furniture, or indeed anything else in the
'domestic economy' line to exercise my industry or
mechanical ingenuity upon; and as to imitating
Brown, I may as well at once confess that that I have
in my composition none of that determined
perseverance and untiring patience that produces
'self-made' and 'self-taught' men...

Thomas Wright, *Some Habits and Customs of the Working
Classes* 1867

In the second half of the nineteenth century, Britain became
unprecedentedly wealthy. Its trade grew from £67,000,000 in 1800 to
£615,000,000 by the century's end, in part because of the new
commercial opportunities offered within its rapidly expanding Empire. In
1800 the Empire had contained a total of only 19,000,000 people, of
which six out of every seven were British, but a century later its
population had risen to 296,000,000, the British now accounting for
fewer than one in seven of its citizens.

The 40,000,000 inhabitants of Britain were unequally distributed, England being far more heavily populated than Wales, Scotland or Ireland. The majority of the population lived now in urban areas, or, as the industrial cities and the great ports developed their own systems of cheap public transport, in the dormitory communities which fringed them, the new 'suburbia'. Britain's eight largest cities contained more than a quarter of the total population. By 1900, the population of London – including the 118 square miles of Greater London – had risen to 6,500,000. Glasgow had 782,000 inhabitants, Liverpool 645,000, Manchester 645,000 and Birmingham 522,000. Then came Sheffield with 381,000, Belfast with 348,000 and Bristol with 339,000.

Internal reasons for the increase in trading were many and varied. Swelling urban populations led to an unprecedented growth in house building. Charles Greville in 1845 observed of Birkenhead, 'Not many years ago the land was an unprofitable marsh...[now] they are building in every direction.' The building was not confined to the industrial towns. Buxton's population grew from 1,569 in 1841 to 3,717 by 1871, while in the same period Harrogate rose from 4,785 to 6,843. London in the 1850s and 60s was a mass of builder's scaffolding, although there were many still alive who could remember walking into the green fields beyond the Haymarket, or who could remember the rustic pursuits of old London. The artist Benjamin Haydon recalled being told that within living memory a fox had been killed in Cavendish Square, and that 'where Berkeley Square now stands was an excellent place for Snipe'. Overall urban land values in the UK rose from £3,000,000 in 1845 to £15,500,000 twenty years later, then to more than £31,000,000 by 1885.

The new railways played a crucial part, both in the development of trade – the mine owners and factory bosses were quick to see the advantages of being served by rail – and in pushing up land values, as the new railway companies paid handsomely for the privilege of laying their tracks over farmland. Many landowners who had invested in mining on their lands thus benefited twice over from the railways. As J.E. Denison, the squire of Ossington, wrote to William Huskisson in 1830:

> I have just been in Durham travelling on one railroad, and inspecting the progress of another which passes through Coal property of mine there – I have been astonished at the fruits which spring from planting these iron rails on the ground – Liverpool is not a greater lesson of the results of free Trade than the Darlington railroad is, of the effects of free and cheap communication.

The growth of the railways in the UK during the second half of the

nineteenth century was certainly remarkable:

	Miles of track in use	Passenger carried (Millions)
1850	6,084	67.4
1860	9,069	153.5
1870	13,562	322.2
1880	15,563	596.6
1890	17,281	796.3
1900	18,680	1,114.6

In all this it is the growth in rail passengers which is most impressive. From the 1840s, when the chairman of the Brighton Railway Company, Sir Rowland Hill, was organising the first train excursions, to the end of the century, when the number of passengers carried by rail first exceeded a billion, the total length of railway tracks in the UK tripled, but the number of passengers travelling on them multiplied by more than sixteen.

Many Britishers left the Mother Country to live and work in the far-flung corners of the Empire. Between the year of the Great Exhibition and the end of the century, 12,680,000 people emigrated, while in the same period Britain accepted only half that number, 5,987,000, as immigrants. This unprecedented international traffic did not however, result in the creation of multi-cultural societies. Like other colonialists before them, the British imposed their own notions of civilisation upon their subjects, promoting the British language, British religion, British law, British education and British manners – as well as promulgating particular British notions of industry and art.

The development of the factory system and the growth in trade had made Britain 'the workshop of the world' and swelled the British middle class. By the middle of the century the annual income of the middle classes was between £150 and £400 a year, while the lower middle class average was £90. But British trade and British factories depended still upon a vast underclass of poorly-paid manual workers for their successful operation. Yet this vast working class was neither out of sight nor out of mind. Their living conditions were now chronicled, not just by the great industrial novelists, but by social commentaries which found a swelling readership through the growing numbers of newspapers and magazines. Among them were Lord Shaftesbury's reports of the dreadful working conditions in mines, factories and sweatshops, Engels' descriptions of the Manchester poor, Sir James Kay-Shuttleworth's countrywide investigations into British schools. There were others such as Dr. William Gilbert, the father of the famous librettist, whose *Dives and Lazarus*

(1858), subtitled 'The adventures of a medical man in a low neighbourhood', vividly described the disease and squalor he found in Victorian London. Whereas it had been quite possible for Jane Austen to be unaware of the barbarities which surrounded her, social injustice and deprivation were harder to ignore in the second half of the century. By 1860, 20% of the population were regular readers of magazines, and the annual numbers of published titles rose steadily, from 2,600 in the 1850s to more than 6,000 by 1900.

Although Richard Cobden could as late as 1850 still remark irritably of Heyshott – a village of 400 inhabitants only 50 miles from London – that:

> ...the only newspapers which enter the parish are two copies of Bell's Weekly Messenger, a sound old Tory protectionist much valued by drowsy farmers.

Such pockets of innocence, even in the countryside, were becoming harder to find. The number of newspapers and magazines published in Britain grew steadily, and showed an accelerated increase towards the last decades of the century:

	No. of Newspapers	No. of Magazines
1850	1,165	213
1870	1,390	626
1880	1,986	1,097
1890	2,234	1,778
1900	2,488	2,446

Newspapers would reach their highest sales in the twentieth century but at the end of Victoria's reign, magazine publication had already reached its zenith.

There were thus few households unaware of Britain's great industrial growth or ignorant of the social questions which industrialisation raised. Contemporary publications endlessly considered the social consequences of what, after the 1880s, began to be called 'the Industrial Revolution'. Some, such as Andrew Ure in *The Philosophy of Manufactures* (1835), believed that the new industrial system would rid the workplace of the harmful effects of the subdivision of labour 'so fruitful of jealousies and strikes among the workmen', for the simple reason that operating a factory machine required none of the old skills of the artisan:

> In the uniformity of human nature it happens that the more skilful the workman, the more self-willed and intractible he is apt to become, and, of course, the less fit a

component or a mechanical system, in which, by occasional irregularities, he may do great damage to the whole. The grand object, therefore, of the modern manufacture is through the union of capital and science, to reduce the task of his work people to the exercise of vigilance and dexterity – faculties, when concentrated to one process, speedily brought to perfection in the young.

Later and more radical voices, like Marx and Engels, saw class warfare and revolution as inevitable. Others, such as Herbert Spenser in *Social Statics* (1951) defended competitive industrialism, denied the need for any form of state intervention, and like Ure suggested that the system of *laissez faire* created the best possible conditions for all classes of person.

For others the 'best possible' had to be something more than the simple acceptance of the Victorian mines and mills as they were, and the attempt was made to blend older notions of 'industriousness' with the economic stringencies of the new industrial system. This is the concern of the best-known of the Victorian social philosophers, Samuel Smiles. His interests are clearly set out in the titles of his best-known books, *The Lives of the Engineers* (1862), *Character* (1871), *Thrift* (1875), *Duty* (1887), and most memorably of all in his first and best-known work *Self-Help*. This latter was a runaway success, not only in Britain but throughout the whole of the English-speaking world. A year after its 1859 publication, it had sold 20,000 copies, by 1889, 150,000, and by 1905 more than a quarter of a million.

Smiles' writing laid emphasis not upon the need for political solidarity amongst the working class, but upon the rewards which would surely follow from the individual self-help of each of its members:

> As steady application to work is the healthiest training for every individual so it is the best discipline of a state. Honourable industry travels the same road with duty; and Providence has closely linked both with happiness.

In Smiles' sense, 'industry' involved not only applying oneself assiduously to one's work – even though work may be done in the harshest of factory conditions – but also the earnest pursuit of self-improvement. Smiles shared Dickens' disgust with the self-centered captains of industry. Like the novelist, he was at pains to stress that they should nurture their wider social obligations to other classes, but differed from Dickens by asserting that factory bosses must not be allowed to salve their consciences by 'giving money, blankets, coals and such like to the poor'. In Smiles' view, charitable donations by the rich offered no long-term solution to society's ills. The doctrine of self-help was greatly to be preferred; over time, it was bound to make the working class 'as enlightened, polite and independent as the other classes of society':

> Whatever is done *for* men and classes to a certain extent takes away the stimulus and necessity of doing for themselves...no laws, however astringent, can make the idle industrious, the thirftless provident, or the drunken sober.

'Doing for oneself' involved the careful and constructive use of each person's spare time, the pursuit of self-education and perhaps the personal acquisition of a science or one of the 'useful' arts:

> The grand object aimed at should be to make the great mass of the people virtuous, intelligent, well-informed, and well-educated; and to open up to them new sources of pleasure and happiness. Knowledge is of itself one of the highest enjoyments.

Smiles wished his doctrine of self-help to be applied to 'the great mass of the people', and so projected an ideal society which was fortuitously composed of individuals educating themselves to work in harmony with its Providentially-given laws, social classes and economic systems. It is assumed that God not only approves of the industrial system, but demands that its workers should work hard and thankfully within it. Smiles was thus open to the charge which Charles Kingsley had laid against himself, and other preachers to the poor:

> We have used the Bible as if it were a mere special constable's handbook – an opium-dose for keeping beasts of burden patient while they are being loaded – a mere book to keep the poor in order...We have told you that the Bible preached the rights of property and the duties of labour, when (God knows!) for once that it does that, it preaches ten times over the *duties of property* and the *rights of labour*.

Smiles does not attempt to resolve the conflict between the pursuit of personal freedom and the need to maintain industrial discipline and public order. On the one hand, he asserts that there was 'no such thing' as the state, but, not on the other hand, also contends that Victorian industrial society, with its massed ranks of workers ranged in uneasy confrontation with owners and managers, was a necessary scaffolding to support civilised life, and its structure should not be questioned.

After the scares of 1848, it was understandable that writers such as Smiles should stress the fixed and unchanging nature of Victorian society. The threat of revolution had been lifted. The Great Exhibition, by equating industrial innovation with progress, and civilisation with industrial development, had, as Prince Albert had hoped, celebrated the dawn of an industrial millennium. And although this materialism led some of the later Victorians to repudiate the Great Exhibition and all that it stood for (seeing it, in Frederic Harrison's words as an 'appalling vulgarity'), for others it was to remain a high point of Victorian achievement, when the industriousness of the artisan merged seamlessly

with the machinations of the new industrial system.

What could not be doubted was that it had also reshaped the popular understanding of art and the purposes of art. As eighteenth century notions of pure art had overshadowed the older notion of art as skill, so the Great Exhibition signalled the predominance of a new conception of art. For the artist was now expected to have a utilitarian function; art was a *utility*. Not just for Smiles, but also for a number of his contemporaries, none of 'the arts' was now important unless it was in some obvious way 'improving' or 'useful' – not as a function of industriousness, but as a handmaiden to production industry and industrial work. When Palmerston was being asked to support the purchase of the Italian Majolica for the new museum in South Kensington, he is reported to have put the classical utilitarian question, 'What is the use of such rubbish to our manufacturers?'

Usefulness in art could of course, take many forms. The arts could be a wholesome and improving recreation for the labourer, could give the housewife a useful social accomplishment, but were at their utilitarian best when they served the needs of production industry. It was this notion of art as utility which informed both the new Industrial Schools and the Schools of Design, and which led to John Ruskin's famous outburst in the 1870s:

> The tap root of all this mischief is to produce some ability in the student to make money by designing for manufacture. No student who makes this his primary object will be able to design at all, and the very words 'School of Design' involve the profoundest of art fallacies.

The same feelings ignited William Morris's rebellion against the compromises of industrialisation, and led to his insistence that the artist should return to the study of nature and the demands of natural materials, rather than the needs of mass production industry. As Morris reflected in his *Textiles, Arts and Craft Essays* (1893):

> Never forget the material you are working with, and try always to use it for doing what it can do best; if you feel yourself hampered by the material in which you are working, instead of being helped by it, you have so far not learned your businesss, any more than a poet has, who complains of the hardship of working in measure and rhyme.

In their different ways Ruskin and Morris thus harked back to the earlier notion of the artist, as 'unacknowledged legislator of mankind', drawing inspiration from nature. But in reasserting this they stood apart from the mechanistic temper of their time. As the first editorial of *Engineering* bluntly said in 1866:

> No man ever stands as close to Nature as the engineer, none other dare, or can bid her to do this or that, as the engineer may do and does daily...our profession is working out a grand plan for civilisation.

Or, to quote Dr. Whewell, the learned apologist for the Great Exhibition, one last time:

> ...man's power of making may show itself not only in the beautiful *texture* of language, the grand *machinery* of the epic, the sublime display of poetic *imagery*, but in these material works.

Thus the highest creation of painter and poet was for a time held to be equal with, or somewhat inferior to, the 'material works' of the new engineer/artist. Strange mechanical inventions filled the catalogues of the 1860s and 1870s. To take just one example of these 'material works', one advertised creation was a bed unit with twin wardrobes, which illustrated 'man's power of making' in a rather curious way. Having a cork-filled base, the bed unit would prove buoyant should the sleeper during the night be unexpectedly swept out to sea – one wardrobe then becoming a 'self-acting washing stand' and the other a useful 'patent portable water closet'...

Thus, in slightly demented form, the earthbound spirit of Bounderby lived on. 'Fanciful people' were used in the way I.K. Brunel used them to embellish Paddington Station after it was completed, or in the way Sir Joseph Bazalgete used them to decorate the plinths of the Crossness pumping station in Abbey Wood after the building of his grand metropolitan sewerage system. The pure artist was relegated to being a servant of industrial society, not a partner in it, a decorator of the new industrial crafts.

With this new definition in mind, it was natural for the rulers of the Empire to export the British concept of 'useful' art alongside their industrial systems, and to feel no qualms about picturing their Empire as a vast social continuum which ranged from the ignoble savagery of its primitive peoples to the practical 'civilisation' and the useful arts of its industrial core. Thus contemporary writers found little to question in the layout of the *Fine Arts, Industrial and Maritime Exhibition* held in Cardiff in 1896, when it ranged its exhibits on a scale from 'primitive' – an 'African Jungle' which had lions, monkeys, crocodiles and Zulu families 'living naturally' in it – to the 'advanced', functioning replicas of industrial sites, including a fully operational Welsh coal mine, and a working gold mine 'in South Africa'.

The Victorians now excluded more than they included when they used the word 'art' and in particular made an ever-sharper distinction between

the newly-sanctified useful arts and what were perceived of as 'timewasting' traditional pastimes and 'old-fashioned' entertainments. In 1870 The *Tonic Sol-fa Reporter* encapsulated the new exclusivity perfectly. When urging the adoption of its music teaching system by every dilligent British family, it claimed that not the least of the system's useful virtues was that it would now keep people 'from the dangers of the theatre, the snares of the dancing saloons, and the dissipation of the drinking shops' – three of the traditional pleasures of the British people.

Indeed, the 1870s and 1880s saw increased legislation, nationally and locally, against popular and 'non-useful' amusements, the authorities acting to ensure that what people read, saw and heard should be useful and 'uplifting'. To take an important instance, the *Fairs Act 1871* gave the Home Secretary new powers to abolish traditional fairs. Sometimes this was in accordance with the wishes of the local authorities who, knowing that the commercial and hiring functions of the old fairs had largely disappeared, thought them a potential nuisance and requested that they be discontinued. Such petitions would usually show the authorities' continuing 'fear of the mob', as in this 1875 request from Sawbridgeworth in Hertfordshire:

...Even the last lingering shadow of pretence for these Fairs – the sale of Stock – is rapidly passing away; for, in the opinion of competent judges, the supply of stock is yearly becoming more limited in extent and inferior in quality...

But while these Fairs are of the smallest possible conceivable worth in a commercial point of view, indefensibly and indisputedly they are the prolific seed plots and occasions of the most hideous forms of moral and social evil – drunkenness – whoredom – robbery – idleness and neglect of work...

Sometimes the locals obstinately preferred to keep their fairs. Nevertheless, under the 1871 Act, the Home Secretary could still take action, should he decide that such gatherings were 'injurious to the inhabitants of the towns where the fairs are held'. As a result some, like those held in the woollen towns of Ilkley and Otley, were closed down in spite of the protests of their citizens. For the travelling showmen, the situation further worsened when in 1874 the long-held freedom to sell intoxicating liquor on fair days was removed from them, and instead they had to apply for occasional licenses in each town they visited. In the early 1880s, George Smith M.P. even proposed that in addition to enrolling their children in the local school, showmen should be compelled to register their travelling vans with each local authority they worked in, and open them to regular government inspection – but that proposal at least was not adopted.

Many local authorities in any case needed no urging to persecute the showmen. Imbued with the new civic conscience, they felt it their duty to 'improve the tastes' of their communities by providing only 'healthy amusement...such as would educate them and lift them up.' Certainly that was the stated objective of one of the speakers in a debate in the Birmingham Council Chamber in July 1875 when the Corporation discussed banning all fairs from Corporation streets and land. Some speakers in the debate were certain that such public amusements were only indulged in by a minority. One said that at fair times:

> A large amount of wages was ...lost to many industrious men who would pursue their calling but who were locked out in consequence of some drunken few...having chosen to idle away the time and stop the machinery.

Yet, largely as a result of Chamberlain's vigorous defense of 'the amusements of the people' late in the debate, the Birmingham fairs on this occasion were saved. So was the Nottingham Goose Fair which in 1879 survived an investigation by the Nottingham Town and Country Social Guild which had declared that the fair promoted 'immorality, venereal disease and intemperance'. Yet in other cities and towns the tide could still run against the popular amusements. In Manchester the Knot Mill Fair, Acres Fair and the Whit Monday Fair were all banned in 1876.

The pressure upon showmen to present their entertainments as 'improving' or 'uplifting' became ever greater, and bills mixed the language of the fairground barker with that of the pulpit. An illustration of this internal tension can be found in the history of the magic lantern show, which briefly flourished as a popular entertainment in the middle and later years of the century. W.H. Goldring, in a piece written for *The Official Magic Latern Journal* in January 1891, recalls that one of the delights of watching magic lantern shows in his childhood was the moving slide which showed a man apparently eating dead rats. He describes the scene in the village school at Wixhall in Shropshire:

> All the blankets and the bedquilts in the neighbourhood were used in darkening the innumerable windows in the schoolroom, which was a very large one, capable of holding some hundreds. The falling snow, Babes in the Wood, all these things paled before the final climax – the man swallowing rats. With the other boys I started counting...

But such simple pleasures became unnacceptable in the new climate. In 1895, C. Goodwin Norton, supposedly the national advocate of the traditional delights of the magic lantern, wrote censoriously in *The Lantern and How To Use It*:

Such slides as a man eating rats are now out of date, and are accountable in great measure for much of the unpopularity of the lantern with persons possessing the slightest artistic taste.

Questions of the fitness of moving pictures for persons of 'artistic taste' were, of course, to take a quite different form in the following year, when the debate on edible rats was abruptly terminated by the arrival of moving film.

Local reformers continued to make strenuous efforts to replace traditional pleasures with more rational pastimes. In Cornwall one Thomas Trevaskis, the 'Temperance Father of the West', declared that the oldest of the Cornish festivals, the Padstow Hobby-Horse, was a scene of 'riot, debauchery and general licentiousness'. He asked the locals to consider whether they would now give up their irrational pastime? If so, he would entertain them at his personal expense, and in a much healthier manner:

> It is for you to consult against that time, whether you will give your vain practices of Hobby for the more rational amusement of eating roast beef.

In another part of the country, the old coaching town of Newark enjoyed the reputation of having an unusually large number of public houses and being a brewing town in its own right – by 1881 its 14,018 inhabitants included no fewer than 115 brewers – facts which troubled the 370 members of the town's three lodges of the teetotal 'International Order of Good Templars'. The Templars were delighted when Viscountess Ossington decided to try to lure the citizens away from the ale houses by establishing a temperance hotel within the town, and the Ossington Coffee Palace, containing assembly rooms, public coffee room, dormitories for travellers, a billiard room and a library duly opened on 16th. November 1882. It did well enough, but did not harm the town's inn trade one jot.

Such efforts were pinpricks in comparison with the national efforts of civic reformers to bring about wholesale reform of the public houses, a movement which in the long term had serious implications for artists and their audiences. Early legislation in the form of the *Police Act 1839* and the *Acts* of 1854 and 1864 established closing hours, first for Sundays and then for weekdays. Those limitations at first had little effect upon the singing halls which thrived in public houses in the industrial North. (Manchester in particular had a large number – one street in Ancoats had six of them – and some, such as the Trafford Arms near Victoria Bridge, charging only 2d. for admission, catered for as many as three or four hundred people a night). Nor did the early legislation have much effect

upon the growing number of 'music halls' now operating in London and the Northern industrial towns.

PUB PROVISION
Ratio of public houses to population in major English cities, in 1896

	Pubs		People
MANCHESTER	1	to	168
SHEFFIELD	1	to	176
BIRMINGHAM	1	to	1,215
LIVERPOOL	1	to	1,279
LEEDS	1	to	1,345
LONDON	1	to	1,395

However, the *Wine and Beerhouse Act 1869* was a different matter. The smaller singing halls, the music halls and the popular dance halls had flourished by making use of the traditional rights of beerhouses to have music played and sung on their premises, and had established themselves in the beerhouses' cellars and side rooms. Some provincial cities had already taken action to bring them to heel – the *Leeds Improvement Act 1866* had, for instance, already established that the dancing, singing and music halls in that city would henceforth operate under annual licence – and London's places of entertainment were now brought under similar control. All London publicans had to apply for a separate licence before there could legally be any form of singing or dancing on their premises. A decade later, after the passing of *The Public Entertainments Act 1875*, and the *Metropolis Management and Building Act 1878*, London premises of all kinds were additionally forbidden from staging public performances until they had been inspected and issued with a public theatre licence.

Some provincial cities moved to adopt the same kind of licensing powers, but for a period it was unclear whether the provisions of the 1878 Act could be said to cover theatres and halls outside London, an uncertainty resolved by a tragic series of events in the South West. Until the early 1880s, Exeter's Theatre Royal had been one of the most successful on the circuits, but during the night of February 7th. 1885, the theatre suffered a catastrophic fire and was burned to the ground. A subscription fund was at once set up by a rapidly-formed Theatre Company for the purpose of raising capital for a new theatre, and soon attracted more than 1,000 subscribers at £10 each. Land was purchased for £3,000 at the junction of North Road and Longbrook Street, and the new building erected at a total cost of some £6,500. It opened in 1887

with Pinero's *The Magistrate*. The layout of the steeply-raked interior of the new theatre was highly praised, not least because the gallery was now tucked away at the rear of the upper circle, dispensing with the old nuisance of the 'gods' dropping their rubbish on those beneath them in the pit.

However, a few weeks after the theatre's opening, when a nearly-full house was settling down to watch George R. Sim's *Romany Rye,* spectators were startled by a loud explosion from backstage, followed a few moments later by fierce flames and billowing smoke from behind one of the scenery drops. Gas flares had set fire to one of the coloured gauzes. In panic, the terrified audience fled for the exits, but unfortunately the crush at the one door leading out from the back of the gallery was too great, and the upward-spreading flames, devouring the untreated wood with which the auditorium was lined, took a terrible toll of those trying to scramble to safety. In the morning, when rescuers could finally get into the building, it was found that 186 people, largely from the gallery and thus from the poorer areas of the town, had been burned to death.

A relief fund was immediately opened and soon totalled more than £20,000, including subscriptions of £100 from both Henry Irving and Queen Victoria. The inquest, which lasted eight days, decided that the architect had been irresponsible in his designs and recommended that henceforth the stringent regulations of the 1878 Act should apply not just to London but to every theatre in the country. At the same time, some chose to see the fire as a fitting judgement upon those who eschewed self improvement and attended low entertainments. Their view was chillingly put by the Reverend J. Tremelling, pastor of the Zion Bible Christian Chapel in Torre, whose sermon was reported on the Sunday following the fire:

> The painful calamity...would not have occurred had not something been wrong in the management, or morals, or both. To allow two or three thousand people to place their lives in the hands of a few vain, drunken, ignorant, thoughtless stage players was a mistake. It was the morality of the question and the theatre-going tendency that lay at the bottom of the mischief, for if the morality which governed the numerous spectators was of a higher order the probability was that they would have been alive today.

There could hardly be a better illustration of the righteous wrath still heaped upon the 'theatre-going tendency' three hundred years after the Puritans began their campaign to close the Elizabethan theatres.

The drama, though freer of legal restraint, was still considered to be subversive of industriousness, and as a result in the latter part of the

century, it was also bereft of Royal patronage. The authorities reserved their approval for popular support for the 'improving' arts, and particularly those which the Queen – an accomplished amateur musician and water colourist – was known to practise. Most particularly, the Victorians took pride in the growth of popular interest in serious music. As Francis Hueffer wrote in 1887:

> It is no exaggeration to say that with the exception perhaps of natural science...there is no branch of human knowledge, or of human art, in which the change that the half-century of the Queen's reign has wrought is as great as it is in love of music.

Decorous music-making was again a feature of middle and lower-middle class homes, some of them equipped not only with the new upright pianos (which could now be bought for between nine and twenty five guineas), but with organs. Sales of sheet music soared. Between 1877 and the turn of the century, an amazing 500,000 copies were sold of the sheet music of one of the most famous of all Victorian pieces, *The Lost Chord*.

In 1871 the Albert Hall was opened by the Queen. Attendance at its Penny Subscription Concerts, priced cheaply 'to enable all classes to enjoy music' immediately confounded all expectation. More than 2,000 people regularly crowded the galleries and many had to be turned away. Promenade concerts – an idea imported from Paris in the 1830s – were hugely popular at the Drury Lane theatre in the early 1840s under Louis Jullien, and at Covent Garden in the 1870s, before being successfully resurrected in the 1890s by Charles Wood. Choral singing returned to favour: a festival in York Minster in 1861 featured a choir of 2,700 'trained singers', and choral days for young people at the resited Crystal Palace would be attended by as many as 3,800 young people. The oratorio became a particular favourite with the Victorians who believed, in the words of *Groves Dictionary* in 1889, 'The Oratorio is to the Musician the exact analogy of what the Cathedral is to the Architect.' In the new civic halls huge composite choirs were marshalled to sing such sacred works as Mendelssohn's *Elijah*, Sterndale-Bennett's *The Women of Samaria* or Charles Villiers Stanford's *The Three Holy Children*. Most popular of all was Handel's *Messiah*, whose impact on Gladstone's daughter Mary may be judged from the entry in her diary for 17 March 1872:

> To the *Messiah*. No words can possibly describe its effect upon me...It is all-absorbing, takes entire possession of your whole being – it is divine...

She was not alone in her admiration of the composer. More than a quarter

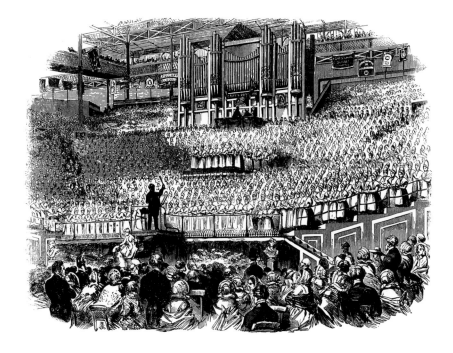

Figure 11 The 'Massed Choirs at Sydenham', in the shell of the old Crystal Palace, offer one rebuttal to Lord Keynes' assertion that until the Second World War neither music nor drama had any popular following, and that Britain had no worthwhile public buildings in which they could be enjoyed.

London Illustrated News

of a million people attended the Handel Festivals at the Crystal Palace in each of the years 1857, 1859, 1862 and 1865.

The Victorians also looked with pride on the growth of interest in the visual and decorative arts. Henry Cole, a seminal figure of his age, was able to say proudly on his retirement from public life in 1873 that since its opening in 1857, the South Kensington Museum had seen 'more than twelve millions of visitors'. He also took pride in the fact that before his death, the 'Shilling Paint Box', created and marketed by the Royal Academy to encourage 'all sorts of people' to discover for themselves the pleasures of painting, had been bought by more than a million amateur painters.

Yet the struggle for seriousness was constantly undermined by the wilful catholicism of popular taste. The theatre, in all its forms, relentlessly grew in popularity. The music festivals and promenade concerts may have drawn unprecedentedly large audiences, but the music halls and minor theatres drew greater numbers still. The swelling of the London theatre audience in particular is indicated not just by the growing numbers of theatres in the capital during the second half of the century – the total number of theatre seats available in London relative to its population was three times as high in 1895 as in 1995 – but by the increase in the number of long-running London productions:

	Over 100 Prefs.	Over 200 Prefs.	Over 300 Prefs.
1840s	5	1	0
1850s	16	0	0
1860s	52	11	6
1870s	107	25	9
1880s	157	46	22
1890s	169	54	24

Theatrical growth was by no means confined to London. The important *Theatres Report 1892* – the first significant economic analysis of a part of what a century afterwards was called 'the arts industry' – reported that there were at the beginning of the 1890s some 1,300 licensed places of amusement in England, that the theatre regularly employed 350,000 people and could be capitalised at more than £6,000,000. Ten years later, at the turn of the century, even those impressive figures had nearly doubled.

There were many signs that whatever official action was taken to suppress traditional entertainments and amusements, they generally kept their hold on popular taste. Nor is there much evidence for the

authorities' assertions that the people who formed 'the theatre-going tendency' or who enjoyed the fairs were an idle and drunken rabble. Descriptions of the crowds attending public lectures, at the promenade concerts, or thronging the music halls often sound remarkably alike. We might reasonably assume that many Victorians privately did not accept that there was an unbreachable gulf between improvement and entertainment.

It seems that as the span of Victorian entertainment grew broader – messing about on the river, cycling holidays, watching professional soccer, attending scientific lectures, going to a musical show, roller skating – so did many find it easier to straddle extremes. Hoardings advertised concerts of sacred music alongside raffish music hall bills; cultural salons of great elegance had some of the most sordid brothels in Europe as neighbours; the poetry of Tennyson was on sale beside openly pornographic and sensational literature, ranging from *The Pearl*, which began its notorious monthly publication in July 1879, to the much less shocking 'yellow novels' which could be purchased from W.H.Smith's new railway station bookstalls. The evidence suggests that whatever the authorities may have done to denigrate them, the Victorian public nevertheless found it easy to recognise improving qualities in the popular arts. Perhaps one of the most telling verdicts on the Victorians authorities' unceasing attempts to make education and art the exclusive providers of improvement is that in 1881, a decade after Forster's famous education act, George Newnes was able to found *Tit-Bits*, a gossipy newsheet, confident of an *immediate* daily circulation of 800,000.

The state of affairs in Britain's schools to which Prince Albert had drawn attention in the 1840s did not change for some time. In 1961, a Royal Commission under the Duke of Newcastle offered the opinion that not more than a fourth of British children left school reasonably educated. Forster's *Elementary Education Act 1870*, which attempted to make elementary education available to all, was therefore intended to remedy that situation. In practice, however, there was still widespread absenteeism, for many parents could not afford the fees, and it was not until 1891 and the *Assisted Education Act* that a capitation grant was given to all schools enabling them to stop charging all pupils. By the mid-nineties practically all the nation's children – some 5,500,000 – were on the registers of Britain's 20,022 Elementary day schools, and the annual cost of education, £5,800,000, had for the first time become a major item in the state budget.

The curriculum of the new schools centered largely on the 'three Rs', and in the arts was notable as much as for what was left out as for what

was taught. Such literature as was admitted earned its small place by acting as a repository of noble and improving thoughts, conveniently read in the form of bowdlerised extracts published in a school reader. Adult novels were, of course, missing from school bookshelves, although Forster's Act helped create a readership for a spate of new children's novels. Apart from the occasional staging of religious scenes, the new state schools excluded drama from the curriculum altogether. The visual arts (to compound confusions, the word 'art' within the education system usually referred to drawing and painting *exclusively*) were, however, taught, albeit in a restricted way. 'Art' classes were held in formal design. Pupils were also instructed in the rules of perspective, and in the rudiments of light and shade, as they drew their carefully constructed 'compositions'. There was no oil painting, no portraiture or landscapes, while political cartoons – a central part of the cultural heritage – were as rigorously excluded from the British classroom as were the poetry of Chaucer, the plays of the Restoration or traditional folk songs. As the writer H.G. Wells was to observe:

> The Education Act of 1870 was not an Act for common universal education, it was an Act to educate the lower classes for employment along lower class lines, and with specially trained, inferior teachers who had no university quality.

For the mass of people unable to purchase a public school education there were some chinks of light. From 1857, it had at least been possible to enrol in the new National Schools of Art and Design. The art school curriculum had a strong emphasis on formal design, but it provided a rudimentary form of artistic education for some youngsters. The schools were developed by the Government Committee of Council on Education, and were at first primed by a modest state grant – although as the numbers of 'Art Schools' grew, the grant paradoxically shrank:

	Grant £	No. of Art Schools	No. of Students
1857	6,850	17	2,454
1863	4,005	90	16,180

In 1864, the Committee of Council recommended that the central government grant be withdrawn, and that the schools should henceforth be 'self-supporting', relying on fees and support from local factory owners destined to employ the young artisans. Shortly afterwards, freed of this responsibility, central government in 1868 did venture its first

award to musical education when it offered a £500 annual grant to the Royal College of Music, which had been re-established – though as a teaching institution rather than as the grant-giving body of the previous century – in 1823.

Music education meanwhile had grown considerably, largely through two systems, promoted respectively by John Hullah and John Curwen, and each based on different forms of music teaching then in vogue on the continent. Both relied upon substituting syllables for notes – doh, ray, me, fah, soh, lah ti for CDEFGAB in the key of C – and the drawback for both was that the notation could not really cope with anything written in another key, when notes exist for which there is no syllable. Under these systems, everything had therefore to be simplified and transposed into the key of C.

In addition to creating and running a national system of music examinations – in twenty years more than 25,000 people gained his musical qualifications – Hullah also ran a large part-time academy, first at Exeter Hall in London and then after 1847 in St Martin's Hall in Long Acre, which was rebuilt in 1850 to contain a 3,000 seat concert hall. In a passage redolent of 'self-help' Hurrah enthuses over the dedication of his Exeter Hall students:

> Our meetings include many a family circle entire – husbands and wives, brothers and sisters, parents and children; and these, in many instances, taught by one another.

While a anonymous contributor to *Household Words*, after observing Hullah at work in St. Martin's in 1852, is more impressed by the social mix that his teaching attracted:

> The pupils belong to every class and calling, the highest ranks of the aristocracy, the members of almost every trade and profession, the industrious mechanic and workman; and they all mingle in one common pursuit, without regard to status or degree.

St Martin's burnt down in 1860, and although Hullah still held a number of appointments – including that of organist at Charterhouse – he remained ambitious for the adoption of his own system. Unfortunately when the Government decided to make music teaching in schools compulsory in 1872, they decided that of the two it was Curwen's Tonic Sol-fa system that was to be more strongly recommended. They then rather surprisingly compounded the difficulties by making Hullah Chief Music Inspector of Schools in the same year.

The new Chief Inspector was however magnanimous enough to

acknowledge that the Curwen system had equal virtues with his own, and ten years after the Forster Act it was evident that many teachers in any case preferred to teach their pupils by ear:

School Board Schools 1880-81 (brought into being by the Forster Act)
 By ear 4,681 Hullah system 86 Tonic Sol-fa 1,414
Other Schools (England and Wales)
 By ear 17,470 Hullah system 628 Tonic Sol-fa 1,278
Schools in Scotland
 By ear 1,280 Hullah system 8 Tonic Sol-fa 1,648

Further analysis of the Tonic Sol-fa college books suggests that although Curwen's system generally attracted fewer schoolmasters and schoolmistresses than did Hullah's, Tonic Sol-fa was nevertheless preferred by clergy and choirmasters. Certainly religious music published in this form was cheap and popular; one Tonic Sol-fa edition of the *Messiah* alone sold 39,000 copies.

Unsurprisingly government support for technological education was very much greater than it was for music or art. In 1878 several of the City companies, in co-operation with the Corporation of London, had established an *Institute for the advancement of Technical Education*, and this had been followed by a Royal Commission, which had reported on the needs of technical education in 1882. The resultant *Technical Instruction Act 1889* authorised County Councils and the Boroughs to raise a penny rate for the purposes of such teaching. More importantly, a year later, central government raised no less than £750,000 to be distributed between the local authorities as 'matching money' towards the better establishment of technical education. We know enough of the cast of mind of the Victorian authorities not to be surprised by the fact that they raised the money for this improving form of education by imposing swingeing new taxes on beer and spirits.

The last decades of the century nevertheless saw an immense surge in leisure spending and in leisure provision, in degrees which varied according to the spending power and mobility of each class. Dividing lines are never quite absolute however. Before it chanced upon using 'illuminations' as a major attraction, the 'cotton resort' of Blackpool had for many years extended its season by running a high class music festival, whereas some of the balls held in Bath were described as 'scandalous' and as attracting 'low life'. Yet whatever the local vagaries, in almost every British town and city, whatever the class of its citizens or visitors, the battle between the improvers and the entertainers was in some form being waged.

It was in Birmingham, where as early as 1867 the enlightened civic authority had not only created a free library and opened the Birmingham Museum and Art gallery, but were also helping to promote facilities such as the 'Elementary Singing Classes' established in the Midlands Institute. However, these civic amenities were constantly matched by local speculators investing in popular entertainments. In 1856, James Scott had built and opened the Birmingham Music Hall, a concert room with a capacity of 1,850, but by the mid-1880s running as a popular theatre, in part financed by a row of shops which Mr Rogers, the new owner, had built beneath it. Then in 1863, a Birmingham businessman, George Biber, opened the 'London Museum' in Park Street, and in 1868 a local inventor, Mr Inshaw, created and opened the Steam Clock Music Hall in Ladywood. Mr Blore built the Theatre Royal in Aston as a private investment in 1895 and was promptly upstaged by a local cab proprietor, who opened the better-sited 'Palace of Delight' in Bristol Street the following year. Then in 1899, another Birmingham business family, Henry and James Draysey, opened the spectacular Hippodrome Circus with a capacity of more than 3,000.

Birmingham was an unusually enlightened local authority, but its mixture of public and commercial enterprise was typical of urban leisure provision in England during the late nineteenth century. The 'improving' facilities – libraries, museums, galleries and parks – were usually built and run by the local authority, often acting in concert with public subscription schemes. The interplay between the local authority and public subscription was sometimes, as in the case of Manchester's Free Trade Hall, labyrinth. The first hall, erected to house meetings of the Anti-Corn Law League, was erected in 11 days by 100 men in 1840. It housed 4,000 and was financed exclusively by public subscription. In 1842, the hall's capacity was enlarged to 8,000, and over the next decade it housed the 'Concerts for the People' which in 1851 became the Monday Evening Concerts, one of the 'Classical Monday Pops' of Gilbert and Sullivan's *Patience*. Then in 1855, the hall was drastically rebuilt under the control of a newly-formed Manchester Public Hall Company, with a greater involvement by the Manchester City Council, but still relying on public subscription for the majority of the £40,000 development money. Its largest auditorium now had a capacity of only 5,000. In the early years of the twentieth century, gradually increasing support was needed from the City authorities, and finally in 1920 they purchased it outright from the Company for £90,000.

By contrast, many centres of entertainment in the latter part of the nineteenth century were built and sustained wholly by the private

investment of one or more individuals. These were the 'self-made men' of the Great Exhibition, whose motives – for all their protestations that they were doing it all in the cause of moral improvement – were straightforwardly those of following up a good business prospect. For investing in theatres, circuses, pleasure gardens, dioramas or dance halls was now thought to be as sound as putting money into building, the railways or the production industries. The *Financial News* of 15 February 1887 for instance commiserated with speculators who were nervous of fluctuating foreign markets, and recommended putting money in the music hall instead, for the simple reason that:

> ...whenever it has been decently and prudently managed it has yielded large fortunes...if it continues to refine itself and heap novelty on novelty as it does, it will go on growing.

The last decades of the century in England offer many examples of speculators taking their profits from industry and putting them into safe and reliable speculations such as the new dancing rooms, skating rinks, indoor circuses or, of course the music halls. In Manchester, there was William Henry Broadhead, who built and opened the Osborne theatre in 1896, and the Metropole in 1898, with the avowed purpose of giving the working classes 'dramatic productions of an uplifting moral nature...at prices they could afford', but from which he proceeded to draw healthy profits through the years of his retirement. There are also many examples of travel and catering companies, and indeed of resort authorities, finding it expedient to open galleries and theatres to widen their appeal to the public, and guarantee their profits. The best-known example of this is probably the Criterion Restaurant, which was opened in 1873 by Spiers and Pond in what was then called Regent Circus, Piccadilly, at a cost of £100,000. In the centre of the new building was an underground hall, intended as a concert room, but which the proprietors decided would be more profitably used as a theatre. The Criterion opened in 1874, a curiosity in which even the upper gallery was reached by going down stairs, and into which air had to be constantly pumped 'to save the audience from being asphyxiated'.

One of the earliest of enterprising nineteenth century cultural speculators was Joseph Pitt, who in his youth had earned his living by holding 'gentlemen's horses for a penny'. Becoming, by degrees, a property owner in his native Cheltenham, he acquired enough wealth to buy 100 acres north of the town and there built nothing less than a complete new spa town, Pittsville, with 600 houses, a pump room and pleasure gardens, 'rivalling its parent Cheltenham, both in extent and

importance'. The Pittsville season ran from May to September, a band playing each morning and afternoon in the pleasure gardens. Subscriptions varied from 5s. which admitted the holder to the garden walks for one month, to £2.2s., which enabled a family to take the waters for a full season. Between 1830 and 1840, there were also several special events during the season – concerts, public dinners and firework displays – for which there was an additional charge. Pitt, as a result, became a wealthy man.

People and firms who made money from the arts and entertainment not infrequently ploughed their profits back into what was growing into a flourishing business sector. For instance, the 'father of the halls', the former pub landlord Charles Morton, spent between £30,000 and £40,000 of his own profits in 1851 when he adapted the pub annexe of the Canterbury as a music hall. The musical firm of Chappell's built St. James's Hall, Piccadilly in 1858 at a cost of some £70,000, using it to promote business by displaying their pianos and music on their premises and promoting their own contracted artists on its stage (twenty years later, Chappell's rivals, Novello, were sponsoring concerts given by *their* contracted artists at the new Albert Hall). The theatrical producer and owner of the Savoy, Richard D'Oyly Carte, used his accumulated fortune to build and open the Royal English Opera House (now the Palace Theatre) in Cambridge Circus in 1891, although his hopes for English Opera were not realised and in the following year he had to sell the theatre and it became a music hall. The actor Charles Wyndham, much less wealthy, had to rely on ten theatrical friends acting as guarantors of £1,000 each before he could proceed with his partner Joseph Pyke to build Wyndham's Theatre, which opened in 1897. The tightness of the budget did not, however, deter the flamboyant Wyndham from giving the entirety of the first receipts – some £4,000 – to the Aldershot Branch of the Soldiers' Wives and Families Association.

Some benefactors of the arts were still motivated by genuine philanthropy. One such was the sugar magnate Henry Tate, who generously bequeathed his collection of paintings to the nation in 1890, and became so embarrased by the government's dithering, that he then offered to pay for the building of a gallery to house them. However, even that offer was spurned, as in their turn the Corporation of London demanded far too high a price for the proposed site. Eventually, after many months of negotiation, the Gladstone government offered the Millbank site in return for the paintings and a benefaction from Tate. The Tate Gallery finally opened in 1897.

Among the most notable patrons of the arts in Victoria's reign were the

Butes of Cardiff, reportedly the third richest family in Great Britain. The third Marquess of Bute, the model for the hero of Disraeli's novel *Lothair*, reputedly spoke twenty languages and was an expert on Biblical and medieval history, on heraldry and on archeology. Local support ranged from financing the new Cardiff Pier to promoting the local drama. He owned Cardiff Castle, and promoted free Sunday concerts in its grounds throughout his adult life, while the family subscription to the National Eisteddfod was throughout the nineteenth century invariably the largest.

THE NATIONAL EISTEDFOD
Cardiff 1899
Subscriptions

		£	s	d
The Marquis of Bute	(Donation)	150	0	0
	Subscription	10	10	0
W. Richards-Morgan M.P,	(Donation)	42	0	0
	Subscription	10	10	0
4 others at £10. 10s.		42	0	0
3 at £5. 5s.		15	15	0
3 at £5. 0s.		15	0	0
2 at £3. 3s.		6	6	0
6 at £2. 2s.		12	12	0
40 at £1. 1s.		42	0	0
159 at 10s. 6d.		83	9	6
		430	2	6

Another Cardiff benefactor was the industrialist Christopher Talbot, patron of the painter Milo Griffiths and of seascape artist James Harris, whose investment in the nearby port led to the rare British distinction of him having a complete township named after him. Shortly after Talbot's death in 1890, another Welsh industrialist, Richard Glynn Vivian, achieved the rather more common feat of giving his name to a major art gallery, when he gave his collection of paintings, sculptures and china, together with a bequest of £10,000, to what became Swansea's Glynn Vivian Art Gallery. At the gallery's 1909 opening Vivian, at the age of 84, announced he was giving a further endowment of £1,000 to the gallery so that a man could be employed to teach 'poor young ladies to copy the manufactures' that were in the gallery, so that they could earn their own livelihoods.

It was an interesting echo of the past, for by that time livings were hard

to earn from simple craft work, the enveloping age of mass production had rendered the term 'manufactures' antiquated, and most importantly perspectives on art and industry had shifted again. The first stirrings of change are set out clearly enough in Oscar Wilde's 1885 review of a public lecture given by the painter Whistler, and published in the *Pall Mall Gazette* on the 21st. February:

> ..this attitude of the primitive anthropophagous philistine formed the text of the lecture and was the attitude which Mr Whistler entreated his audience to adopt towards art. Remembering, no doubt, many charming invitations to wonderful private views, this fashionable assemblage seemed somewhat aghast, and not a little amused, at being told that the slightest appearance among a civilised people of any joy in beautiful things is a grave impertinence to all painters; but Mr Whistler was relentless and, with charming ease and much grace of manner, explained to the public that the only thing they should cultivate was ugliness, and that on their permanent stupidity rested all the hopes of art in the future.

> The scene was in every respect delightful; he stood there like a miniature Mephistopholes, mocking the majority! He was like a brilliant surgeon lecturing to a class composed of subjects destined ultimately for dissection, and solemnly assuring them how valuable to science their maladies were, and how absolutely uninteresting the slightest symptoms of health on their part would be. In fairness to the audience, however, I must say that they seemed extremely gratified at being rid of the dreadful responsibility of admiring anything...

> Having thus made a holocaust of humanity, Mr. Whistler turned to Nature and in a few moments convicted her of the Crystal Palace, Bank Holidays and a general overcrowding of detail, both in omnibuses and in landscapes, and then, in a passage of singular beauty, not unlike one that occurs in Corot's letters, spoke of the artistic value of dim dawns and dusks, when the mean facts of life are lost in exquisite and evanescent effects, when common things are touched with mystery and transfigured with beauty, when the warehouses become as palaces and the tall chimneys of the factory seem like campaniles in the silver air.

The linking of the Crystal Palace, and the tall chimneys of the factory, with the 'mean facts of life' is clear enough. So is the assertion that art is much more than ornamentation, a means of enabling the human spirit to transmute even the ravages of the industrial revolution into something beautiful. Wilde goes further, insisting that 'art' is a transcendant quality uniting music and the literary and dramatic creators with Whistler and his circle. The term must not be kidnapped for the exclusive use of the visual artists:

> As long as a painter is a painter merely, he should not be allowed to talk of anything but mediums and meglip, and on those subjects should be compelled to

hold his tongue; it is only when he becomes an artist that the secret laws of artistic creation are revealed to him. For there are not many arts, but one art merely – poem, picture and Parthenon, sonnet and statue – all are in their essence the same, and he who knows one knows all.

The ornate flourishes of Wilde's style may cause us to overlook the courage of his remarks, just as Whistler's ironic persiflage may have allowed his audience to miss his underlying seriousness. Yet the battle with utilitarian art had been seriously joined. And that same battle, against both the belittling of art, and the false divisions forced upon it, was carried on in a quite different way by another eminent Victorian, Henry Irving. It is clear from all that Irving wrote and said – and he was an indefatigable public speaker – that he regarded his years as the head of the Lyceum company as a crusade to re-establish the drama as an art form, alongside music, painting and literature.

When he had gone to the Lyceum in 1879 the division between the serious and 'improving' arts and vulgar entertainments such as those enjoyed by 'the theatre-going tendency', was at its height. Musicians and painters had their Royal Academies, and gained their knighthoods, but actors had neither. Irving systematically set out to change the authorities' perception of the drama, by engaging in long and elaborate public discussion of the 'art' of acting – an action which included the purchase of the most high-brow of the theatrical journals *The Theatre* – by systematically wining and dining the guardians of public taste in his private backstage dining room, the 'Green Room', by courting the patronage of the most accessible member of the Royal Family, the Prince of Wales, and above all by involving Britain's leading painters and musicians as colleagues in the preparation of each of his meticulous Lyceum productions.

His campaign took many years to come to fruition. He and his acolytes proclaimed that he had been offered a knighthood in 1883, but had declined it. (Even to casual onlookers, Irving's apparent action had seemed curious, and the subsequent release of the diaries of the then Cabinet Secretary have revealed that although the possibility of a knighthood for Irving was twice discussed, he was not in fact actually offered one, it being felt that as an undivorced man he had 'too great an intimacy' with his co-star Ellen Terry. It was not until 1896, when the affair with Ellen Terry had long cooled, that he was in fact knighted.)

There are other elements of Irving's long battle which are important. One is his insistence that the theatre is *not* a part of a production industry, but has its own artistic dictates. Ironically, one of his best-known

remarks, that 'the theatre must succeed as a business, or it will fail as an art' is often used to suggest that he meant the opposite, that the theatre must organise itself on commercial and industrial lines, or it cannot compete in the market place.

The remark was made in the course of one of Irving's lectures in Edinburgh in 1881. It is quite clear from the context that he does not intend the word 'business' to mean 'commercial and industrial activity', but something akin to 'professional expertise'. And that business, that professional expertise, is nurtured both by tradition and the dictates of the general public, and cannot be falsely reshaped by outsiders, however well-intentioned:

> And so I would say of what we sometimes hear so much about – dramatic reform. It is not needed; or, if it is, all the reform that is wanted will be effected by the operation of public opinion upon the administration of a good theatre. That is the true reforming agency, with this great advantage, that reforms which come by public opinion are sure, while those that come without public opinion cannot be relied upon. The dramatic reformers are very well-meaning people. They show great enthusiasm. They are new converts to the theatre, most of them, and they have the zeal of converts. But it is scarcely according to knowledge. These ladies and gentlemen have scarely studied the conditions of theatrical enterprise, which must be carried on as a business or it will fail as an art...it will be quite hopeless to attempt to induce the general body of a purely artistic class to make louder and more fussy protestations of virtue and religion than other people.

Life changed rapidly in the 1890s. As Norman Stone has memorably put it, 'In 1895 Henry James acquired electric lighting; in 1896 he rode a bicycle; in 1897 he wrote on a typewriter; in 1898 he saw a cinematograph'. One might be equally dramatic and say that in the year of Irving's knighthood the first moving film was shown in London, the first flat disc gramophone record was played, and if he had chosen to do so, the actor could have witnessed the first London to Brighton motor race. All these changes would bring new forms of industry, would reshape the nature of the arts, and would have a profound effect upon 'the operation of public opinion'.

The Horrors of Tourism

In Bruges town is many a street
Whence busy life hath fled;
Where, without hurry noiseless feet
The grass-grown pavement tread.
There heard we, halting in the shade
Flung from a Convent-dower,
A harp that tuneful prelude made
To a voice of thrilling power.

The measure, simple truth to tell,
Was fit for some gay throng;
Though from the same grim turret fell
The shadow and the song.
When silent were both voice and chords,
The strain seemed doubly dear,
*Yet sad as sweet, – for **English** words*
Had fallen upon the ear.

William Wordsworth, *Incident at Bruges* from
Memorials of a Tour on the Continent 1820

It is hardly surprising that Wordsworth should have found himself in Bruges in 1820, for, once the wars with France had finally ended, well-to-do British tourists were eager to resume their travels, though it meant forsaking some of their domestic recreations – the seasons in the spa resorts, walking in the Scottish Highlands and 'dipping' on the British bathing beaches - for the warmer Continent.

By the end of the eighteenth century, the British spas had largely shed their purely medicinal image, and had become elegant resorts for the aristocracy and middle classes. In the eighteenth century, running a spa had been good business. Between the opening of the first spas at Bath and Buxton in the sixteenth century, and 1815, when the French wars ended,

175 spa centres of various kinds had been opened in this country. Many had been quite small, consisting of little more than a well in the grounds of a private house, and some of the smaller enterprises, such as those at Richmond in Surrey, or Wellingborough in Northamptonshire, had run dry or closed down by the end of the century. Others, like Epsom or Dulwich, were now little used. But during the wars, most of the larger spas had thrived, particularly newer resorts such as Malvern, Leamington or Matlock, which had more than one spa centre and so could accommodate a larger influx of domestic tourists. But although some of the older centres – Bath, Scarborough or Tunbridge Wells – may have had only one spa site, they had other compensations. Public subscription had built spacious facilities, such as the elegant new assembly rooms, and seven of the larger spa towns – Bath, Buxton, Cheltenham, Harrogate, Leamington, Scarborough and Tunbridge Wells – had public theatres. They also featured landscaped gardens and well-appointed coffee houses, in which music was played and newspapers could be read. At the end of the century, Bath had three such salons, while Tunbridge Wells had two, one for men and (unusually) one for women. In total, there were some forty substantial spa resorts still operating in Britain at the beginning of the nineteenth century.

It was frequently the landowners themselves who developed the spas discovered on their land, as a straightforward commercial investment. This was almost always the case with the smaller developments, but still happened with larger ones. The Duke of Devonshire had first developed the extensive spa facilities at Lower Buxton, which adjoined the old spa town on the hill, in the 1780s.

BUXTON 1846
Full-time Traders

92	Hotel and Lodging House proprietors
35	Food retailers (including 13 grocers and 11 butchers)
20	Clothes retailers
14	Buxton Momento sellers
10	Farmers
10	Professional people
8	Coach and Transport business
7	Miscellaneous traders
7	Builders
4	Schoolmasters
4	Surgeons
3	Physicians

3 Librarians
2 Blacksmiths
1 Basket Maker

In Bristol, the Hot Springs site at Clifton was developed by the Merchant Venturers. Sometimes a consortium of local landowners and merchants would form their own company in order to develop a spa, as at Askern in Yorkshire, where the Manor Baths were opened in 1814 at a cost of £1,000. However, many sites were also owned by local authorities, and at the beginning of the nineteenth century, Scarborough, Beverley and Northampton were among those under municipal control.

Whoever owned the land on which the spa stood, it was most commonly public subscription that raised the capital for the new facilities. Subscription schemes were, for example, used to build the early lending libraries which played such a central role in the social life of the spas, acting amongst other things as agencies for the lodgings and servants which were in demand from visitors, as booking offices for the great variety of concerts, plays and balls presented during the season, and as collection points for charitable appeals. Less conventionally, when it became clear that at the height of the season in the most popular spa towns the existing accommodation could not contain the greatly increased numbers of Sunday worshippers, subscription appeals were set up to build new chapels to contain the overflow.

Visitors to the resorts also paid by subscription both to use the spa facilities, and to gain admittance to other attractions such as the gardens, assembly rooms, theatres and concert halls. That cost could vary from £3.3s. for a full season's use of a spa and pump room, to a weekly 2s.6d. to use a special facility such as Lord Aylesford's Leamington well. In almost all the spas there were concessions for the poor. Buxton had a Charity Fund dating from the sixteenth century which had enabled it to set up a 'charity bath' for the poor, and Leamington followed suit in 1806. In Somersham in Huntingdonshire, the poor and needy were admitted free in the very early morning, from 5 a.m. to 7 a.m., while in Bath they were admitted at any hour of the day at the greatly reduced charge of 6d.

Admittance to the earliest of the new bathing beaches was equally circumscribed. Following the lead given by Scarborough, where taking the spa waters was successfully combined with sea bathing, a number of shoreline landowners developed new seaside 'resorts' which bore many of the same architectural characteristics as the inland spas. New centres such

as Brighton, Southampton and Bridlington had squares and lodging crescents, assembly rooms, gardens and sheltered promenades. Thirteen of the thirty four seaside resorts developed by the beginning of the nineteenth century also had bath-houses with rooms for hot and cold baths fed by tidal waters – but in many resorts sea-bathing itself was becoming fashionable. By 1806, twenty five resorts had collections of horse-drawn 'bathing machines' which were decorously towed out into shallow seas so that their bathing-suited occupants – strictly separated by sex, and still wrapped in bathing cloaks until the waters closed over them – could descend into the waters unobserved. Scarborough owned forty such machines. The social life of the new seaside resorts was no less formal than it was in the spas; in both there was a master of ceremonies who acted as entertainments officer, making sure that the round of bathing, promenading, library-going and conversation in the coffee houses, together with the balls, assemblies, lectures, plays and concerts were all conducted with 'the utmost propriety'.

The nineteenth century saw rapid growth in the number and variety of seaside resorts. Early in the century Dr. Arnold had learned to his surprise that none of the boys in his Sixth Form at Rugby had ever seen the sea, but by the century's end, the majority of the population had some acquaintance with seaside resorts, if not as hotel residents, then as 'day trippers'. At some resorts, they would arrive by steamer, having taken the 6d. steamer down the Thames from London to Gravesend or Margate, or sailed from Liverpool to Birkenhead or the Isle of Man. Many of Britain's rivers also became holiday locations in their own right. After the *Factory Act* of 1833, which gave all people under eighteen years of age the right to eight half-day holidays a year, in addition to Christmas Day and Good Friday, it was alleged that many London youths spent their half day holiday daring each other to 'run' from one side of the Thames to the other, leaping from deck to deck on the hopelessly overcrowded river.

In holiday travel, the railways at first were less important than the steamers. Indeed the *Select Committee on Railways 1840* observed that railways were primarily intended:

> ...to convey the labourer to that spot where his labour might be most highly remunerated...[and by that means] the health and enjoyment of the mechanics, artisans, and poor inhabitants of the large towns would be promoted, by the facility with which they would be enabled to remove themselves and their families into healthier districts and less crowded habitations.

Nevertheless before very long the trains were being used by all classes of people, and for all kinds of recreational puposes:

Tavistock House,
6th. March 1854

To Mark Lemon
Dear Mark,
Would you like a day down to the sea – Dover for instance – any day this week? A stroll and a breeze? Any day but Thursday (when I dine with old Charles Kemble) would suit me. I am, all the week, on a regimen of fresh air,

Ever Affectionately,
Charles Dickens

By then the pioneer work of the far-seeing Secretary of the South Midland Temperance Society, Thomas Cook, had led to the appearance of the 'excursion train'. Sometimes promoted by the railways themselves, and sometimes hired by a single factory to take its workers for a 'day out' of the smoky city, the excursion train offered cheap 'day returns' to its customers. On Bank Holidays in particular they poured into the large resorts which had grown up to serve particular industrial populations: Blackpool for Lancashire, Yarmouth for East Anglia, Aberystwyth for Wales, Southend for London.

The Industrial Revolution brought seaside holidays to the masses, and imposed its own organisational pattern on the new resorts. For holidays were taken *en bloc* by all workers in each of the industrial towns. In what was still called the 'wakes week' all of the factory furnaces in the borough would shut down so the majority of the working population would have to take their holidays at the same time and, perforce, often in the same resort. The workpeople from one factory would thus often travel to and from their day trips and holidays on the same train. As the music hall song put it:

> We all go the same way home –
> All the collection in the same direction,
> All go the same way home
> So there's no need to part at all
> We all go the same way home.

By agreement, 'Wakes weeks' were staggered across an area, so that, for instance, the factory workers of Blackburn, Bolton and Wigan did not take their excursion trains to Blackpool all in the same week.

In the early days of rail travel, it seems to have been the custom simply to take a few day excursions during the holiday, but by the end of the century it had become quite usual for working class families to spend a few days, or even a full week, away from their homes 'on their holidays'. In order to get away, holidaymakers were often willing to put up with

spartan conditions. Many of the popular resorts were forced to ponder the problem of what to do with the visitors who had arrived by train but who could not afford accommodation, and so 'slept rough' in the sand dunes or in the promenade shelters. Even for those who could afford entry to lodging houses, there would be shared and overcrowded rooms, while those who could not afford access to a bedroom sometimes slept downstairs on the dining room chairs, their heads folded in their arms on the lodging house table.

Yet it was worth enduring the uncomfortable 'diggings', for seaside resorts offered a fleeting chance to be free of the heavy social restraints the authorities put upon workaday life. On holiday one could enjoy oneself without feeling guilty. The 'free time' was time allocated to you by the industrial system, just as the working shifts were allocated to you during the rest of the year, and so the holiday was an industrial indulgence. In the resorts, you could enjoy the entertainment without constraint – without being told by the authorities that what you were doing was undermining proper industrious habits, and without being condemned to eternal fire and brimstone by the new evangelists. The working class holidaymaker was on parole from the industrial prison, afforded a tantalising glimpse of a New Jerusalem. Glover-Kind's famous music hall song perfectly caught the sense of longing and liberation which the seaside resorts evoked:

> Oh I do like to be beside the seaside.
> I do like to be beside the sea,
> I do like to stroll upon the Prom, Prom, Prom,
> Where the brass bands play Tiddley-om-pom-pom!
> So just let me be beside the seaside
> I'll be beside myself with glee –
> And there's lots of girls beside
> I should like to be beside
> Beside the seaside, beside the sea!

Compared with this ecstatic sense of freedom, the rigours of sleeping and eating rough paled into insignificance. Many of the holidaymakers would in any case take their meals like Gus Elen:

> Now for breakfast I never fink of 'aving tea,
> I likes 'arf a pint of ale,
> For my dinner I likes a little bit o' meat,
> And a 'arf a pint of ale,
> For my tea I likes a little bit o' fish
> And a 'arf a pint of ale,

And for supper I likes a crust o' bread and cheese,
And a pint and a 'arf of ale!

However, eating out in Victorian Britain, whether for the visiting tourist or the impoverished citizen, was not usually a pleasant experience. Charles Dickens railed memorably against the meals that were provided at 'refreshment stations' in the course of the longer rail journeys:

> What with skimming over the open landscape, what with mining in the damp bowels of the earth, what with banging, booming and shrieking the miles away, I am hungry when I arrive at the "Refreshment" station where I am expected. Please to observe, expected. I have said, I am hungry; perhaps I should say, with greater point and force, that I am to some extent exhausted, and that I need – in the expressive French sense of the word – to be restored. What is provided for my restoration? The apartment that is to restore me is a wind trap, cunningly set to inveigle all the draughts in that country-side, and to communicate a special intensity and velocity to them as they rotate in two hurricanes: one, about my wretched head: one, about my wretched legs. The training of the young ladies behind the bar who are to restore me, has been from their infancy directed to the assumption of a defiant dramatic show that I am *not* expected...I find that I must either scald my throat by instantly ladling into it, against time and for no wager, brown hot water stiffed with flour; or I must make myself flaky and sick with Banbury cake; or I must stuff into my delicate organisation, a currant pin-cushion which I know will swell into immeasurable dimensions when it has got there; or, I must extort from an iron-bound quarry, with a fork, as if I were farming an inhospitable soil, some glutinous lumps of gristle and grease, called pork-pie.

Meals in the resort hotels seem to have been little better, and in the mid-nineteenth century, even well-heeled visitors to seaside or spa found only a limited number of alternative eating places to choose from, with stolid and overcooked fare.

Even in the heart of the capital, there were few good British restaurants, as Charles Dickens the Younger points out in his *London Guide* for 1879:

> A very few years ago the expectant diner, who required, in the public rooms of London, something better than a cut off the joint, or a chop or a steak, would have had but a limited number of tables at his command. A really good dinner was almost entirely confined to the regions of clubland, and, with one or two exceptions, respectable restaurants, to which a lady could be taken, may be said hardly to have existed at all.

However, in spite of the hardships of travelling to them, and their dull cuisine, the seaside resorts grew hugely popular; becoming bigger, more garish, and more raucous, all of which spurred the better-off in their search for more dignified and cultivated recreations elsewhere. So there

was from the first a clear division between well-off British 'tourists', who still visited the spas and walked the Scottish hills, but who generally preferred travelling on the continent; the middle-class 'visitors' in the hotels of Torquay and Cromer; and the 'holidaymakers' and 'trippers' flocking into Blackpool and Southend in their tens of thousands.

Thus there is more than a touch of fastidious disdain, as well as prurience, in Thackeray's 1847 observations of the holidaymakers and trippers confusedly thronging the Brighton seafront:

> ...the cabs, the flys, the shandry-dans, the sedan chairs with the poor invalids inside; the old maids, the dowagers' chariots, out of which you see countenances scarcely less deathlike...The hacks mounted by young ladies from the equestrian schools, by whose side the riding-masters canter confidently...

However Thackeray's observations on the 'old maids' and 'young ladies' do emphasise an important, and sometimes overlooked, merit of the new resorts. In the later Victorian age they played a small but significant part in the social emancipation of women, doing for working class women what the spas had previously done for their middle class sisters. For in the popular seaside resorts, women were able to enjoy themselves on equal terms with men, in contrast to the demarcations which still existed even within popular working class recreations like the music hall. The heavily masculine ambience was one of the things Max Beerbohm noticed when he ventured inside a music hall in the year of the Queen's Jubilee:

> I was filled with an awful, but pleasant, sense of audacity in venturing into such a place, so plebeian and unhallowed a den, as a music hall; and I was relieved though slightly disappointed also, at finding that the Pavilion seemed very like a theatre, except that the men around us were mostly smoking, and not in evening clothes, and that there was alongside of the stalls an extensive drinking bar, of which the barmaids were the only – or almost the only – ladies present, and that the stage was occupied by one man only.

But the entertainment provided for both women and men at the new resorts was revealing in other ways. Art galleries – which the government and larger local authorities were directly subsiding elsewhere – were little in evidence in the popular seaside resorts. There was, however, dramatic and musical entertainment in abundance. There were also fairs and circuses, firework displays and balloon ascents, fishing, boating, archery and bowls. The beach had its perambulating donkeys, and those relaxing on the sands, though not permitted casually to run into the sea and bathe, were allowed to 'paddle' on the edge of the sea, providing only their feet were visible.

There were also performing 'minstrels' stolling the sands, or playing in

groups on makeshift stages. The seaside authorities made attempts to control them, but it was an uphill task – crowds would turn on police or officials who tried to stop 'illegal' busking. W. H. Leverton, who after 1882 ran the Box Office at the Haymarket theatre, recalls a time in his youth when, finding themselves out of work in the summer months, he and a few friends decided to pass the summer as minstrels:

> ...I wrote round to various seaside resorts asking for permission to perform on the front. No replies came. We then made up our minds to go to Weymouth, which we had heard was at that time short of talent (?). Turner and I went down, and, after a long wait at the town hall, saw the mayor – a fussy little man. We explained our intentions.
>
> "Certainly not!" he snapped. "Too many of you people about already."
>
> We asked what would happen if we performed *without* permission
>
> "Well," snarled the official, "last week a man got four weeks for 'awkin' fish without a licence, so its up to you.
>
> "Thanks very much," we observed, and came home.
>
> The next day I had a letter from Frederick Hex, the Town Clerk of Torquay, which was one of the many places I had written to, saying we might go there and give our entertainment on the sands, or in the street, provided that we did not interfere with police regulations...
>
> Our idea was to perform at night only. We wore evening dress and dominoes, with rather small masks, which covered our eyes and noses...we found a spot at the foot of Rock Walk, opposite the Princess Gardens, and started our programme. Well, we were a great success, and after showing for just on two hours, and having made several collections, we went home. Turner and I eagerly emptied our collecting bag, and were delighted with the result...We kept this up for eight weeks, had our day to ourselves, worked two hours every evening, and did well enough to have a real good holiday at no expense, and thoroughly enjoyed the experience. We became very popular, and many were the rumours as to who we were – we never unmasked.
>
> Frederick Hex made us an offer to come the following year at a salary, to appear on the Princess Pier, which had recently opened, and this offer we accepted. But I think we really enjoyed the busking and its uncertainty more.

Even the earliest of these seaside piers, built as landing stages for the steamers, boasted promenades, saloons and musical bandstands. In many places they housed formal entertainments which complemented the casual minstrels on the beach. On Margate pier for instance, which

opened in 1808 having cost £100,000 to build, a band played all day. But such non-stop musical entertainment was not universally popular; Thackeray found the continuous blaring of the brass band at Dover far too much for him, and even the great populist Dickens pronounced the incessant music on the Broadstairs promenade insupportable.

The quality of music was less strained in other resorts. Of particular note was Bournemouth, whose musical fare in 1876 had been provided by a rather unreliable band of Italians, previously employed at Bath. Subsequent attempts by the local authority to improve standards took a concrete form in 1892 when the corporation hired for the season a first class military band of twenty one players. The following year Dan Godfrey was commissioned to form a band of some thirty high quality instrumentalists, which became the nucleus of the Bournemouth Municipal Orchestra. Other leading resorts, such as Eastbourne, Scarborough and Torquay, also had their own resident orchestras, as did a number of the leading spa towns. Harrogate had an orchestra 'under the baton of A.E. Bartle' which gave twice-daily programmes in the town's Concert Hall, and in 1890 led the reporter of the *Harrogate Pictorial* to pontificate smugly that, 'Yorkshire is a music-loving county...In the heart of such a shire, the musical catering must be of the highest to find acceptance.' Yet even resorts which did not have to satisfy the exalted tastes of Yorkshire audiences employed fine musicians; in 1898, for example, Surtees Corne began a nine year engagement as musical director of the orchestra in the modest Lincolnshire resort of Skegness.

Skegness provides us with a concise picture of the development of a Victorian seaside resort. It stands on a notably fluctuating coastline, and has regularly suffered from the encroachment of the North Sea. Leyland, writing in 1540, gives an early account of the changes the sea had wrought:

> Went to Skegness, sometime a great haven towne...Mr. Paynelle said unto me, that there was once a haven and a towne, walled and having a castle. The old towne is clene consumed and eaten up by the sea, part of a church of it stood of late. For old Skegnesse, now builded a pore new thing.

In the early part of the nineteenth century it was little more than a straggling coastal settlement, extending along some six miles of sea front, with a population of 134 in 1801, which had risen to a meagre 150 by the year of the Great Exhibition. The land was owned by the Earl of Scarborough who, seeing its potential as a watering place for the scattered market towns of Lincolnshire and the fast-growing industrial

cities of Nottingham, Sheffield and Leicester, laid plans in 1870 to build it up as a resort. Plans for road-building, water-supply and sewage disposal facilities to service the new town were speedily drawn up. By the end of the year the Earl had secured a loan of £120,000 from the Clergy Mutual Insurance Company, and his land agent. Mr Henry Vivian Tippett, was ready to supervise the development work.

Fortuitously, the Earl was approached by the Great Northern Railway Line Co. in 1871 asking the landowner's permission for them to build a new railway line linking Skegness with Boston and Lincoln, and hence with inland industrial areas. Permission was readily given, and the coming of the railway gave added impetus to the sale of building plots in the new town, which were advertised to speculators in the railway stations at King's Cross, Peterborough, Grantham, Retford, Doncaster, Sheffield, Derby, Nottingham, Leeds, Bradford and Grimsby. The resort was taking shape; the railway station opened in 1872 and five hotels – Hildreds, Sea View, The Vine, Ship and the Lumley Hotel – had opened in the town by the end of the decade. The town's healthy, 'bracing' image was reinforced in 1876 by the opening of the Lady Scarborough Convalescent Home on the edge of the town.

Meanwhile there had been another important development. In November 1877 a group of local businessmen had met in the New Inn, by Hildreds Hotel, to consider whether Skegness should have a pier. After several meetings it was decided to go ahead, and a new private company, the Skegness Pier Co. Ltd., was formed to oversee its erection. H.V. Tippett was its chairman, and its board – an cunningly-contrived cross-section of local business interests – contained two local hotel proprietors, Charles Hildred, and Hobson Dunkley of Sea View; the promoter of the local railway extension, James Wainfleet; a Spilsby solicitor, John Thimbleby; a local printer, T.A. Bellamy; the leading local tenant farmer, William Everington; the Reverend H.T. Cheales of Friskney; Colonel Grantham of Spilsby and Edward Charlesworth of Nottingham. Money was to be raised for its construction from the sale of shares and from privately negotiated bank loans, but meanwhile the board advertised a national competition for 'the best design of a Promenade Pier', which had as its prize £50, and the contract to build it.

From forty four entries, the design submitted by Clarke and Pickwell, civil engineers, Yorkshire Buildings, Hull was adjudged the winner. Their proposal was for a cast-iron pier 1,817 feet in length, 25 feet wide, with projecting bays at intervals of 120 feet. At its furthest point was a broad platform, 222 feet in length and 122 feet wide, on which was to be erected a concert hall seating 700 people. The whole was to be lit by gas, with an

SKEGNESS PIER SALOON

Chairman and Managing Director - - MR. C. F. GRANTHAM, J.P.

Deputy Chairman - - - - - - - MR. GEO. DUNKLEY

Programme.

Sunday, August 16th. 1908.

Musical Director - - - - Mr. SURTEES CORNE

AFTERNOON.

1. Overture "Stradella" Flotow
2. Song
3. Serenade Espagnole Betjemann
4. Song
5. Fantasia "Lohengrin" Wagner
6. Song
7. Norwegian Scenes Matt
8. Song
9. Extract from Casse Noisette Suite Tschaikowsky
10. Song
11. Paraphrase "Loreley" Nesvadba

God Save the King

EVENING.

1. Overture "Oberon" Weber
2. Song
3. Gipsy Suite Ed German
4. Song
5. Violin Solo "Nocturne" Chopin Mr. VAL. MARRIOTT
6. Overture "Fingals Cave" Mendelssohn

INTERVAL.

7. Gavotte "Yellow Jasmine" Cowen
8. Song
9. Chant Sans paroles Tschaikowsky
10. Song
11. March "Tannhauser" Wagne

God Save the King.

P. E. Cash. Manager

JAS. MORRILL, THE "HERALD" PRESS, SKEGNESS

Figure 12 The Sunday programme in the Skegness Pier Saloon, 1906.

Skegness Public Library

elaborate turnstile entrance. Clark and Pickwell deposited outline plans for the project on the 28th. November 1878, which were followed in subsequent months by more detailed specifications. When the foundation stone of the new pier was laid on 5th. November 1879, estimates of its total cost amounted to £19,000. The Earl of Scarborough acquired an interest in the new company in 1880, and by the time the pier was opened, on Whit Saturday, 4th. June 1881, at an eventual cost of £20,840.11s. 4d., he had become the majority shareholder.

Skegness pier was one of the largest of the eighty two piers erected around Britain's coastline between 1815 and 1890, and proved an immediate draw, particularly to day trippers. On August Bank Holiday 1882, twenty four rail excursions arrived in Skegness station, bringing 19,000 people in to the resort. On the same Bank Holiday of the following year there were even more trains, and 20,200 people paid the 1d. admission to the pier. On average, through the 1890s, the Skegness Pier Company annually recorded more than 100,000 pier admissions and, after paying dividends to their shareholders, each year on average carried forward a balance of some £400.

By the end of the century, a public subscription fund had also raised £600 to erect a striking Jubilee Clock on the promenade, and Skegness had all the usual ingredients of a successful late Victorian resort. The railway linked it to major industrial towns, from which its carefully advertised 'bracing' attractions drew some 250,000 visitors a year. It had hotels, gardens, libraries, safe bathing facilities, a long promenade (atop a practical and very necessary sea wall), tree-lined avenues, and an attractive pier, over a third of a mile long, from which steamers ran down the coast to Hunstanton and about which, in July 1893, a Leicester visitor eulogised in the *Skegness Herald*:

> Stretching far out into the sea. with its splendid promenade and cosy shelters terminating into a spacious 'head' and landing stage, the Pier presents many advantages to visitors in quest of recreation and rest. Excellent entertainments are given in the saloon daily. The programme is of such a comprehensive character – ranging from the classical to the grotesque – that the most diversified tastes should be fully satisfied.

> Pleasant resting places are afforded by the seats around the saloon in which the band also plays during the morning and here we may sit and enjoy the pleasant breezes and if so desired watch the 'sandscribers' display their unusual artistic talents.

Bathed in such warm praise, Skegness must have felt its long-term success was assured, but already there were rivals to challenge the seaside resorts.

Some of the competition came from the more enlightened industrial bosses who created much more pleasant living conditions for their employees. First in this field was Lord Lever, who in 1888 began to build an 'industrial village', Port Sunlight, for the employees of his new Birkenhead soap factory. It was designed by William Owen, of Warrington, and contained good workmen's cottages, with more substantial houses for the managerial staff, and was set picturesquely around a sunken park. In the centre of the village was an institute with several public rooms, a library, general store and post office. As a contemporary observer noted approvingly:

> A singulary vivid impression of rusticity was created. Nothing seems to have been neglected which may produce in the town-dweller the impression that he has indeed gone back to the land.

Lever was followed by the 'chocolate kings', George Cadbury, who developed Bourneville in the suburbs of Birmingham, and Seebohm Rowntree, whose model community offered pleasant living conditions to his own workforce and suggested one way in which the poverty and deprivation he had uncovered in his 1901 survey of life in York might be alleviated.

The Garden City movement, which grew rapidly during the first years of the century, was fuelled by such people, but drew its particular inspiration from the writings of a previously unknown shorthand clerk, Ebenezer Howard. In 1902 Howard republished a pamphlet he had written four years previously, now under its better-known title *Garden Cities of Tomorrow*. It struck an immediate chord, and within a few months had been translated into French, German, Italian and Russian. Garden City Associations sprang up across Europe, determined to put Howard's visionary ideas into practice. Garden Cities were to be limited in size to 6,000 acres, self-governing and limited to 32,000 inhabitants. By 1903, a joint-stock company, of architects, enlightened businessmen and local churchmen had been formed to build the first British Garden City, at Letchworth. Three years later a similar company was formed to create Hampstead Garden Suburb, and new Garden City projects came thick and fast: in Welwyn, Romford, Chester, Manchester and Liverpool.

Howard believed that Garden Cities should, as far as possible, be self-sufficient and that their dwellers should seek uplifting recreation within their own community, and not need to go outside it. So in the Collegium, the 3,000 seater-hall that was developed at Port Sunlight in the early years of the century, there would be lectures, educational film shows and concerts of sacred music, but little in the way of brass bands or

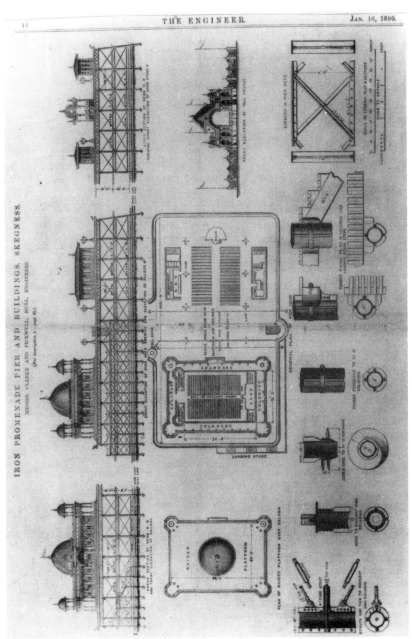

Figure 13 The attractive plans for Skegness Pier show a practical marriage between industry and art.

musical comedies. Alcoholic drink was not permitted to be publicly sold or consumed there in the early days (and later only in strictly controlled circumstances). Other recreational pioneers were less moralistic. In Nottingham in 1900, Jesse Boot purchased land by the River Trent to build a recreational centre for his employees. It had a spacious pavilion – large enough for regular dinners and dances – tennis courts, gardens – in which firework displays were held – an outdoor swimming pool and a children's playground. It was run by a committee elected from the workforce.

Competition to the seaside resorts also came from the inland local authorities. High Street traders had not always been best pleased when the improvers had closed down the local fairs, and refused facilities to the travelling showmen, nor had they all welcomed the mass outflow of trade during the wakes weeks. If the city had good public facilities – Liverpool for example at the end of the century had the new St. George's Hall, and five theatres – then the losses caused by people spending some of their time and money out of the city could be minimised, by outsiders being attracted in to them. It was noteworthy for example that a strong programme of musical and dramatic entertainments such as that offered at the Glasgow People's Palace could draw large regional audiences: 770,800 in 1898, the year of its opening, 500,000 in 1899 and 550,000 in 1900. But where the local facilities were insufficient to attract inward spending, then the effects of the annual holiday exodus were keenly felt. When that happened some of the larger towns and cities turned to a well-understood device to attract custom back into the cities and towns – an exhibition or a festival.

Britain had established a premier position as an organiser of exhibitions in 1851, and it had an even longer festival tradition in music and had a drama festival in the eighteenth century when, in 1769, after protracted negotiations with David Garrick, the Stratford Corporation promoted the first Stratford-on-Avon Shakespeare Festival. This aimed to celebrate the Jubilee of the immortal bard, to bring his birthplace into general notice, attract business, and (as a trade-off) to acquire from Garrick the gift of a Shakespeare bust to adorn their new town hall. But the festival was not a success, in part because the celebrations included almost everything except the plays of Shakespeare, in part because of bad weather, but largely because the organisers had given practically no thought to the necessary infrastructures of travel and accommodation which must underpin any festival. As a result, many fashionable visitors became lost, or bogged down in filthy Warwickshire roads, and were then forced to pay extortionate prices to sleep in local barns and haylofts.

Moreover, as so many festival organisers have since discovered, it is always important for festivals to retain the general support of the local populace. The Stratford-on-Avon authorities had plainly not done so, as this splenetic Londoner, writing to *The St. James Chronicle* shortly after the event (October 14, 1769), makes clear:

> The low people of Stratford-on-Avon are without doubt as ignorant as any in the whole Island. I could not possibly imagine that there were such beings in the most remote, and least frequented Parts of the Kingdom. I talked with many, particularly the old People, and not one of them but was frightened at the Preparations for the Jubilee, and did not know what they were about. Many of them thought that Mr. Garrick would raise Devils, and fly in a Chariot about the Town. They ordered those whom they had Power over, not to stir out the Day of the Jubilee...
>
> It is impossible to describe their Absurdity, and indeed Providence seems by producing Shakespeare and the rest of his Townsmen, to shew the two Extremes of Human Nature.

Thus the first British drama festival was a damp squib. By contrast music festivals had a longer, more settled, and greatly more successful, history. The cathedral cities which housed them were better able to accommodate visitors, and the purposes of such festivals were less blurred. For example, from its inception, the Three Choirs Festival offered charitable help to the widows and orphans of clergymen in the West of England. Certainly they were better run; the music festivals which were beginning to flourish around 1760 in places as different as Derby, Salisbury and Sheffield were managed by experienced committees of clergy and lay people.

The nineteenth century saw a considerable revival of sporting festivals, sometimes staged after the supposed manner of the ancient 'Olympics'. Although the Olympics were not officially resurrected as an international sporting competition until 1896, competitive athletic and professional sporting events were staged with increasing frequency in the later years of the industrial revolution. That brought a general commercialisation of sport, for which Rick Gruneau offers an explanation:

> Political economists refer to this process as the creation of capitalism's universal market or the transformation of all areas of human exprience into relationships governed by economic exchange. Amateurism notwithstanding, sporting competition became clearly drawn into the universal market during the latter half of the nineteenth century.

The basis of this change lies in the incorporation of various forms of traditional work into wage-labour and industrial routine, which created a separation between work-time, owned by an employer, and leisure-time,

which was one's own. However, the choices available during 'leisure'-time were shaped by the degree to which the new forms of industrial work had destroyed traditional forms of family and community-life and their accompanying spaces, times and opportunities for amusement. As a result time spent away from work gradually became dependant upon the marketplace as a source of personal gratification.

An additional explanation is that local authorities began to see regular sporting matches and longer sports festivals as one means of bringing leisure spending, and its trading spin-off, back into their towns and cities. At all events many cities – Newcastle, Birmingham and Leeds among them – began staging regular athletics meetings. Sequences of first class cricket matches began to be called 'festivals', and were marketed by host towns as 'packages' which included hotel accommodation. City authorities began to take a practical interest in the success of their new professional soccer teams. And capitalism's 'universal market' also extended into rural Britain. In the late nineteenth century, at Wenlock in Shropshire there was for nearly four decades an annual sporting festival which was referred to proudly as an 'Olympiad'.

The trading side, even of small festivals, was always important, but it is noteworthy that when the international Olympics were once more under way, it became paramount. The 1900 Olympic Games, held in Paris, were staged in conjunction with the Paris Universal Exhibition. The 1904 games were held alongside the St. Louis World Fair. There was now sophisticated knowledge, much refined since 1851, about how large-scale exhibitions and festivals should be run: budgeted, marketed and promoted, with all the details of transport and accommodation in their place. Major cities were now able to set up permanent exhibition centres, which could accommodate huge crowds flocking to their increasingly regular set-piece attractions.

Thus, whether they recognised it or not, at the turn of the twentieth century, the Skegness authorities faced powerful rivals for the excursion trade. In London particularly, major international exhibitions and festivals became regular events, occuring two or three times each year. They were accommodated in a growing number of venues: the Crystal Palace was still going strong, Earls Court was operating in the late 1890s, Olympia had opened in 1906 and the 'Great White City' at Shepherd's Bush opened in 1908. All attracted huge crowds. More than 4,000,000 people visited the *Festival of India and Ceylon* at Earls Court in 1895 (where visitors had the chance to enjoy a ride on the Great Ferris Wheel which was a prominent feature of the exhibition grounds). 8,000,000

people attended the *Franco-British Exhibition* at the White City in 1908, and similar numbers the 1909 *Imperial Alliance Exhibition*, and the *Japan-British Exhibition* of the following year.

The new transport possibilities opened up by the railways were extended further by the coming of electric tramways. As late as 1896 Sheffield had still used 310 horses to draw its trams, but the coming of the city's electric tramcars in 1899 quickly led to the horses' early retirement. In 1902 a Wolverhampton Alderman, William H. Jones, conveyed his delight at the new combination of rail and electric tramways which brought the crowds to the opening of the *Wolverhampton Exhibition of Arts and Industries*:

> In addition to the pleasure afforded by the opening of the Wolverhampton Exhibition, six miles of new electric trams were also opened on the same day, which gave additional cause for rejoicing. Fortunately the weather was fine. The railway trains brought in a continuous stream of persons from outside. It was as though half the population of the surrounding towns was coming in to see the show, and towards noon the crowds became very dense.

The resorts were thus being given a run for their money both by the more far-seeing industrialists and by the cities themselves, with the railways benefiting from both sides in the battle.

As Edwardian Britain grew wealthier, and railway and steamers became cheaper and quicker, some of the rigid walls separating the 'tourist' from the humble holidaymaker began to crumble slightly. Some working class people even went on trips to the Continent, just like 'the swells'. In *The Coster Girl in Paris*, 'The sweetheart of the people' Marie Lloyd was able able to tell her admirers that she had just returned from a Continental 'oneymoon:

> *Seen the twinkle in me eye?*
> *Just come back from France, that's why–*
> *Me and Bill went over there to spend our 'oneymoon.*
> *First time I'd been in foreign parts,*
> *Did I like it? Bless your hearts!*
> *Can't say any more than that it ended up too soon.*
> *But don't think I've done with good old England –*
> *not likely,*
> *Born and bred down 'Ackney road, ah! an' proud to*
> *own it too.*
> *You like me make-up?*
> *Ain't it great?*
> *The latest thing from Paris – straight!*
> *Gives a girl a chance to show what she can do!*

The demarcation line between the genteel watering places, like Bognor, and the popular seaside resorts like Blackpool also became slightly fuzzier. Scarborough, Brighton and Blackpool itself all developed segments of their seafronts in different ways to suit the tastes of different classes of visitors. Yet in spite of these modest developments, and despite the massive social and technological changes of the first half of the twentieth century, during that period the overall patterns of holiday-making in Britain changed comparatively little. The surviving spas – Bath, Harrogate, Buxton – looked little different in the nineteen thirties from the way they had looked at the end of the eighteenth century. Most of the seaside resorts, with their piers, military bands and stately promenades, looked and sounded much the same as during the Boer War. The well-to-do still drove off (now in their 'tourers') on Continental holidays, and Nottingham folk still queued for the Saturday excursions to Skegness, although after the *1938 Holidays with Pay Act*, the excursionists probably had a little more money in their pockets.

Even after the Second World War the old pattern was still discernible, though conditions had inevitably become more spartan. The war had impoverished Britain. Generous wartime loans to this country had left it with a debt to the United States in excess of ten billion pounds. Even though the average wage was low – just £6 a week – there was little to spend it on. Clothing, flour, eggs and milk were not de-rationed until 1950. In 1946 and 47 government propaganda still urged people to take their holidays at home (probably wisely, as the resort beaches still harboured the live land mines which had been laid to foil an enemy invasion). But by 1948 things had begun to change, and there was a new kind of seaside holiday on offer. Several of the forces barracks which had been hurriedly built on the coastline during the war, being of no further military use, had been cheaply bought and quickly renovated by speculators and turned into post-war 'holiday camps'.

The 'holiday camp' had been created in the 1930s when, first at Skegness and later at Clacton, Billy Butlin had offered chalet accommodation, full board and free entertainment in his camps for some £4.00 a week. Many of the post-war holiday camps were rather less comfortable than Butlins, but all the camps offered a different kind of experience from the unfettered freedom of the old working class holiday. They were highly regimented, with campers being woken for early morning exercises much as the wartime troops had been woken for their drill. The meals had to be queued for, and a constant cackle of loudspeaker instructions directed campers to the next item on the day's programme. In the evening, there was stage entertainment – usually a

variety bill of entertainers doing the routines that had served them well in the wartime entertainments unit, ENSA. And a further, slightly unnerving, similarity with a wartime barracks was that campers had often to apply for passes before they could leave the holiday compound. So, unsurprisingly, even the best of the camps did not survive the affluence and general freedom of the sixties. Some were refurbished and functioned largely as 'conference centres'. Others closed, not least because of the competition from 'caravan parks', the spreading outcrops of rusty 'statics' which became a familiar sight on Britain's coastline.

The sixties witnessed a further dramatic change in the nature of the British holiday when jet-engined planes began to be used for passenger transport. A new swathe of holiday destinations was brought within the reach of those who could afford it, spreading further afield than even the rich young aristocrats on the Grand Tour had dared to venture. People no longer booked their holiday transport, holiday accommodation and holiday entertainment separately, but purchased them ready-parcelled from one of the new kinds of 'travel agency'. Thus the notion of the 'package holiday', with its mechanical resonances of conveyor belt satisfaction, was born. The old linguistic distinctions between 'tourists', 'holidaymakers', 'visitors' and 'trippers' quickly disappeared, and everyone travelling away from home for any purpose at all became a 'tourist' – a term which had once meant a discriminating individual travelling to seek enlightenment, but which now merely indicated that one had become a statistic in a robotic new 'industry'.

'Tourist industry' was the first of several bureaucratic oxymorons which were to bruise our national ability to consider cultural questions with any clarity ('health industry', 'education industry' and the odious 'arts industry' were to follow). Those who spoke of a 'tourist industry' wished to cleanse the word industry of its pejorative associations (as in 'drug industry' or 'sex industry') and instead hoped to convey something positive involving 'good business sense' or practical hard-headedness. Yet as we have seen, commentators on the nineteenth century factory system had already bestowed on the term a precise meaning. There were good and bad industrialists but an *industrial system* was one in which production processes worked at optimum capacity to produce standardised goods to yield the highest possible profit. A tourist, on the other hand, had previously been considered a discriminating and perceptive individual, *not* an entity which could be standardised, packaged, sold and exploited for profit.

As its use became widespread in the 1960s and early 70s, the catch-all term 'tourist industry' in fact covered an ever-increasing number of

constituent parts. The old divide between work and holidays became less clear. Business persons now attended between two and three 'business conferences' each year, which mingled work and recreation and were staged at large 'conference centres', which customarily would have the facilities of a good hotel, with evening entertainment and daytime sports facilities such as gymnasia, tennis courts and a golf links. For the middle classes and upper working class, it also became quite usual not just to take one holiday but two or three short breaks each year, though these tended to be grouped by age and recreational interests rather than specifically by class, with special 'packages' for a huge range of people and interests – the under-30s, gays, singles, old age pensioners, walkers, gastronomers, anglers and detective story addicts. For the upper classes, the second 'holiday home' now meant owning, or having a 'part-share' in, a Continental villa, though to the working class the holiday home was still likely to be a small caravan.

There was a noticeable tendency for all places touched by the 'tourist industry' to become more and more alike. Whether eating in Hong Kong, Toronto or Kensington, the range of food and drink on offer to visitors often seemed much the same, while the cluster of 'themed' establishments which served it looked disarmingly like every other restaurant area, anywhere – the 'Indian', 'Chinese', 'Mexican' or 'French' dining places looking more like theatrical settings than outposts of their supposed country of origin. Though brochures for 'breaks' and 'getaways' usually promised a 'distinctive' cultural experience, tourist districts tended to become increasingly alike, while tourist shows too often consisted of synthetically marketed packages of supposedly traditional song and dance, watched by visitors who viewed them, if anything, through the eyes of social anthropologists rather than art critics.

In the 1980s, some arts bureaucrats tried to harness the supposedly successful and supposedly highly profitable 'tourist industry' to the arts, for example claiming that research showed that visitors were primarily attracted to Britain by its readily accessible 'heritage' and its cheaply-ticketed subsidised arts, that incomers were, in Evelyn Waugh's memorable phrase, 'trapped in the machinery of uplift'.

Yet there was a basic flaw in the argument, for it looks from the figures as if the same social groups who benefit most from arts subsidy also go most on short 'breaks' overseas. This would not matter if overall the 'tourist industry' were profitable, but it is not. In the early eighties Britain began to show a loss on its 'tourist account'. In 1982, Britons going overseas on holiday spent £3,650,000,000, while incoming tourists spent only £3,184,000,000, making a loss of some £466,000,000. That overall

loss has grown greater year by year and now stands at around £4,000,000,000 a year. State subsidy to the arts might thus contribute to the loss the 'tourist industry' makes. Because home admissions to arts events are priced so low, British people are enabled to spend more and more of their money on overseas holidays. Although these same low gallery admissions and comparatively low theatre ticket prices may also be a factor in attracting incoming tourists, the visitors' spending on the arts does not begin to make good the huge net loss sustained by British tourists' spending abroad.

Mass, Messages and the Media

> Many influential people share with thoughtful
> legislators a growing concern about the problem of
> leisure. Enforced unemployment has already made it
> serious, and with the shorter working day which is a
> certainty of the future, it will become more so.
> Cultural recreation needs stimulus and direction.
>
> *The League of Audiences*, 1936.

In spite of the misgivings of Samuel Smiles, charitable giving by the Victorians remained impressively high. Charity was, however, directed towards work rather than leisure, and towards industriousness rather than art. It is estimated that during the 1860s donations to charity amounted to more than £7,000,000 annually in London alone, a figure not far short of the total Poor Law expenditure for the whole of England and Wales, and it rose steadily in each decade. But charity had a clearly defined role in the overall scheme of things. It was not loosely scattered amongst 'good causes', of varying merit, but firmly steered towards those who were thought able to profit by it. Whereas expenditure under the Poor Law was for the totally poor and destitute, who were 'beyond charity', charitable giving was targeted on the indigent, who were (in theory at any rate) able with such assistance to increase their labouring skills, move to where new employment was available, live more frugally or simply work harder. The sanctimonious added that the merely indigent – unlike paupers – thus showed their value to society by being the cause of charitable actions in others.

For the poor and destitute the Victorian authorities provided union

workhouses. No fewer than 554 of these were built in Britain in the half century following the *Poor Law Amendment Act* of 1834. Those seeking relief in them over the following century included people of all ages – between 1834 and 1908 roughly a third of all workhouse entrants were children under sixteen – and in all states of health. It was whole families that were admitted; an inviolable rule was that a man or woman could not sacrifice themselves for the sake of their loved ones when they had failed to provide for them. But although they were admitted as families, once past the workhouse gatekeeper, families were broken up, and allocated to separate blocks for men, women and children in which they were to live and work.

All workhouses were run by a Master and his wife, who were in turn supervised by boards of guardians, assembled from local landowners, usually farmers and small businessmen with an eye for economies in the running costs. Though women were technically eligible for both duties, there were no women workhouse masters and the first woman guardian did not appear until 1875 – though after that there was a steady increase and there were more than 1200 woman guardians by 1910.

Workhouse life was spartan. Paupers wore rough standard uniforms, and had their hair cropped. The men were not allowed to have razors and in many establishments were shaved only once a week. The workhouse diet was strictly controlled. Inmates were allowed between 137 oz. and 182 oz. of solid food each week, which usually comprised bread, cheese, gruel, soup and potatoes. Only occasionally was there bacon or meat, but some institutions did have an annual 'treat', a special meal provided by the local parish, at which there would be ham and even, on occasion, beer. But in the ordinary run of things, no alcohol was allowed and, contrary to popular myth, the workhouse masters were not permitted to serve seasonal pudding at Christmas time.

The workhouses were of course the supreme embodiment of what later became called 'the Victorian work ethic'. They existed above all to 'instil the habit of work' in their inmates – in the belief that it was a moral lack of industriousness which led paupers into penury. Inmates were supposed to spend each day searching for regular work outside, but for those who were too old or otherwise unable to make the long journey to distant factory gates, as well as for the families of those who were seeking employment, there was a full day of toil within the workhouse. Some tasks involved the maintenance of the workhouse fabric, but in the yards and workrooms other businesses were carried on. The women sewed, made household trinkets and toys, while for the men there was stone breaking, chopping of firewood, and the nail-tearing task of oakum

picking – pulling apart old hempen ropes in order to provide the material used to caulk ships. The workhouse authorities sold the products, but did not of course pay their workers, as that would have weakened the incentive to find outside work.

The *Poor Law Report,* which preceded the Act of 1834, contains a characteristically Benthamite statement that such unremitting work was in itself sufficient for the full life, in words that Josiah Bounderby might have uttered:

> The association of the utility of labour to both parties, the employer as well as the employed, is one which we consider it most important to preserve and strengthens; and we deem everything mischievous which unnecessarily gives at a repulsive aspect.

In truth, the daily routine of the workhouse allowed little leisure, and there were no mischievous entertainments. Even the most enlightened of masters was constrained by rigid legislation, and by the constant supervision of his cost-conscious guardians. In the nineteenth century workhouse authorities were not even permitted to use their funds to assist inmates to return to the outside world, as a handbook for guardians, published in 1871, makes clear:

> [The workhouse] function is to relieve destitution actually existing, and not to expend the money of the ratepayers in preventing a person from becoming destitute – they can only expend the poor rates in supplying the destitute with actual necessaries such as food, clothing or lodging...Expenditure incurred for the purpose of setting a poor person up in trade, in purchasing implements or tools of trade for them...is illegal.

In the twentieth century came gradual relaxation of the rules. Inmates were permitted to keep some personal possessions, more attention was paid to the inmates' recreation, and in 1913 an order was made compelling the removal of children from Britain's workhouses. But they remained a fixed point in the increasingly complicated map of British attitudes to industriousness and recreation. Throughout the first decades of the century, the workhouses co-existed with the new houses of pleasure – the movie palaces, jazz clubs and dance halls – and the boards of workhouse guardians continued to supervise them. When they were finally dissolved in 1930, the duties of the guardians passed to county and county borough councils. Many workhouses disappeared, although a few were still functioning, albeit on a greatly reduced scale, in the nineteen forties.

Meanwhile, before the First World War, and most decidedly in the

decades which followed it, leisure, which only a century before had been possessed by a cultivated minority, had increasingly become the province of the majority. This had many causes. The working week became shorter, and as wages rose, leisure itself became a more desirable commodity. To absorb the newly-gained free time and leisure spending, the range of recreational amenities grew – parks, exhibition halls, sports grounds, dance halls, cinemas. For many the range of recreational activities widened as cycling brought new pastimes within reach, and what was not accessible on a bike could be reached on the cheap new urban transport systems. Homes were better-lit and more comfortable and domestic practices such as cooking, decorating and gardening, which once had been pursued out of necessity, increasingly with the increase in leisure time were cultivated as domestic arts. Although the consequences of this were not always quite what was expected, as Emily Post tartly observed in *Etiquette* (1922):

> To the old saying that man built the house, but woman made of it a 'home' might be added the modern supplement that woman accepted cooking as a chore but man has made of it a recreation.

In all, the increase in leisure and the rapid development of mass entertainment in the early twentieth century together liberated the majority of people from the iron grip of the work ethic, but brought huge new problems in their wake.

The development of each mass medium brought fresh concerns. The popular press, moving pictures, radio and television were each in turn presumed to be lowering social standards, harmful to the individual spirit, destructive of the traditional culture, and hostile to the living arts. But the growth of the mass media was inextricably interlinked with the increase in leisure, and it was in large part the perceived threat from the mass media that led to the agonising over the 'problem' of leisure. The new media gave the mass of people the opportunity to partake in things for which they had neither been bred nor educated.

The arts world assumed a defensive posture, characterised by the feeling that art must itself be diminished by being suddenly accessible to so many. 'Art', as an epithet, was taken back into the possession of the metropolitan élite. This was most famously illustrated by the visual arts establishment's long refusal to acknowledge that photography was art, but it was an attitude which spread across all art forms. In the world of books the distinction between journalists, mere tradesmen, and writers, who were artists, deepened, while the legitimate theatre widened the gulf between itself and the rest of the profession. 'I resent their being alluded

to as actors and actresses,' said the West End stage actor Fred Kerr of film performers, adding that the cinema might be conceded a certain entertainment value, 'if only we could be spared the ravings of the press about its artistry.'

The League of Audiences, a powerful between-the-wars precursor of the Arts Council of Great Britain, was directly and unequivocally hostile to the radio, gramophone and cinema. The League's major purpose was to promote 'the personal, as distinct from the mechanised interpretations of music and drama', although its influential Vice Presidents – B. Seebohm Rowntree, R.H.Tawney and Lady Howard de Walden – were also concerned to address the historical imbalance within state funding in Britain, proposing:

> ...to organise in every constituency a demand from the electors that the government shall give to Music and Drama the practical recognition which it already gives to Libraries, Museums and Picture Galleries.

Their mission statement anticipates in its breadth the British Culture Ministry of sixty years later, although it is less mealy-mouthed about its desire to shape popular taste. The League existed:

> ...to *preach* (sic) a wider and richer use of leisure; and to this end encourage all art, research , scholarship, travel, crafts and sport...

The main emphasis was always placed upon the living arts, which were assumed to be in mortal danger from 'mechanised' forms (the same threat still occupied the mind of Lord Keynes when, in the course of his 1945 broadcast outlining the purposes of the new Arts Council, he suddenly proclaimed, "Death to Hollywood"). To counter this mechanical threat, the League of Audiences proposed the creation of eight cultural animators, 'Commissioners for Art', whose task would be to stir up grass roots support for the living British arts in what were then called the provinces, but which would later be called 'the regions'.

Yet such stirring calls to battle were hardly necessary, for in spite of the ballyhoo caused by the coming of moving pictures, dance records and sound radio, the professional arts were in good order, and prospering, not merely because of private philanthropy, but also because of the continuing commercial investment of businessmen and the support of small subscribers.

The Sheffield cutler J.G.Graves was just one of the new breed of public-spirited industrialists whose philanthropic record at the end of the nineteenth and beginning of the twentieth century makes impressive reading. In 1893, Graves inaugurated a series of lectures and musical

evenings for working men at St. John's Methodist Chapel in Sheffield. In 1916, he became an art collector, purchasing more than 1,200 works for his collection; in 1926, gave a 154 acre park (later known as Graves Park) to the city, and two years later gave £10,000 for the purchase of Eccleshall Woods as another public park. In 1929, he made his largest series of donations so far, giving £20,000 towards the building of what eventually became known as the Graves Art Gallery, £10,000 towards the rebuilding of Sheffield Central Library and a further gift of parkland, Concord Park, to the city. To all this he added a substantial gift to the new gallery of paintings from his own private collection.

In the following year, the Graves Charitable Trust was formed, funded by shares in his business, J.G.Graves Ltd., to the tune of some £400,000. Thereafter, the Trust cooperated with the corporation on a number of projects and in 1933, when the Graves Art Gallery opened, was involved in building a 'model village' of some 230 houses for the aged and infirm in the Sheffield suburbs. Yet his personal donations continued. In 1936, an extension to Graves Park was purchased and opened to the public. In 1937, there was a donation of £27,000 to the Weston Park Museum, and the Graves extension to the Mappin Art Gallery. In 1939, Graves purchased the Grice Collection of Chinese ivories for the city, and there was the gift of the ornamental fountain in the city centre, the Sheffield YMCA, the Richmond Sports Park and the children's playgrounds, not to mention the gift, during his last years, of £250,000 to the British Second World War effort.

Graves' generosity can be set alongside that of many others, some well-known, such as John Christie and Samuel Courtauld, whose names are firmly associated with Glyndebourne and the Courtauld Institute, others less-celebrated, such as the Clark family in Somerset; Jesse Boot, a donor to many Midlands causes, including the building of Nottingham's Albert Hall; the Talbots of Swansea, whose generosity embraced paying for the training of local musicians and the donation of six Hondecoeter paintings to the National Museum of Wales, and such forgotten benefactors as Stephen Mitchell, a tobacco manufacturer from Glasgow, who had in 1874 bequeathed £67,000 'for the establishment and endowment of a large public library in Glasgow with all the modern accessories connected with it', and was thus Britain's first major tobacco sponsor.

Yet in 'the era of the stock exchange', the philanthropy of private industrialists was more than matched by straightforward commercial investment. Investors were attracted to the newly businesslike touring theatre, which had been reorganised into huge and highly profitable

cartels. In 1901, when the London Pavilion paid 9%, and the best-known music-hall, the Oxford, paid 12%, the leaders of the new touring theatre, Moss Empires, newly capitalised at £1,500,000, paid no less than 12.5% to their shareholders. Equally profitable were the new music agencies – W. Norman Neruda and Co., Mitchell and Ashbrooke's and the long-lasting Ibbs and Tillett.

Perhaps most salutary is the fact that in the early decades of the twentieth century, when the live arts were supposedly under grave threat both from the new mass media and from ruthless capitalism, and before the worlds of art and entertainment had organised themselves into their rigid and mutually exclusive categories, there were some fifteen or more fully-manned unsubsidised opera companies touring Britain, all with substantial popular support, all making profits for their private owners. Some of them – the Rousby Opera Company, the Quinlan Company, the Burns-Crotty Company – have disappeared from the public memory, but others, such as the original D'Oyly Carte Opera Company, playing the light operas of Gilbert and Sullivan in their original production formats, and the stylish Moody-Manners Company, are still remembered. One of the best-known, the Carl Rosa Opera Company, founded in 1875, was still presenting an ambitious touring repertoire of operas sung in English in the late 1950s.

However the commonest form of financing arts organisations at the end of the nineteenth and in the first decades of the twentieth century was still public subscription. From the public subscription appeal which established the Leeds City Art Gallery in 1887, to the subscription scheme to set up the guarantee fund of £143,000 to mount the *Scottish Exhibition of National History, Art and Industry* in Glasgow in 1911 the first appeal for funds for a major development was always to the likely beneficiaries, who would take a continuing interest in the well-being of the organisation to which they had subscribed.

Subscription schemes worked on a smaller scale, and particularly in the amateur world. Amateur operatic societies – the movement was sufficiently widespread for a mutual aid society, the National Operatic and Dramatic Association, to be formed as early as 1899 – were usually formed and run on members' subscriptions. So were societies of water colourists and amateur choral societies, but the importance of subscription schemes was best illustrated by the swelling amateur brass band movement. This built upon Britain's rich traditions in domestic instrumental music-making, but also drew from the world of amateur sport the idea of holding competitive meetings. So rapidly did this spread that by 1895 there were already 222 brass band competitions in Britain,

and by the turn of the century an estimated 40,000 amateur brass bands. One firm of instrument makers had more than 10,000 on its books alone. Whereas the military bands were paid for from regimental funds, amateur bands were sustained by a network of subscription schemes: by annual donations from local supporters or, in the case of the industrial and colliery bands, by modest weekly 'subs' from the players themselves.

Histories of the theatre naturally lay emphasis on the creation of the Birmingham Repertory Theatre by the 'tea millionaire' Sir Barry Jackson, but again it is worth noting that a much larger proportion of the thirty or forty other repertory companies which flourished in Britain between the wars were sustained by popular subscription schemes than by the philanthropy of one rich man. Northampton Repertory Company for instance was founded in 1927 by a group of local businessmen who raised the necessary capital by selling 2,000 subscription shares at £1 each. The Manchester (Rusholme) Repertory Theatre was likewise founded in 1923 by public subscription, and then sustained by 450 other subscribers who each agreed to 'indemnify the Theatre against loss to the extent of £10 spread over the next FIVE YEARS, not more than £2 to be called up in any one year'. In York in 1935, local businessmen raised £2,300 in £1 subscription shares to form the York Citizens' Theatre Ltd. and establish weekly repertory in the city. Many of the rep. companies also had 'membership' schemes in which keen local theatregoers could have priority booking and attend social functions – Oldham Rep. had 3,600 'members' by 1939 – and the larger companies publicised lists of local 'patrons' who may not have gone to the shows but were expected to make an annual donation to funds. The prestigious Sheffield Rep. boasted over forty local 'patrons' in 1936, during which year the theatre made a profit of £1,353.

Underlying the commercial development of the arts and the media was the new popular press, and the associated growth in advertising. The invention of the cylinder printing presses, the development of a rapid transport network and the general growth in literacy were all significant factors in the burgeoning of what by the end of the century had became known, at first dismissively, as the 'newspaper industry', but of greater importance had been the removal, in 1855, of the Stamp Duty on newspapers, and the final removal, in 1853, of the lesser-known, but much more punitive, Advertisement Tax. It had at one time cost the proprietors as much as 3s.6d. in tax for each advertisement in their newspapers.

With the right conditions in place the growth of a popular press, based on untaxed advertising revenue and high daily sales, was rapid. W.T.

Stead in the 1880s refashioned the *Pall Mall Gazzette* into the first crusading daily paper. T.P. O' Connor's *Star*, the first $^1/_2$d. evening paper, sold 142,000 on its first day. In 1896, the first *Daily Mail*, selling at 1d., sold 397,215. Then with the coming of the $^1/_2$d. *Daily Express* in 1900, the *Daily Mirror* and *Daily Sketch* in l909, and then the *Daily Herald* in 1912, habits in popular reading were firmly established. With the habit of daily reading went other habits, reinforced by the pattern of advertisement to be found in different kinds of newspaper. From the first the popular daily newspapers reported in detail on the lives of the stars of the moving pictures, the careers of sports stars and the amazing feats of show people but, unlike *The Times* and *The Telegraphs*, contained virtually no mention of major exhibitions, concerts or stage plays.

Curiously, in view of what was to happen, one of the few art forms which did not at first fall into one or other of the mutually antagonistic cultural camps was grand opera. In the early days of radio, when broadcasting was itself little more than an advertising gimmick to promote the sake of cheap domestic radio receivers, operatic recitals were surprisingly frequent. It is noteworthy that when Lord Northcliffe, the highly entrepreneurial proprietor of the *Daily Mail*, decided in 1920 to sponsor a broadcast from the Marconi transmitting station at Chelmsford as a newspaper publicity stunt, it was to a famous operatic diva, Dame Nellie Melba, that he turned. Pictures of the formidable Dame Nellie at the microphone, cloche hat firmly in place and handbag at the ready, were then gratifyingly flashed across the world.

By 1921, when broadcasting was still an informal adjunct to the radio manufacturing industry, operatic recitals had become an established feature of the programme, although, as ever, new technology created its own problems. Lauritz Melchior, the tenor, who broadcast both from Chelmsford and later from Savoy Hill, so unnerved everyone by his unquenchable belief that the louder he sang, the more people would be able to hear him, that the technicians were eventually forced to take the bulky microphones into the adjoining rooms and ask him to sing through an open door. The multi-talented head of Marconi's experimental radio section, P.P. Eckersley, who fashioned many early broadcast programmes off-the-cuff for a listenership at whose tastes he could only guess, of course had no problems with the new technology, but it is interesting that, with an open choice, he several times chose to broadcast versions of grand operas in which, accompanying himself on the transmission hut's one piano, he sang all the parts himself.

In 1923, the private British Broadcasting Company was formed, to co-ordinate broadcasting nationally. It was financed by subscription from

the 24 leading radio manufacturers and broadcasters, of which Marconi (now working from Studio 2LO on top of Marconi House in London) was by far the largest. The new BBC appointed its first general manager, J.C.W. Reith, son of a Scottish Presbyterian Minister, at a salary of £1,750, prompting him to write rather ominously in his diary, 'I am profoundly thankful to God for all His goodness in this matter. It is all His doing.' Early in the following year, on 18th. January 1923, the British Broadcasting Company received its license from the Postmaster General and national broadcasting began.

It was nearly four years until the private company was transformed into a public service, and the British Broadcasting Company became the British Broadcasting Corporation. Yet from the first, Reith ran the fledgling BBC as if its purposes were wholly to elevate public taste and not, as had certainly been the case in its earlier Marconi days, to provide listeners with a range of entertainment. To the criticism that many listeners found the programmes too determinedly wholesome, Reith offered his famous reply:

> It is occasionally indicated to us that we are setting out to give the public what we think they need – and not what they want, but few know what they want and very few what they need.

Making it clear that in contrast he, Reith, most certainly *did* know what people needed. Indeed his critical certainty was allied to an unyielding moral certainty, and a determination that firm monopolistic control of cultural assets by enlightened providers is invariably right. As he declared to the *1923 Crawford Committee* on the scope of the broadcasting service:

> ...central control...is essential ethically, in order that one general policy may be maintained throughout the country and definite standards promulgated.

Reith did not believe that central control should be exercised by government – a belief which the B.B.C.'s independent reporting of the 1926 General Strike, which infuriated the Cabinet, made apparent – but he had no faith in the *vox populii* either. He was certainly no state lackey, but he was an unashamed élitist.

The Corporation was formed on the stroke of midnight, December 31st., 1926. It was a new kind of public body, under license from government, and with a board of governers discreetly drawn from the ranks of the Great and the Good by the Postmaster General, but it was not financed from taxes, as were the national Museums and Galleries. Nor did the new B.B.C. continue to be financed from the private sector.

Instead it drew its income, as so many other British cultural organisations had done through the centuries, from the annual subscriptions of its supporters.

From 1904 the *Wireless Telegraphy Act* had made it necessary for anyone who owned a radio transmitter or receiver to purchase an annual license from the Post Office. Originally the act had been intended as a cunning deterrent to foreign spies, who it was felt would not relish having to buy a license knowing that their names would go on an official register of persons using radio sets. When ownership of radio sets became widespread in the early 1920s the authorities saw no need to meddle with the legislation, archaic though it may have been, as income from radio licenses – in 1922 there were 22,000 license-holders, and by 1926 this had leapt to more than 2,000,000 – was growing usefully. And it was this curious licensing system which enabled the government to keep a degree of control over the new Corporation without having to make the state broadcasting service a drain upon the already overburdened exchequer. People would continue to buy radio licenses from the Post Office, at a level to be determined by the government, and a substantial part of the collected monies would be handed over to the British Broadcasting Corporation. Until the mid-nineteen-thirties the license fee was 10s., of which 5s. 5d. went to the government and 4s. 7d. went to the B.B.C.. (Of this sum, the B.B.C. spent on average 2s. 6¹⁄₂d. on the actual programmes.)

Under Reith, the B.B.C. grew rapidly. When he was first appointed, he had four assistants. By 1926, the B.B.C. employed 773 people, and by 1931, when it moved to its new £350,000 premises, Broadcasting House in Portland Place, more than 1,300. At the end of the twenties, the B.B.C. was already established as the largest individual employer of artists in the country. Its new Drama Department was already employing actors to stage more than 150 of its own productions each year. Under its robust music director, Percy Pitts, it had developed its own fine symphony orchestra; Adrian Boult had taken over its conductorship in 1929. It employed more than a dozen 'announcers' who were responsible for the continuity items, and more than 30 people who were solely concerned with children's broadcasting, which already took up 6% of broadcasting time. In the realms of Dance Music – which occupied 11.5% of broadcast time – the Corporation employed many of the leading dance bands of the day – Lew Stone's, Roy Fox's and Bert Ambrose – and also ran their own B.B.C. Dance Band, at first conducted by Jack Payne and later by Henry Hall. In addition, Reith's B.B.C. was a generous employer of artists, art critics and academics who contributed nightly to the 'discussions' which took up 11% of the time of the new 'National Service'.

Figure 14 Listening to the radio in a railway carriage, *circa* 1927: an early combination of two quite different developments in twentieth century communications.

Hulton Picture Library

Much, however, was excluded. Broad popular entertainment, including a range of pantomime and music hall humour, was, in the interests of 'upholding standards', forbidden. 'The slap-stick, red-nosed comedian is dead,' announced the 1931 B.B.C. *Yearbook* firmly. Nothing was broadcast which involved gambling, and there were no game shows with prizes. Only the blander sorts of popular music were heard; jazz music was an extreme rarity and scat singing was banned outright. Announcers were forbidden to use phrases such as 'hot music'. In 1934 *Melody Maker* published a cartoon showing 'Auntie B.B.C.' putting an urchin labelled 'Listening Public' over her knee and spanking him, with the caption, 'There, brat! Whether you like it or not, your mind's got to be elevated!'.

Certainly in its early years, the B.B.C. did much to elevate musical minds. Indeed its considerable financial clout enabled it to act as a generous patron of many of the bands, orchestras and opera companies which it employed, either paying lavishly for broadcast performances – as early as 1925 the B.B.C. paid the Carl Rosa Company some £3,000 (equivalent to their share of a week's takings in a theatre) to give one studio performance of their touring *Carmen* – or sharing B.B.C. resources with them. In the early years, players in the B.B.C. Symphony Orchestra had also worked in the Covent Garden pit, and the B.B.C. Choral Singers were regularly used to swell the sound of the Covent Garden chorus.

The philanthropic side of Reith was evident in 1927 when, with the death of their co-founder, Robert Newman, it was feared that the Promenade Concerts which he and Sir Henry Wood had started in 1895 would collapse. Instead, Reith stepped in and negotiated a long-term contract with William Boosey, the owner of the Queen's Hall in which where the concerts were staged. The 'proms' would now be broadcast each year with 'Sir Henry Wood and his Symphony Orchestra' under terms that were sufficiently generous to satisfy Boosey and delight Sir Henry:

> I was really elated. I realised that the work of such a large part of my life had been saved from an untimely death. I do not think I ever conducted Elgar's joyous *Cockayne* overture with greater elan.

However the patrician side of Reith's nature in some measure helped raise cultural barriers. His belief that people needed grand opera was matched by an equally firm belief that they did not also need such popular arts as jazz, pantomime or 'red-nosed comics'. In the late twenties, with mass unemployment giving a new and bitter edge to the term 'leisure', his obduracy started to shift Britain's opera companies away from reliance on public support, and towards partial dependancy on official patronage.

A substantial part of the license money was being spent in fees and assistance to Covent Garden – there were twelve full length operas being transmitted from the Garden each year – but Reith was almost as generous to Sadler's Wells, the Old Vic and the ever-reliable Carl Rosa Company. When, in 1930, in addition to the B.B.C.'s support, Reith also contrived to negotiate an additional government grant to the Covent Garden Opera Syndicate, there was disquiet in the popular press, the *Daily Express* commenting:

> There are better ways of spending £17,500 than on subsidising a form of art which is not characteristic of the British people.

Shades of Addison! Although it was, given the fearful economic and social problems of the time, in truth a mild enough comment. Critics of Reith's élitism might have gone further, and drawn lessons from the huge commercial success of a medium which had by 1930 established itself as wholly 'characteristic of the British people' – the cinema.

Following the first British demonstration of moving film at the Regent Street Polytechnic in 1896, the 'film industry' grew rapidly, although in their early years 'movies' found their audience not in purpose-built cinemas but by infiltrating other, well-established, forms of public entertainment. Short films became a regular item in stage variety shows, sometimes (as happened at the Empire, Leicester Square) becoming so popular that they became the chief attraction (though, in early days projectors were still so primitive that films had to be interspersed with stage acts whose function was made clear by their title of 'lantern coolers'). Film or kine booths were soon a prominent attraction at the fairs. In 1900, Hull Fair, for instance, had no fewer than nine travelling kine shows.

Meanwhile, showmen adapted a variety of other public buildings to accommodate what was seen at first as merely the latest craze. The Dara Roller Skating Rink in Camden Town was adapted for film shows in 1903; the Loughborough Corn Exchange became a regular venue for travelling cinema showmen after its refurbishment in 1901; Fosset's Circus Building in Mansfield was crudely adapted for the new movies in 1904. Then as the 'latest craze' began to show increasing signs of longevity, a large number of theatres were turned into full- or part-time cinemas. In Edinburgh, for example, the Palladium Theatre in East Fountainbridge became a cinema in 1902; in the same year Princess's Theatre in Nicholson Street became the La Scala Electric Theatre; and in 1920 the Grand Theatre in St. Stephen's Street became the Grand Picture House.

It was not until 1908 that the first purpose-built cinema was erected. Given their fairground ancestry, it is not surprising that the first cinemas were frequently owned and managed by itinerant showmen who had grown weary of the legislative hassles which now attended the fairs and travelling circuses, and who welcomed the opportunity to settle down. This in turn was one of the root causes of the simmering mutual suspicion between theatre and cinema. The legitimate theatre managers insisted that they spoke for a respectable art, with long and honourable traditions (and Royal support), whereas the new cinemas were merely a vulgar modern manifestation of fairground showmanship, with all its discreditable associations of mob revelry.

Discreditable or not, it was a highly popular manifestation. By the time of the outbreak of the First World War there were, for example, already 27 cinemas in Liverpool and more than 120 in Manchester. By 1817 three and a half million British people were going to the cinema each day. By the early twenties – at the time of the first Marconi broadcasts – there were some 4,000 established cinemas in Britain, with the *Kine Year Book 1921* speaking of the need for at least another 2,000. The coming of 'talking' pictures in 1928 further accelerated the growth – in 1929 more than 300 new 'super cinemas' with facilities for sound were under construction – and by 1939 there were no fewer than 5,500 sound-equipped cinemas in Britain.

The production side of the British film industry – though inevitably very much smaller than its American counterpart – was by the early thirties a considerable employer of artists, writers, designers, and of course actors, while in the last decade of silent films the cinemas themselves had become overwhelmingly the largest employers of British musicians. In the larger cinemas there were orchestras of twelve to fifteen players, though in the medium-sized houses an ensemble of two violins, cello, harmonium, piano and drums was more usual, while in the smaller 'flea pits' there might be only a piano. As late as 1929, the cinema was still employing four fifths of all professional musicians, more than 30,000 people, but as 'talking pictures' became more generally established, the cinema orchestras rapidly collapsed.

Some displaced musicians found employment in the dance halls which began to proliferate in urban areas. By the early thirties there were more than 3,000 such halls in Britain and over the following decades a visit to the local 'Palais de Danse' became almost as fixed a part of the weekly leisure schedule as was going to the pictures. Others joined the itinerant bands which played in the town and village halls, at private functions and in middle class tea rooms. And a few found employment in the record

Figure 15 The sale of records had been much boosted in the First World War, when soldiers listened to wind-up gramophones in the trenches.

industry, but in the early 1930s that was not in good shape. In America in particular, there had been a spectacular fall in record sales; between 1927 and 1932, annual sales fell from 104,000,000 to 6,000,000. In Britain the fall had been less spectacular, but sufficient to put nearly all of the small record companies out of business, and leave the two biggest companies, H.M.I. and Decca, with a joint monopoly of the market.

Until the mid-thirties, there were no British 'recording stars'. The bands, singers and entertainers who made records relied upon their popularity on radio, or, less frequently, on the stage, to sell their records. Radio was the most powerful as well as the most prestigious medium in Britain. Singers on variety bills were promoted less for their musical accomplishments than for the fact that they were 'broadcasters'. When the well-known variety performer Max Miller made his first films he was rather oddly advertised as being a 'radio star', as was fellow comedian Sandy Powell when he made recordings of some of his well-known stage routines.

The new media at times seemed to infect the performing arts with their commercialism. One of their most paradoxical effects was that leading figures in music and drama, while protesting the crassness of the 'newspaper industry', 'advertising industry', 'film industry' and 'recording industry', nevertheless began defensively to reorganise their own realms into the familiar industrial battalions of management and unions. The Musicians Union, formed in 1921, not only swelled its numbers but became much more militant in wage negotiations after the catastrophic collapse of the cinema orchestras. In the theatre the two major management associations – the Society of West End Theatre Managers and the countrywide Theatrical Managers Association – were after 1930 confronted by the first properly organised theatrical trade union, Equity.

An important consequence of the unionisation of drama was that the chasm between amateur and professional artists, not just in an economic sense but in terms of critical estimation, became very much wider. There were 3,000 amateur dramatic societies affiliated to the British Drama League in the midthirties, but they had virtually no links with the professional theatre. Whereas it made little sense to ask whether a poet or a landscape painter was a full professional, it was absolutely essential to ask whether an actor was, as Equity and the management associations now combined to operate a closed shop.

Meanwhile the long-standing fears that the management associations had expressed about the impact of film and radio upon the economics of live theatre were proving unfounded. As early as 1911, the Society of West End Managers had resolved:

a) That in the opinion of this Society the giving of facilities to the Managers of the Picture Palace Theatres enabling them to take cinematographs records, or films, and so to reproduce theatrical performances, is very prejudicial to the general interests of the theatrical profession and is accordingly greatly to be deprecated.

b) this society trusts that members will accordingly refrain from giving any such facilities.

And in 1923 the Theatrical Managers Association joined with S.W.E.T.M. in determining that the theatres could not 'give any facilities' to broadcasters. Until the mid-thirties it was only rarely – and usually with considerable misgivings – that the management associations permitted excerpts from their stage shows to be broadcast, although it gradually became apparent that, far from extinguishing public interest, the filming or broadcasting of a live show usually increased box office demand. In spite of the assumed 'competition' from radio and films, and in spite of the lack of government subsidy, interest in serious theatre, like interest in serious music, remained high. As William Armstrong said of the Liverpool Rep in the 1930s:

> For years we were financially successful, and in spite of weekly expenses of £500, made a regular profit. But this miracle was not achieved by deserting rep. and exploiting London successes. Some of our biggest financial successes were plays like Sherwood's *The Road to Rome*, Sierra's *The Kingdom of God*, Schauffler's *Parnell*, Priestley's *Time and the Conways* and Huxley's *The World of Light*. We made money on all our Shakespearean productions.

In post-war Britain, with all the resources of state subsidy and with all the expertise of state bureaucrats, it was to prove impossible to recreate that close association of an excellent provincial theatre company with a large and intelligent audience over any length of time.

The serious anxieties about the new mass media, and the 'culture industry' of which they were the harbingers, were about much more than their supposed economic impact. The real concerns were of an altogether broader and deeper kind. Foremost among them was the way in which the concentration upon mass sales in mass markets tended to turn large segments of those parts of the national culture which were 'characteristic of the British people' into industrial and economic processes in which all feeding and experience was standardised and packaged. As Theodor Adorno and Max Horkheimer remarked in their seminal paper *The Culture Industry; Enlightenment as Mass Deceptions (1945)*:

In the culture industry the individual is an illusion not merely because of the standardisation of the means of production. He is tolerated only so long as his complete identification with the generality is unquestioned. Pseudo individuality is rife; from the standardised jazz improvisation to the exceptional film star whose hair curls over her eye to demonstrate her individuality. What is individual is no more than the generality's power to stamp the accidental detail so firmly that it is accepted as such.

Just as within the consumerist society advertisers must constantly sow the seeds of dissatisfaction with yesterday's purchases, so that more will be bought tomorrow, their constant necessity to increase sales must impel media moguls to incite an ever-increasing consumption of their wares, while pursuing a perpetually receding satisfaction. In the commercial media advertising and product thus blend into one process. In Adorno and Horkheimer's terms:

> The culture industry perpetually cheats its customers of what it perpetually promises. The promissory note which, with its plots and staging, it draws on pleasure is endlessly prolongued; the promise, which is all that the spectacle consists of, is illusory: all that it actually confirms is that the real point will never be reached, that the diner must be satisfied with the menu.

A second great anxiety about the mass media must be that they contribute significantly to what is a further distinguishing feature of life within economically advanced countries – the paucity of achievable satisfactions.

Instead of engaging with reality the generality of media productions offer escape, a flight into various kinds of utopia, about which Richard Dyer observes:

> ...the utopianism is contained in the feelings it embodies. It presents, head-on as it were, what utopia would feel like rather than how it would be organised.

Sometimes, as might be expected in an urbanised post-industrial society, utopia is set within an idealised rural setting, but more frequently still it is set in an agreeably sanitised corner of the recent past.

This is so in that most characteristic of media productions, the soap opera. From the first British soap opera – *The English Family Robinson*, first broadcast in 1937, to the present televised sagas of *Eastenders* or the long-running *Coronation Street*, though presented with a veneer of contemporaneity, the social mores of the characters are in fact always ten or twenty years out of date. Many of their characters still live in extended families, shop for their weekly groceries at the corner shop, meet their

friends in the agreeably folksy snug of the local public house and lay the table for high tea. There seem to be few home computers, mobile phones and out-of-town shopping malls in the soap opera world. Nevertheless, soap opera characters are made to appear more 'real' than ordinary neighbours are, and together with pop stars, the Royal family, television presenters and a few sporting stars, form part of a daily saga, a manufactured daily substitute for real living, which is ceaselessly promoted by British newspapers, magazines, radio and television. It is a relentlessly manipulated illusion of 'reality', its constantly deferred satisfactions making it indistinguishable from the advertising process, designed to smother and displace all first hand experience. Adorno and Horkheimer once more:

> The might of industrial society is lodged in men's minds. The entertainments manufacturers know that their products will be consumed with alertness even when the customer is distraught, for each of them is a model of the huge economic machinery which has always sustained the masses, whether at work or at leisure – which is akin to work.

The mass media, which in their organisation and sales seem so often to replicate all the dehumanising aspects of Victorian industry, promote many varieties of apprehension. In the minds of the authorities they raise the awful spectre of power passing to the people. ('Mass,' as Raymond Williams reminded us, 'is only a new word for mob.') To cultural planners, they seem, unjustly, to be powerful invaders of leisure time who must surely standardise human response and wipe out all creative and minority pursuits. To the critics each new medium seems likely to presage the death of art. Yet in turn each new medium has the potential – when an alert segment of the supposedly inert mass of the general public (sometimes unexpectedly) recognises a distinctive talent – to produce works which go against the grain of the 'huge economic machinery' and contend to be recognised as individual works of art: Charles Parker's radio documentaries, Orson Welles' *Citizen Kane*, post-war *Guiness* advertisements, the *Sergeant Pepper* album, *The Hitchhiker's Guide to the Galaxy*.

What is certain is that the growth of the mass media has contributed to a disturbance in the English language which has made talking about 'work' and 'leisure', 'industry' and 'art' even more difficult than it was before. But that disturbance has been only partly of the media's doing. It is true that the tycoons of the new media have generally flaunted their commercialism by calling their films and records 'products', their patrons 'consumers' and their creative processes an 'industry'. But it is the

reaction of the high arts world which has exacerbated the confusion. Although it might have been an opportunity, the growth of the mass media in Britain has instead been seen as a threat to the cultural interests of the metropolitan arts establishment (although simultaneously often proving highly remunerative for them). The arts and the mass media might have found it possible, in some fields, to work in partnership but instead it has been seen as a simple confrontation between good and evil. In terror of a new populism the arts elite has chosen to stigmatise each of the new media in turn as an automatic enemy of excellence.

Consequently, in the banal but effective phrases of Noël Coward's *Twentieth Century Blues:*

> *In this great illusions,*
> *Chaos and confusion*
> *People seem to lose their way.*

As the 'media industries' grew ever more powerful there were further drastic realignments of the concepts of 'work' and 'leisure', and 'industry' and then 'art' were once more persuasively redefined. Yet the most dramatic shift in meaning was perhaps Lord Keynes' 1945 announcement that henceforward in post-war Britain all forms of legitimate 'art' (and not merely the plausibly educational arts organizations) were to be perceived as charitable causes, and hence set apart from the 'huge economic machinery' which sustained the mass media. 'The arts' were moreover to be a new kind of charity. No longer would they be supported by voluntary subscriptions from the general public, but would be paid for from general taxation.

It was that – rather than the trivial sums which post-war governments actually allotted to the arts – which was the major cultural realignment in post-war Britain. It was a development which both downgraded straightforward commercial activity in the British arts, and further weakened the remaining links between arts organisations and the general public. State bureaucrats insidiously became the new arbiters of taste, and by their new power had a profound effect upon surviving commercial markets. For example the hugely successful post-war British sales of paintings were largely generated within state-supported 'charities' – the subsidised galleries whose state-aided curators bestowed upon favoured artists their highly bankable reputations.

Elsewhere, the new alignment led to another curiosity. Post-war Britain saw the growth of a network of 'arts centres', nearly all operating as charities, nearly all subsidised by the state, run by high-minded local trustees, and largely staffed by public-spirited volunteers. Their function

seemed to be to offer purposeful relaxation to the otherwise unemployed and to disseminate inspirational particles of high art to the culturally deprived – while offering them a new kind of utopian vision, a Britain given over as completely to 'leisure' as Samuel Smiles had once advocated the giving-over of Victorian society to work. Advocates of the post-war state 'arts centres' were soon zealously insisting that it was a civic duty for 'every town to have one', all in defiance of Orwell's warning that in modern states the authorities conspire:

> ...to turn the writer, and every other artist as well, into a minor official working on themes handed down from above.

As had happened in the case of another kind of institution a century before, plans of the 'ideal' arts centre were now drawn up by the state authorities and sent to Town Halls throughout the country. It was by no means the only way in which the post-war arts centres, set up alongside the new 'cultural industries', echoed the aims, function and charitable purposes of the Victorian workhouses during the industrial revolution.

Nationalisation of the Arts

> It is impossible to over-dramatise the coming crisis as
> it potentially strikes a blow at the very core of
> industrialised society – the work ethic. We have based
> our social structures on this ethic and now it would
> appear that it is to become redundant along with
> millions of other people. To accommodate this shock
> there will have to be major changes throughout
> society.
>
> Clive Jenkins and Barrie Shearman,
> *The Collapse of Work 1979*

> Being good in business is the most fascinating kind of
> art...making money is art and working is art and
> good business is the best art.
>
> Andy Warhol, *The Philosophy of Andy Warhol 1975*

The authorised version of our recent cultural history rests on two axioms about government and the arts. The first is that governments demonstrate their good will towards the national culture by having arts policies. The second is that unless there are arts policies and art subsidy systems in place, the actions of governments are of little significance to them. Each is demonstrably false. The wider legislative actions of British governments throughout the nineteenth and early twentieth century – before such a thing as a national 'arts policy' was even considered – profoundly affected artists, the composition of the arts and the way the arts reached their publics. More recent administrations, far from demonstrating a newly-discovered benevolence towards British culture, have in practice wrought great harm to it by their 'arts policies'.

The word 'policy' has in any case a shady history. Until our own time, it was a tricky and disreputable quality, akin to 'deceit' or 'cunning'. It was

not a term commonly used of groups or societies but more usually of individuals, and usually disreputable ones. In the nineteenth century, scheming landlords may have had policies but respectable City companies most certainly did not. Consequently, although Victoria's governments often took decisive action in such fields as health and education, they did not speak of their 'health policies' or 'education policies' while they were doing so. Rather, they adduced the correct course of action in each area from their general political principles. It was only when dealing with countries that had the misfortune to exist beyond the boundaries of the British Empire that the term was regularly used. The British Cabinet did feel it prudent, when dealing with Johnny Foreigner, to have a *policy*, but it was not the sort of thing one inflicted on one's own people. Having a government 'arts policy' would have seemed as alien to the governments of Gladstone or Disraeli as a proposal that all British marriages should be arranged and solemnised by the Home Office.

Although in the latter part of the nineteenth century British governments promoted universal education; subsidised specialist training in music and art; legislated for countrywide free library provision; directly financed the building and running of the National Galleries, equipping them with generous acquisition funds; permitted the new local authorities to spend a portion of their rates income on supporting local arts; removed the Stamp Tax and Advertising Tax and paved the way for a publishing boom; framed laws which made it possible for theatres and music, dance, concert and exhibition halls to be built in Britain's towns and cities; partnered the private sector in the provision of a national network of museums, and gave encouragement to the private interests which created both the 1851 *Great Exhibition,* and its many siblings – all actions which may be thought to speak of a certain cultural enlightenment – they did it all without the hint of a formal 'arts policy'.

That should not be taken to mean that Victorian governments so loved the arts that they felt impelled to promote them for their own pure sake. Nor did their actions invariably stem from a political calculation that what they were doing would bring the greatest benefit to the greatest number of people. Government motives were – and are – much more complicated that that, and the results of government actions in any case rarely were what legislators expected. For instance, it is unlikely that government officials had the great end-of-the century growth in novel-reading at the forefront of their minds when they legislated for universal education, and hence for near-universal literacy. In like fashion, nineteenth century governments financed the new National Galleries for an applied political purpose – in the words of the painter Benjamin Robert Haydon, they

wished to promote an 'improvement in manufactures'. They cannot have known that they were, in fact, creating shrines to pure art.

We have already seen that a major reason for creating the Great Exhibition was the authorities' wish to counter dangerous republican sentiment, and to damp down the revolutionary fervour of the time, and noted that the 'improving' civic amenities – the libraries, town halls, assembly rooms, museums and galleries which after 1850 proliferated in Britain's towns and cities – were frequently built not with the intention of enriching the lives of the workers, but to counter what was seen as the growing threat from growing working class leisure. Meanwhile, the remaining fairs and carnivals, together with the new resorts, were not allowed to continue and to grow because working people deserved a good time, but because they were containable arenas, which the authorities could monitor and if necessary control, for the volatile pleasure-seeking of the proletarian mass.

Government actions can sometimes be explained even more simply. On occasion it seems that they just follow diplomatic fashion, creating certain kinds of cultural amenity because that is what civilised nations do. The creation of the British National Gallery seems just a case. When the Gallery first opened its doors at 100 Pall Mall in 1824, it followed on the heels of the opening of a similar institution in Berlin the previous year, and the establishment of National Galleries in Vienna in 1781, Paris in 1793, Amsterdam in 1808 and Madrid in 1809. Although having a National Gallery had become a mark of a civilised European nation, there was a noticeable lack of enthusiasm for it amongst British politicians. They rather tended towards the view that their compatriots were not of a character likely to benefit from such an institution, Lord Farnborough (one of the first Trustees) considering that 'those in inferior stations would find great difficulty in attaining a taste for the liberal arts'. Sir Robert Peel offered the pious if rather forlorn hope that in addition to showing pictures, the new Gallery might somehow lead 'to the cementing of the bonds of union between the richer and poorer orders'.

100 Pall Mall was the former town house of John Julius Angerstein, whose collection of pictures had been purchased by the government from the repayment by Austria of loans made to them by the British Treasury in 1795 and 1797. Sir George Beaumont followed this by giving his Old Masters to the nation, in the hope that 'by easy access to such works of art the public taste might improve'. The two formed the nucleus of the new national collection. In the parliamentary debates which preceded the National Gallery's establishment, the Chancellor of the Exchequer, commenting on Sir George's gift, expressed himself hopeful that his

'noble example would be followed by many similar acts...the results of which will be the establishment of a splendid Gallery...worthy of the nation'. It was a justified hope. The National Gallery received many large subsequent bequests, including those from Howell Carr in 1831, Wynn Ellis in 1876 and George Salting in 1910.

The Gallery has, however, always remained the direct responsibility of the state. It was the Treasury which financed William Wilkins' Trafalgar Square building, which opened in 1838 and which still houses the national collection. The staff – first led by a Keeper and an Assistant Keeper, and from 1855 by a Director – were paid as government employees. Private bequests were from the first matched by special purchasing funds made available by government. As early as 1825, parliament made a special grant to enable the Trustees to buy Correggio's *Madonna of the Basket* and in 1855 the Treasury mandarins awarded the National Gallery Trustees an annual purchase grant of £10,000. The National Gallery of Scotland received a similar, though smaller, grant after its opening in 1859, and so by 1860 the British government was irrevocably committed to the ongoing financial support of the visual arts.

In 1868, the government voted an annual grant of £500 a year to the teaching at the new Royal Academy of Music. This was thought to be a proper groove for state support, which would do nothing to warp either music's strong commercial base or its traditional links with the church. Amongst other things, it was an important politicial gesture, for it could then be said that the British government now followed most civilised European countries in supporting 'Music and The Arts'. (The descriptive term 'the arts' was used much less generally than the qualitative 'art', and commonly meant what it came to mean in the schools – drawing and painting.) Elsewhere, the British were disinclined to follow France's example and offer support to the theatre, not least because many leading theatrical lights had an instinctive aversion to what they saw as the threat of state control. Their fears were summarised by Beerbohm Tree in 1891 in a lecture to the Playgoers Club:

> It sometimes happens that, in his attempt to evade the quicksands of the Bankruptcy Court, the manager perishes in the stagment waters of commercialism. It is obvious that a manager should be freed from these sordid considerations and I believe that in almost every country but England the theatres are state-subventioned. It is an open question, however, in a country in which individualism in all departments has taken strong root, and where state encouragement or interference is looked upon askance – whether a national or subsidised theatre would be for the ultimate benefit of the community.

Those opposed to state aid were also fond of citing the Comédie Française, where performances were said to be over-institutionalised and dull. As Tree darkly added, 'Other countries do not tend to show that the State-subsidised theatres are in touch with the age.' Moreover it was the Crown, not Parliament, which had traditionally patronised the stage. So it was not until 1945, with the creation of the Arts Council of Great Britain, that state aid to drama was established in Britain.

It is at this point necessary to remind ourselves that state subvention is only one of the ways in which governments shape the way each of the art forms develops. Although the way taxpayers' money is spent is plainly of concern to arts managers, the forms of taxation and the means by which taxes are levied are also important. The generally low taxation of the Victorian era – when the government reintroduced Income Tax in 1842 those who paid tax paid only 7d. in the pound – gave an added dimension to the growing 'problem' of leisure, for in the opinion of the reformers low taxation left too much money in the pockets of the workers. Even so until the First World War taxation continued to be directed primarily at the well-to-do. In 1894 Estate (or 'Death') Duties were introduced, but only for those leaving more than £10,000. In 1909 a 'Surtax' was added to Income Tax but only for those earning more than £2,000 a year.

In the nineteenth century the system of local government developed rapidly. The new local authorities were allowed to levy local taxes (or rates) on their householders, but it was central government which directed how rateable income must be spent. Three bills shaped the system. *The Local Government Act* of 1888 gave the new County Councils responsibility for levying rates and for the countywide maintainane of roads, bridges and lunatic asylums. The *London County Council Act* of 1889 established a unique authoriry for the capital, while the *Local Government Act* of 1894 created rural and urban district councils, with their own tiers of responsibility.

There were few discretionary areas of spending, but they included the right of the new Councils to spend up to 1d. in each pound on music and the arts. This was more honoured in the breach than in the observance. Some authorities spent virtually nothing at all while others, particularly the resorts, who felt that that a two hundred and fortieth part of each pound was far too low a maximum, spent much more. As early as 1879 Blackpool successfully applied for the power to spend 2d. in each pound, while others simply bent the government rules. Many of the major resorts – including the Matlocks, Yarmouth, Scarborough and Tenby – were spending well in excess of a 1d. rate at the outbreak of the First World War. By 1925 even

respectable Folkestone was spending an annual £1,400, equivalent to a 1½d rate, Bath was spending £5,898, a 3½d. rate, and Morecambe was spending no less than £2,800, equivalent to 7p. in the pound.

The fact that local authorities generally escaped penalty is partly because there is no clear definition in British law of what does or does not constitute 'the arts', but also because of the radically different intentions of the various local 'improvement acts' of the second part of the nineteenth century. In new industrial towns such acts generally aimed to clamp down on potential disorder, by imposing strict licensing conditions on shopkeepers, publicans and visiting showmen. By contrast improvement acts in the resorts generally aimed to increase the capacities and accessibility of local amenities. Where influential local residents objected to others developing their town as a popular resort, as happened at Blackpool in the middle of the nineteenth century, the legislators would hedge their bets. For example, the *Blackpool Improvement Act* of 1853 emphasised the need for better Sunday observance and greater decorum on the beach (particularly over the matter of mixed bathing), but still permitted the local authorities to license bathing-machines, donkeys, pleasure-boats, cabs and cafés to cater for the visitors.

Between the wars, there were a number of parliamentary moves to loosen the constraints on local authourities' expenditure on the arts, and to permit them to do more than provide concerts. In 1925 a bill was drafted which in its original from contained these paragraphs:

> Any part of the park or ground...for the purpose of bands of music may be used for the purposes of music *or other entertainments.*

> Any expenditure by the local authority...shall not, when added together, exceed in any one year an amount equal to that which would be produced by *a rate ot two pence in the pound..., for such higher rate in the pound as may be approved by the Minister of Health...*[Our emphasis]

The looseness of the phrasing greatly alarmed the theatrical managers' associations, and strong representations resulted in the following sentences being inserted during the Lords reading of the bill:

> Provided that the following restrictions shall have effect with respect to any concert or other entertainment provided by the Local Authority under this section, that is say-

> 1. No stage play shall be performed, and

> 2. The concert or other entertainment shall not include any performance in the nature of a variety entertainment, and

3. No cinematograph film, other than a film illustrative of questions relating to health or disease shall be shown, and

4. No scenery, theatrical costumes or scenic or theatrical accessories shall be used.

So in the event, the *1925 Public Health (Amendment) Act* effectively stopped local authorities from directly promoting any form of live drama, or from showing films – with the unappealing exception of works which dwelt upon the question of disease – until well after the Second World War.

Nearly all forms of central taxation irrespective of their ostensible purpose will have some effect upon the ways in which artists reach their publics. Those which are plainly directed at the arts – such as the Entertainments Tax which was first levied on admission to the performing arts in 1916, as a 'temporary wartime measure', and which in fact lasted until 1958 – often have unexpected effects. The scope of the Entertainments Tax was gradually widened between the wars to take in an ever-wider span of sporting and recreational activities, and its rates on the higher prices steadily increased. In 1924 came one of many drastic revisions in which the Tax was abolished on all admissions up to 6d. in price, and lessened on all those up to 1s. 3d. This led to an outcry from the concert hall and theatre managers (who had virtually no seats at such low prices), but greatly boosted the profits of the cinema managers. So the Entertainments Tax, designed to be levied impartially, in fact helped to build massive popular support for the British cinema.

Central and local government's relationship with the British film industry has, however, been less benevolent in other areas. In the early years government came near to assuming control of the content of films. The *Cinematograph Act 1909* had given local authorities the power to licence cinemas. It was clear that this act was solely concerned with public safety but when, in 1910, London County Council's decision to restrict the Sunday showing of films was challenged in the courts, it was held that the 1909 act was 'intended to confer on the county councils a discretion as to the conditions they will impose, so long as those conditions are not unreasonable', and taken to mean that local authorities also had powers of censorship over the content of films.

The film industry became alarmed by the implications of this and in 1912 they approached the Home Secretary to ask him to take the initiative in setting up an independent censorship body. The Home Secretary refused, pointing out that the power of censorship appeared to lie with the licensing bodies, and that the film industry moguls should set up their own body and attempt to gain the co-operation of the local authorities. The industry duly set up its impartial body, the British Board

of Film Censors, with a President, Mr. G.A. Redford, and four film examiners, and film producers were thereafter obligated to send their films to the Board for licensing

However, the Board did not at first gain the full cooperation of the local authorities, and some were actually stimulated into more active censorship by the Board's creation. There was a feeling in the words of a *Bioscope* editorial (November 25, 1915), that:

> The trade has got to make a move...to obtain Government approval and recognition of an Official Censor Board.

In 1916, the Home Secretary, Herbert Samuel, called a conference of local authorities to consider the problem of film censorship. He told them that the existing censorship arrangements were not adequate, and that following discussions with a number of chief constables he was convinced that the recent increase in juvenile delinquency was, to a considerable extent, 'due to demoralising cinematograph films'. He thought there was much to be said for 'a new Board of Censorship which would contain representatives of the Home Office' – in effect a government-controlled censorship. In November of that year, Samuel announced that official censorship in the film industry, with a new board of censors chaired by a Home Office nominee, would begin its work on January 1st. 1917.

That it did not do so was not because of any thing so grand as a change in official policy, but simply because there was a fortuitous change of officials. Samuel was replaced by a new Home Secretary, Sir George Cave, who was less interested in the film business than this predecessor and who reverted to the original belief that powers of censorship should remain vested in the local authorities. Meanwhile, G.A. Redford died, and was replaced by T.P. O'Connor M.P. as chairman of the British Board of Film Censors. Years of uneasy truce followed, but gradually the Board gained the confidence of the local authorities – in 1920, Middlesex County Council made it a condition of their cinema licenses that the Board's certificates should be adopted, and in 1921 London County Council followed suit – and there have not since been any sustained attempts to reimpose central government film censorship. The 'typically British' situation for more than half a century has been that the industry's own Board, which is set up and paid for by the industry, gives a licence to all films shown in Britain, but that any local authority may, if it wishes, overrule the Board's decisions.

It was not until the forties that the British government played any direct part in the financing of film production in Britain. Until then it had been in the hands of commercial speculators, most notably the shadowy figure

of J. Arthur Rank, who spent and re-made his immense fortune in the film industry and who was destined to be in 1948 the unwitting progenitor of the first post-war government body to offer subsidies for film production, the National Film Finance Corporation.

Rank, from a highly successful milling family, was a multimillionaire businessman, a Freemason, Methodist and Sunday School teacher, but had no particular interest in films. It was not until the age of 40 that he became involved in their production, joining a religious pressure group called the Guild of Light, whose members believed that the mainstream cinema was morally corrosive and that instead films should be used to spread the Christian message. In 1934, Rank financed his first two films, *Mastership*, which cost £2,000 and lasted 20 minutes, and *Inasmuch*, about St. Francis of Assisi, which provided a first starring film role for Donald Wolfit. Both were evangelical in tone and with a simple Christian message. These first films were not shown in conventional cinemas, but given special screenings in churches, schools and youth clubs. Later the religious arm of the Rank organisation was in effect to offer subsidies to enable Christian groups to put on suitably improving shows; offering films, screens and 16mm. projectors for hire at low rates.

By the mid-thirties, Rank, whoseems to have found little difficulty in reconciling his hard-headed business interests with his puritanical Methodism, had also become convinced of the profitable opportunities offered by the mainstream cinema. He did not discard his religious film interests, but moved additionally and substantially into commercial film-making, setting up Pinewood Studios with Henry Boot in 1936, and his own studio, Norwood, the following year. He also began his ten-year-long takeover of British cinema chains, which was to include Oscar Deutsch's 310 Odeon cinemas ('Odeon' standing for Oscar Deutsch Entertains Our Nation) and the 275 Gaumont British ones, and was thus launched towards his eventual dominance of both the production and distribution side of the British film industry.

Yet in the mid-thirties, for all its seeming busyness the production side of the British film industry was in trouble. To try to stem the inflow of American films and give the British film makers a chance the government in the *Cinematograph Act 1927* had imposed a ten-year 'quota system' on British exhibitors, under which they were forced to include a proportion of British-made films in their programmes. The act had not been wholly successful. Good American films, which the public wanted to see but which were in excess of the quota, had to be stockpiled so there were long delays before they were released, while the required British element was being made up of 'quota quickies' – cheap films hurriedly made, which

made profits but which also lowered the reputation of British studios.

The various attempts by government to 'regulate' the British film industry, and to steer a course between the commercial demands of the British film makers and the huge public appetite for American films, now entered choppy waters. As the quota decade came to its end a Government committee chaired by Lord Moyne pondered the industry's future. They decided that on the whole, the quota system had achieved its ends and proposed its extension for another ten year period. To deal with the low level of 'quota quickies', the committee proposed that in future there would be a 'quality test', administered by a new *Goverment Film Commission* – although in the event this proposal was rejected by parliament. Noting the increasingly parlous state of British film producers the Moyne report also called for the creation of a film-financing agency, but this was also rejected, as was a further Moyne suggestion that workers in the precarious film industry ought to be protected by a Fair Wages Clause.

The Moyne report (though not all of the legislation which followed it) was in many ways a blueprint for later government policies towards the film industry, and in one particular respect was painfully prescient. The government legislation of 1937 followed Moyne's suggestion that what it termed 'art' films should be exempted from the quota restrictions, providing that they were not seen by too many people. Thus in the cinema, as in so many other realms, 'art' became by definition a minority activity. An 'art' cinema was always going to be a small cinema, catering for the unconventional minority that liked 'art' films. Yet this slightly pejorative use of the term, which firmly links 'art' with 'minority tastes', and with crankiness generally, meant that it became harder for serious critics to pose the question of whether successful British films such as Korda's *The Private Life of Henry VIII* (1933) or Rank's *Turn of the Tide* (1935) could be considered works of art, as they would seem to have been disqualified even if they had enjoyed only slight popular success.

Overall the finances of the British film companies were in a bad way. Rank's *Turn of the Tide* had cost £30,000 to shoot but got back only £18,000 at the box office. Whereas American films were in the thirties earning on average £50,000,000 a year from British cinema-goers, British-made films, without access to the huge American market, rarely made profits. Yet in the decade following the introduction of 'talkies', film production in Britain continued to expand. Between 1928 and 1938, the amount of working studio space quadrupled, and in 1937/8, British studios produced no fewer than 228 films. But much of this growth was on borrowed capital, which persistently failed to show a return to

speculators, and a number of private companies which had been heavy investors – such as the Prudential Assurance Company which had spent more than £10,000,000 on film production – began to draw back. Studios at Twickenham and Lime Grove closed down. Korda's staff at London Films had large salary cuts. Gaumont British Distributors folded. In 1938/9, the British produced barely half the films completed during the previous year.

Only J. Arthur Rank, with his huge family fortune enabling him to pick up the pieces as others collapsed, came out of the mid-thirties in a stronger position. A staunch Conservative, Rank now gained the ear of friends close to the government. He was approached by Lord Portal, who had been Chairman of the 1936 Berlin Olympics, and who was a trouble-shooter for the Conservative Party, and asked to do something about British movies before the industry collapsed. He set to with a will, setting up a holding company to finance developments, The General Cinema Finance Corporation, with money from, amongst others, Lord Luke (of Bovril), Lord Lindenberg (of Japhets Bank) and Sir Edward Mountain (of Eagle Star Insurance). He moved heavily into the production of feature films, distributing them on the growing Rank circuits. By the end of the war, Rank was established as the undoubted leader, if not quite the sole dictator, of the commercial film industry in Britain.

Between 1945 and 1947, Rank made renewed efforts to gain screenings for his films in the United States, and was alarmed to learn in 1947 that the post-war Labour Government intended to impose a swingeing 75% levy on all imported U.S. films, with the intention of passing on the revenue to British film makers. Its immediate effect was not only to put a stop on all Rank films being shown in the States, but provoked the Hollywood producers into a short-lived boycott of British cinemas. When the levy was lifted after a few months in March 1948, a pent-up flood of American film releases swamped British cinemas. Attendances soared, reaching their highest-ever peak in the history of British cinema – although the Rank Organisation claimed that the actions of the government had harmed British film producers and had cost them £20,000,000.

Rank was now locked in battle with the Labour government, and in particular with the President of the Board of Trade, Harold Wilson. When Wilson, aiming to help the British film industry, now raised the quota of British films to be shown in British cinemas to 45% he was angered that Rank would not co-operate and apparently made no attempt to reach his agreed target of 47 feature films, preferring to make a small number of prestige works. (*Oliver Twist, Hamlet, Scott of the Antarctic* and *Red Shoes* were all made in 1948.)

Thereafter, and not without a certain irony, Wilson chose to regard Rank as irredeemably commercial, the business soul of mainstream cinema. In opposition to this base commercialism, Wilson set up the government's own National Film Finance Corporation in 1948, with state funds to subsidise independent film producers. This underscored the distinction between mainstream commercial cinema and the making of educational or 'art' films, a divide which had opened up during the Second World War, when the government-financed Film Unit of the Army Bureau of Current Affairs had produced films as a form of educational service.

In television, things happened in the reverse way. Out of public service broadcasting came the television 'industry'. The first steps towards this were taken in the dying days of the first post-war Labour administration, when in July 1951 it published the report of the *Beveridge Committee on Broadcasting*. The report advocated the continuance of the B.B.C. monopoly and the *status quo*:

> ...the best interests of British broadcasting require the continuance of the corporation on substantially the present basis. All the alternatives to the present system that have been suggested are open to substantial objections and the government are satisfied that they would result in a serious decline in the service to the public.

Almost immediately after its publication in July, the Labour party was defeated at the polls and the incoming Conservative administration took a fresh look at public broadcasting. In May 1952, it issued its own White Paper which substantially accepted the Beveridge Report but which added that 'successive licenses granted to the B.B.C. have not of themselves established the corporation as the sole authority for all broadcasting in the UK'. Specifically it opened the door to the possibility of future competition within the fledgling television service:

> The present government have come to the conclusion that in the expanding field of television, provision should be made to admit some element of competition when the calls on capital resources at present needed for purposes of greater national importance make this feasible.

Even this modest proposal, which envisaged little more than a degree of state-supported competition within the B.B.C., ruffled many feathers. It seemed to be welcoming what in the post-war era was seen as the major threat to British Culture – the Americanisation of our way of life. In the heated House of Commons Debate on the White Paper Herbert Morrison spoke from the opposition benches of the kind of thing that would surely follow if we loosened the B.B.C.'s monopoly. In a four-hour period of children's television in the USA there had been:

13 murders and assorted killings, four sluggings, six kidnappings, five hold-ups, three explosions, three instances of blackmail and extortion, three thefts, two armed robberies, two cases of arson, one lynching, one torture scene and one miscarriage. In a half hour there were 104 gun shootings, and during 20 minutes, sudden death was shudderingly described 14 times.

Nevertheless, the government pressed ahead and in November 1953 published its *Memorandum on Television Policy*. This proposed a new television corporation, set up on the same lines as the B.B.C., but with its income drawn from advertising rather than the licence fee:

> The corporation would be set up by Statute for an initial period of, say, ten years and would like the B.B.C. operate under licence from the Postmaster General. Its methods of working, contracting for programmes and regulating advertisements would be open to revision at any time and certainly to review before 1962 when the B.B.C. s present charter expires.

Like the B.B.C. the new body would be 'at arm's length' from government and would have day-to-day control over its affairs. In order to exercise effective control it would have the right to:

(1) call for programme schedules and scripts in advance.
(2) require the companies to make sound and visual records of programmes for subsequent examination.
(3) forbid the broadcasting of specified classes of matter.
(4) regulate advertisements.

The new corporation would be required to remain impartial on all controversial issues, to keep silent about its own views and in religious affairs would be bound by a new Central Religious Authority Committee. Hours of broadcasting would be stipulated by the Postmaster General. The *Memorandum* concluded by saying that it intended:

> to introduce an element of competition into television and enable private enterprise to play a fuller part in the development of this important and growing factor in our lives; to reduce to a minimum the financial commitments of the state; and...to proceed with caution into this new field and to safeguard the medium of information and entertainment from the risk of abuse or lowering of standards.

The 1953 *Memorandum* is notable for two other reasons. It is the first post-war government utterance on cultural matters in which Economic Competition is elevated above the Maintenance of Standards, and secondly it is remarkable for its frankness. Rarely has the state's natural wish to have maximum control allied to the lowest possible public expenditure been more clearly expressed.

Following its publication and a noisy, though finally approving, passage

through the House of Commons the Act introducing the *Independent Television Authority* became law on July 30th. 1954. Five days later, the composition of the first ITA Board was announced: Sir Charles Colston, Lord Aberdare of Duffryn, Lt-Col Arthur Chichester, Sir Henry Hinchliffe, Dr. T.J. Honeyman, Lord Layton, Miss M.E. Popham, Miss Dilys Powell, Mr. G.B. Thorneycroft and, as Chairman, the current Chairman of the Arts Council of Great Britain, Sir Kenneth Clark.

The Board immediately set about its first major task, choosing the contractors to provide the programmes for each of the new ITA regions. There were some predetermined constraints. Those holding office in the new contracted companies must normally be resident in Britain, and must not be linked with advertising. The Board added its own criteria, which included offering proof of strong financial resources (as programmes would have to be made before advertising revenue was gathered in) coupled with proof of ability to make a range of good quality programmes. The process of selection continued until the early months of 1955, and on the 22nd. September, 1955, the first contractors, Granada TV, were able to begin their scheduled broadcasting.

The early years of ITA brought many cultural changes with them. The decidedly Americanised format of many independent TV shows showed the British that television in the States was by no means always worse than its British counterpart. More surprisingly, the balance of programmes on the independent channel was much the same as that seen on the B.B.C..

COMPARISION OF CATERGORIES IN B.B.C. AND I.T.V.
Programmes in June 1962

	I.T.V.			B.B.C.		
	Hours	Mins	%	Hours	Min	%
News	4	18	7	4	17	6
Talks, documentaries	7	50	12	9	18	13
Religious	2	59	5	2	30	4
Schools	2	30	4	4	38	7
Children's programmes	7	19	12	7	53	12
Plays and serials	8	57	14	8	38	12
Variety, light entertainment	4	52	8	3	42	5
Films	12	59	20	5	49	9
Qizzez, panel games	2	0	3	1	16	2
Sports	9	39	15	14	53	20
Afternoon programmes				2	32	4
Welsh language				3	52	6
TOTAL	63	23	100	69	18	100

The impact on artists was considerable, as television now became a major employer of actors, musicians, writers and designers, and the advertising industry – now topped by glossy and lucrative television commercials – became Britain's largest single employer of musicians, actors, animators and designers. Quite noticeably, the old division between the commercial sector and the public services began to crumble, as Sir Kenneth Clark makes clear in his autobiography:

> Eighteen months after I had become chairman of the Arts Council I took on a gigantic and far from delicate operation, the founding of the Independent Television Authority, and enjoyed it almost as much as I disenjoyed the Arts Council...

> Like all pseudo-intellectuals I had at first been hostile to the idea of television. It seemed to threaten the humanising predominance of books, which was the background of our lives. I remember vividly the moment in the garden at Upper Terrace when a forceful and intelligent lady named Vera Poliakov made me realise the enormous importance of television and its powers for good or evil. I was converted in a flash. During the long argument that had preceded the passing of the Television Act I had been in two minds. It was obvious that Commercial Television would produce a *cloaca maxima* of rubbish, but the television produced by the B.B.C. was often extremely dismal. Even the most virtuous of institutions cannot help taking advantage of monopolies. I realised that television was above all a popular medium, and believed that commercial television might add some element of vital vulgarity which is not without its virtue. Who would want to close down the *Daily Mirror* and the *Daily Express* and leave the average man with nothing to read but *The Times* or *The Guardian*? Added to which, my experience in the Ministry of Information had taught me that the *Mirror* and the *Express* often come out with truths that the establishment wanted to suppress.

> When, therefore, Lord de la Warr, who as Postmaster General was in charge of installing Independent Television, asked me by telephone if I would be a member of the new Board, I gave a guarded assent. Next day he rang me up again and said 'You might as well be hung for a sheep as a lamb. Will you be Chairman?' This required more thought, and I asked to see a copy of the Television Act. Reading it carefully I saw a number of ways in which the Authority could intervene and prevent the vulgarity of commercialism from having things all its own way.

> Why did Buck de la Warr invite me? I can only suppose that my name had respectable associations, and he thought that it might allay criticism in what might be called Athaenaeum circles. In this he was mistaken. Their odium was not allayed, but was focussed on me, and when, soon after my appointment was announced, I entered the dining-room of the Athaenaeum (as a guest) I was booed.

Although in the mid-fifties the frontiers dividing the commercial sector from the public services were becoming blurred, the hostility of parts of

the metropolitan arts élite towards anything suggesting populism was it seemed as fierce as ever.

The exception was in the post-war state education system, which had been drastically remodelled by the *1945 Education Act*. Introduced by the then minister of education, R.A. Butler, the act had raised the school-leaving age to 15, and provided free secondary education for everyone. The act did not arouse the ire of the anti-populists because the secondary education was to be of sharply different kinds. After assessment at the age of eleven, most children were sent to 'secondary modern' schools, where they were given a basic artisan education, some were sent to 'technical schools', where they were given more advanced preparation for work in industry and the new technologies, and a minority were admitted free of charge to the grammar schools, where a form of classical education could be received.

This system began to be broken up in the late sixties when some county authorities preferred to develop comprehensive schools which all secondary schoolchildren attended and within which in theory differences in intellectual and creative ability could be accommodated. The 'eleven plus' examination was less frequently used as the single most important predictor of a child's abilities, and when other county authorities chose to divide their entire school systems into first schools, middle schools and upper schools the last remnants of the Butler Act started to disappear.

By the late seventies, the differences between the county systems were marked. In a remaining few – Lincolnshire, for example – traditional grammar schools still operated within a virtually unchanged system. In others, such as Leicestershire, there existed a completely new system of 'village colleges', communal centres open late into the evening in which traditional boundaries between subjects were of little account, and where parents and even grandparents were welcome to join the schools orchestras, or work in the art rooms.

However, in the early eighties the highly varied education system found itself at odds with the driving mercantile spirit of the times. It began to be said that it was no longer appropriate to refer to education as a service. It should be viewed as an 'industry', and as such it was 'failing' the nation's businessmen. Mrs Thatcher's government set about the partial privatisation of the 'industry', allowing schools to accept private funds in order to 'opt out' of local education control. Schools remaining within the system had a new form of 'managerial responsibility' imposed upon them, under which they were asked to take a higher degree of financial control. This partial decentralisation was, however, accompanied by a

much more centralised, and more prescriptive academic control. For the first time Britain adopted a national school curriculum. The balance shifted to science and the new technologies, with such things as pottery, school drama and instrumental music teaching becoming marginalised. By the year 2,000, the arts certainly played a less central role in the nation s schools than they had thirty years before.

The post-war redefinition of 'the arts' had in any case seemed to suggest that they were a middle class preserve, a sophisticated amusement for a highly vocal and politically powerful minority, rather than items in common ownership, or a common educational resource. Certainly, the educational authorities and the arts funding authorities had never worked in full harmony. There was nothing about the post-war 'Arts Council', in its first decades, to suggest either that it was allied to state education, or that it had any intention of leading a mass cultural crusade to change public attitudes. A comparison between British government spending in education and the subvention in the arts makes the point clearer:

	Government spending on education in UK £	Government spending on Art Council £
1945	112,000,000	175,000
1950	272,000,000	600,000
1955	410,600,000	785,000
1960	917,300,000	1,218,000
1965	1,114,900,000	3,205,000

In 1965, the year of Jennie Lee's White Paper, the government was still spending *nearly four hundred times* as much on education as on 'the arts'.

Yet, of course, to say that is to fall into the trap that post-war governments have set, encouraging us to discuss 'the arts' as if they are simply and solely those things which the state subsidises – and letting the government get away with saying that they have satisfied cultural demands as soon as a reasonable level of state aid has been given to these chosen icons. That is profoundly misleading, as dangerous as pretending that the size of the industrial grants given to the shipyards, to De Lorean cars or the tobacco industry is an indication of the health of industry at large and the esteem in which it is held.

It was one of the many sad aspects of the 1965 White Paper that it should so unthinkingly exclude so much from its own definition of 'the arts'. For in 1965 the arts were, in their broadest definition, to be found flourishing in so many places: in rural communities, on records, in the

popular press, in photographers' galleries, on fashion catwalks, in commercial books, on showgrounds, in clubs, on film, on tape and in bars, just as in our own time art may also be found on fax machines, television screens or on the internet.

The arts, in the form of literature, could even have flourished at the centre of the new National Curriculum, for that, as Richard Hoggart reminds us in *The Way We Live* (1995), was the original intention:

> Incidentally, the National Curriculum was first floated by a Labour Prime Minister, James Callaghan; there is much to be said in its favour.
>
> The committee which proposed a national curriculum in literature thought that all children should be introduced to some of the masterpieces of English literature. They believed there were such writings, that their value could not be culturally or historically explained away, that they are among the greatest achievements of this nation and that, properly presented, they can interest and excite children.

But the spirit of the times has decreed otherwise, and such literature as is taught in schools is now, like much in music, drama and the visual arts, relativistically chosen and more concerned to be politically correct than stimulating. The prevailing mood is caught by a sentence which Dr Hoggart quotes from an Arts Council discussion paper: 'Wedgwood and Elgar are not better than Tupperware or Bob Marley – they just belong to different clubs.' And from solemn assurances by the Royal National Theatre and the Royal Shakespeare Company that because of its offensive racial stereotyping they cannot envisage putting Shakespeare's *Othello* in their programmes for the forseeable future.

It is fairly easy to demonstrate the form that 'nationalisation' of the arts has taken. Post-war governments have found it convenient to persuasively redefine and marginalise the arts, preserving a part of them as emblematic figments which must, for the general good, be ritually 'supported'. This 'support of the arts', endlessly written up, reviewed and revised, and flourishingly presented as the core of a comprehensive 'arts policy', is then used to distract attention from more important, but less readily soluble cultural questions. So the question of the financing of the Royal Opera House is examined by a succession of high-powered committees containing the best minds in the land, but other, and more pervasive cultural phenomena – *The Sun* newspaper, for example – are officially ignored.

Indeed, one way of highlighting the government's real attitudes towards the national culture, as against the midget exhortations of its post-war 'arts policies', is to contrast the labyrinth constraints now placed on the artist – in the myriad licensing acts' the *Copyright Acts* of 1956 and 1988,

and the *1994 Criminal Justice and Public Order Act* for example – with the notable lack of government intervention in 'the freedom of the press'. It is hard to avoid the overall judgement that whereas teachers are directed by government as to what they may teach, and artists' ownership of and payment for their work is now constrained by a thick net of legislation, tabloid journalists still negotiate their own terms and salary and write pretty much as they please.

The most telling insight into the British government's real cultural attitudes has however lain in their shifting attitudes to gambling, culminating in the re-establishment in the 1990s of a national lottery. In 1826, the Select Committee had determined that through the state lottery 'idleness, dissipation and poverty' had been increased and that gambling generally was destructive of a spirit of industry. That attitude had informed the British government's attitude to gambling through the first decades of the twentieth century. Off-course betting on dogs or horses had been illegal up to the introduction of Licensed Betting Offices (Betting Shops) in 1961. The government had approved of the Football Association's actions when, as a part of their vendetta against the gambling on football matches introduced by the 'pools' firms, they refused for a time to allow their football fixtures to be published in advance in the newspapers. Until the introduction of the 1976 *Lotteries and Amusements Act* neither national nor local government had played any direct part in the promotion of a twentieth century lottery.

Yet, although gambling was morally harmful, it was also highly profitable, to the Treasury no less than the pools promoters. In 1947, the Labour government, having dismissed a backbench proposal to nationalise the pools and the gambling industry as 'unthinkable', instead levied a 10% tax (the Pools Betting Duty) on the promoters. This was raised to 20% in 1948 and finally to 30% in 1949, raising £17,218,392 in 1951 and £21,078,137 in 1953. Such sums spoke for themselves. In 1956, the government introduced the Premium Bonds Scheme, the first state lottery since 1826. The *Betting Act* 1960 permitted the licensing of gambling casinos and the introduction of licensed betting shops in Britain. Commercial firms were now licensed to promote games of bingo in old cinemas and assembly halls, and bingo became another supposed cause of the imminent death of live theatre, cinema and ballroom dancing. The 1976 Act then permitted local authorities to hold regular lotteries for local 'good causes', and first the ITA and then the BBC relaxed the limits which had been put on game show prizes. By the late eighties, the old prohibitions had largely been forgotten. The British had become inveterate gamblers and were now ready for the national lottery.

If the 'millennium celebrations' in the year 2,000 were to set out accurately to reflect the British way of life then the largest section of the Greenwich Millennium Dome would surely have to be reserved for Gambling. For the British now spend more on gambling than on any other form of recreation. By contrast the 1951 *Festival of Britain* took place in a Britain which was not only without national lottery, but which had no casinos, betting shops or premium bonds either.

The 1951 Festival was financed by government alone. There was no sponsorship from the private sector, nor did it receive any charitable (or lottery) donations. Its purpose was in part a piece of post-war flag-waving, but also an attempt to give purposeful new direction to a nation still living in austerity and shocked by the ravages of war. From its avowed purposes and its chosen contents, the 1951 Exhibition gives a further valuable insight into the cultural attitudes of British governments. It bore the sub-title 'The Autobiography of a Nation':

> Conceived among the untidy ruins of a war and fashioned through days of harsh economy, this Festival is a challenge to the sloughs of the present and a shaft of confidence cast forth against the future. It will leave behind not just a record of what we have thought of ourselves in the year 1951, but, in a fair community founded where once there was a slum, in an avenue of trees or in some work of art, a reminder of what we have done to write this single, adventurous year into our national and local history. Other demonstrations here and abroad have shown a country's art, its industries or its institutions, but none has tried like this to recreate a people's personality from birth to maturity. This we shall not do by any system of abstractions, but by letting the work of British men and women, past and present, give evidence of their belief and purpose. It will be the work not of one city but of the whole nation. The Festival will exhibit our standards in the arts and in design, our integrity and imagination in the sciences and in industry, the values – personal and collective – which have designed and now operate our society. And, as in any autobiography, the manner of the telling will be as revealing as the facts we set down.

The only building remaining from the 1951 exhibition is of course the Royal Festival Hall. The larger part of the exhibition site, now built over, was the 'Dome of Discovery', which investigated exploration within the fields of architecture and engineering and attempted to show 'how Britain has contributed to the worlds enquiry about itself and about the universe and about how it has applied this knowledge'. The second largest building contained an agricultural exhibition, 'The Land and its People', which commemorated aspects of rural British life. Other pavilions showed such things as 'how design and science help in our homes'.

The South Bank Exhibition, for all its affected populism, showed a

Figure 16 The Festival of Britain 1951

partial and essentially patronising view of what life was like for most British people. In a frequently quoted passage from *The Age of Austerity* (1963) Michael Frayn puts point strongly:

> ...there was almost no-one of working-class background concerned in planning the Festival, and nothing about the result to suggest that the working-class were anything more than the lovable human but essentially inert objects of benevolent administration. In fact Festival Britain was the Britain of the radical middle-class – the do-gooders, the readers of the *New Statesman*, the *Guardian* and the *Observer*; the signers of petitions, and the backbone of the B.B.C..

A perusal of the 1951 cultural programme lends support to Frayn's view. There are performances at the Royal Opera House and at the London County Council's Royal Festival Hall, seasons at the Old Vic, at the St. James with Laurence Olivier's company and a new play by Christopher Fry to be performed in Southwark Cathedral. Arts events in Bath, Bournemouth, York and Edinburgh are highlighted, and an introduction to 'The Arts in a Country City' turns out to be far-flung Norwich. The official festival programme deals in loving detail with the university towns of Oxford and Cambridge, but with no others.

The Secretary General, reviewing the fact that the Arts Council of Great Britain had been asked to distribute small grants to street and village celebrations around the country, shudderingly hoped that they would never have to do such a thing again, as such contact with ordinary people was well beyond their competence. The Festival organisers were, however, less terrified of rural and provincial Britain than was the Arts Council. The South Bank show was complemented by a travelling Festival Exhibition, which visited the following:

Manchester	: May 5 – 26
Leeds	: June 25 – July 14
Birmingham	: August 4 – 25
Nottingham	: September 15 – October 6

And, even more surprisingly, by a floating Festival Exhibition, mounted in S.S. Campania, and like the other two divided into three main sections: the Land of Britain, Discovery and The People at Home. It was rather smaller and its itinerary more varied, including Southampton (May 4–14), Dundee (May 18–26), Newcastle (May 30–June 16) Hull (June 20–30), Plymouth (July 5–14), Bristol (July 18–28), Cardiff (July 31–August 11), Belfast (August 15–September 1), Birkenhead (September 5–14) and Glasgow (September 18–October 6). Whatever else may be said of the 1951 Exhibition, great efforts were put into making it a genuinely countrywide celebration, and not an exclusively metropolitan event.

The Mirage of the Millennium

Erect Thy tabernacle here,
The New Jerusalem send down,
Thyself amidst Thy saints appear
And seat us on Thy dazzling throne.

Methodist Hymn 18th. Century

It may seem churlish to point out that in all probability we have for some time been retreating from the end of the second calendar millennium, but it is nevertheless the case. Even more disturbingly, our well-chronicled dithering over the form our rejoicing should take suggests that we harbour only the haziest idea of what exactly the significance of 'the millennium' might be. In fact, there are at least four sharply distinguishable trains of millenarial thought. For the purposes of marking the year 2,000 we seem to have dissolved them all into one roseate and steamy cloud, but it will be useful to remind ourselves of them here.

To deal first with the purely numerical aspect of the millennium (or, to be more precise, the bi-millennium) we have to face the likelihood that, owing to a calendar mistake made some 1400 years ago, we let the real anniversary go by without marking it at all. That our calendar is based upon the wrong dating of Christ's birth is not of course a new idea. The astronomer Johannes Kepler suggested more than three centuries ago that Jesus was actually born seven years earlier than the Christian calendar indicates. Many notable astronomers and historians have since agreed with him, and most recently an eminent astrophysicist at Rome

Observatory, Professor Giovanni Baratta, has dramatically revised Kepler's view and suggested that Christ was born twelve years before his official nativity.

Baratta agrees with Kepler that the sixth century Scythian monk, Dionysius Exiguous, who created the calendar since used by the Western world, made several crucial errors. He failed to take the year zero, the one between 1 BC and 1 AD, into his calculations, and also omitted the four-year period when Augustus ruled under the name of Octavian. Exiguous also seems to have omitted the first two years in the rule of the Emperor Tiberius, who reigned following the death of his step-father Augustus in 14 AD.

Thus some of the evidence seems to support Kepler's seven year theory, but in two further respects Baratta's suggestion seems the more likely. First, there is some evidence that Exiguous also miscalculated over the number of 'leap years' there had been during the long Roman Empire, which in itself suggests that Christ's birth was even earlier than Kepler thought. Secondly, and more importantly, Baratta insists that modern astronomical research suggests that the unusually bright star which passed across the Middle East at the time of the Nativity was seen in 12 BC, and not in 7 BC as Kepler had surmised. The one thing which does seems certain is that our calendars, as records of the time which has passed since Christ s birth, are almost certainly wrong, and it would have been more appropriate to celebrate the end of the second millennium in 1993, if Kepler were correct, or in 1988, if Professor Baratta is.

However, although there may frequently be an upsurge of fervour in the last years of a century – there was considerable millenarial excitement in the 1890s – the significance of the millennium is not usually just a matter of arithmetic. Nor do we usually celebrate the *passing* of a thousand (or two thousand) years. In the other senses of the term we, anticipate – more often with dread than pleasure – the *beginning* of a millennium rather than the fact that it has ended. This important point becomes clearer when we turn to the three other main ways, in addition to simply counting the calendar years, in which philosophers, prophets and artists may speak of the coming of a millennium:

(a) A *Christian Millennium*, during which the chosen few, or angels, will live in harmony within the New Jerusalem – a pleasantry which will be preceded by Judgement Day when the ungodly will be utterly destroyed, probably by being incinerated in fire and brimstone.

(b) An *Arcadian Millennium*, a time of harmonious co-existence for a chosen few, who will live for ever on the bounty of the earth. Although this happy state also has its down side for the majority, as

it is customarily preceded by the destruction of the chosen few's enemies, all inferior races, diseases and predatory animals. It is sometimes arrived at by the chosen ones simply cutting themselves off from the tainted majority and living in pantisocratic bliss.

(c) A *Servile Millennium*. The threat of durance vile is frequently held over mankind to urge it to mend its ways. For the great majority, a Servile Millennium spells not destruction, but a long period of monotonous enslavement within a robotic and self-renewing system.

There is also the *Prelapsarian Millennium*, a half-remembered past time when people lived in harmony, of which the Garden of Eden was the first. There are also many variations of a *Scientific Millennium* in which machines, robots or computers will remove all irksome tasks from the human race – this should render life wholly comfortable but generally does not turn out well. There are several others, but the central point to make is that these are all very different visions and cannot readily co-exist. One cannot simply look forward to, or look back back on, a millennium without having been told which sort of millennium it was. Even when the nature of a particular millennium is made clear, it does not follow that it deserves to be *celebrated*, still less celebrated by fireworks, funfairs and ferris wheels.

The most memorable description of the Christian Millenium is to be found in the last book of the Bible, *The Book of Revelation*. In reading it becomes quite clear that the number 1,000 is in fact of comparatively little significance. It is merely the possible length of the first stage of the Millennium (*Revelation* 20:4), although the passage rather reads as if the author was just writing down the biggest number his readers could comprehend:

> And I saw thrones, and they sat upon them, and judgement was given unto them; and I saw the souls of them that had been beheaded for the testimony of Jesus and for the word of God, and such as worshisped not the beast, neither his image and upon their forehead and upon their hand; and they lived and reigned with Christ a thousand years.

After which time the ungodly will be raised from the dead and tempted one last time by Satan before The Prince of Darkness will finally be cast into his own fiery pit (*Revelation* 20:7–10):

> And when the thousand years are finished, Satan shall be loosed out of his prison.

> And shall come forth to deceive the nations which are in the far corners of the earth. Gog and Magog, to gather them together to the war; the number of whom is as the sand of the sea.

And they went up over the breadth of the earth, and compassed the camp of the saints about, and the beloved city, and fire came down out of heaven, and devoured them.

And the devil that deceived them was cast into the lake of fire and brimstone, where are also the beast and prophet; and they shall be tormented day and night for ever and ever.

After which, the righteous resume their life with the saints in the holy city for all eternity (*Revelation* 21: 1-4):

And I saw a new heaven and a new earth: for the first heaven and the first earth are passed away; and the sea is no more.

And I saw the holy city, New Jerusalem, coming down out of heaven from God, made ready as a bride adorned for her husband.

And I heard a great voice out of the throne saying, Behold, the tabernacle of God is with men, and he shall dwell with them, and they shall be his peoples, and God himself shall be with them and be their God.

And he shall wipe away every tear from their eyes; and death shall be no more; neither shall there be mourning, nor crying, nor pain, any more; the first things are passed away.

There is corroboration in *Daniel* 8:27 that the reward of the righteous will last for much more than a thousand years – indeed for all eternity:

And the kingdom and the dominion, and the greatness of the kingdoms under the whole heaven, shall be given to the people of the saints of the Most High; is kingdom is an everlasting kingdom, and all dominions shall serve and obey him.

Nowhere does the Bible say that the Christian millennium will *commence* after a thousand years have passed, still less after two thousand. All Scripture says is that once the millennium is under way, the chosen will enjoy the New Jerusalem for more than a thousand years. Indeed, the Bible makes it clear that the early Christians did not expect to have to wait for anything like that long before the Second Coming and Judgement Day. Indeed there is one specific assurance, again in *Revelation*, that the waiting time would be cut to less than four years (11:3):

...and they shall prophecy a thousand, two hundred and threescore days...

Members of the early Christian Church seem to have been quite certain that the Second Coming would take place within their natural lifetimes.

In the event it did not occur as quickly as had been expected, but the

blazing imagery of *Revelation* burned into the Christian mind, and fire in the heavens, smoking brimstone and the New Jerusalem recur as vivid images down the centuries, each time that expectations of Judgement Day and the coming of the millennium flare up. By the year 1,000 – although the Bible had given that date no particular significance – we know from the *Anglo-Saxon Chronicles* that those vivid Biblical prophecies still preyed on people's minds. There was great perturbation throughout the land, much recantation of past sins and, significantly, as the momentous date approached, 'flying dragons were seen' in the sky.

Yet still the Day of Judgement did not arrive, although there were regular flurries of expectation through the centuries. In the sixteenth, for example, there were many outbreaks of millenarial frenzy. By 1560, the writings of the formidable French seer 'Nostradamus' were already circulating in England – although his readers were doubtless pleased to observe that in the 10th. Quatrain of his *Prophecies* he had placed the end of the world encouragingly far into the future:

> In the year 1999 and seven months, from the sky will come a great frightening king. To raise again the great King of the Mongols. Before, after, Mars shall reign happily.

But most English prophets brought much more immediate alarm to their contemporaries. In 1561, one John Moore was whipped and thrown into prison for claiming to be Christ at the Second Coming, and his friend William Jeffrey was dealt with in similar fashion for claiming to be the reincarnation of the Apostle Peter. In 1586, a shoemaker from Essex, John White, announced he was a second John the Baptist, while an Essex minister, Ralph Durden, capped this by proclaiming that he was the King of Kings and the Lord of Lords who would shortly lead the saints into Jerusalem. As the courtier Anthony Marten mordantly observed in 1589, England could hardly claim to unprepared, considering:

> ...the number of prophets that God doth daily send to admonish all people of the latter day, and to give them warning to be in readiness.

Yet the following century saw even greater millenarial clamour.

One of the best known of the early visionaries was Lady Eleanor Davis, daughter of the Earl of Castlehaven. In 1625 she claimed that she 'heard early in the morning a voice from Heaven, speaking as through a trumpet these words: "There is nineteen years and a half to the Judgement Day"'. These words inaugurated her long career as a prophet of imminent doom, which was punctuated by long periods of incarceration. She served a prison sentence in 1638 for defiling the altar hangings in

Litchfield Cathedral, and for then sitting on the episcopal throne while claiming to be Primate of all England. Unsurprisingly, her enemies referred to her by a waspish anagram of Dame Eleanor Davis; 'Never so mad a Ladie'.

The years leading up to the Civil War were years of religious as much as political ferment. In 1629 a Huntingdonshire woman, Jane Hawkins, had an ecstatic vision of the imminent downfall of the Anglican Bishops and their replacement by the true church, which she joyfully shared with her local congregation, before being forcibly removed from the pulpit. In 1636, two weavers, Richard Farnham and John Bull, claimed to have been granted heavenly powers and attracted a considerable following of young women who were said at the men's trial to be 'esteemed by understanding men to be women of good parts, honest of conversation and very ready in the Scriptures'. 'I am one of the two witnesses that are spoken of in the 11 of *Revelation*,' announced Farnham, 'The Lord hath given me power for the opening and shutting of the heavens.' In Bristol in 1639, a local widow, Grace Cary, was convinced by a dream that the fiery destruction of England was imminent, and thereafter followed the King around the country, warning him that he must repent and seek forgiveness or he would be destroyed in the coming conflagration.

During the Civil War, millenarial missionaries regularly offered their revelations to both sides. As early as May 1643 Parliamentary troops were relishing a prophecy that Christ was coming to destroy King Charles, and that the Earl of Essex would be revealed to be John the Baptist. In 1647, a preacher at Ely Cathedral, William Sedgwick, set out hotfoot for the capital with the news 'that the world will be at an end within fourteen days, Christ then coming in judgement...' Cromwell's meetings with his army chiefs were interrupted on at least half a dozen occasions between 1647 and 1654 so that sympathetic divines could tell him of their most recent visions and prognostications, while Grace Cary was only one of a small army of soothsayers who advised the King. Roland Bateman, a Royalist prophet, proudly boasted in 1644 that no-one had 'knowledge of the Scripture, but King Charles and himself and three Lords. And...when he...is put to death after three days, he shall rise again and then we shall see whom he will save and whom he will he will damn.' In just one year, 1649, a third of all books published, more than eighty volumes, were on the subject of the Day of Judgement and the coming millennium.

It was the Roundheads who felt most strongly that they were living through the final days of this world, for the Biblical prophecies seemed conveniently to harmonise with their immediate political aims. King

Charles was Satan, and the Royalists the ungodly and both must be cast down into the fire and brimstone. Only then could the righteous begin the millennium as the new saints. Many assumed that the year 1659 would prove to be the end of the world – scholars had decided that 1,659 years had elapsed between the Flood and Christ's birth – and the early 1650s saw the emergence of a new political group who were ready, following the execution of King Charles in 1649, to give history a push in the right direction, should it need it. These were the Fifth Monarchy Men, who assumed that as had been foretold in *Revelation* the four great monarchies of past times – Babylonian, Persian, Greek and Roman – would after 1659 be followed by a fifth, the Monarchy of the Saints. This would be marked, rather endearingly, by the abolition of tithes, the reform of the law, the raising of the humble, and the pulling down of the great, particularly the King. There would then be no painful labour, no premature death and no famine: 'there is no creature comfort, no outward blessing, which the Saints shall then want.' However, when the fateful year of 1659 had passed, with Satan long dead and Charles II restored to the throne, the Fifth Monarchy Men quietly melted back into their country houses. Although there was some lingering millenarianism immediately after the Restoration – 1666 was for a while touted as being a likely starting date – it was more than a century before the next major outbreak of millenarial fervour.

This occurred in the 1790s, and was characterised less by anti-Royalist sentiment than by its pro-industriousness. According to the new prophets, idleness, dishonesty and commercial duplicity were to be scourged from the earth in order to make way for the honest workers. At its crudest level, this was illustrated by the outpourings of Richard Brothers, a retired naval captain who for some reason had it in for the prosperous City traders. He had seen visions of the coming destruction of London and its merchants who:

> ...have drunk of the wine of the wrath of Babylon's fornication, and the kings of the earth have committed fornication with her, and the merchants of the earth are waxed rich through the abundance of her delicacies...

The industrious poor would be spared the divine wrath, and in England there would be a mixture of 'sorrow and great woe, mingled with joy unspeakable' – though it is clear that London merchants would not number among the joyful:

> The Pestilence shall sweep away the Locusts that eat up the harvest of industry, and the Earthquake shall swallow up the monstrous *Leviathan*, with all his train. In all these things the poor, the honest, the virtuous and the patriotic, shall rejoice.

This kind of pseudo-biblical ranting was typical of the millenarianists around the end of the eighteenth century. It reached something of a crescendo in the alarming outpourings of the Devon farmer's daughter, Johanna Southcott:

> O England! O England! England! the axe is laid to the trees, and it must and will be cut down, ye know not the days of your visitation...The midnight-hour is coming for you all, and will burst upon you... 'Who is he that cometh from Edom, with dyed garments from Bozrah; that speaketh in righteousness, mighty to save all that trust in him; but of mine enemies I will rend them in mine anger, and trample them in my fury; for the day of vengeance is in mv heart and the year of my redeemed is come.

Such apocalyptic sentiment also took firm root in the new Methodism, whose early hymns are full of terrifying warnings of the fate awaiting the ungodly:

> *There is a dreadful hell*
> *And everlasting pains*
> *Where sinners must with devils dwell*
> *In darkness, fire and chains.*

The note here, one of almost manic delight in the prospect of suffering and eternal perdition, takes a yet more extreme form in another Methodist hymn:

> *Ah, lovely Appearance of Death*
> *No Sight upon Earth is so fair,*
> *Not all the gay Pageants that breathe*
> *Can with a dead body compare.*

Charles Wesley's macabre composition celebrates not only the notion of 'Holy Dying', but includes a faint reminder of another Methodist obsession, the belief that indulgence in 'gay Pageants' – the popular pleasures – would at Judgement Day most certainly lead to exclusion from the New Jerusalem.

The most vivid, as well as the most questioning, statement of turn of the century millenarianism is however to be found in the work of William Blake. In 'The New Jerusalem' he brings together the smoky imagery of the factory and the dazzling apocalyptic metaphors of *Revelation* to ask whether the dark and unnatural forces unleashed by industrial development have extinguished all hope of the Christian Millennium:

> *And did those feet in ancient time*
> *Walk upon England's mountains green?*
> *And was the holy Lamb of God*
> *On England's pleasant pastures seen?*

And did the Countenance divine
Shine forth upon our clouded hills?
And was Jerusalem builded here?
Among these dark Satanic mills?

The conclusion is triumphant, the poet urging that we join him in the fight, which he will wage unceasingly:

Till we have built Jerusalem
In England's green and pleasant Land.

Yet this is not the Jerusalem of *The Book of Revelation*, sent down from heaven, but one 'built' by people who have to do more than merely avoid temptation in order to enter it. It is gained by intense mental strife. In Blake's poem, the fiery terrors of the apocalypse and the peace of the millennium are aspects of a continuous spiritual battle.

In that spiritual battle it is art which transmutes the mechanical industrial exprience into something Godly. For Blake, art has a saintly and *physical* power capable of combatting the earthly and demonic powers of factory, mill – or indeed whole armies:

"Now Art has lost its mental charms
France shall subdue the World in Arms."
So spoke an Angel at my birth,
Then said, "Descend thee upon Earth
Renew the Arts on Britain's shore
With works of Art their armies meet
And War shall sink beneath thy feet"

Blake's Jerusalem is thus different again from the carefully landscaped vision of millenarial bliss evoked by one of the best-known works of his contemporary, Samuel Taylor Coleridge:

In Xanadu did KUBLA KHAN
A stately pleasure dome decree:
Where Alph, the sacred river, ran
Through caverns measureless to man
Down to a sunless sea.

So twice five miles of fertile ground
With walls and towers were girded round:
And there were gardens bright with sinuous rills
Where blossomed many an incense-bearing tree;
And here were forests ancient as the hills,
Enfolding sunny spots of greenery.

Coleridge and his fellow poets did not confront industrialisation and do battle with it, as did Blake. Instead, the Romantics looked forward to an Arcadian millennium, their pantisocracy an escape from urban industrial life and the power of the machine. The pleasure dome at Xanadu, symbolically, is set in peaceful gardens and enclosed by walls and towers which conveniently shut out the creeping industrialisation beyond.

The Socialist William Morris was much less fanciful. His Arcadian vision was less concerned with finding a retreat for art, than with its vigorous engagement with the real world. His mentor Ruskin had already warned against letting the machinery of economics dominate every aspect of life. For Ruskin political economy had proved to be:

> Neither an art nor a science, but a system of conduct and legislature, founded in the sciences, directed by the arts, and impossible, except under certain conditions of moral culture...

Morris in turn raged against the embedded Victorian belief that civilisation was created and sustained wholly by an economic growth dependant upon industrial processes:

> Apart from the desire to produce beautiful things, the leading passion of my life has been and is hatred of modern civilisation...What shall I say concerning its mastery of and its waste of mechanical power...Its contempt ot simple pleasure, which everyone could enjoy but for its folly? Its eyeless vulgarity which has destroyed art, the one certain solace of labour?

Against this mechanised 'modern civilisation' Morris sets the great potential of art:

> ...civilisation has reduced the workman to such a skinny and pitiful existence, that he scarcely knows how to frame a desire for any life much better than that which he now endures perforce. *It is the province of art to set the ideal of a full and reasonable life before him.*

The Arcadian vision is modest. It is also practical, and involves accommodation with the machine. People will still have to work, but:

> If the necessary reasonable work be of a mechanical kind, I must be helped to do it by a machine, not to cheapen my labour, but so that as little time as possible may be spent upon it... I know that to some cultivated people, people of the artistic turn of mind, machinery is particularly distasteful...[but] it is the allowing machines to be our masters and not our servants that so injures the beauty of life nowadays.

Neither Blake's crusading zeal nor Morris's intensely practical common sense survived into the twentieth century. Post-industrial society came to

be viewed with unalloyed pessimism by the great majority of writers, film-makers and social philosophers. All warned that mankind must now serve out millennia of grim servility to the machine.

For D.H.Lawrence, hope was almost extinguished. In *Nottingham and the Mining Countryside* he bitterly rails against the meanness of spirit that industrialisation had brought:

> The real tragedy of England, as I see it, is the tragedy of ugliness. The country is so lovely; the man-made England is so vile...though perhaps nobody knew it, it was ugliness which betrayed the spirit of man, in the nineteenth century. The great crime which the moneyed classes and promoters of industry committed in the palmy Victorian days was the condemnation of the workers to ugliness, ugliness, ugliness; meanness and formless and ugly surroundings, ugly ideals, ugly religion, ugly hope, ugly love, ugly clothes, ugly furniture, ugly houses, ugly relationship between workers and employers. The human soul needs actual beauty even more than bread.

But his solution is despairing, an impotent raging against overwhelming forces:

> Do away with it all, then. At no matter what cost, start in to alter it. Never mind about wages and industrial squabbling. Turn the attention elsewhere. Pull down my native village to the last brick.

Lawrence had had little real hope that he could turn the English towards civic enlightenment, but even he could not have imagined that, far from being pulled down to the last brick, his old home and Eastwood village, in all their ugliness, would be unblushingly sold as Tourist attractions within the 'national heritage'.

Yet that kind of cultural inversion is wholly characteristic of our times. Artists and social commentators will warn of some new degradation of the human spirit, some new mechanical brutality, only to have it successfully packaged and sold as a tourist attraction, an 'entertainment' or, even more sadly, as an 'artistic experience':

> Yet these people were clothed in plesant fabrics that must at times need renewal, and their sandals, though undecorated, were fairly complex specimens of metal-work. Somehow these things must be made. And the little people displayed no vestige of a creative tendency. There were no shops, no workshops, no signs of importation among them. They spent all their time in playing gently, in bathing in the river, in making love in a half playful fashion, in eating fruit and sleeping. I could not see how things were kept going .

This is not a description of a *Club Med* holiday, nor of a visit to *Disneyland*, where the economic and practical machinery is likewise kept

hidden from view, but a passage from H.G.Wells' 1895 novel *The Time Machine*, intended as a salutary warning about the future of mankind.

In like fashion many later warnings of a servile millennium have had their sting drawn, because the actuality has been packaged and sold as a pleasurable experience. Some works, like Kubrick's 1971 film *A Clockwork Orange* have had elements recycled as fashion statements. Others, such as Herbert Read's gloomy vision of what life might be like in 1984, written twenty years before that date, and intended as the direst of moral warnings:

> ...passive entertainment will fill ever-expanding periods of non-employment. Bigger and better stadia will be built to accommodate vaster and vaster crowds of football fans...

are now read simply as predictions – in that case offering a more or less benevolent solution to 'the problem of leisure'. In like fashion, Read's morose prophecy of the likely spread of the gambling habit:

> Another form of excitement will find its outlet in betting shops, which will have proliferated in every city, in every street. By 1984 gambling will have been nationalised and will be the greatest single source of revenue.

was not seen as a terrible warning, which we ignored at our peril, but judged like a piece of fairground fortune-telling, as a slightly-too-cautious prediction of the happy state of affairs that now exists. For government sponsored gambling is no longer even confined to betting shops, but can be indulged in shops of every kind in every high street in the country.

The seminal work of prophecy for the servile millennium was of course George Orwell's *1984*. The date of the title was chosen fairly arbitarily, by inverting the last two numbers in the date of its composition, 1948, but nevertheless its apparent precision led to a certain amount of righteous self-congratulation as 1984 went by and we had not, apparently, fallen into the servile state that Orwell had 'prophesied'. Yet that self-congratulation may have been premature. If the book is read again, not as a simple piece of predictive science-fiction, but as a book with a wider and more visionary purpose, we may find cause at the turn of the century to reconsider its value.

Orwell's dark vision is of a completely industrialised continent, in which all workers (or proles) are kept under 24 hour observation by prying television cameras. The ruling authorities meanwhile have appropriated all the old means of communication. As a result, the common language has been drained of virtually all meaning, and political content is boiled down to endlessly-repeated sound bites:

WAR IS PEACE

FREEDOM IS SLAVERY

IGNORANCE IS STRENGTH

The hero, Winston Smith, is attempting to keep a dairy, a record of his individual life (out of sight of the prying telescreens for keeping a personal dairy is of course illegal), but when he attempts to write it:

> It was curious that he seemed not merely to have lost the power of expressing himself, but even to have forgotten what it was that he had originally intended to say.

All of the proles' entertainments and recreations are vacuous in content and strictly controlled by the government – even the most popular pastime of all, the familiar-sounding state lottery:

> The Lottery with its weekly payout of enormous prizes was the one public event to which the proles paid serious attention. It was probable that there were some millions of proles for whom the Lottery was the principle if not the only reason for remaining alive. It was their delight, their folly, their anodyne, their intellectual stimulant. Where the lottery was concerned, even people who could barely read and write seemed capable of intricate calculations and staggering feats of memory. There was a whole tribe of men who made a living simply by selling systems, forecasts and lucky amulets. Winston had nothing to do with the running of the Lottery, which was managed by the Ministry of Plenty, but he was aware (indeed everyone in the Party was aware) that the prizes were largely imaginary. Only small sums were actually paid out, the winners of the big prizes being non-existent persons.

Winston's attempts to discover for himself whether life was in some way better in the past are constantly thwarted. This is partly because of the way they have drained words of their multilayered meanings, and partly because of the ways in which the 1984 'spin doctors' both rewrite history, and package all contemporary information. It has therefore become difficult to even ask the question, and impossible to know how a reliable answer might be framed.

Although its view is unrelentingly bleak, the importance of *1984* is that it is a millenarial vision of the fourth kind, warning of the long servility we shall have to endure, not from the domination of machines, or the media, or overcrowding of the planet, or any of the familar ogres of science fiction, but if we allow our language to be drained of meaning, and hence lose our capacity for moral action. Above all *1984* exhorts us to fight for the English language and the rich rich history which it carries:

When *Oldspeak* had been once and for all superceded, the last link with the past would have been severed. History had already been rewritten, but fragments of the literature of the past survived here and there, imperfectly censored, and so long as one retained one's knowledge of *Oldspeak* it was possible to read them. In the future, such fragments, even if they chanced o survive, would be unintelligible and untranslatable.

Orwell's book stands in opposition to the 'postmodernist' assertion that words have an arbitary correspondence to reality, and that there can be no such thing as historical truth. It is a warning that we must be on our guard against the the Big Brothers amongst our contemporary cultural critics – like Keith Jenkins in *'What is History?'* (1995):

> Today we live within the general condition of *postmodernity*. We do not have a choice about this. For postmodernity is not an 'idealogy' or a position we can choose to subcribe to or not; postmodernity is precisely our condition; it is our fate.

Although the language may be in a state of decline, we still have sufficient *Oldspeak* to reject the idea that a gobbet of the academic world's fashionable phrase-making is 'precisely our condition', just as we can object to being forced to celebrate the collapse of much of the human world by paying eavily to visit the government's 'Millennium Experience'.

The millennial pessimism of our artists is not all pervasive. It has not altogether wiped out hopes of Judgement Day and the coming of a Christian Millennium. The last fifty years in particular have seen the sudden growth, and sometimes the sudden death, of a large number of small adventist groups who have announced the imminent end of all things, repaired to the top of a nearby mountain and then, when the expected holocaust has not occurred, trooped sheepishly down again. More seriously, a number of cults have nurtured the idea that the only way to gain admittance to the New Jerusalem was to shuffle sharply off this mortal coil by committing mass suicide. In 1997 a group of young men in the U.S. killed themselves in just such a way, believing that a flying saucer was waiting to transport their eternal selves up to a passing comet.

In 1959 Carl Gustav Jung, in his short book *'Flying Saucers: A modern Myth of Things Seen in the Sky'*, suggested that the growing number of UFO sightings reflected archetypes and religious myths within the collective human unconscious, and that flying saucers were an important item of mental furniture associated with widespread apprehension about Judgement Day and the 'new' millennium. The characteristically round, or dome-shaped, objects were, he argued, havens which offered both security and a means of escape from the coming destruction.

Certainly modern imagery is replete with them. Charles Handy, a widely-read spiritual guru of the managerial classes, evokes just such an object in *The Empty Raincoat*. Handy believes that the future can only be copied with by what he calls 'second curve' thinking, 'the discipline which says that the past might not be the best guide to the future, that there might be another way, and that 'some 'myths of the future' as Schwartz calls them, will help'. Handy believes that the myth that will best help his readers cope with future stress is an archetypal image which Jung would readily recognise, in what he terms the 'doughnut principle':

> The doughnut in question is an American doughnut, the kind with a hole in the middle, rather than the British version which has jam instead of a hole. The doughnut principle, however, requires an inside-out doughnut, one with the hole on the outside and the dough in the middle. It can only, therefore, be an imaginary doughnut, a conceptual doughnut, one for thinking with, not eating.

A 'conceptual doughnut' is also as good an image as any to describe the way in which the British have chosen to mark the year 2,000; millennium celebrations which only wincingly glance at the past and which shy away from offering a vision of the future; which set out to be both a secular trade fair and a vehicle for spiritual renewal; which set out 'to explain the British to themselves', but which end as sugary dough surrounded by hot air. It should not surprise us that the politician planning the millennium 'experience' has proudly referred to the dome as his doughnut.

Yet we still do not know the purposes of this celebration. Meanwhile, in an effort to accommodate all possible points of view, the organisers offer soothing pieties. Eva Jiricna, the architect designing the Dome's so-called 'Spirit Level', denies, for instance, that the millennium should be seen as a specifically Christian idea, and announces that the image of the Cross and the Redemption would not be appropriate as millennium imagery. She is searching for another theme:

> It will be about being better human beings in the new millennium, which is what all the religions want.

But what are 'better' human beings, if we are not to judge from a particular ideological standpoint? If the celebrations are to be built on such non-judgemental emptiness, then there is room in the Millennium Dome not only for 'all the religions' but for those totalitarian dogmas which have their own versions of the millennium, and their own views of what 'better human beings' might be. It would seem that at the turn of the century we do not want to make a distinction between the *Bible*, *Das Kapital* and *Mein Kampf*.

Shadows and Illusions

Words strain,
Crack and sometimes break, under the burden,
Under the tension, slip, slide, perish,
Decay with imprecision, will not stay in place,
Will not stay still. Shrieking voices
Scolding, mocking or merely chattering
Always assail them.

T.S.Eliot, *Four Quartets* 1944

The first direct request for state aid for the performing arts came from a group of stage performers during the winter of 1914. A few well-known personalities, led by the actor Seymour Hicks and his musical wife Ellaline Terriss, decided that it would be a valuable contribution to the war effort if they went over to France and entertained the troops at Christmas time. Lord Burnham agreed to put up half the money for the expedition, and Ellaline Terriss describes how she and Hicks approached the War Office for the rest:

> At first I don't think, from the questions we were called upon to answer, any such thing as entertainment for the soldiers in the War zone had entered the heads of those who were directing operations. Indeed, Lord Kitchener, after enquiring when we wanted to start and being told Xmas Eve, asked if we thought the British Army was going to stop fighting on Xmas Day?

Funds were, however, forthcoming, and Britain's first state-subsidised performing arts company set off for France on December 22nd. 1914 in a convoy of ten motor cars:

> We arrived at Boulogne in the darkness of a late December afternoon. To our surprise, on reaching the pier, we heard a great shout go up. It was thronged with

soldiers who had heard we were arriving. An hour from our time of landing we were giving our first concert in the Casino.

Later in the war, the performing arts received one further crumb of state assistance when the War Office gave a grant to the young Basil Dean to support his network of Garrison Theatres. For the most part, however, it was a case of the performing artists raising funds for the war efforts, and the war charities, through a network of charitable matinees and special performances for the invalided troops. As Ellaline Terriss again recalls:

> There was much for my profession to do and they did it well. It was only their duty, I know, but with a few miserable exeptions (always to be found in any large community) they none of them shirked anything, most of them going about their duty in the must unostentatious manner. As only one instance among hundreds, I remember meeting Mr. Nelson Keys looking very tired going to his theatre. He had done five hospital turns that day, and that was the reason he smilingly said, 'I feel a little cheap', and there were many others like him.

The main beneficiaries of the artists' work during the years of carnage were the Red Cross and the St. John Ambulance Brigade. No-one suggested that the artists' work for the troops should itself be registered as a charitable cause.

The generosity of spirit which had motivated luminaries such as Ellaline Terriss, Nelson Keys and Gladys Cooper did not evaporate at the war's end. Eleanor Elder, the co-founder of the *Arts League of Service* speaks of the immediate post-war period as a time 'when many fine ideas of social reconstruction were finding expression':

> The world was to be rebuilt, the brotherhood so vividly realised in the trenches was never to be forgotten: the benefits to mankind of education, culture and art were to be shared by all, and the word 'League', inspired by the belief in an all-embracing League of Nations, was the word of the hour and was not synonymous with football as it is today.

The Arts League came formally into being at a meeting held in the London Studio Theatre on May 23rd. 1919, attended by over 100 artists. The League's purpose was not to raise funds for charitable purposes, but to spread the arts to disadvantaged sections of society. Among the speakers at the first meeting was W.L. George, who advocated that the gathering should be equally concerned with the welfare of artists as with arts provision. It should not stop at declaring itself as just another society, but should aim at becoming a fully-fledged trade union for artists: 'Hang together, or you will hang separately'. The new League decided that it would concentrate upon spreading the work of visual artists as well as

writers and performers. Artists such as Henry Moore, Wyndham Lewis and Paul Nash featured in early art exhibitions, while the League also advocated cheap provision of artists' studios. An early member of its Council was Dan Rider, the founder of the militant War Rents League, which had fought against excessive rentals being charged on all kinds of properties in wartime, and who was thus already known to almost every working artist struggling to maintain a studio.

By the mid-1920s, however, the emphasis had settled on the performing arts and on the work of the touring ALS companies which travelled Britain, giving nightly performances in places where there was otherwise no professional provision. Their programmes consisted of an intriguing mixture of drama, dance and folk song, endlessly changed and modified to suit their different audiences. The largest part of the League's income was from the box office – the highest 'top' price charged was three shillings – but the members of the company were also subsidised by their hosts (who frequently offered free food and accommodation) and by a variety of other supports: an anonymous benefactor who gave £25 to help with their very first tour, the Sussex Labour Party who assisted with a tour of local village halls, George Bernard Shaw who waived a part of the royalties to which he was entitled, the Carnegie Trustees who gave a grant to the League in 1922.

And in 1930, the non-profit-sharing ALS was permitted to register itself under the Charitable Organisations Act. This was primarily for the purposes of gaining tax relief. As a result:

> The entertainments tax, against which we had appealed Mr. Baldwin as early as the year 1919, and which he then regretfully refused, was lifted from us during the last years of our existence, but by this time conditions had altered so rapidly that it was too late for us to benefit substantially. Villages were no longer isolated, but linked to the towns by chains of buses. A mushroom growth of cinemas had sprung up everywhere, and in a number of places occupied the one and only hall, which was now barred against us.

Yet, as we have seen, the growth of the cinema between the wars did not by any means obliterate the live theatre, and an equal cause of the League's eventual demise was the parallel growth in the drama, amateur and professional:

> The truth of the matter was that the very success of the ALS was now proving its downfall. The entertainments that the League had stimulated the country people into providing for themselves were superceding the Travelling Theatre. The secretaries of the numerous amateur groups, which had flourished everywhere in our trail, now wrote that our dates clashed with their productions and festivals. We were warned off one city, where a repertory company had recently been

started, and threatened with a boycott by the local press if we returned to the small hall where we had played successfully for a number of years. It was a compliment that we did not appreciate. All this, with the added competition of other little travelling theatres, some of whom were imitating our variety programme, made it clear that if the Arts League of Service was to continue it must find some extra source of revenue.

Many other sources – including playing a season at London's Royal Court Theatre – were tried, but at no time did the League consider asking for state aid, believing that governments could never support anything but staid and conventional art:

> Our programme was so large that looking back it seems that only a Ministry of Fine Arts could have carried it out. And such a thing would have been impossible. For we claimed recognition for the modern artists, and the orthodox regarded us with suspicion as revolutionists and extremists.

The Arts League of Service finally folded in the summer of 1937, selling off their vehicles, scenery and costumes in order to meet their mounting debts.

In the following Winter another group of theatrical impressarios, chaired by Basil Dean, held their first informal meetings. They believed that a second European war was inevitable, and were looking to create a wartime organisation within which West End and variety entertainments could be offered to troops and factory workers. The new organisation would carry on the ALS touring work on a larger scale, but would also draw from Dean's First World War experience with the Garrison theatres, particularly in the matter of its finances. For from the first the Entertainments National Services Association, as it came to be called, was conceived as a state-funded organisation.

When it came into formal existence in the autumn of 1939, ENSA proved to be a broad church: an amalgam of the 'legitimate' and 'illegitimate' stage, straight drama and variety theatre, opera, orchestral music and swing. Serious actors such as Robert Donat, John Gielgud, James Mason and Vivien Leigh worked for it alongside entertainers as varied as Joyce Grenfell, Noël Coward and Tommy Trinder. Indeed, by the end of the war it was estimated that four out of five stage artistes had worked for ENSA, and 500,000,000 people had seen its shows. Its total state subsidy for the five years of war, passed to it through the armed services vote – was a remarkable £14,000,000. However, its organisation – the whole of ENSA's operations throughout the war were directed from the requisitioned Drury Lane theatre – was notoriously ramshackable, and, unsurprisingly, there was competition for the privilege of providing wartime entertainment from within the armed forces themselves. The

Royal Air Force supported its own touring *RAF Gang Show*, directed by Ralph Reader. Charles Smith, Director of the Brighton Theatre Royal, set up Mobile Entertainments for the Southern Area which each week sent out two plays, two concert parties and a film show to tour the defense positions in southern England. The army also promoted its own touring concert party, *Stars in Battledress*, which was directed by Basil Brown.

Meanwhile, amidst the rush by the entertainers to offer what Kenneth Clark haughtily described as 'the kind of entertainment that is supposed to be more suitable in a national emergency' there were organisations being set up by the improvers to educate the war workers and elevate their tastes. Within a few weeks of Dunkirk, the army decided to try to raise spirits by establishing weekly discussion groups for the demoralised troops. The unit set up to achieve this, titled the Army Bureau of Current Affairs, had as its head W.E. Williams, a prominent figure from the pre-war world of adult education. Williams' most decisive act was setting up a Play Unit within the Bureau, to give the troops short 'documentary dramatisations' (none lasted more than forty minutes) of various contemporary problems, which were then thrown open for discussion. Later in the war, the ABCA Film Unit produced short documentary films with the same function.

Back in wartime London Kenneth Clark was, with others, busily setting up another agency, which was to be the genesis of the post-war Arts Council of Great Britain. Its cultural ambitions were much narrower than those of ENSA, and most obviously resembled those of the old Arts League of Service. The aims of the new organisation were:

1. To provide opportunities for hearing good music and for the enjoyment of the arts generally among people who, on account of wartime conditions, are cut off from these things.
2. To encourage music-making and play-acting among the people themselves.

The *Committee* (later the *Council*) *for the Encouragement of Music and the Arts* received a first grant of £25,000 from the wartime Board of Education, to match an award of £25,000 from the American-based Pilgrim Trust.

For a year and more CEMA did much as the ALS had done: mount small exhibitions, send out small-scale tours, and encourage amateur work. But then, as was later recorded in an Arts Council publication, *The First Ten Years 1946–56*, the organisation changed its nature:

CEMA was, to begin with, a patron of help-yourself activities in music and drama, a sponsor of amateur exercises in play-acting and music-making; but soon it began to enlarge its sphere and influence in a variety of ways. Instead of being simply a grant-aiding body assisting amateur societies it began direct provision on its own account.

It also began to reorganise itself in ways which the post-war Arts Council was to make familiar. It established CEMA officers in each of the 'regions' which had been designated for the purposes of civil defense, and formed 'panels' of artists and managers in each of the major art form areas whose duty was to advise the CEMA officers.

However, the interests of the new body shifted again, away from direct promotion of their own performing arts companies to giving 'guarantees against loss' to professional opera and theatre companies – in much the same way that the first Royal Academy of Music had assisted the Italian Opera House at the beginning of the eighteenth century. This further shift in CEMA practice was immediately welcolmed by the music and drama world, as signalling the state's commitment to the wartime support of the professional theatre. As the young director Tyrone Guthrie wrote in 1944:

> CEMA has been set up under the aegis of the Board of Education and financed by the Treasury. It has power to offer such managements as it sees fit, both status and financial aid. As yet the status is a little vague, and the aid is no more than a limited guarantee against loss. Nevertheless the principle of state patronage of the theatre is established and the practise is working well.

Although it had not at first been an easy task for the wartime mandarins to find legitimate ways of giving support to existing professional companies – particularly to West End producers whose activities were, under normal circumstances, highly profitable. State funds could only be used for clearly designated educational or otherwise improving purposes; they could not be used as investments in what auditors would see as highly speculative ventures.

The difficulty was resolved early in 1942. H.M. Tennant, major London producers, were presenting Britain's leading stage actor, John Gielgud, in a touring production of Shakespeare's *Macbeth*. The management wished to bring it into London, which was, with nightly air raids, a risky and expensive proposition, so they made application for a CEMA 'guarantee against loss'. Initially CEMA could not help, for H.M. Tennant's was plainly a commercial organisation. However following 'discussions' it was agreed the matter could be resolved by setting up a separate non-profit-distributing company, in the same form that the Arts League of Service had adopted. This 'charitable' company,

Tennant Plays Limited, would present the Gielgud production in London. It would 'lose' any profits it inadvertently made by paying the parent company a suitable 'management charge', so that it could be seen as both non-profit-distributing and educational, and thus be technically eligible for a state grant. This proved a successful manoeuvre and soon the practice of setting up a second 'charitable' company alongside its commercial 'parent' was followed by every leading British theatrical producer.

By such accidents of history what later came to be called the 'British system' of state subvention to the performing arts became established, and CEMA and its sibling Arts Council were able to designate their chosen quality institutions 'charities', like the Red Cross and St. John Ambulance Brigade. This not only helped to widen the notion of what a charity might be, but also led to a new, and narrower, definition of 'the arts'.

The original incorporation of the Arts Council under Royal Charter (9 August 1946) had said that the new Council existed '...for the purpose of developing greater knowledge, understanding and practice of the fine arts exclusively'. In practice, as *The First Ten Years 1946-56* more bluntly put it:

> The Arts Council believes, then, that the first claim upon its attention and assistance is that of maintaining in London and the larger cities effective power houses of opera, music and drama; for unless there quality institutions can be maintained the arts are bound to decline into mediocrity.

For the first time in British cultural history 'the arts' are described as consisting of *nothing more than* an élite group of charitable performing arts organisations. By this new definition, unless a handful of chosen theatres, opera houses and concert halls could be 'maintained' (i.e. subsidised), then it seemed that the whole of 'the arts' – the state-supported national galleries and museums, the arts in the education service and the B.B.C., the commercial music world, film, and all rural, folk and amateur art – was 'bound to decline into mediocrity'. A few token organisations were thus made to stand for the whole spectrum of British culture, and any critical evaluation of their worth was silenced by the imperative need to 'maintain' them.

This led to a new and catastrophic divide within British culture. The giving of state subsidy bestowed upon the recipient not just the status of being a 'quality organisation', but considerable economic advantages. Subsidised organisations were charities and thus obtained a mandatory 50% reduction in taxes on their premises, or 'rates' as they were then

called. They paid no entertainments tax, and, of course, received a further state award in the shape of a guarantee against loss' from the Arts Council of Great Britain. Arts Council clients were thus given immense advantages in their competition with providers from the private sector: in effect the operations of the new Arts Council imposed a tax upon the majority of cultural providers.

When in 1956, W.E. Williams, now made Secretary General of the Arts Council, was asked to comment on this, he replied rather disingenuously that 'the distinction must be drawn between art and entertainment', as if it were long established in Britain that 'art' could be distinguished by the degree of support it received from the state. Asked in particular whether he approved of the anomaly whereby the commercial theatres paid heavy taxes, and the subsidised Arts Council clients paid none, the Secretary General replied that he *did* approve:

> It is our business...to look after our own chicks which, in this case, are the non-profit repertory theatres ...Parliament has accepted the principle of protecting non-profit-distributing companies, and it is with these that the Arts Council is concerned. We are, in that sense, a vested interest...If Entertainments Tax were cancelled, or even reduced, the non-profit companies would suffer financially.

In other words, the Arts Council at that time considered it no part of its purposes to support the entirety of the performing arts, let alone other cultural sectors which had a claim to be considered 'fine arts'. They were willing to accept that the Entertainments Tax discriminated in favour of their clients, and sought to justify this by claiming that everything subsidised was high art, and everything which ran commercially was mere entertainment. 'We are conscious of the fact,' Williams went on, 'that, were the Tax to go, our own particular chicks would be in dire jeopardy'.

This persuasive new definition of 'the arts' depended upon the promulgation of another myth – that until the outbreak of the Second World War the great mass of people had enjoyed no contact with the arts, and that Britain had been without any worthwhile arts facilities. Keynes' claims that Britain had never had any decent arts buildings, that before the Second World War you could count the number of museums 'on the fingers of one hand' and that only since the state began to offer subsidies had the great majority of the British people had their musical and dramatic tastes developed, were endlessly repeated, heedless of the fact that, as we have seen in the course of this book, each assertion was demonstrably untrue.

To these was now added another historical falsehood. Our brief study

has suggested that the glories of literature, of music, of drama and the folk arts have throughout British history largely been borne by commercial organisations, supported at times by Royal patronage or by the churches, but most commonly by the subscriptions of those people, high and low, who had their own direct interest in the art. Yet it was now asserted that the British arts had *never* been sustained by the general public at all, but owed their entire existence to the high-minded support of a small group of the discriminating rich. And as high post-war taxes had now made the giving of such support difficult, the state had a duty to replace the rich connoisseurs with their own money and their own experts. This startling revision of cultural history first saw the light of day in a much-admired 1949 book by Mary Glasgow and B. Ifor Evans, *The Arts in England*:

> Among the older generation there were still, even until 1939, men who combined wealth, taste and generosity and so were desirous and able to encourage the creation and distribution of the arts in which they were interested.

The familiar names are then rehearsed: Sir Barry Jackson of the Birmingham Rep and the Malvern Festival, John Christie of Glyndebourne Opera and the art patron, Samuel Courtauld:

> All these men were interested in standards, by their private endeavours deeply benefited the community. It is difficult to see that they can ever have successors. Great wealth, as it was understood even thirty years ago, has been made impossible by the increasing incidence of income tax, surtax and death duties, while the uncertainy of economics values has greatly increased the cost of all artistic production.

There is no mention of those other arts activities that were flourishing by other means in 1949 – the West End theatre, Penguin paperback books, the commercial reps, the Carl Rosa Opera Company, Bertram Mills Circus, the chains of popular dance halls, the cinemas in which Britons were spending more than £50,000,000 a year. But then the new definition of 'the arts' meant that the caprices of the general public could be safely discounted. That was mere commercialism. It was the tastes and quirky pleasures of a handful of rich patrons which had moulded the true 'arts'. Notice the dexterity with which Glasgow and Evans imply that artists had until then always been dependent upon private patronage, and would not wish to have any involvement with commerce and the general public:

> The caprice and self-indulgence of patrons have often been a theme for comment; but, on the other side, it may be remembered that art is highly individualistic and that the artist prefers to work through an individual, even a difficult individual,

than through anything as impersonal as a committe or government department. Further, while there may be more than one person, any bureaucratic organisation is likely to develop monopolistic tendencies.

Once the loss of the patron had been felt, the State which had destroyed the patron by heavy taxation had itself to step in, by some means or another, if the functions of patronage were to continue. Though in England one could not expect this to happen neatly or logically, yet it was the necessity for continuing the more stimulating elements in patronage at its best that led to such activities as those of the Arts Council of Great Britain.

The change in the audience for the arts may not be so immediately obvious, but it is impressive....during the war...it was discovered that a large and genuine audience for music existed...The success during the war years of the great classics on the stage, often performed and witnessed under conditions of great difficulty, showed that there was also an increased and enthusiastic audience for the drama... In the visual arts the early efforts of the British Institute of Adult Education to provide travelling exhibitions in very varied parts of the country showed that there was in England a spontaneous interest in pictures, sculpture and other forms of design among unexpected sections of the population...

All this is in its way encouraging. The state has discovered agencies to meet a fresh need and the existence of that need is shown by new and larger audiences.

Glasgow and Evans imply that the great mass of the British public – the 'unexpected sections of the population' – had never played any part in the fashioning or creation of art. The loss of the private patron meant that the state 'had to step in'. This benevolent act meant that the great mass of ordinary people were now making their first tentative contacts with music, drama and the visual arts.

Yet this was all a monstrous untruth. Not only had 'unexpected sections of the population' long given their financial support to artists and arts institutions, they had for centuries been a responsive public for all kinds of music, drama and art. It had been discovered 'that a large and genuine audience for music existed' in Britain more than two hundred years previously, when thousands had flocked to hear Handel's music, and discovered again in the second half of the nineteenth century, when the crowds travelled to the great music festivals. And the 'increased and enthusiastic audience for the drama' which the mandarins 'discovered' in the nineteen forties was less than half the size of the enthusiastic British theatre audience which the parliamentary *1892 Report* had described. While only a cultural hermit could affect to judge the 'spontaneous interest' shown in the small travelling exhibitions of the BIAE as being of greater significance than the crowds which had poured in to the new

national galleries during Victoria's reign.

By the mid-sixties, with the advent of a new Labour government (which had made much of its spiritual links with the new 'youth culture'), there were the first serious signs of a crack in the establishment facade. In 1965, Wilson's government produced the first (and, to date, only) White Paper on the arts, entitled *Policy for the Arts: The First Steps*. The Paper purported to be on the side of 'the young', seemed eager to tackle the problem of the yawning divide between the state-supported minority arts and the hugely popular new commercial arts activity in fashion, photography, and popular music, which the young were supporting in their tens of thousands. But it was curiously unwilling to acknowledge that it was the nature of state support which created the problem.

Its tone was one of flaccid exhortation. Young people, the document assured its readers, 'will want gaiety and colour, informality and experimentation.' And they would, it seemed, get all of these things from the state-subsidy system, once the British people threw off the unfortunate legacy of commercialism. For we could not ignore;

> ... the drabness, uniformity and joylessness of much of the social furniture we have inherited from the industrial revolution.

All that was needed was to brighten the subsidised arts up a bit, for:

> ...There is no reason why attractive presentation should be left to those whose primary concern is with quantity and profitability.

The White Paper did little to challenge the immediate post-war notion that whereas commercial processes produced nothing but entertainment, state subsidy given to charitable organisations invariably produced 'the arts' – or the comfortable assumption that a government's cultural philosophy could be deduced from the size of its annual grant to the Arts Council. (That was in any case a tokenistic argument: although it is true that during the first Wilson government the annual ACGB grant was indeed increased, its importance in the scheme of things can be guessed by noticing that it was never more than *one thirtieth* of the Labour government's annual income from gambling taxes.)

Yet the modest confusions of the sixties paled into insignificance compared with the pounding critical rationality received from Mrs Thatcher's Conservative governments. The Prime Minister's first Arts Minister, Norman St. John Stevas, opened the campaign in the early eighties by announcing that he was looking for state aid to 'the arts' *now* to be matched by private and industrial sponsorship. This curious initiative – based upon the post-war presumption that the state had until

then borne the sole responsibility for the high arts, and that vulgar commerce should now be only too glad to raise its snout from the trough and bankroll its betters – was a decided failure. At first the Arts Council – which seemed ready to save its own skin by scurrying to do the new government's bidding – attempted to impose rigorous conditions on its clients, insisting that they found 'matching money' from the private sector. They even held a succession of 'training days' in which the subsidised organisations were taught how to approach eager industrialists for additional cash. However, it soon became clear that overall the state was spending more on trying to implement the new system than any new money it was receiving from the private sector, while smaller organisations were discovering that although they were now obliged to have 'fund-raising' officers on their staffs, the biggest part of private sponsorship was still going, unsurprisingly, to the larger organisations.

A second change, which showed itself in the mid-eighties, was much more serious. It derived from Mrs Thatcher's avowed belief that both the former public sevices and leisure activities should now be viewed as *industries*, with their cost-effectiveness judged in the same way as in production industry. Everything – charities, sport, the churches, the arts, social service – was now to be costed and 'managed'. Until that point, Britain's major cultural bodies had resisted the idea that what they were concerned with was either the production of goods or services, but in the face of a powerfully doctrinaire government, they capitulated. Whereas the 1965 White Paper had seen 'the social furniture we have inherited from the industrial revolution' as a deadening emcumbrance, twenty years later, the Arts Council chose to see the new industrialisation as a liberating force. 'The arts ' trumpeted Luke Rittner, the new ACGB Secretary General, 'are a successful part of Great Britain plc.' That was all.

The newly-concocted 'arts industry' had to be dressed up as a government success, but in order that its supposed buoyancy and profitability might appear plausible, it had to embrace the formerly-despised commercial sectors. 'The arts' thus smearily encompassed both the charitable arts (quickly, though rather implausibly, repackaged as an 'experimental test bed', with state subsidy newly designated as 'risk capital') and the profitable realms of art – publishing, the private galleries, the commercial theatre, popular music, the record industry and film. 'We depend upon the idea that the arts are a good investment,' said the *British Council Report 1985/6,* not just in themselves, but as a means of improving Britain's reputation abroad.'

The industrial processes which would produce these profitable exports were described by the *Art Council Report 1986/7*. The state-subsidised charities and the commercial sector were to be treated in the same way, as parts of one 'arts industry'. Arts Council officers, it seemed, were no longer to be concerned with responding to the finished product, but would be working to 'minimise overheads', 'optimise production levels' in line with market needs and carrying out 'audits of current management practice'. They would, of course, also be examining the 'sales potential' of each of the new arts factory products and monitoring the workforce with 'appraisal teams'.

Every kind of virtue was now claimed for the amorphous product of this new 'industry'. The 'arts' it produced were both small-scale, challenging, in urgent need of subsidy – and hugely profitable, with the power to inspire and unite whole nations. Every possible function and benefit of this miraculous entity – in all its historical guises and acting all at once – was now called into service. One of the Arts Council's many glossy pamphlets, *Urban Renaissance: The Role of the Arts in Urban Regeneration*, gives something of the all-inclusive claims being made for 'the arts':

> The arts can make a substantial contribution to the longer-term revitalising of depressed urban areas. Theatre, music and the visual arts – and the facilities for their enjoyment – are essential ingredients in the mix of cultural environmental and receational amenities which reinforces economic growth and development. They attract tourism and the jobs it brings. More importantly, they can serve as the main catalyst for the wholesale regeneration of an area. They provide focal points for community pride and identity. Equally importantly, they make a contribution to bringing together communities which might otherwise be divided.

The 'arts industry' was now analysed and described as if it possessed a concrete, unified essence, and was not simply a bureaucratic invention. The Policy Studies Institute was in 1988 paid to research and produce a full industrial report, *The Economic Importance of the Arts in Britain*. This announced that it would relate:

> ...the role of the arts to the fact that we live in an era of industrial restructuring characterised by the growing importance of the service industries (especially in the areas of finance, knowledge, travel and entertainment) and of industries based on new technologies exploiting information and the media.

It is characteristic of the age that a supposedly rational document should announce that it was a 'fact' that we were living in a drastically altered state of being, an 'era of industrial restructuring characterised by the growing importance of the service industries'. It was rather as if the

young Queen Victoria's advisers had told her that it was an unalterable 'fact' that she was living in an age of poverty, or Cromwell's lieutenants had urged their leader to accept the 'fact' that they were living in an age of witchcraft. Yet in the eighties changes in bureaucratic terminology increasingly masqueraded as 'facts', as changes in the human condition. Not only were 'the arts' now deemed to be an 'industry', but they also now existed within 'the electronic age', and had suddenly become a 'part of Europe'. Meanwhile 'postmodernism' had led us towards new ways of understanding (or 'deconstructing') them – without reference to their history, or the critical framework in which they had hitherto been understood.

The authors of *The Economic Importance of the Arts in Britian* were of the opinion that things become more important when people described them in economic terms; but they believed that – in defiance of the long traditions that the values of the arts lay in their social, moral and aesthetic meanings – simply because they wanted to. It was not a *fact* that in the late eighties our religious, social and moral selves were being redefined within an 'area of industrial restructuring'. All that was a fact was that bureaucrats chose to make use of a series of powerful terms – 'industry' and 'art' prominent among them – to promote vaguely-defined new political entities.

For the bureaucratic 'arts' of the late eighties were a shadowy and highly conceptual notion, bearing little relationship to the actual work of artists. Nor did 'the arts industry' ever exist, except as a political entity, a phrase in a 'planning document or a notional economic counter in international trade. Real artists did not – and never could – constitute an 'industry'. Composers, painters, dancers and jewellers did not work in similar production lines, with similar materials, assembling different parts of the same product. What linked artists was not their similarities in production methods, but the high significance which the public has historically given, and continues to give, to their distinct and separate works. Describing the *whole* of art as a production industry is not only to discount the public's powers of discrimination, but falsely to standardise quite different kinds of work created within utterly different creative realms

Yet such terminology continued to be used, and by many people who should have known better. 'The arts create a climate of optimism,' chortled the Arts Council's Secretary General in 1985 (doubtless with such prominent twentieth century roisterers as Franz Kafka, Samuel Beckett and Francis Bacon in mind), '– the "can do" attitude essential to developing the "enterprise culture" this Government hopes to bring to depressed areas.' The new yuppie culture thus revelled in treating 'the

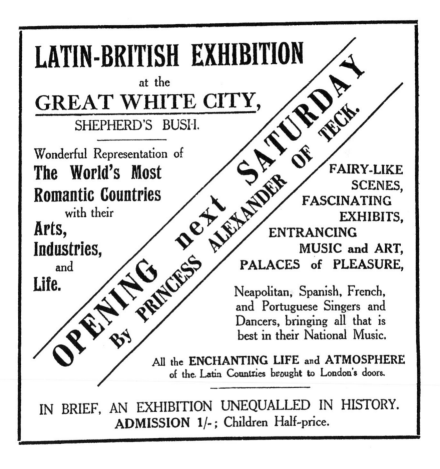

Figure 17 Advertisements for the International Exhibitions which were a regular feature of London life before the First World War, such as this one for the 1912 Latin-British Exhibition, show that Industry and the Arts were still quite seperate entities.

arts' as economic commodities, adrift in a postmodernist universe, for it absolved them from the effort of making historical or critical judgements. As in Orwell's *1984*, the new terminology made it hard to remember what the arts had once been.

Yet it cannot be stressed too often that this new definition of 'the arts' tore the arts from their historical roots and deprived them of meaning. As T.S. Eliot wisely (though politically incorrectly) said in 1919 in *Tradition and the Individual Talent*:

> No poet, no artist of any art, has his complete meaning alone. His significance, his appreciation is the appreciation of his relation to the dead poets and artists,

Secondly, because the newly-defined bureaucratic 'arts' had no real substance, the promises of the 'arts industry' were also false. The arts did not automatically commercially regenerate inner cities, or bring whole communities together, or attract investment. If the promotional arts publications of the eighties had been real company prospectuses, their authors would surely have been prosecuted for fraud. In Dryden's words:

> *Some in clandestine companies combine:*
> *Invent new stocks to trade beyond the line:*
> *With air and empty names beguile the town,*
> *And raise new credits first, then cry 'em down:*
> *Divide the empty nothing into shares*
> *And set the crowd together by the ears.*

The fractures which showed themselves within the 'arts industry' in the early nineties were as inevitable, and as forecastable, as the collapse of the South Sea Bubble had been. The Arts Council of Great Britain was hung, redrawn and quartered. There were mass resignations by living artists from arts council panels; growing hostility from arts critics to the increasingly bizarre judgements of the arts bureaucrats; outright hostility from the general public towards what the bureaucrats termed 'public art'; the near-collapse of the regional statesubsidised theatre; confusion over the funding of orchestras, and day after day in the press an unprecedented infantile bickering over 'standards' and 'resources' which could only mean that the 'British system', and the critical language which had sustained it, had broken down beyond repair.

Attention was diverted from this confusion when, in the early 1990s, it became clear that the Conservative government intended, after a lapse of a hundred and seventy years, to reinstate a national lottery in Britain. It was launched with a powerful propagandist campaign to persuade punters that by buying tickets they were not so much gambling as giving

to charity. Initially, the lottery was promoted with heartrending photographs of crippled children, and elderly people in wheelchairs (although, in fact, hospitals and the medical profession were not direct beneficiaries) and with a characteristically slick campaign which insisted, in Prime Minister Major's words, that with the new lottery 'everybody was a winner'.

The fact that playing the lottery now became Britain's major leisure pastime was submerged in florid rhetoric arguing that state-sponsored gambling was bringing us to a new moral, academic and creative richness. The then Heritage Minister, Virginia Bottomley, quoted approvingly the words of a well-known North Eastern businessman:

> Sir Ernest Hall said recently that "Through the lottery we have an opportunity to do for our Towns and Cities what the enlightened patronage of the Papacy and the Medicis did for the Cities of Italy. We can realise Blake's dream of making England 'an envied Storehouse of Intellectual Riches'".

Although such willed disingenuousness was possible only if the speaker brushed over the harm that the state lottery had once done, and ignored the possibility that the hysteria and false promises of the new state lottery might help to make Britain the kind of place in which 'intellectual riches' would have no meaning. Accordingly, the state lottery added to the general cultural confusion.

Even the notion of 'charities' had become distended and blurred. The old sense of 'charity' – a group of volunteers giving their time freely to a deserving cause, to help assuage hunger, pain or suffering – was now being swamped by a new breed of corporate charities, big businesses with highly-paid employees, who retained the many tax advantages which charities had traditionally enjoyed, but whose objects had little to do with obviously deserving causes. The new British 'charitable sector' contained some 185,000 organisations, had an annual turnover in excess of £18 billion, and employed more than 600,000 people – with the average salary of the directors of the top 100 charities averaging out at just under £80,000 a year. The relief from taxation which British charities enjoy exceeds £2 billion a year.

The lottery compounded the moral and economic confusion which reigned in the charitable sector. The definition of charitable causes had now become so broad that it was hard to see any connection with what charities had once been. Public schools, the Arts Council, the Royal Opera House, the Wellcome Trust were now all designated charities in the same way as Dr. Barnado's or the Red Cross had once been. Nor was it true that charities were sustained any longer by genuine public

philanthropy. Increasingly, they were sustained by taxpayers' money given to them by government, which saw the 'charitable sector' as a convenient way of dealing with marginal but irritating social questions. Thus the arts councils, all charities, were financed partly by direct government grant and partly by the state lottery – monies on which no tax was paid. They were then able to heavily subsidise the rebuilding and revitalising of the Royal Opera House, itself also a charity. (Meanwhile, the National Council for Voluntary Organisations reported that in the first year of the new lottery, donations to the small 'genuine' charities, still largely run by volunteers, had declined by £376,000,000.)

It thus became ever more clear that what afflicted the arts world was less 'industrial restructuring' than wholesale *linguistic* restructuring. All boundaries were blurred, as critics gave way to economic and political 'experts', and morality yielded to the imperatives of economics. Old and valued terms were torn from their long-held roots of meaning. This deliberate confusion allowed such morally disreputable pieces of trumpery as a national lottery, once ignominiously discarded by the state, to be brought back and relaunched by the political spin-doctors. 'The arts' became more and more shadowy in nature; they now simultanously united and divided us, conveyed mindless optimism and promoted anguished thought – while artists were simultaneously seen as successful industrialists and abject mendicants. Meanwhile, the word 'industry' no longer referred either to hard work nor to the processes of manufacture. In its limp new sense 'industry' just meant *sales* – profitable activity in the market.

Britain's new Secretary of State for Culture, Media and Sport in the new Labour government, Chris Smith, made this unblushingly clear in *The Times* (15. 7. 97), when he assented to the embarrassing notion – so eerily reminiscent of the cant of the first Wilson government – that Britain should now be 'restyled' as 'Cool Britannia'. The former Department of National Heritage had, it appeared, been renamed the Department of Culture because:

> The name Department of National Heritage was as inadequate an as partial as its unofficial alternative, the Ministry of Fun. Worse, it was inaccurate. Heritage looks to the past. We look to the future.

Indeed at the site of the Millennium Exhibition one could read the prominently displayed announcement that 'The Future can, and must, be controlled', although primarily Smith was looking to the future balance of payments, for it was plain that he saw 'Cool Britannia' as being the province, not of the creative arts, but of the Board of Trade. He now

justified what was usually termed the 'cultural industries' in much the same terms that previous administrations had justified arms sales:

> The new department represents much more than a change of name. It is a change of direction. It is a recognition that cultural and leisure activities are of growing significance, not only to individuals they are also of rapidly growing economic importance.
>
> They are the basic fuel of our hugely successful international tourist industry, and the heart of a series of activities in which Britain is genuinely a world leader – from music, theatre, television and software to such rising industries as fashion, advertising, product design and architecture.
>
> ...The continuing strength of our 'creative industries' opens up the prospect of Britain enjoying immense competitive advantage, as economic activity becomes even more global and ever more competitive. These creative industries go much wider than any conventional definition of the arts...

Indeed they do. They go very much wider than the high arts, popular arts, folk arts, domestic arts, media arts or any other previous understanding of what might have some significance within the British culture.

Perhaps the most misleading pretence of all is that the strange new 'creative' or 'cultural industries' are some kind of natural development within a carefully-considered British system of cultural support. As our study has shown, the British system, such as it is, has developed almost entirely by chance. In the 1930s, if the fenland people had not found Lord Keynes and his fellow Cambridge apostles so unattractive they might well have supported the local theatre by the usual subscription method, and Keynes might have been less personally involved in the business of patronage, and in setting up the Arts Council in that particularly patrician way. Again, had R.A. Butler had his way in 1944, the post-war Arts Council might well have borne the epithet 'Royal', and built upon the Royal patronage of past centuries, instead of insisting that all it was doing was entirely without precedent.

Instead of simply producing the 1965 White Paper – so long on pieties and so short on practicalities – the British system of arts support would surely have been radically different if Mr Wilson's government had taken cultural provision more seriously and drawn the whole spectrum of the arts into a national pattern of cultural provision. As it would surely have been different again if Mrs Thatcher had followed her instincts and privatised the Arts Council, tearing away the protective cover it enjoys as a government-sponsored 'charity', and thus putting all kinds of arts organisations on an equal legal footing.

Had the Arts Council not in its turn capitulated so cravenly (and so unnecessarily) to what they perceived as Mrs Thatcher's ideologies; had Mr Major's government not decided that people could be persuaded that a revived state lottery would bring universal benefit; had the mandarins of the arts world flirted less with the new economic Europe, and understood a little more about the ways in which British culture was already truly 'European', then the 'British system' might have been utterly different. It is a system that has developed by chance, a history marked by ever-changing signposts.

And at the end of this long and convoluted story come the horrors of the 'cultural industries'. It would seem that any tawdry distraction now qualifies as an 'art' – providing that it is under the government's control and a part of a money-making process. In Mr Smith's words:

> The department's interests cover the spectrum of life in Britain, from the popular culture of music, television and the drama of the lottery draw *(sic)* to those areas of the arts which, in Matthew Arnold's classic definition of culture are "a pursuit of total perfection by means of getting to know... 'the best which has been thought and said in the world'.

Could anything be more revealing of the authorities' disdain for the real arts and their living audiences – indeed, could anything be more patronising – than the cynical way in which the state lottery has been repositioned on the political board? In the nineteenth and early twentieth century a state lottery was considered to be an abhorrence, with values that were destructive of both art and public charity. Then, insidiously, it became morally neutral, a prime means of raising funds for good causes. Finally it has taken its place within the government-defined 'creative industries' as a fully-fledged 'art experience' in its own right.

Meanwhile governments have taken to themselves not only the right to decide what shall be deemed 'art', but also the right to announce which artistic ventures shall enjoy public support and even, with the advent of the millennium, what shall constitute an 'experience'. Note for example the assurance with which the reigning Culture Secretary bestows the epithet 'public', and the freedom he feels in negotiating on behalf of 'the ordinary people of Britain', as he gives his views to the diners at the Annual Dinner of the Royal Academy on 22 May 1997:

> I believe strongly that London needs a first-rank, globally-recognised venue for opera. I think that it is right for us to ensure that public support is available to it. But I want to see better access for the ordinary people of Britain in return for that support. That is why the commitments already given, for some cheaper seats and for more television broadcasting, are welcome.

Exhibition poses age-old question: But is it art?

Figure 18 *'But Is It Art?'* became at the end of the twentieth century one of the most familiar of headlines. Newspapers sneeringly asked the question of those things which presumed to *be* art, while daily awarding the title of 'artist' to footballers, dress designers, restaurateurs, wine makers and television performers.

Venessa Beecroft at the ICA *The Times* 28.10.97

'Public support' means of course 'taxpayer's money', so it would be interesting to see whether the Minister's arguments could actually convince a gathering of ordinary people – a group of redundant Yorkshire miners, say – that a few lower-priced seats and a couple of extra televised operas justified the government in feeling that it was 'right' to pass on their taxes to the Royal Opera House in the name of *public* support for a charitable cause?

Just as it would be interesting, for once, to hear 'ordinary people' debate the notions of 'access' and 'standards' that so concern the metropolitan arts establishment, so would it be good to have the reactions of genuine artists to our cultural policy-makers. How bracing it would be to witness Blake's volcanic fury at the kind of New Jerusalem we are building, or to see Hogarth's commentary upon the 'Millennium Experience'. Or, come to that, to read Arnold's analysis of whether the 'Cultural Industries' should really take their place, together with the Lottery Draw, alongside 'the best that has been thought and said'.

Yet the voices of artists, like the voices of the general public, are now of little account. It is government and government bureaucracies that shape the language and the social and economic systems into which art must now fit. As Ian Robinson remarks, 'We must have a literature, if only for the sake of keeping 'A'-level going'. Likewise the smooth running of the national economy demands that each year the state must produce a predetermined amount of 'art' to sustain the place of the 'arts industry' within the government's regular accounts of contemporary British life, the glossy brochures which tell us that the ordinary people of Britain had no kind of meaningful life before the invention of the state's 'cultural industries'.

Yet it remains open to us to reject all such lies about the past, and all the empty phrases contemporary politicians use. We can choose once more to speak in ordinary English, to speak of 'art' and 'industry' in their full complexity and richness, not as items of smeary political propaganda. There could be no better way of marking the beginning of the twenty first century than by a new-found determination to speak our language well, and to take renewed pride in our real cultural history.

Appendix 1

Comparison of cultural facilities and artists working in Cardiff, Leicester, Nottingham and Sheffield, 1850, 1900, 1950

c.1850	Cardiff	Leicester	Nottingham	Sheffield
population	c. 18,000	c. 59,000	c. 57,407	c. 135,000
architects	11	n/r	n/r	18
artists	1	7	10	15
billiard rooms	1	3	2	n/r
bookbinders, stationers, booksellers	17	31	33	53
brewers	3	n/r	n/r	28
dancing teachers	1	1	3	25
drawing teachers	1	n/r	n/r	1
eating and coffee houses	16	9	14	28
fairs	1	1	1	2
hotels, inns, taverns, beer houses	268	276	250	321
libraries	6	6	11	8
local newspapers	3	4	4	6
museums	1	1	1	2
music and instrument shops	5	7	7	11
musicians and music teachers	5	10	21	36
newsagents	5	6	5	52
pawnbrokers	9	n/r	n/r	27
photographers	1	1	1	6
piano tuners	n/r	n/r	7	5
picture dealers	1	n/r	4	n/r
printers	4	12	21	14
public house working men's libraries	n/r	n/r	6	n/r
theatres	2	1	1	5
writing teachers	n/r	n/r	1	1

SOURCES. Local Trades Directories, advertisements in local newspapers and (for 1950) listings in telephone directories.

n/r Not recorded (or evidence contradictory).

c.1900	Cardiff	Leicester	Nottingham	Sheffield
population	c. 200,000	c. 219,000	c. 220,000	c. 381,000
architects, surveyors	44	38	n/r	62
artists	n/r	n/r	40	37
artists' and photographic material dealers	3	n/r	12	10
billiard rooms	1	n/r	1	1
boarding houses, lodgings	n/r	3	11	161
bookbinders	12	17	18	41
booksellers, stationers	28	31	38	202
brewers, malters	15	14	6	34
choirs	4	3	3	3
coffee houses	37	10	n/r	15
dancing teachers	n/r	n/r	10	5
dining, refreshment rooms	74	23	64	115
drawing teachers	n/r	n/r	5	4
hotels, public houses, inns	355	383	556	1,169
libraries	8	11	18	14
local newspapers and periodicals	8	7	10	9
museums, art galleries	1	1	1	5
musicians and music teachers	45	44	196	227
newsagents	95	73	166	330
nurserymen, florists	23	21	14	43
orchestras	2	1	1	2
organ builders	3	3	1	5
parks, gardens and recreation grounds	11	14	13	15
pawnbrokers	34	27	52	142
photographers	27	28	37	65
picture dealers	22	n/r	12	12
picture frame makers	16	26	1	43
printers and lithographers	33	53	29	107
public halls	12	8	16	9
publishers	3	14	9	10
sculptors	n/r	n/r	10	14
taxidermists	1	9	1	2
theatres	4	3	4	4
woodcarvers	2	3	1	2
music, instrument dealers	12	30	21	}205
piano dealers	9	3	}42	
piano tuners, repairers	12	3		25

c.1950	Cardiff	Leicester	Nottingham	Sheffield
population	c. 243,632	c. 285,181	c. 299,402	c. 512,834
architects, surveyors	28	79	44	54
artists	8	4	5	5
billiard rooms	5	8	11	27
bookbinders	6	21	12	14
booksellers	28	24	16	39
brewers	8	9	10	15
cinemas	23	25	39	59
dance halls	6	5	5	8
gramophone dealers	2	n/r	4	3
halls for concerts etc	9	8	1	9
hotels	25	30	46	37
local newspapers	8	5	9	6
museums, art galleries	1	5	3	6
musicians, band agents	1	n/r	2	n/r
newsagents	n/r	n/r	214	105
organ builders	2	2	2	4
parks, recreation grounds	3	11	26	19
photographers	33	30	23	38
piano tuners, repairers	11	7	13	19
picture dealers	13	1	2	4
picture frame makers	5	4	3	5
printers	21	117	33	94
public houses	230	264	377	874
public libraries	20	26	41	38
publishers	2	6	4	5
restaurants, cafés, refreshment rooms	149	74	139	100
sculptors	3	1	n/r	4
stationers	20	72	42	99
teachers of dancing	11	14	11	38
teachers of elocution	1	4	7	18
teachers of music	37	97	74	{144
teachers of singing	5	5	4	
theatres	3	3	6	7
music, instrument dealers	12	6	7	{23
piano dealers	4	1	2	

Commentary on Sources

This is a generalist work, in which the authors have drawn freely both from their own archival research, and from a wide range of writers, critics, cultural analysts, historians, philosophers and economists whose works seem to bear upon the subject – as well as from specialists in cultural studies, arts management studies and media studies.

The following includes notes on sources not directly given in the text, and includes in addition those books and papers which the authors have found particularly useful as references and as background reading. Of necessity this cannot fully cover each aspect of such a broad-ranging study, but it is hoped that it provides starting points for those wishing to follow up aspects of the work.

A collection of publications relating in particular to the development of the arts and popular entertainment in London and used in this study has been lodged in the Gresham Collection at London's Guildhall Library.

All are published in the U.K. unless otherwise stated.

Introduction

The standard cultural history is Ford B. (ed.) *The Cambridge Cultural History of Britain* (9 Vols), Cambridge University Press 1988–95. A useful adjunct to the somewhat patrician view of culture taken by some of that study's contributors is MacKechnie, S., *Popular Entertainment through the Ages*, Sampson Low 1936, which despite its lack of footnotes or references, remains the best-written and most authoritative account of the development of the popular arts in Britain so far published. Of much very broader scope, and a source for much of the political and legal information in this book, is Charles Arnold Baker's excellent *Companion to British History*, Longcross 1997.

Questions of language are at the heart of our inquiry, and it will always be useful to read or re-read T.S. Eliot, *Notes Towards the Definition of*

Culture, Faber 1948, and the two seminal works by Raymond Williams, *Culture and Society 1780–1950*, Pelican 1961, and *Keywords*, Fontana 1976. More recent is Ian Robinson's *The Survival of English*, Brynmill 1981, the introduction to which, 'Language and Life', should be studied by anyone concerned with the way the language of public relations has replaced critical dialogue in our universities and arts councils.

Key texts for understanding the postmodernist notions currently gripping our universities are Hutcheon, L., *The Politics of Postmodernism*, Routledge 1989, and Evans, R.J., *In Defence of History*, Granta 1997. The modern belief that economists should of right make cultural judgements is, along with much else, called into question by Omerod, P., *The Death of Economics*, Faber 1994, and the disturbing fact that modern economics seem, like critics and cultural policy-makers, to have cut themselves off from their historical roots, is sorrowfully described in Kadish, A., *Historians, Economists and Economic History*, Routledge 1989.

Keynes' famous 1945 broadcast, from which his remarks are taken, was published in *The Listener* 12 July 1945, and reprinted as an appendix to Pick J., *Vile Jelly: The Birth, Life and Lingering Death of the Arts Council of Great Britain*, Brynmill Press 1993. Keynes own self-confidence, superiority and 'contempt towards all the rest of the unconverted world' is discussed in Leavis, F.R., 'Keynes, Lawrence and Cambridge' in *The Common Pursuit*, Chatto and Windus 1952, while the activities of Keynes' Cambridge circle, including what the author tartly describes as 'the higher sodomy', are laid bare in Deacon, R., *The Cambridge Apostles*, U.S.A. : Farrar, Straus and Giroux 1986. Keynes failure to persuade the citizens of Cambridge to join a subscription scheme is recorded in a privately printed memoir, Norman Higgins, *The Cambridge Arts Theatre 1936–1968: A Personal Record*, Cambridge 1968.

An important work, not just for this chapter, but for the whole of the study is Herbert Read, *Art and Industry*, Faber 1952. The significance of calling antagonisms in the workplace *industrial* relations is made clearer by reading The Bullock Committee: *Report of the Committee of Enquiry into Industrial Democracy*, H.M.S.O. 1977. Difficulties posed by the 'industrialisation' of cultural processes can initially be understood by a careful reading of Frith, S., 'The Industrialisation of Music' in *Music for Pleasure*, Polity 1988.

The wartime debate about whether the post-war Arts Council should have borne the epithet 'Royal' is analysed with care by Leventhal, F.M., 'The Best for the Most: CEMA and State Sponsorship of the Arts in

Wartime, 1939–1945' in *Twentieth Century British History*, Vol. 1 No. 3 1990. R.A. Butler's part in the debate is also alluded to amusingly in Witts, R., *Artist Unknown: An Alternative History of the Arts Council*, Little, Brown 1998.

1. The Virgin Queen

The best study of the complex interaction between the arts and the developing economy of Elizabethan England remains L.C. Knights, *Drama and Society in the Age of Jonson*, Peregrine 1927. Valuable illustration of the importance of the painters and miniaturists in Elizabeth's reign is in Trevelyan, G.M., *Illustrated English Social History*, Vol 2., Pelican 1964. The musical world is described in Mackerness, E.D., *A Social History of English Music*, Routledge 1964. The standard life of Sir Thomas Gresham is Burgon, J.W., *The Life and Times of Sir Thomas Gresham*, London 1839, while a useful account of Sir Thomas foundation of Gresham College is in *A Brief History of Gresham College 1597–1997*, Gresham 1998.

Keynes comments on the Elizabethan economy and trade are in *The General Theory of Employment, Interest and Money*, Harrap 1936. Christopher Hill illuminatingly describes developing attitudes to work and profit in 'The Industrious Sort of People' in *Society and Puritanism in Pre-Revolutionary England*, Seeker and Warburg 1964. An entertainingly different view of the growing effect of the Puritans, in such matters as the way the Queen danced on the Sabbath, is to be found in Fryer, P., 'The Grundy Sunday' in *Mrs Grundy: Studies in English Prudery*, Dobson 1963, and the way the arguments spilled over into the nineteenth and early twentieth century is entertainingly described in Turner, E.S., 'Sin and Saturday' in *Roads to Ruin*, Penguin 1966.

Of the many works which discuss the management and economics of Shakespeare's companies, the two most useful are Beckerman, S., *Shakespeare At The Globe 1599–1609*, Collier-Macmillan 1962, and Knutson, R.L., *The Repertory of Shakespeare's Company 1594–1613*, U.S.A.: Arkankas Press 1991.

2. The Royal Enclosures

A subtle and highly readable analysis of Royal power and patronage forms one of the main themes of Colley, L., *Britons: Forging the Nation 1707–1837*, Pimlico 1992. More polemical, and more concerned with nineteenth and twentieth century history, is Kinsley Martin's *The Crown and the Establishment*, Penguin 1963. Cooler and dryer is Ziegler, P., *Crown and People*, Cape 1978. Ian Bevan's *Royal Performance*,

Hutchinson 1954, is aimed at the popular market but contains useful anecdotal material.

Astley's employment of Dibdin is described in Speaight G. (ed.) *Memoirs of Charles Dibdin the Younger*, Society for Theatre Research 1956, while benefit performances of all kinds are acutely analysed in St. Vincent Troubridge, *The Benefit System in the British Theatre*, Society for Theatre Research 1967. The necessary background to understanding the milieu of the Kit-Cat Club is in Plumb. J., *England in the Eighteenth Century*, [Rvsd. ed.] Harmondsworth 1964, and the development of the Italian Opera in Britain is chronicled in detail by Nalbach, D. *The King's Theatre 1704–1867*, Society for Theatre Research 1972.

Yates' appeal to the Birmingham tradesmen to support a Theatre Royal in Birmingham is recounted in Salberg, D., *Ring Down the Curtain*, Cortney 1980. [A mock 'Commission of Inquiry' into the social seclusion of Queen Victoria, published in Charles Bradlaugh's *The National Reformer* on 18 September 1870 was to commend Birmingham for its continuously anti-Royal sentiments.] Shipley's work is described in detail in Allen, D.G.C., *William Shipley: Founder of the Royal Society of Arts*, Scolar 1968. Macready's outbust against Royal patronage is in Trewin, J.C. (ed.) *The Journal of William Charles Macready*, Longman's, Green and Co. 1967.

3. Industriousness and the Lottery

Much of the early material in this chapter is to be found in the special 'lottery edition' of William Hone's *Every Day Book* for 1828, published to mark the 'final appearance' of state lottery in Britain. Some of the later material is in the voluminous survey by Hodder, E., *The Life of a Century*, George Newnes 1901. The battle between the industrious working class and various pastimes, a contest sharpened by the rise of Methodism, is described in some detail in Harrison, J.F.C., *The Common People: A History from the Norman Conquest to the Present*, Fontana 1984.

A useful introduction to the mores of gambling is Walker, M.B., *The Psychology of Gambling*, Pergamon 1992, while Clapson, M. *A Bit of a Flutter: Popular Gambling and English Society, c. 1823–1961*, Manchester University Press 1992, well describes the ways in which gambling and lotteries have edged back into political favour. Maria Edgeworth's novelette, *The Lottery*, which contains some useful descriptions of the lottery in full operation, was republished in a cheap edition in 1996 by Phoenix. An account of the *Art Unions Act 1846* is in Charles Arnold Baker's *Practical Law for Arts Administrators*, City Arts 1983.

4. The Glory of Commercial Art

Quite the best general account of the arts in the eighteenth century is Brewer J., *The Pleasures of the Imagination: English Culture in the Eighteenth Century*, Harper-Collins 1997, a book which can be read in conjunction with complementary studies such as Borsay, P., *The English Urban Renaissance Culture and Society in the Provincial Town 1660–1770*, Clarendon 1989; Pears, I., *The Discovery of Painting: The Growth in the Interest in the Arts in England*, Garland 1985, and Robert Lacy's *Sotherby's: Bidding for Class*, Little, Brown 1998, which deals head-on with the way in which art collectors may have hoped to buy social status. Two other works which contain valuable background material are Impey, O.R. and Macgregor (eds.), *The Origins of Museums*, Clarendon 1985, and Herd, H. *The March of Journalism*, Allen and Unwin 1952, which deals uncensoriously with the eighteenth and nineteenth century development of newspapers and magazines in Britain.

Useful reflections of the different sides of Augustan society can be found in Coke, D., *The Muse's Bower: Vauxhall Gardens 1728–1786*, Sudbury 1978, while the coffee houses and brothels of Covent Garden are racily described in Burford, E.J., *Wits, Wenches and Wantons*, Robert Hale 1986. The earliest Friendly Societies are discussed in E.P. Thompson's classic *The Making of the Working Class*, Pelican 1968, while an interesting, though contentious, account of the history of Freemasonry in Britain can be found in Knight, S., *The Brotherhood*, Granada 1984,

The range of Cobbett's scorn can be gleaned from Sambrook, J., *William Cobbett*, Routledge and Kegan Paul 1973. Two fine studies of the century's leading artists are Poulson, R., *Hogarth*, Ratgers University Press 1992, and Penny, N. (ed.) *Reynolds*, Weidenfeld and Nicholson 1986, and an interesting study of the popular stage is Bevis, R.W., *The Laughing Tradition: Stage Comedy in Garrick's Day*, U.S.A.: University Georgia, 1980.

There are illuminating sidelights on the difficulties faced by women artists in Davis, T., *Actresses as Working Women*, Routledge 1991, and Vickery, A., *The Gentleman's Daughter: Women's Lives in Georgetown England*, USA: Yale 1998. The successful careers of Charlotte Clarke and 'Madame de la Nash' are recounted in Speaight, G., *The History of the English Puppet Theatre*, Harrap 1955. Accounts of the eighteenth century's greatest financial collapse are numerous, but the liveliest is in Mackay, W., 'The South Sea Bubble' in *Popular Delusions and the Madness of Crowds*, U.S.A.: New York 1852. William Hickey's memoirs are in Hudson, R. (ed.) *Memoirs of a Georgian Rake: William Hickey*, The Folio Society 1995.

Dr Edwards' account of the finances of weaving businesses is in *Growth of The British Cotton Trade*, Manchester University Press 1967. Dr Flynn is quoted in Mathias, P. and Davis, *The First Industrial Revolution*, Blackwell 1989. Growth in the quantity and quality of 'the reading public' is succinctly described by Protherough, R., 'Readers and Reading Publics' in *The Journal of Arts Policy and Management*, City University, Vol. 1 No. 3, December 1984, and in greater detail by Raymond Williams in *The Long Revolution*, Penguin 1965.

Ducrow's career is painstakingly described by Saxon, A.H. in *Life and Art of Andrew Ducrow*, U.S.A.: Archon 1979, while the same author has described Ducrow's problems with charities in 'The Tyranny of Charity: Andrew Ducrow in the Provinces' in *Nineteenth Century Theatre Research*, Vol. 1 No. 2, Autumn 1973.

The bizarre attractions of the fairground are memorably chronicled by Ricky Jay, *Learned Pias and Fireproof Women*, Hale 1986.

5. Industrial Revolution

The most focussed accounts of the shifts of wealth and power in the earliest stages of the industrial revolution are contained in the essays in Ward, J.T. and Wilson (eds.), *Land and Industry: The Landed Estate and the Industrial Revolution*, David and Charles 1971.

John Byng's revealing accounts of his travels are now found in Adamson, D., *Rides Around Britain: John Byng, Viscount Torrington*, The Folio Society 1996. Etruria is described in detail in Reilly, R., *Wedgwood*, Woodbridge 1989. Further questions about skills and the manufactures are interestingly raised by Roodhouse, S.C., *Arkwright's Mum Could Do It: Creativity and Innovation*, Inaugural Lecture of Arkwright Society Series, University of Derby 1995. Work ballads are placed in context by Pearsall, R., *Victorian Popular Music*, David and Charles 1973.

Aspects of Plymouth's 'arts precinct' are discussed in Trewin, J.C., *Portrait of Plymouth*, Hale 1973, while Garrard, J., *Leadership and Power in Victorian Industrial Towns 1830–1880*, Manchester University Press 1983, has some interesting accounts of the power-broking involved in building the new civic amenities of the nineteenth century. The confusions resulting from the conflict between the desires to elevate popular taste and to meet popular demand are memorably illustrated by Robert Snape, who points out that public libraries not infrequently contained billards and games rooms in 'Betting, Billiards and Smoking: Leisure in Public Libraries', *Leisure Studies II*, E and F N Spon 1992.

The provincial concert rooms form a part of an excellent analysis by

Bailey, P., 'Custom, Capital and Culture in the Victorian Music Hall' in Storch, R.D. (ed.), *Popular Culture and Custom in Nineteenth Century England*, Croom Helm 1982. The 'penny gaffs' are described in Cross, G.B., *Next Week – East Lynne*, U.S.A.: Associated University Presses 1977. William Hone's trials for 'blasphemous libel', which made him such an improbable working class hero, are described by E.P. Thompson (*op cit*)

6. The Great Exhibition

The main source for the chapter is the *Official Catalogue of the Exhibition of the Industry of All Nations 1851*, although the staunchly supportive commentaries throughout the spring summer of 1851 in *The Times* and the *London Illustrated News* are of great interest – particularly when compared to the press coverage in the run-up to the 1951 *Festival of Britain*, and the *Millennium Experience* of the year 2,000.

Political background to the Great Exhibition is contained in LeMay, G.H. 'The Ministerial Crisis of 1851' in *History Today*, Vol. 1, June 1950, in Fay, C.B., *The Palace of Industry 1851*, Cambridge University Press 1950, and in Asa Briggs' 'The Crystal Palace and the Men of 1851' in his *Victorian People*, Pelican 1965. The extract from Queen Victoria's letters is taken from Benson, A.C. and Esher (eds.) *The Letters of Queen Victoria: A Selection*, Black 1908. Delgardo, A., 'The Great Exhibition', in *Victorian Entertainment*, David and Charles 1971, offers brief but useful illustrative material while the waxworks exhibitions are described in Cottrell, L., *Madame Tussaud*, Evans 1951.

The importance of the *Great Exhibition of Art Treasures* to Manchester and the country at large can be better estimated after reading Kidd, A.J. and Roberts, *City, Class and Culture: Studies of cultural production and social policy in Victorian Manchester*, Manchester University Press 1985. Michael Harrison's essay in that volume, 'Art and Philanthropy: T.C. Horsall and The Manchester Art Museum' also provides useful background material to understanding the later nineteenth century.

7. Provision for the People

The surge to urban living is discussed in Olsen, D.J., *The Growth of Victorian London*, Batsford 1976, while its consequences for the countryside are analysed in Mingay, G.E., *Rural Life in Victorian England*, Sutton 1976. Smiles work is analysed in Asa Briggs' essay, 'Samuel Smiles and the Gospel of Work' published in *Victorian People* (*op cit*), in which Charles Kingsley is quoted. Ruskin's 1870 outburst and

Dr Whewell's philosophising are both discussed in Gillian Naylor's excellent essay, Design, Craft and Industry' in Ford, B. (ed.), *The Cambridge Cultural History of Britain*, Cambridge University Press Vol. 7, 1989. The rise in the importance of the engineer is well documented in Gerstl, J.E. and Hutton, *Engineers: The Anatomy of a Profession*, Tavistock 1966.

The world of the magic lantern is precisely evoked in a little study by Gordon, C., *By Gaslight in Winter: A Victorian Family History Through the Magic Lantern*, Elm Tree 1980. Newark's brewing history is racily recounted in Pask, B.M., *Newark: The Bounty of Beer*, Notts. County Council and Newark and Sherwood District Council 1997, and the tragic Exeter fire is described in Crane, H., *Playbill*, Macdonald and Evans 1980. The growth in Victorian music-making of all kinds is described by Maurice Wilson Disher in *Victorian Song. From Diva to Drawing Room*, Phoenix 1955; the spread of education and the rise in reading in the late nineteenth century analysed by Hunter, I., *Culture and Government: the emergence of Literary Education*, Macmillan 1988, and some of the causes of the nineteenth century rise in the West End audience described in Pick, J., *The West End: Mismanagement and Snobbery*, Windmill 1983.

H.G. Wells' comments on the 1870 Act come from *The Outline of History, Everyman* 1920. Much of the material on Hullah comes from Meckerness, E.D. (*op cit.*). Wilde's importance has been significantly enhanced in a recent biography by Richard Ellmann, *Oscar Wilde*, Penguin 1988, and his *Pall Mall Gazette* review is republished in Holland, M. (ed.), *Oscar Wilde: Letters and Essays*, Folio Society 1995. There have been no better books written on Irving than the *Personal Reminiscences of Henry Irving*, written by his manager Bram Stoker, published by Heinemann in 1907, and the standard biography, Irving, L., *Henry Irving: The Actor and His World*, Faber 1951. His remarks on the necessity of an art 'succeeding as a business' – so generally misunderstood – are published in *The Drama Addresses of Henry Irving*, Heinemann 1895.

8. The Horrors of Tourism

The best British source is Ousby, I., *The Englishman's England: Taste, Travel and the Rise of Tourism*, Cambridge University Press 1990, while the world-wide phenomenon is described by Feifer, P., *Tourism in History*, U.S.A.: Stein and Day 1986. Tourism's origins are examined by Towner, J., 'The Grand Tour: A Key Phase in the History of Tourism' in *Annals of Tourism Research* 1985. The authoritative history of the spa

resors is Hembry, P., *British Spas from 1815 to the Present*, Athlone 1997, while details of the growth of Britain's premier seaside resort may be found in Walton, J., *Respectable Morality and the Rise of the Entertainments Industry: The Case of Blackpool*, in *Literature and History*, Vol. l, Thames Polytechnic 1975.

Charles Dickens' letter is from *The Unpublished Letters of Charles Dickens to Mark Lemon*, Halton and Truscott Smith 1927. *Retreshments for Travellers* was first published in 1865 in a collection of Dickens pieces, *The Uncommercial Traveller*, taken from *All the Year Round*, and is now published, with additions, in the *Oxford Illustrated Dickens*, OUP 1958. *The London Dictionary and Guide Book for 1879* by Charles Dickens the Younger was published in that year by Howard Baker.

The content of music hall songs is analysed by Colin MacInness in *Sweet Saturday Night*, Panther Arts 1967. W.H. Leverton's reminiscences of his pierrot days in Weymouth and Torquay are in 'A Busking Interlude' in *Through the Box Office Window*, T. Werner Laurie 1932. A short history of the pier's construction is given in Thompson, A.E., *Skegness Pier 1881–1978*, Albert E. Thompson 1989. The authoritative survey of housing and the garden city movement is contained in Cole, G.D.H. and Postgate, *The Common People 1746–1946*, (revsd.) Methuen 1946, and Bowley, M., *Housing and the State 1919–1944*, Allen and Unwin 1945.

The infamous Stratford Jubilee is beautifully described by Stockholm, J.M., *Garrick's Folly: The Shakespeare Jubilee of 1769*, Methuen 1964. Rick Gruneau's essay 'Commercialism and the Modern Olympics' is in Tomlinson, A. and Whannel (eds.), *Five Ring Circus; Money, Power and Politics at the Olympic Games*, Pluto Press 1984. There is brief but useful information on the between-the-wars holiday camps in Yass, M., *Britain Between the Wars 1918–1939*, Wayland 1975.

9. Mass, Messages and the Media

Workhouses are graphically described in Crowther, M.A., The *Workhouse System 1834–1929*, Basford 1981. Useful information on the funding of the repertory companies between the wars is in Jarrams, R., *Weekly Rep*, Peter Andrew 1991. The richest source of early broadcasting history in Britain is Asa Briggs' *The History of Broadcasting in the United Kingdom* Vols 1 and 2 OUP 1961, 1965, but a succinct account of its beginnings can also be found in Parker, D., *Radio: The Early Years*, David and Charles.

Cinema's beginnings are recorded in Barr, C., *All our Yesterdays: Ninety Years of British Cinema*, B.F.I. 1986, and in Perry, G., *The Great British Picture Show*, Paladin 1975. The cinema buildings are lovingly

described in Atwell, D., *Cathedrals of the Movies*, Architectural Press 1980: one British studio in George Perry's *Forever Ealing*, Pavilion 1985, and one British film entrepreneur in Moorehead, C., *Sydney Bernstein*, Cape 1984. The career of the man who dominated the British cinema for so long is examined in Wakelin, M., *J. Arthur Rank*, Lion 1996 – while his actions may be better understood after reading Thomson, G. and Brake, *Policy and Politics in British Methodism*, Esdall 1984. The growth and tribulations of the developing music profession are recounted in detail in Erlich, C., *The Music Profession in Britain since the Eighteenth Century*, Clarendon Press 1985, while the activities of three early music impressarios are pithily recounted in Stockdale, F., *Emperors of Song*, Murray 1998.

Adorno, T. and Horkheimer's frequently quoted essay, 'The Culture Industry: Enlightenment as Mass Deception' is from their *Dialectic of Enlightenment* (trans. John Cumming), U.S.A.: The Seabury Press 1972. Richard Dyer's paper 'Entertainment and Utopia', which argues that the seeming escapism of mass entertainment nevertheless meets real needs, was first published in *Movie* in 1977. The comfortable world of one soap opera was acutely analysed in Hobson, V., *Crossroads: The Making of a Soap Opera*, Methuen 1982, while the old-fashioned air of another, 'Coronation Street', was gently dissected by Roy Hattersley in his *Granada Lecture* 1993. A recent analysis suggesting that news and soap operas are now equally sentimental is contained within Mark Steyn's essay, 'All Venusians Now' in Anderson, D. and Digby, *Faking It: the Sentimentalisaion of Modern Society*, Social Affairs Unit 1998. A contrary (pro-feminist) analysis of aspects of popular culture may be found in Judith Williamson's *Consuming Passions*, Marion Boyars 1986.

Orwell's remark is taken from his 1947 essay, 'The Prevention of Literature'. The authorities' plans for the 'ideal' workhouse were published in the *Fifth Annual Report of the Poor-Law Commissioners 1839* and can be revealingly studied alongside the post-war state promotion of the 'ideal' arts centre in *Plans for an Arts Centre*, Lund Humphreys 1946.

10. Nationalisation of the Arts

The history of the National Gallery is succinctly given in Potterton, H., *A Guide to the National Gallery*, 1990, and that of the Tate, in more detail, in Spalding, F., *The Tate: A History*, Tate Publishing 1998. Beerbohm Tree's remarks are in Tree, H.B., *Thoughts and Afterthoughts*, Cassell 1913, and Kenneth Clark's in the second part of his autobiography, *The Other Half*, Murray 1971. Standard descriptions of

the post-war school systems are Stewart, J., *The Making of the Primary School*, Open University Press 1986, and Rubinstein, D. and Simon, *The Evolution of the British Comprehensive School 1926–1972*, Routledge 1973.

Two interesting books warned of post-war trends towards cultural vacuity, Katz, E. and Gurewitch, *The Secularisation of Leisure*, Faber 1976, and Walvin, J., *Leisure and Society 1850–1950*, Longman 1978, but more important than either is Richard Hoggart's *The Way We Live Now*, Chatto and Windus 1995, which offers a scathing indictment of the relativism of the times, and which covers the widest possible cultural field.

The apologia for the 1951 *Festival of Britain* is taken from *The Official Book of the Festival of Britain*, Lund Humphreys 1951. It is in W.E. William's 'Secretary General' report in the *Annual Report of the Arts Council 1951/2* that his distaste for working with street parties and local galas is expressed.

11. The Mirage of the Millennium

Two recent publications which may prove useful are Benjamin, M., *Living at the End of the World*, Picador 1997, and Hanna, N. (ed.), *The Rough Guide to the Year 2,000*, Rough Guides 1998.

Some of the problems in correctly dating 'The Millennium' are tersely summarised by Arnold-Baker, C., *Against the Monstrous Millennium*, New Law Journal 70, 1997. A useful source both for the biblical and early historical material in this chapter (apart from *The Bible* itself, which seems to have been more or less ignored in the press debates about why the Millennium matters) is the impressive study by Thomas, K., *Religion and the Decline of Magic*, (revsd.) Weidenfeld and Nicholson 1997. Nostradamus' forecast – the accuracy of which will have been demonstrated shortly after the publication of this book – is contained in *The Prophecies of Nostradamus*, Geddes and Grosset 1996.

Joanna Southcott's words are from *A Warning to the World*, 1804. Ruskin and Morris' views are discussed by Naylor, G. (*op cit*). Lawrence's essay was first published in *The New Adelphi*, June–August 1930. Herbert Read's vision of the future was first published in *The New Scientist*, and subsequently in *The World in 1984*, Penguin 1964.

Carl Gustav Young's explanation of millennial hysteria is wryly discussed by Showalter, E., *Histories: Hysterical Epidemics and Modern Culture*, Picador 1997. Charles Handy's theories are very gradually revealed in Handy, C., *The Empty Raincoat: Making Sense of the Future*, Arrow Books 1995. Eva Jiricna was quoted in *The Observer*, 1 March 1998. A suggestion as to the means whereby the incoming government

was persuaded to proceed with the Millennium Dome was offered by Simon, S. 'How New Labour Was Made to Love the Dome' in *The Spectator*, 23 August 1997.

12. Shadows and Illusion

A particularly useful source book for the first decades after the war is Marwick, A., *British Society Since 1945*, Pelican 1982. The descriptions of the first state-subsidised performing arts company are taken from Ellaline Terriss, *Ellaline Terriss By Herself*, Cassell 1928, and those of the Arts League of Service from Eleanor Elder, *Travelling Players: The Arts League of Service*, Muller 1939. Tyrone Guthrie's comments are contained in Guthrie, T., *A Life in the Theatre*, Hamish Hamilton 1959.

The 'devil's compact' between arts charities and the arts councils, which led to such absurdities in the administration of the entertainments tax, is divertingly recounted by A.P. Herbert in his classic *No Fine On Fun*, Methuen 1957. The life of the patron whose influence was supposedly extinguished by high post-war taxation is chronicled in Blunt, W., *John Christie of Glyndebourne*, Geoffrey Bles 1968. *Policy for the Arts: The First Steps* was published by H.M.S.O. in 1965.

Notions of 'cultural diplomacy' are unblushingly discussed in Mitchell, J.M., *International Cultural Relations*, Allen and Unwin 1986, while other aspects of the 'management'-dominated 1980s may be gleaned from Wright, W., *Britain in the Age of Economic Management*, OUP 1979, Gershuny, J. *After Industrial Society: The Emerging Self-Service Industry*, Macmillan 1979, and Gill, C., *Work, Unemployment and the New Technology*, Polity Press 1985. Two useful essays on the way 'management' has operated within what is now often known as 'the education industry' are Lowe, R., 'Educating for Industry' and Fielden, J., 'The Shifting Culture of Higher Education' in Wright, P.W., *Industry and Higher Education*, OUP 1990.

Virginia Bottomley's ringing endorsement of Sir Ernest Hall was given in the *Royal Academy of Arts* Annual Dinner, 3 June 1996. Attention was drawn to the current confusion over public charities by Matthew Parris in *The Times* 12 December 1997, and countered by an article in the same newspaper by Dr. Frank Prochaska, 'Let charity begin with charities', 19 December 1997.

There are many provoking guides to our cultural state as we pass (or finish, or begin) 'The Millennium', including the excellent Hoggart (*op cit*) and James, O., *Britain on the Couch*, Century 1998. Ian Robinson's remark is taken from his sharp and witty 1998 essay 'Faking Emotion' in *Faking It* (*op cit*).

The notion of *Cool Brittania* was first hymned on the eponymous track of a Bonzo Dog Doo Dah Band L.P. in 1964 (Solo: Stanshall, V.) and which had the pretensions of Wilson's New Labour Government as one of its targets. By the time that the new Culture Secretary published his book (Smith, C., *Creative Britain* Faber 1998), a collection of short speeches for the most part delivered to exclusive Central London arts gatherings, he was warning us that the phrase was overused.

In view of the authorities' seeming wish to submerge artists within the toils of the new 'creative industries', and to replace art with any kind of created event or construct deemed by them to be sufficiently glamorous and profit-making, perhaps the most appropriate final recommendation should be Calcutt, A., *Arrested Development; Pop Culture and the Erosion of Adulthood*, Cassell 1998.

INDEX

ART WORKS
mentioned in text

[b – fiction; f – film or t.v. production; p – play; m – music or opera; pm – poem; v – painting, engraving or sculpture.]

PROCLAMATIONS, ACTS OF PARLIAMENT and AMENDMENTS mentioned in text